Yale
Publications
in the
History of
Art

Walter Cahn, editor

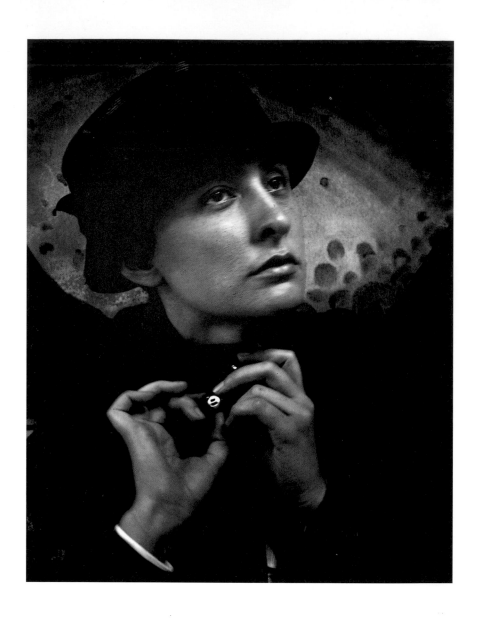

Ambition & Love in Modern American Art

Jonathan Weinberg

Yale University Press · New Haven & London

Published with assistance from the foundation established in memory of Calvin Chapin of the Class of 1788, Yale College.

Also published with the assistance of the Frederick W. Hilles Publication Fund of Yale University.

Yale Publications in the History of Art are works of critical and historical scholarship by authors formerly or now associated with the Department of the History of Art of Yale University. Begun in 1939, the series embraces the field of art-historical studies in its widest and most inclusive definition.

Series logo designed by Josef Albers and reproduced with permission of the Josef Albers Foundation.

Frontispiece: Alfred Stieglitz, *Georgia O'Keefe: A Portrait—Head,* 1918, silver gelatin developed-out print mounted on paper board, 9 ¾ x 7 ¹¹/₁₆ in. National Gallery of Art, Washington, D.C., Alfred Stieglitz Collection

Designed by Richard Hendel
Set in New Baskerville, Bodoni, and Didot types by B. Williams & Associates
Printed in Italy
by Conti Tipocolor

Library of Congress Cataloging-in-Publication Data
Weinberg, Jonathan, 1957–
Ambition and love in modern American art / Jonathan Weinberg.
 p. cm.—(Yale publications in the history of art)
Includes bibliographical references and index.
ISBN 0-300-08187-1 (alk. paper)
1. Art, American—Themes, motives. 2. Art, Modern—20th century—United States—Themes, motives. I. Title. II. Series.
N6512.W387 2001
709'.73'0904—dc21 00-011955

A catalogue record for this book is available from the British Library.

10 9 8 7 6 5 4 3 2 1

Contents

Acknowledgments, vii

Introduction: Behaving Talented, ix

PARENTS

1 Origins: The Artist's Mother, 3

2 Picasso in Pollock, 29

3 Staged Artist: Sally Mann's *Immediate Family,* 54

AUTONOMY

4 The Hands of the Artist:

 Alfred Stieglitz's Photographs of Georgia O'Keeffe, 73

5 Woman without Men: O'Keeffe's Spaces, 104

6 A Rake Progresses:

 David Hockney and Late Modernist Painting, 139

COLLABORATIONS

7 Famous Artists:

 Agee and Evans, Caldwell and Bourke-White, 179

8 The Bombing of Basquiat, 211

9 Advertisements for the Dead, 242

 Notes, 275

 Index, 301

 Photo Credits, 313

FOR NICK

Acknowledgments

One of the themes of this book is the power of names. And so it is fitting that I begin by mentioning the names of those who helped me along the way. I thank the following friends and scholars for their assistance: Amy Cassandra Albinson, Michael Bongiorni, Randall Boursheidt, Richard Brettell, T. J. Clark, Benita Eisler, Betsy Fahlman, Richard Field, Ann Gibson, Elizabeth Glassman, Romy Golan, Sarah Greenough, Serge Guilbaut, Barbara Haskell, Elizabeth Hellman, Anne Higonnet, Kellie Jones, Bruce Kellner, Wayne Koestenbaum, Marilyn Kushner, David Lida, Barbara Buhler Lynes, Patrick McCaughey, Maurie McInnis, Cindy "Gert" McMullin, Richard Marshall, Richard Martin, Patrick Moore, Linda Nochlin, John O'Brian, James and Elana Ponet, George Renz, James Robinson, Cynthia Russett, Emily Sobel, Thomas Sokolowski, John Smith, Sally Stein, Robert Farris Thompson, Alan Trachtenberg, Marina van Zuylen, Alan Wallach, Edmund White, Cecile Whiting, Patricia Willis, Kristina Wilson, William S. Wilson, and Andrea Wood.

I particularly wish to thank David Hockney for meeting with me and sharing his thoughts on his work. My warmest appreciation goes to Alejandro Anreus and Diana Linden, collaborators on another book project, for their advice and friendship.

The following institutions graciously offered their help: the Beinecke Rare Book and Manuscript Library of Yale University, the Demuth Foundation, the Estate Project, the Georgia O'Keeffe Foundation, the Georgia O'Keeffe Museum, the NAMES Project, the National Gallery of Art, and the Andy Warhol Museum.

I had a strong team at Yale University Press producing this book. Judy Metro, senior editor, enthusiastically supported this project from the beginning, and Patricia Fidler and Jeffrey Schier saw it through to the end. The book reflects the superb editing and criticism of Karen Gangel, manuscript editor, and the excellent design of Rich Hendel. Susan Smits and Christopher Dobosz undertook the difficult task of obtaining illustrations and permissions.

The research and materials for this book were supported by Yale Uni-

versity, through a Mellon Fellowship, a Senior Faculty Fellowship, and grants from the Griswold Fund and the Fund for Lesbian and Gay Studies. Diane Dillon, Barbara Buhler Lynes, Catherine Lynn, and Anne Wagner read sections of the book and gave me invaluable criticism. Michael Lobel's suggestions were enormously important for the final shape of the book. I want to thank Thomas Crow, Maria Georgopoulou, Christopher Wood, and Mimi Yiengpruksakwan for their intellectual stimulation, advice, and support. The decency and courage of Esther da Costa Meyer have been a storehouse of strength for me during some difficult times. We have both been fortunate to have had Vincent Scully as our adviser when we were students at Yale. He continues to be our mentor and hero. Two friends are everywhere in this book: Eugene Glynn, who introduced me to art history, and Maurice Sendak, who inspired me to paint. I count them among my extended family, along with Rhoda Wolf, and my partner and collaborator, Nicholas Boshnack, for whom *Ambition and Love in Modern American Art* is dedicated.

Introduction: Behaving Talented

Ambition and Love in Modern American Art begins with the premise that the question of quality in art—the value we assign to an artist's style and practice—cannot be separated from the issues of fame and desire. Twentieth-century artists work not only in the studio but also on the world of public opinion. Making great art involves constructing a suitable context for an artistic practice, fitting into a historical or critical construct, establishing an audience, forging a reputation and name. Even the rejection of authorship through such strategies of reproduction and appropriation has become a means to fame in the modern and postmodern art market.

Various attempts to disengage the work of art from the supposed distraction of the signature have done little to dilute the value of the name. According to Linda Merrill, when James McNeill Whistler worried that his signature might "interfere with aesthetic experience," he developed a butterfly as his attribute.[1] Removing his signature might seem like an act of modesty. In fact, at first Whistler's butterfly did not register as a signature, but eventually it became synonymous with the artist, drawing more attention to his name than if he had simply signed his canvases. In effect, Whistler had invented a trademark for himself that he stamped on all his pictures and publications.

The trademark suggests not only authorship but also money, and money was at the center of the scandal concerning Whistler's *Nocturne in Black and Gold: The Falling Rocket* (fig. 1). Whistler sued John Ruskin in response to Ruskin's famous charge against the painter and his nocturne: "I have seen, and heard, much of Cockney impudence before now; but never expected to hear a coxcomb ask two hundred guineas for flinging a pot of paint in the public's face."[2] As Merrill points out, the passage is rarely quoted in context where it is a postscript to a discussion of the proper relationship of labor to a just society. Ruskin was less concerned about market prices than he was with the idea that a given work of art demonstrate a high degree of craft. Nevertheless, the reference to an inflated price has the unintended result of fixating the reader's attention on the relationship of art making to money. And to

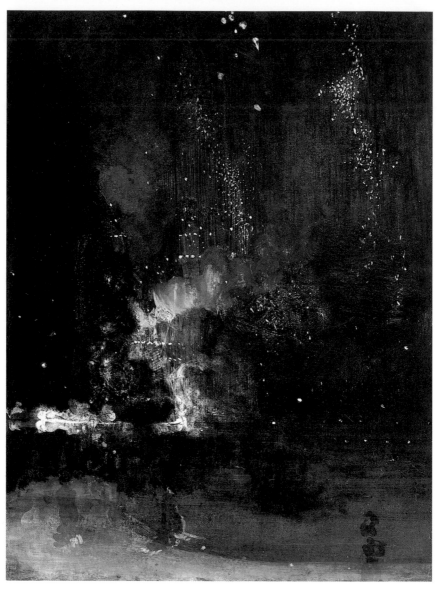

FIGURE 1 *James McNeill Whistler,* Nocturne in Black and Gold: The Falling
Rocket, *ca. 1875, oil on panel, 23 ¹¹/₁₆ x 18 ³/₈ in. Detroit Institute of Arts, gift of Dexter
M. Ferry, Jr.*

Verdict for plaintiff. **Damages one farthing.**

FIGURE 2 *James McNeill Whistler, "Verdict for plaintiff. Damages one farthing," from James McNeill Whistler,* The Gentle Art of Making Enemies *(London, 1890)*

defend Ruskin against libel, his lawyer spent considerable time in court determining whether two hundred guineas was an appropriate amount for a canvas that took Whistler only a day and a half to paint. Ruskin was given to decry industrial society's emphasis on money, but his suggestion that Whistler was gouging his customers implies that works of art had a proper monetary value. Likewise, for all of Whistler's supposed espousal of a doctrine of art for art's sake, he was well aware that price was equated with status. In the end, it was a low monetary award—one farthing—that invalidated Whistler's victory in the libel suit. But, as Merrill points out, this "ignominious farthing was turned into a trophy."[3] Whistler created an image of the settlement in which his surrogate, the butterfly, wraps itself around a farthing (fig. 2). The effect is to confuse the artist's signature with the coin of the realm.

The fuss made over Whistler's *Nocturne in Black and Gold: The Falling Rocket* is puzzling: it is a surprisingly small picture, measuring just twenty-four by eighteen inches, and it contains no scantily clad prostitutes or downcast peasants, no attacks on religion or government. Whistler's painting is dwarfed by the other scandalous paintings of the avant-garde: Courbet's *Burial at Ornans,* Manet's *Le Déjeuner sur l'herbe,* Picasso's *Les Demoiselles d'Avignon,* Duchamp's *Nude Descending the Staircase,* and so on. But the very modesty of *Nocturne in Black and Gold* con-

tributed to the picture's scandal. To its critics it seemed to be almost nothing at all. Burne-Jones, defending Ruskin from Whistler's charge of libel, said of the *Nocturne* that at best it should be regarded as a "sketch," not a finished painting.[4] Others at the trial compared Whistler's pictures to wallpaper. The emptiness of Whistler's *Nocturne in Black and Gold* suggested that he was incompetent or lazy, and the artist's price of two hundred guineas was called a scam or joke.

Of course, the scandal of Whistler's work was in part the scandal of Whistler's behavior, his ostentatious dress, and his unconventional lifestyle. Degas supposedly said to Whistler, "You behave as though you have no talent."[5] The implication is that only an untalented artist would make a spectacle of himself as Whistler did by suing Ruskin. After all, what does it matter what critics write? Degas probably thought that making great pictures was an activity that occurs in the studio and that questions of fame and sales are extraneous to questions of quality. In contrast, Whistler invited publicity and scandal. He sensed that artistic reputations were forged through establishing contexts, setting prices, positioning oneself in the art world and, if not controlling criticism, making sure that the artist was its subject. Whistler sensed that talent is a matter of convincing others that you are talented.

Like Whistler's, Georgia O'Keeffe's biography has seemed to take precedence over the appreciation of her art. She too courted scandal when she posed nude for Alfred Stieglitz. But in contrast to Whistler, she worried about the ill effects of being concerned with what others might think about her work. In one of her earliest extant letters, she writes to her friend Anita Politzer that Stieglitz is her ideal audience: "I believe I would rather have Stieglitz like something—anything I had done—than anyone else I know of—I have always thought that." But then she worries:

> I dont [*sic*] see why we ever think of what others think of what we do—no matter who they are—isn't it enough just to express yourself— If it were to a particular person as music often is—of course we would like them to understand—at least a little—but why should we care about the rest of the crowd—If I make a picture to you why should I care if anyone else likes it or is interested in it or not[—]I am getting a lot of fun out of slaving by myself—The disgusting part is that I so often find myself saying—what would you—or Dorothy—or Mr. Martin or Mr. Dow—or Mr. Bement—or somebody—most any-body—say if they saw it—It is curious how one works for flattery.[6]

O'Keeffe oscillates between the desire for approval from Stieglitz, or Dow, or Politzer, and the insistence that her goal is to express herself. She imagines an ideal audience made up of her closest friends and her former teachers but ends up deciding that the real audience is herself.

In a later letter O'Keeffe returns to a paradox: "I decided I wasn't going to cater to what anyone else might like—why should I—and when you leave that element out of your work there is nothing much left." She adds, "Im [sic] floundering as usual."[7] It turns out that to eliminate entirely the influence of her teachers, friends, and critics is virtually impossible. They inhabit her mind even when they are not present. The artist's own critical faculties are the product of training. Where to make a mark or apply a color, what is worth painting, and what can safely be ignored, finally what constitute an acceptable picture—these are decisions that the artist makes as a result of training and in response to real and imagined audiences. What O'Keeffe calls the artist's desire for "flattery" is a necessary part of the process of finding a voice. Yet at the same time producing an art that is too familiar, too acceptable, also threatens the process of finding a personal style.

At issue here is the problem not just of originality but also of ownership. In another letter O'Keeffe gives Stieglitz carte blanche to do with her drawings as he will: "They were only mine alone till the first person saw them— . . . I wouldn't mind if you wrote me that you had torn them all up—I don't want them—I don't want even to see them—but I'm not always the same—sometime I may have to tear them all up myself—You understand—they are all as much yours as mine."[8]

What may seem like O'Keeffe's greatest compliment to Stieglitz, entrusting him with her work's future, is fraught with anxiety—the idea that either one might have to destroy the work. Or to put it another way, once the picture is created and seen, it ceases to be the artist's work at all. The shifting from creating to exhibiting, which is the very means by which the artist's name becomes a well-known commodity, is destabilizing. O'Keeffe loses touch with what belongs to herself and what belongs to her audience.

This book grapples with twentieth-century artists' anxiety about the presence and absence of the self in the work of art. O'Keeffe's words suggest to me the famous statements by Jackson Pollock and Jasper Johns about their relationship to their work. In the chapter "Picasso in Pollock" I make much of the curious pronouncement that Pollock had found a way into his painting. Built into this entrance was the possibility

of falling out: "When I am *in* my painting, I'm not aware of what I am doing. It is only after a sort of 'get acquainted' period that I see what I have been about. I have no fears about making changes, destroying the image, etc., because the painting has a life of its own. I try to let it come through. It is only when I lose contact with the painting that the result is a mess."[9]

When Pollock loses contact with the work of art, it is a mess. In contrast, Johns consciously attempted to depersonalize the aesthetic process by detaching himself from his work: "I have attempted to develop my thinking in such a way that the work I've done is not me—not to confuse my feelings with what I produced. I didn't want my work to be exposure of my feelings. Abstract Expressionism was so lively—personal identity and painting were more or less the same, and I tried to operate the same way. But I found I couldn't do anything that would be identical with my feelings. So I worked in such a way that I could say that it's not me. That accounts for the separation."[10]

Pollock's and Johns's conceptions of the work of art and its relationship to the artist's self appear to be entirely different. Pollock wants his painting to be him, Johns wants it to be entirely other. Still, both artists conceive of the work of art as an object that defines selfhood. Pollock determines success when there is no distinction between himself and the object. He paradoxically establishes his selfhood by losing himself in his painting. Johns insists that success is determined only when he knows the work of art is not himself. Such a process suggests an erasure of the signs of selfhood in the work of art, hence Johns's reliance on schematic images, things that he said "exist as clear facts."[11] Johns's goal of being entirely outside a work seems to be a less ambitious project than Pollock's, but in fact, to know what is not the self, one must have a conception of what is the self. Johns's ideal of separation is a chimera, since it is impossible to divorce the subject from its objects. And so if Pollock's complete identification with the work of art is impossible, so is John's disidentification.

In O'Keeffe's worries about the opinions of her teachers, or Johns's rejection of an Abstract Expressionist aesthetic, we sense what Harold Bloom calls the "anxiety of influence," the fear that what one wants to say has already been said. The chapter "Picasso in Pollock" draws heavily from Bloom's work. I have come to believe, however, that Bloom's conception of aesthetic influence is far too narrow, too dependent on a limiting conception of the Oedipal process. For Bloom, "strong" poets are driven by competition with their poetic fathers who threaten their

sense of selfhood. The young artist is always belated because what he would like to say has already been said by earlier masters. But surely, if the story of artistic influence is truly a family romance, it is driven by multiple mothers, fathers, and siblings. Its terms are more complex, nonlinear, and less predictable than Bloom suggests. Bloom himself admits that he is largely uninterested in the social context of art. He writes that he is well aware that other factors contribute to artistic careers and affect the content of artists' work, but that is not his interest: "That even the strongest poets are subject to influences not poetic is obvious even to me, but . . . my concern is only with *the poet in a poet*."[12] But in truth Bloom is not only interpreting poetic influence. He also relentlessly sets up and defends a particular canon. Although I am not concerned with creating or critiquing such a canon, I think the question of how canons are formed cannot be separated from the social forces that Bloom feels are inessential to understanding the "poet in a poet." Artistic competition and influence are not merely a matter of Bloom's aesthetic borrowings and transformations; they have a social component. The very relentlessness of Bloom's story of artists fighting over ever diminishing artistic turf has the quality of an economic and political struggle.

Alfred Stieglitz reportedly claimed that to photograph is to make love.[13] David Hockney was moved by Peter Adam's assertion that "painting is like love making." He said to Adam: "I must express the feeling—that of love. I think one wants the art to communicate, to share an experience and make it so that it can be relived, vividly."[14] Several of the chapters in this book focus on how works of art might express love. Whistler's *Arrangement in Grey and Black: Portrait of the Painter's Mother* is an adoring son's homage to his mother. Stieglitz's photographs of O'Keeffe are images of seduction and flattery. Charles Demuth's poster portraits are gestures of friendship. And Sally Mann's images are akin to a mother's embrace. But if the work of art embodies private affection, it is also about seducing the public; to paraphrase Norman Mailer, it is an advertisement for the self.

Freud claimed that the artist's longing for fame, money, and power goes hand in hand with the wish for love. In his *Introductory Lectures on Psycho-Analysis* he claims that the artist "desires to win honour, power, wealth, fame and the love of women; but he lacks the means for achieving these satisfactions." Freud supposes that the artistic constitution "includes a strong capacity for sublimation . . . with a certain degree of laxity in the repressions which are decisive for a conflict." Like "any

other unsatisfied man" the artist daydreams, but unlike nonartists he knows how to "work over his day-dreams in such a way as to make them lose what is too personal about them" and "he understands, too, how to tone them down so that they do not easily betray their origin from proscribed sources." The artist also attaches to the work of art "so large a yield of pleasure to this representation of his unconscious phantasy that, for the time being at least, repressions are outweighed and lifted by it." According to Freud the artistic process begins with the artist's frustrated desires but ends with fulfillment. The successful artist "makes it possible for other people once more to derive consolation and alleviation from their own sources of pleasure in their unconscious which have become inaccessible to them; he earns their gratitude and admiration and he has thus achieved *through* his phantasy what originally he had achieved only in his phantasy—honour, power and the love of women."[15]

There is much reason to discount Freud's analysis of what motivates artistic creation. Freud assumes from the outset that the artist is male, and that he is driven by heterosexual longing (an odd lapse given Freud's famous study of Leonardo's homosexual tendencies).[16] Even if we attribute Freud's chauvinism and heterosexism to the prejudices of fin-de-siècle Vienna, there are other problems. Freud assumes the late Romantic concept that the artist is "in rudiments an introvert, not far removed from neurosis." The artist's "excessively powerful instinctual needs" impel him to make art. Indeed, in separating artistic production from other acts of inspiration—the discovery of a vaccine, the invention of a new machine, the design of a highway—he reveals a questionable notion that artists are somehow different from other types of creative individuals. Yet, where Freud seems to endorse the concept that the artist is set off from the businessman and scientist, he does not flatter the profession. The passage ends with a decidedly anti-Romantic view of the artist's motivations. Although elsewhere Freud claims he is rendered mute by the problem of artistic genius, in this passage there is nothing about the ineffability of the creative process. Rather it is described as the translation of pedestrian daydreams into more permanent and satisfying form. Freud's artist is, therefore, not so much a dreamer as a realist, and art is "the path that leads back from phantasy to reality." Frequently Freud compliments artists for their insights that anticipate his own discoveries. *The Introductory Lectures on Psycho-Analysis* are peppered with quotations from poets and novelists. Yet in this passage the artist's realism comes not from understanding the true nature of the human mind but from his talent for converting fantasy into real-

ity. In this sense the artist's fantasies are not fantasies at all, but reasonable predictions of the achievements he or she might actually attain in the world. Above all, Freud's artist, for all his supposed introversion and near neurosis, is no hermit or misanthrope. Like anybody else, he or she is motivated by greed, vanity, and love.

Unlike Freud, I am wary of making general claims about the nature of artists or their difference from the general lot. You will not find in these pages a universal theory of the artist or an explanation of creativity. That is not to say that I do not at times make use of such theories. My goal is not to prove Freud right or wrong, nor to offer up my own theory of creativity, but to use his purposely contentious and, some would say, patronizing assessment of artistic motivation as a springboard for a series of ruminations on the relationship between desire and art. I am fascinated by Freud's idea that artistic production may be driven by a longing for something the artist cannot have. Yet the chapters in this book are not so much about art as sublimation or delayed gratification (the artist turning base metal into gold) as about the way the artistic process is mired in desire, vanity, competition, and even revenge (gold reverting to base metal). How do works of art get, or fail to get, the things that artists want? How does ambition interact with talent and love? What role does the drive for wealth and celebrity play in artistic creation?

I have for the most part sidestepped many of the controversies about Modernism that have obsessed so much of art historical debate of the 1980s and 1990s. Although Clement Greenberg's concept of the history of modern art as a process by which the medium removes everything extraneous to its essential nature has been universally discredited, most studies of twentieth-century art still create narrative in which each new work of art criticizes an early predecessor. Such stories are not false and they are frequently compelling. I tell them myself. But whether a critic sees modern art moving toward the blank canvas or the Brillo box, it seems difficult to avoid a sense of inevitability. Works of art that do not fit into certain paradigms and structures are deemed inconsequential or reactionary. The most successful artist quickly becomes obsolete. Whatever object made the artist famous in the first place (often at a young age) increasingly fulfills his or her contribution to the master narrative. And so it is common to find a painter like Frank Stella bitterly lamenting the prestige of his earliest work because, in all the standard accounts, it has eclipsed everything he did later.[17] It is not that the various artists that I look at in this book were not involved in a critique of

their predecessors. But I think there are ways of looking at their work that do not privilege such cognitive enterprises. One of the reasons I take up Adrian Stokes's writings in the first chapter is his emphasis on the process of making as it is transferred to the viewer. Such making is not only a matter of learning and critiquing the tradition; it is also about forging an experience of integration. To put it another way, Stokes dreams not of the autonomy of the artwork but of the autonomy of the artist and viewer, an autonomy achieved, paradoxically, by means of our merging with the work of art. Such a merging has the quality of love.

Written over a ten-year period, this book reflects my own shifting identification with certain artists and objects that has been worked out during the process of teaching art history and working in the studio as a practicing painter. And yet for all their diversity, my subjects are linked in terms of recurring themes of competition, and the attempt not to compete—the ways in which desire for another's practice merge with erotic desire. I am particularly interested in exploring extreme moments in artistic careers, eccentric acts in which the artist struggles to gain or maintain the attention of an increasingly jaded audience.

This need to engage the viewer often takes the form of an intense competition in which artists seem intent on obliterating the work of their predecessors. Famously, Robert Rauschenberg literally erased a Willem de Kooning drawing. As if to refuse the competitive nature of the art world, certain artists have formed partnerships. Yet competition does not disappear when artists for various reasons decide to collaborate. I discuss at length the anxious quality of the partnership of Walker Evans and James Agee, even as it competes with that of Erskine Caldwell and Margaret Bourke-White. Ego, rather than being repressed in collaboration, is raised to the fore, as was the case of the partnership of Jean-Michel Basquiat and Andy Warhol. My contention is that the gulf between Basquiat and Warhol in terms of age, sexual identity, and race created enormous tensions in their relation and work. Collaboration collapsed into mutual exploitation.

Warhol was not the only one who used Basquiat; he was joined by Julian Schnabel and Rene Ricard among others. Critics like Robert Hughes have used Basquiat's story as a morality play about the wages of celebrity and hype. I, too, could be said to be exploiting the Basquiat story. Thinking about Basquiat's critical reception is a way to recast the theme of the mechanisms of fame in the late twentieth-century art market. But it also brings the issue of race into my discussion. With the ex-

ception of my first chapter, I do not discuss the work of artists of color until the Basquiat chapter, because they have been largely left out of the narratives of fame and competition that are my themes. It has been claimed that Basquiat is the first African American painter to achieve celebrity. The truth is that Henry Ossawa Tanner had a considerable reputation in the beginning of the twentieth century. As I write in Chapter 1, Tanner's portrait of his mother in the manner of Whistler and Eakins expresses an enormous sense of self-confidence. Nevertheless, Tanner had to settle outside the United States to achieve a measure of autonomy. Other African American visual artists have had only relatively short periods of widespread fame: Jacob Lawrence in the late 1930s, Bob Thompson in the 1960s. None have consistently held the attention of the cultural establishment in the manner of a Pollock or an O'Keeffe. Thankfully, we are in the midst of a widespread critique of an art-historical tradition that has ignored the production of black visual artists. I am well aware that by choosing to focus on famous artists, I might seem to be reinforcing that older discourse. By emphasizing the crises within the history of mainstream modernism, however, I hope to suggest the negative impact of the very process of canon formation on all artists, regardless of race or gender. The question I try to raise is not why certain artists were better known than others, but why success seemed unsustainable and unhappy, even for the most privileged.

The book is not linear; it does not tell a single story at all. I purposely avoided a chronological narrative. Instead I have grouped the chapters according to three themes: "Parents" deals with the way the artists' relationship to predecessors and followers takes on the quality of a family; "Autonomy" focuses on the artists' attempt to forge a reputation and the resulting freedom such fame affords; "Collaborations" looks at the impulse to work together rather than compete.

Basquiat, like many of the other artists in this book, was a celebrity— people knew him by sight. Indeed the question of fame and the myth of personality loom so large in his career that many complain it is impossible to focus on Basquiat's art. This same complaint could be raised about the critical reception of almost all the artists in this book—Mann, O'Keeffe, Pollock, Stieglitz, Warhol, and Whistler. Their notoriety makes it difficult to see their pictures. Yet seeing itself is not an unmediated process. All the associations we bring to the process of sight influence what we see. Inevitably, the meanings of works of art are tied to the construction of artistic reputations. Basquiat's paintings, for bet-

ter or worse, must be seen through the lens of how his career was made—and, sadly, unmade.

My first book, *Speaking for Vice: Homosexuality in the Art of Charles Demuth, Marsden Hartley, and the First American Avant-Garde,* explored sexual content as a form of expression, as well as the cultural and political ramifications of representing what was, for the period, a forbidden subject. Since that time, I have become increasingly fascinated by the role of gender and sexuality in the process of forging artistic reputations. Feminist and queer studies have begun to focus on how gender bias permeates American art criticism. For much of the twentieth century, works of art have been judged in terms of supposedly "masculine" and "feminine" qualities. For example, considerable art-historical work has been done on the ways in which Abstract Expressionism was packaged in terms of masculine virtues. In contrast, O'Keeffe's art has been marginalized as inherently feminine. Such essentialist constructs have affected the ways certain artists achieved or failed to achieve success. But gender theory has more to offer the history of art than the pointing out of bias in modernist discourse; it provides new historical and interpretative tools to examine an entire sexualized matrix of interactions among artists, collectors, dealers, critics, and the public.

A colleague of mine, recalling my previous work in queer studies, told me that my writing showed that modern artists and their work were perverse no matter what their sexual orientation. I took this as a compliment. Although only a few of the case studies deal directly with homosexual content, I think the entire book is a *queer* enterprise; not because it sees homosexuality everywhere, but because it takes sexual identity to be an essential component in the question of artistic production and reception. However, it differs from many recent works in queer studies in its pessimism. For example, although I admire the courageous representation of homosexuality by Hockney and Warhol, I do not believe that their move out of the closet absolves their work of certain repressive aspects. At the same time, it is remarkable how quickly our culture has been able to assimilate sexual disruption and scandal into our daily headlines, so that works like those by Sally Mann of her naked children seem less about picturing what we repress than about retelling our favorite stories having to do with our desires; as Foucault might have it, they incite repetitive confessions about sexuality and childhood.[18]

There is another theme in this book that needs some comment: my belief in the viability of painting. Certainly my discussion in the first chapter of what Adrian Stokes calls the "invitation" embodied in painting reflects my career as a practicing artist who uses a brush and paint as his medium of expression. But my status as an artist per se is perhaps more crucial to my obsession with artistic fame than it is to my defense of painting. Some will undoubtedly see in my demystification of artistic achievement, through a discussion of strategies of publicity and competition, a reflection of my own failure to achieve enough artistic recognition. For a long time it has been a popular myth among artists that all art historians are frustrated artists. I admit to being guilty as charged, but then again I have never met an artist, famous or obscure, who was not frustrated, a further reason that the frustrated artist is a key motif of this book.

Parents

1 Origins
The Artist's Mother

*While his genius soars upon the wings of ambition the every day realities
are being regulated by his mother. . . . I do all I can to render his home as
his fathers* [sic] *was.*
—Anna Whistler (Whistler's mother)

Yes—one does like to make one's mummy just as nice as possible!
—James McNeill Whistler

What better place to start a book on ambition, love,
and the artist than with perhaps the most famous
painting by an American: *Arrangement in Grey and
Black: Portrait of the Painter's Mother* (fig. 1.1), or as it is
better known, *Whistler's Mother.* There are other candi-
dates for the title: *George Washington,* by Gilbert Stuart, or *Wash-
ington Crossing the Delaware,* by Emanuel Gottlieb Leutze, or
American Gothic, by Grant Wood. The significance of these
works, however, has little to do with their authorship—it is a
matter of how their style and content fit into our conception of
the inextricably American. Only the title *Whistler's Mother* incor-
porates the artist's name—she is both the American mother and
the artist's mother.

Whistler's painting is also exceptional among a group of
American favorites in that it alone is part of the canon of mod-
ern art. In 1933–34, no less a modernist than Alfred Barr, direc-
tor of the Museum of Modern Art (MoMA), orchestrated a tour
of *Whistler's Mother* throughout the United States. Supposedly
the first painting ever lent by the Louvre to an American insti-
tution, the picture was promoted as one of the six most popu-
lar paintings in the world and insured for half a million dollars.
When it was returned to the Museum of Modern Art, Franklin
Delano Roosevelt's own mother posed for a photo in front of
the picture (fig. 1.2), as if artist and president shared the same

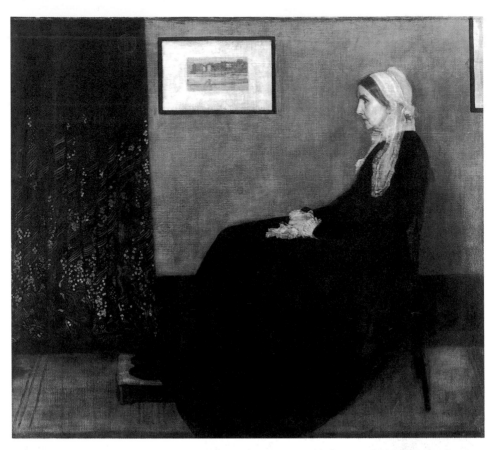

FIGURE 1.1 *James McNeill Whistler,* Arrangement in Grey and Black: Portrait of the Painter's Mother, *1871, oil on canvas, 56 ¾ x 64 in. Musée d'Orsay, Paris*

idealized lineage.[1] But Barr himself was not above exploiting the picture for the cause of modernism. Capitalizing on the painting's simultaneous popularity and impeccable avant-garde credentials, Barr featured the work prominently in his *What Is Modern Painting?* along with a diagram (fig. 1.3) "showing the main lines of Whistler's composition with the figure omitted." The result is "a composition of rectangles," which, according to Barr, "is not very different from the abstract *Composition in White, Black and Red* painted by Mondrian."[2]

"As American as mom and apple pie"—the resonance of this platitude seems potent enough to justify the place of *Whistler's Mother* alongside such national icons as *American Gothic.* Like *American Gothic,* the picture evokes a Puritan tradition. Surely the sense of motherhood as a state of patient suffering at home struck a chord with those anxious

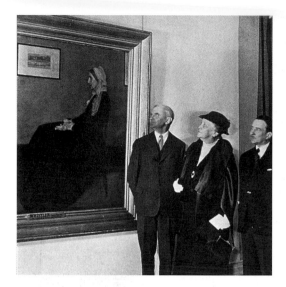

FIGURE 1.2 *Mrs. Roosevelt in front of Whistler's Mother, 1934*

WHISTLER: Arrangement in Grey and Black (Portrait of the Artist's Mother). c. 1871. Oil, 56 x 64". The Louvre Museum, Paris. James Abbott McNeill Whistler, American, b. Lowell, Mass., 1834. Studied in Paris and lived mostly in England. Died in London, 1903.

Diagram showing the main lines of Whistler's composition with the figure omitted.

FIGURE 1.3 *Diagram from Alfred Barr,* What Is Modern Painting? *(New York: Museum of Modern Art, 1943)*

about the rise of women's rights and the imagined threat that women's excursion into previously masculine territory posed to the American family. The painting's triumphal tour of the United States in the midst of the Depression corresponded to a time when the self-worth of males was thought to be particularly endangered by unemployment.[3] Anna Whistler's steadfastness in adversity as a "widowed mother" reinforced prevailing New Deal rhetoric about how women should endure the country's economic turmoil. Yet despite the picture's reinforcement of American values, it is bizarre that a work that was painted in England, by an artist who spent most of his mature life in Europe, and that was purchased by the French government should figure so large in our consciousness. The very association of motherhood and artistic production seems particularly un-American. The American mother's progeny should not be an artist but a farmer, a capitalist, or a politician—surely not the dandy expatriate Whistler. Through some strange mixture of craft, trickery, and luck, Whistler managed to confuse his origins with our origins, the motherhood of the artist, with the motherhood of the nation.

The popularity of *Whistler's Mother* has been tied to the artist's respect and love for his subject. The 1994–95 retrospective catalogue claims that "Whistler goes right to the heart of her character, her pious resignation in accepting the trials of her life."[4] Although Whistler tried to allay such sentimental readings through the original title, *Arrangement in Grey and Black,* and through his repeated pronouncements on the primacy of form and composition, contemporaries like Algernon Swinburne insisted on the picture's "intense pathos of significance and tender depth of expression." Whistler actually denounced Swinburne's words as "An Apostasy."[5] Indeed, Whistler went out of his way to deemphasize its emotive qualities. His mother is posed in absolute profile, as if she were preparing to have her head traced on the wall behind, recalling a silhouette, which, before the advent of the photograph, was the cheapest and most characterless form of portraiture. She stares straight ahead; her hands do nothing but clutch a handkerchief.

Numerous sources have been discussed for the pose of the painting. I believe the crucial example for Whistler was Rembrandt, who executed several images of an old woman who is popularly believed to be his mother. Whistler's portrait is particularly close in feeling to two of Rembrandt's etchings. In the first example (fig. 1.4), a woman sits in almost perfect profile; just a bit of her left eyelash gives us a sense of the other side of her face. In the second version (fig. 1.5), the old lady is

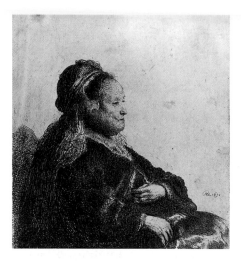 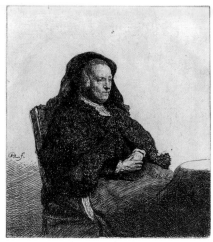

FIGURE 1.4 *Rembrandt Harmensz van Rijn,* The Artist's Mother Seated, in an Oriental Headdress, *1631, etching, 5³/₄ x 5 in. Teylers Museum, Haarlem, the Netherlands*

FIGURE 1.5 *Rembrandt,* Portrait of an Old Woman, *1631, etching, 5 ⁹/₁₆ x 4 ¹⁵/₁₆ in. Yale University Art Gallery, Fritz Achelis Memorial Collection, Gift of Frederick George Achelis, B.A. 1907*

turned toward the viewer, yet she holds her hands in her lap much as Whistler's mother does. There is an intimacy in Rembrandt's image that is missing from Whistler's painting. Rembrandt moves in relatively close, as if to study the features of his subject. Through a complex network of crosshatching he renders the three-dimensionality of his subject's face, hands, and dress. Neither etching is as flat or as abstract as Whistler's picture. If one ignores the face and hands of Whistler's mother, her body is an undifferentiated black shape. And providing so much space around her seated silhouette has a further distancing effect. This distancing appears to have troubled the U.S. Postal Service. Inspired by the national tour, the Postal Service issued a stamp of the picture (fig. 1.6) "in memory and in the honor of the mothers of America." But not before they corrected its apparent faults. The stamp designer cropped the picture so that we seem to be much closer to her face—in the manner of Rembrandt's etchings. And they added a bouquet of flowers to the scene, placing them on the border of the stamp as if it were a windowsill. Of course, such an act of desecration only further enhanced the painting's avant-garde credentials.

Barr himself lodged a protest with the U.S. Postal Service for deni-

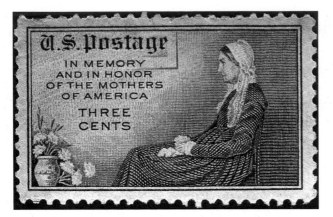

FIGURE 1.6 *U.S. Postal Service, Whistler's Mother stamp, 1934*

grating this important icon of modern art.[6] His criticism was ironic given the fact that in his 1943 *What Is Modern Art?* he was to reduce Whistler's painting to an abstract schema. It is as if in order to claim the painting for the cause of either modernism or motherhood it first had to be dramatically altered and key areas had to be erased or emphasized.[7] The 1997 film *Bean* continues this process of erasure to absurd lengths. The conceit of the film is that Whistler's famous picture has been "repatriated" for $50 million by a Getty-like museum in California. Bean is designated an art-historical expert and given the task of explaining *Whistler's Mother* to the American people. The luckless hero sneezes on the picture and then inadvertently wipes away her face. At the end of the film the painting ends up above Bean's bed with the mother's face converted into a grotesque cartoon. Like Barr and the U.S. Postal Service, Bean remakes Whistler's picture. I believe such alterations were responses to the central paradox of Whistler's picture: its ability to raise sentimental associations of motherhood and to negate them.

The aloofness of *Whistler's Mother* becomes more pronounced if we compare it to the 1897 work of another American expatriate, Henry Ossawa Tanner (fig. 1.7), which is based on Whistler's portrait.[8] Like Whistler, Tanner poses his mother seated, in profile. In the background are curtains, a framed picture and a dado, all elements that Whistler used. Tanner, however, makes some telling changes. Mrs. Tanner leans on her right hand, so that her head is turned slightly toward us, revealing her entire forehead. Instead of passively holding a handkerchief, she holds a fan, ready for use if she becomes too warm. The heat of summer is implied by the fact that she does not need her white shawl,

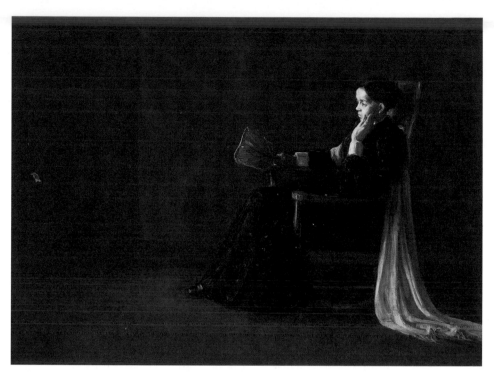

FIGURE 1.7 *Henry Ossawa Tanner,* Portrait of the Artist's Mother, *1897, oil on canvas, 29 ¹/₂ x 39 ¹/₂ in. Philadelphia Museum of Art: Partial Gift of Dr. Rae Alexander-Minter and purchased with the W. P. Wilstach Fund, the George W. Elkins Fund, and funds contributed by the Dietrich Foundation and a private donor*

which has fallen to the ground. Draping down from the chair, it picks up the same bright light that reveals her face. This raking light separates Tanner's mother from the background. The absence of wrinkles, as well as the more active role of her hands, conveys a younger and more vital woman than Anna Whistler. She seems far more corporeal, because her body is not cropped where the dress meets the floor, as is the case of *Whistler's Mother.*

Tanner's adoption of the basic elements of Whistler's painting might seem strange given the fact that he was a student of Thomas Eakins. Eakins's meticulously planned pictures, in which each object is carefully delineated and structured, differ greatly from Whistler's improvisations and his fascination with the dematerialization of atmospheric effects. In Tanner's appropriations we see the classic strategy of an ambitious young artist: that of merging the practices of two seemingly opposing

masters in the hope of fashioning a new style. But Tanner's use of *Whistler's Mother* has a greater significance. If Whistler's painting was an *Arrangement of Grey and Black,* as its title would have it, Tanner's entire career as an African American artist was involved in *arranging* color relationships.[9] To paint his own mother in the manner of Whistler and Eakins was to compete with the most accomplished artists of his time, a goal severely limited in his own country by racism. The painting of his mother is an attempt by Tanner to take his place alongside Whistler and Eakins. But in finding his way into the family of artists Tanner does not deny his familial origins in an African American mother. Indeed, the bright light that pours into the room in the manner of an annunciation and falls lovingly on his mother's face suggests that such origins are transcendent.

Tanner's painting of his mother may be more informal than Whistler's, but it still has the quality of being posed. Mary Cassatt, another expatriate, tried to invest *Reading Le Figaro* (fig. 1.8), one of several portraits of her mother, with a sense of spontaneity that is missing from both Whistler's and Tanner's conceptions. Cassatt seems to have been aware of Whistler's work when she painted this version of her mother. Katherine Cassatt is in a pose similar to Anna Whistler's. However, we are brought in much closer and Cassatt gives her mother something to do. Or to put it another way, her mother refuses to just sit and be painted. As Linda Nochlin has discussed, Cassatt's mother makes use of the time she spends posing by reading the newspaper.[10] Significantly she reads the front page of the paper and not the interior "women's pages," that is, the society or fashion sections. Cassatt's origins are not in the placid and resigned mother of Whistler but in an active, searching intelligence. The glasses on Katherine's nose symbolize a desire to see and know, even as they suggest a lack of vanity. Their precarious position, with their cord dangling down, gives the picture an informal and intimate quality that is missing from Whistler's emblematic image. Like Tanner's mother, Cassatt's does not look particularly old or sedentary.[11]

In a later painting, old age catches up with Cassatt's mother (fig. 1.9). Although in this picture Cassatt does not paint her mother in profile, the overall effect is far closer to *Whistler's Mother.* Katherine's face is lined, and she no longer reads; instead she rests her head on her left hand, while clutching a handkerchief with her right hand, much in the manner of Anna Whistler. In fact, if we imagine shifting our point of view to her side, her pose and manner would recall Whistler's picture.

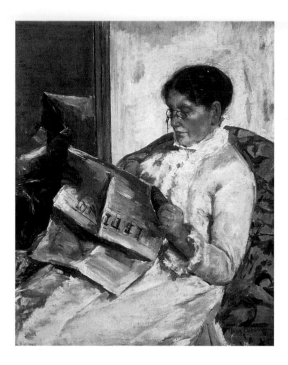

Cassatt's and Whistler's portraits both share a sense of impending death. In this sense they are a return to the earliest known portrait of an artist's mother, the celebrated drawing by Albrecht Dürer (fig. 1.10). It is tempting to think that Whistler, at least, had Dürer in mind when he painted his picture. On the most superficial level Anna Whistler and Barbara Dürer share similar head gear, the fabric of which falls down upon their shoulders. But Dürer's three-quarter view provides us with far more information about his mother's face. Deep shadows emphasize her bone structure. We can actually make out the anatomy of her neck and sense the skeletal structure under her cheek. Perhaps because of the way her skin has wrinkled and pulled back onto the bone, her eyes seem particularly large. Along with the tightly closed mouth and emphatic nose, the eyes of Dürer's mother express precisely the willfulness and personhood that have been attributed to Whistler's portrait.

Despite the silhouette effect, Whistler also conveys a sense of the three-dimensional quality of his mother's head. Indeed the flatness of so much else in the painting—the two framed pictures, the undifferentiated black dress, the patterned, almost straight curtain, the dark dado that runs along the wall, the mere trace of a linear design on the carpet—makes her head seem positively sculptural by comparison. But

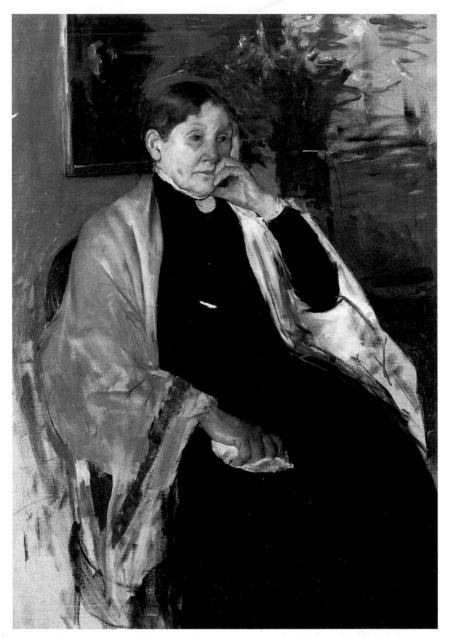

FIGURE 1.9 *Mary Cassatt,* Mrs. Robert S. Cassatt, the Artist's Mother (Katherine Kelso Johnston Cassatt), *ca. 1889, oil on canvas, 38 x 27 in. Fine Arts Museums of San Francisco, Museum purchase, William H. Noble Bequest Fund, 1979.35*

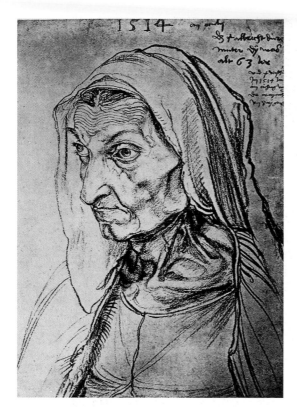

FIGURE 1.10 *Albrecht Dürer,* Dürer's Mother, *1514, drawing, 16 ¾ x 12 in. Kupferstichkabinett, Berlin*

there is only so much information the profile can convey. The head itself is surprisingly small in relationship to the entire canvas (in an earlier stage the entire figure was somewhat larger and higher in the composition).[12] Character is expressed less by Whistler's scrutiny of his mother's face and more by her general deportment and the austere and somber setting.

Like Whistler's mother, Barbara Dürer seems to stare out of the picture, though not at anything in particular. She too appears to be merely posing. The extraordinary way in which charcoal conveys the slight indentation in her chin, or the length of her right eyelashes, or the space between her cheek and hood, evokes a process whereby the artist comes to forget that he is looking at his mother and instead becomes lost in the problem of translating a three-dimensional object into charcoal on paper. Despite the clarity and intensity of Dürer's portrait, it is no easier to gauge its ultimate effect than that of Whistler's picture. We like to think that the human face is legible and that with the aid of biographical information we can interpret the character of the sitter. The very ti-

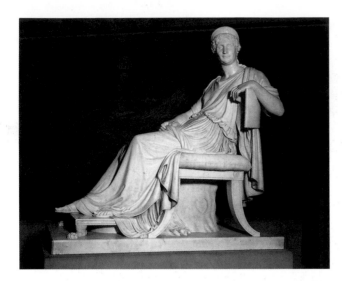

FIGURE 1.11 *Antonio Canova,* Madame Mère (Napoleon's Mother Seated)*, 1804–7, marble, 57 ⅛ x 57 ⅛ x 25 ⅞ in. Devonshire Collection, Chatsworth*

tle "mother" encourages sentimental associations. But the intensity of Dürer's realism has a curiously off-putting effect.

Donald Kuspit, writing on contemporary artists' depictions of their mothers, claims that they "'refute' the mother in the very act of 'realizing' her, that is, negate her as subject by affirming her as object." He speculates that "the artist wants to deny—no doubt only unconsciously—that he or she has a mother." For Kuspit, this is the artist's revenge for having been dependent on the mother as a child. He goes further and argues that the artist "assumes himself or herself to be self-created; there can be no superior creativity to the artist's own, not even the mother's natural creativity."[13]

Kuspit's idea about the negation of the mother is interesting in relation to Whistler's insistence that his picture's ostensible subject matter was of no importance. But the actual portrait has precisely the opposite effect, elevating Whistler's mother to an icon. Another crucial source for the painting was Madame Mère, Antonio Canova's sculpture of Napoleon's mother (fig. 1.11).[14] In glorifying his mother through this association, Whistler raises himself to the level of the so-called man of destiny: his exalted portrait of his mother was not made for his private contemplation. In contrast to the presumably private function of many maternal portraits, including the one by Dürer, Whistler publicly exhibited the picture and carefully orchestrated its purchase by the French government.[15] In asking people to contemplate his mother he effectively extended the concept of the self-portrait to include not only him-

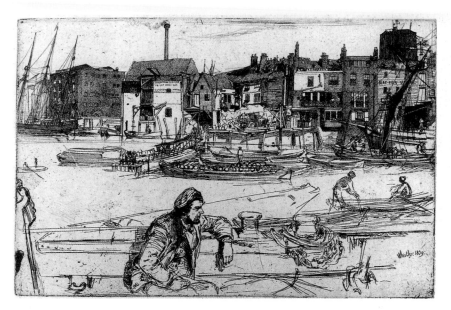

FIGURE 1.12 *James McNeill Whistler,* Black Lion Wharf, *1859, etching, 5 ⅞ x 8 ⅞ in. Yale University Art Gallery, The Edwin M. Herr (Ph.D. 1884) Memorial Collection. Gift of Mrs. Herr in memory of her husband, 9 December 1933*

self but his origins. Interpreted this way, the artist is not so much in competition with his mother; rather, he is acknowledging that she is his ultimate collaborator. Whistler may have had this in mind when he placed one of his own etchings on the wall behind her. After all, she was responsible for his existence in the world—and therefore ultimately his art. At the time of the portrait, Anna actually ran Whistler's household: "While his genius soars upon the wings of ambition the every day realities are being regulated by his mother. . . . I do all I can to render his home as his fathers [*sic*] was."[16] Her words seem overly determined, inviting the most baroque of Oedipal interpretations. The mother gives birth and, with the father's death, helps the son take his position. The painting itself embodies such a narrative in its image within the image.

The print behind Anna is Whistler's *Black Lion Wharf* (fig. 1.12), which depicts a handsome young man sitting along a pier in London. His profiled pose rhymes with that of Whistler's mother. Moreover, through a trick of perspective, Anna's eyes almost line up with the eyes of the young man. This longshoreman is both a surrogate for the father who died so many years before, but whom Anna still mourns, and for Whistler himself. By looking directly outside the frame as if at Whistler's

mother, he suggests the process by which the artist stares at his subject. Yet this reciprocal looking is precisely that denied the viewer by the profiles in both *Black Lion Wharf* and *Whistler's Mother*. It hints at an intimacy of exchange that the mother's rigid portrait and vacant expression negate.

Anna insisted that posing for the picture helped Whistler overcome a crisis in his practice, manifested by his inability to finish commissioned portraits. He was able to complete her portrait relatively quickly, and with splendid results. She wrote of the process that her son "had no nervous fears in painting his Mothers [*sic*] portrait." At first he had some problems with the face: "I heard him ejaculate 'No! I can't get it right! it is impossible to do it as it ought to be done perfectly!'" But with her prayers he tried again and "exclaimed 'Oh Mother it is mastered, it is beautiful!'"[17] She ends her story by writing that her son "would kiss me for it!" By focusing on his mother's likeness, Whistler achieves mastery—he becomes a master. Indeed, *Whistler's Mother* was the means of the artist's entrance into the pantheon of the Louvre. He returns the gift of his birth by *making* his "mummy just as nice as possible."[18] Out of lifeless matter, oil and canvas, brush stroke by brush stroke, he records her features, bestowing immortality on his mother and ensuring his own.

Given Anna Whistler's passionate narrative in which her son is said to "ejaculate" and kiss his mother, we might have expected a less distant and formal portrait. The painting's dark, contained shapes—the silhouetted figure in front of framed pictures—do not evoke the engulfing maternal embrace of Anna Whistler's story. It would be an easy matter to discuss such distancing devices in terms of his mother's interference in his life. For example, Anna may have been partially responsible for forcing Joanna Hiffernan, Whistler's longtime lover and model, to move out of his house in Chelsea.[19] The rigidity of Anna's pose, her body flattened and closed, might be read as precisely a defense against the mother's overwhelming love. Yet such an interpretation only makes the question with which I began this essay more puzzling. How is it that such a cold picture could have become emblematic of motherhood? Rather than limit the interpretation of the painting to Whistler's biography, I want to think about the picture in terms of more general desires for both painting and the mother.

How is painting itself like the mother? This question is at the center of the work of the art critic Adrian Stokes. Although Stokes's writings have

had an enormous influence in England, he has been largely ignored by American art historians, even those like Donald Kuspit, who have a psychoanalytic approach. For Stokes, form is a return to the mother—not the literal mother but the "inner mother," the so-called good object. I worry about the universalizing quality of Stokes's approach to the problem of form and creativity (a fault shared by most psychoanalytic accounts of works of art). I certainly do not endorse his equally universalizing conception of motherhood itself. I turn to Stokes not to offer up an overarching theory either of painting or of the relationship of creativity to child rearing. Instead, I want to make use of Stokes's conception that painting is a form of maternal replacement, as if it were another portrait of the mother to compare with Whistler's. For Stokes the concept of mother, however limited by essentialized constructs of gender, is a way to grapple with the values embodied in art. I particularly admire his attempt to understand the paradoxical qualities of form— what he calls its "invitation"—which I think are present, and not present, in Whistler's *Arrangement in Grey and Black: Portrait of the Painter's Mother.*

Stokes was a follower of the psychoanalyst Melanie Klein, whose theories of childhood development offer an alternative to the castrating mother that dominates the usual Oedipal narratives. Klein stresses the importance of the pre-Oedipal stage. The psychiatrist Eugene Glynn, who first introduced me to the work of both Klein and Stokes, succinctly describes the Kleinian narrative of the mother-infant relationship: "Klein fully accepted Freud's idea of two sets of instincts, sexual and aggressive, in its most radical form, aggression flowing outward from an originally self-directed death instinct. The infant is thus from the moment of birth beset by the severest of dilemmas: quite literally, how to survive its death wish? There is only one way . . . externalize it, put it out 'there.'"[20]

Klein writes: "From the beginning the ego introjects objects 'good' and 'bad', for both of which the mother's breast is the prototype—for good objects when the child obtains it, for bad ones when it fails him."[21] But soon the infant must come to relate to the mother and himself as "whole objects." In establishing an independent ego he or she must also lose the original "loved object." Or as Klein puts it, "Not until the object is loved *as a whole* can its loss be felt as a whole."[22] Becoming an individual is a process of mourning because to be whole is to be severed from the mother, incomplete. According to Stokes, art resolves and heals this split. It restores to the artist and the viewer both the experience of the

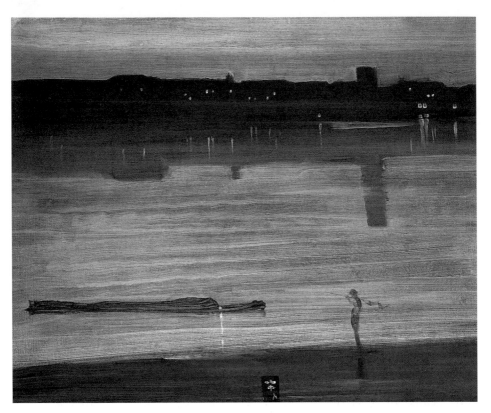

FIGURE 1.13 *James McNeill Whistler,* Nocturne: Blue and Silver—Chelsea, *1871, oil on wood, 19 ³/₄ x 23 ⁷/₈ in. Tate Gallery, London*

"good breast," and the "whole mother."[23] "Form in art . . . reconstitutes the independent, self-sufficient, outside good object, the whole mother whom the infant should accept to be independent from himself, as well as the enveloping good breast of the earliest phase, at the foundation of the ego, the relationship with which is of the merging kind."[24]

Usually particular works of art favor one aspect of object relationships. Whistler's own *Nocturnes* would seem to be what Stokes calls the merging kind of art. They invite the viewer to abandon concrete structure and hard surfaces and lose the self in the absolute. In Whistler's *Nocturne: Blue and Silver—Chelsea* (fig. 1.13), which was painted the same year as his portrait of his mother, a barge, the buildings along the shore, the lights of the street lamps (is that meant to be a human figure in the foreground?), dissolve in atmosphere, even as the picture itself seems on the verge of becoming merely bands of tones. Stokes felt that such flattening effects were particularly conducive to the loss of the

ego. Even in this engulfing art, however, there is a sense of the whole object. We never forget completely that we are looking at a painting. We sense the paint on the surface of the canvas and the importance of the frame. We retain our position outside the picture, or, to put it in Stokes's terms, we are both inside and out: "At the same time the identical formal qualities, such as pattern, that lend themselves to an envelopment theme, are the means also for creating the object-otherness, independence, and selfcontainment of the work of art: it 'works' on its own, 'functions' in the way of an organism: this phantasy accompanies the one of our being enveloped, but is connected with another that projects the ego in terms of an integrated figure in which opposite characteristics coalesce."[25]

Empathetically, something of the same happens to viewers. We lose ourselves and find ourselves in form. Art invites us to consume, even as it remains inviolate and separate. Stokes believed that painting had preeminence among expressive mediums precisely because of the space it retains between the viewer and the image. Such a distance is built into the very process by which the painter applies paint to the canvas: "We have no difficulty in speaking of the painter as the artist *par excellence,* of painting as the representative of art in general. I think that this is because of the instrument, the brush, tipped with the creative material, and because the canvas is worked at arm's length, with the result that the very act of painting as well as the pre-occupation with the representation of space, symbolize not only the restitutive process but a settled distance of the ego from its objects."[26]

The paradoxical qualities of *Whistler's Mother*—its oscillation between sentiment and distance, engulfment and autonomy—are in Stokes's writings the very essence of painting. The flatness of the canvas and its austere framing are one with the maternal embrace. Generalization, pattern, flatness, represent the will to merge, even as the self-reflexivity of these elements ensures that the picture is seen as a picture, a whole object. Stokes writes: "The great work of art is surrounded by silence. It remains palpably 'out there', yet none the less enwraps us; we do not so much absorb as become ourselves absorbed."[27]

In celebrating the autonomous quality of the work of art, Stokes was not far from the modernist critics who were his contemporaries. Indeed he was a formalist. Given to citing Roger Fry and Clive Bell, he was little interested in biography or social content. Yet, unlike a formalist such as Clement Greenberg, he did not think of art making as primarily an enterprise in which each artist takes up a series of problems left by tradi-

tion. His emphasis was on making rather than on art as a critique of other art. Why do artists paint and sculpt? And how does their production work on us?

As Glynn reminds us, Stokes was a romantic who had "the passion for art, the intensity of concern, the almost raw hyperactive quality of a sensibility that threatens at times to engulf all else—the nature is a 19th-century one—determined to order itself by the 20th century's monumental new view, psychoanalysis. Pater analyzed by Freud."[28] If Stokes was uninterested in social and political explanations, he did believe in the social value of art. Form's "invitation" is a model for a better society. Stokes believed that art was a means to cultural redemption, analogous to the loving mother's role in forming the healthy and autonomous individual. Klein wrote about the ways the real "external mother" is the double of the "internal mother." "The visible mother thus provides continuous proofs of what the 'internal' mother is like, whether she is loving or angry, helpful or revengeful." In the ideal mother-child relationship "a certain amount even of unpleasant experiences is of value in this testing of reality by the child if, through overcoming them, he feels that he can retain his objects as well as their love for him and his love for them, and thus preserve or re-establish internal life and harmony in face of dangers."[29] For Stokes, art works on us through an analogous doubling process. Form not only heals our inner anxieties but also suggests what a better outer world might be like: "What is desirable, what has always been desirable, is a milieu fit for adults, for true adults, for heroes of a well-integrated inner world to live in, a society to support that inner world, to project, to re-create its image. The artist is, and always has been, concerned with that image, attempting to assimilate into structures varied aspects of himself and of the world outside."[30]

Although I am drawn to Stokes's concept of the maternal and utopic role of the work of art, it does not account for the sense of morbidity that I feel is present in Whistler's picture. Indeed, Stokes's approach seems more appropriate to the work of Cassatt than to Whistler's. Take another of Cassatt's portraits of her mother, *Mrs. Cassatt Reading to Her Grandchildren* (fig. 1.14). In a certain sense it is like a fragment of *Whistler's Mother*. Katherine Cassatt sits in profile. The frame of the window in the background recalls the framed etching of Whistler's picture. She does not sit alone, however, but is surrounded by her grandchildren, who listen to her read from a book, probably the Bible. Cassatt's gaze is again productive. She does not seem merely to pose for the artist. Even as she is there for her daughter as a subject, she is there for her grand-

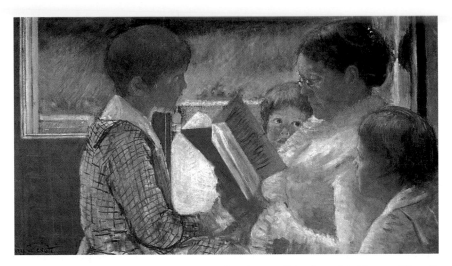

FIGURE 1.14 *Mary Cassatt,* Mrs. Cassatt Reading to Her Grandchildren, *1880, oil on canvas, 22 x 39 ½ in. Private collection*

children. Although she is seen in profile, there is little sense of the formality and idealization of Whistler's picture. She is not the distant or mourning matriarch but a seemingly loving mother-grandmother. But this loving does not engulf the children. They cluster around her. The space of the painting is so contained that the bodies of the children and the grandmother merge. The position of the boy is particularly hard to read. Does he stand before her, or is he seated on her lap? The two girls are closely positioned at either shoulder, listening intently. Cassatt's warm, glowing paint not only blends one figure into another; it also brings the landscape into the room. Skin, cloth, hair, grass, are all a matter of light and brush stroke. Yet this merging effect is countered by the expressive distinctness of the individual figures and the geometry of composition. And Katherine Cassatt's absorption in the story creates a certain sense of distance; there is also the flattening effect of the window frame, the patterned cloth, and the doubling effect of the profiles of the boy and the grandmother. The boy in particular, in the clear delineation of his head, seems very much his own. Mrs. Cassatt accepts the children's intimacy with ease, as if she is used to their bodies; they are of her and not of her. The picture dispenses with the grandiloquent rhetoric of *Whistler's Mother,* the iconic and silent stance of the profiled matriarch.

Ultimately, Cassatt's painting lacks the terror of *Whistler's Mother* that seems so much a part of the process of his making his mother into a

type and an icon. Melanie Klein warned that "idealization is a corollary of persecutory anxiety—a defence against it—and the ideal breast is the counterpart of the devouring breast."[31] The specter of devouring breast evokes the image of the castrating female that I have tried to replace, but here again Stokes is useful, for in his last writings he insisted that the best paintings not only return us to the lost mother but embody the aggression that must be worked through to arrive at restitution. For Stokes, the work of art is the ideal place for working out the artist's and the viewer's anxieties: "I believe that in the creation of art there exists a preliminary element of acting out of aggression, an acting out that then accompanies reparative transformation, by which inequalities, tension and distortions, for instance, are integrated, are made to 'work'." All painting to some degree involves a process of "carving" and "modeling," terms that Stokes borrowed from sculpture. For Stokes the application and removal of paint, the artist's "attack," is a process of violence as well as of creation: "A painter, then, to be so, must be capable of perpetrating defacement; though it be defacement in order to add, create, transform, restore, the attack is defacement none the less."[32]

Whistler was particularly given to a mode of painting that suggests Stokes's terms. We have several accounts of how he would violently rub out or scrap away areas of paint from the canvas, particularly the hands and faces of his sitters, so that it was extremely difficult to ever finish a portrait. This habit must have been especially disturbing to those patrons who patiently posed for days and hours, only to have their faces eradicated. Anna Whistler was proud that Whistler had relatively few of these attacks on the canvas when he painted her portrait, yet even she writes of him screaming out, "No! I can't get it right! It is impossible to do it as it ought to be done." Rather than correct his canvas by painting over mistakes, Whistler tended to scrape back to the surface. He liked the effect of sensing the original support underneath transparent glazes, so that the wall behind his mother takes on the texture of canvas. Stained areas are contrasted to brush strokes of usually white paint. True to the tradition of his hero, Rembrandt, dark areas are thin and transparent, highlights are thicker and opaque.

According to Linda Merrill, Whistler would "scrape a painting down and begin anew, covering his tracks so that the production appeared effortless."[33] She quotes Whistler's observation that "work alone will efface the footsteps of work."[34] The very word *efface* suggests hostility to the subject for being so difficult to paint and an attempt to hide the frustration of not living up to an impossible ideal of genius. But some-

times Whistler does not completely "cover his tracks." Areas of Whistler's pictures, particularly the portraits, are so thin that it is possible to sense the process of scraping and correcting, for example, along the silhouette of Anna Whistler's body. The effect is different from that where the artist allows mistakes to appear under corrections in order to emphasize the process. Whistler did not intend for us to see how his picture came into being. Despite the traces of struggle, the artist's mother seems formed from almost nothing, *carved* from the shadowy aqueous background, fully embodied and complete.

This sense of creation and wholeness exists in the picture alongside its overwhelming presentiment of death. It is not hard to imagine a moment when the artist, in the courses of rendering, suddenly becomes aware that the mother before him is not the mother of childhood. The small footstool upon which Anna Whistler rests her legs (as if without it her feet would dangle above the ground) is an infantalizing touch. No longer young, strong, and protective, she is now an elderly and fragile presence, even childlike. This fragility is very much the subject of that founding portrait of the artist's mother by Dürer. It was completed just two months before she died, and he later wrote on the sheet "and she died in the year 1514 on Tuesday, the sixteenth of May, at two o'clock during the night." The picture's emphasis on the skeletal structure of the face and neck is both an indication of Dürer's skill and a harbinger of his mother's end that predicts his own end. Dürer wrote about his mother's death: "May God grant that I also shall have a blissful end, and that God with his heavenly legion, and my father, mother, and kin will meet me in death, and that almighty God will grant us all eternal life. Amen. And in her death she looked more lovely than in life."[35]

Whistler's portrait encompasses not just the ultimate mortality of his mother but the death of the father as well. At the time of posing for the painting, his mother had spent more than two decades in perpetual mourning for her husband. Significantly, soon after completing the portrait of his mother Whistler posed the patriarchal Thomas Carlyle in a manner almost identical to that used for his mother. He varied the title only as necessary, calling it *Arrangement in Grey and Black #2: Portrait of Thomas Carlyle* (fig. 1.15). This lack of compositional originality has puzzled art historians, but by virtue of their identical poses both pictures become part of the same "family." Placing them side by side, he restores the lost parental couple.

That Whistler manages to avert artistic death and find immortality in a portrait infused with death would come as no surprise to Adrian

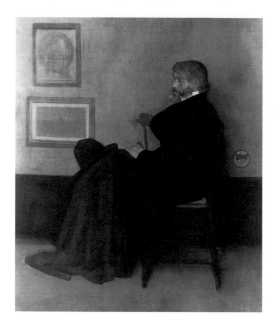

FIGURE 1.15 *James McNeill Whistler,* Arrangement in Grey and Black, No. 2: Portrait of Thomas Carlyle, *1872–73, oil on canvas, 67 ³/₈ x 56 ¹/₂ in. Glasgow Museums: Art Gallery and Museum, Kelvingrove*

Stokes. Stokes saw in form the working through of the death instinct, what Freud claimed was the urge of life to return to the matter out of which it came. Stokes often referred to the work of Hanna Segal, another follower of Melanie Klein, who wrote:

> All artists aim at immortality; their objects must not only be brought back to life, but also the life has to be eternal. And of all human activities art comes nearest to achieving immortality; a great work of art is likely to escape destruction and oblivion.
>
> It is tempting to suggest that this is so because in a great work of art the degree of denial of the death instinct is less than in any other human activity, that the death instinct is acknowledged, as fully as can be borne."[36]

Stokes shared Segal's belief that the greatest works of art confront death. He wrote of Michelangelo's Rondanini *Pietá,* a sculpture that fuses death with the maternal embrace, that "ancient grief and depression calmly occupy the field in virtue of their paraphrase of death: but Michelangelo's Saviour will redeem and carry him: at the very last there is the first love, head by head, mouth at breast, an utterly forlorn contentment that merges gradually with the undivided nature of the final sleep."[37] But listen also to Whistler's own description of his process of vision and how it suggests the artist's confrontation with death and a

longing for oblivion that only the work of art in its immortality resists: "As the light fades and the shadows deepen all petty and exacting details vanish, everything trivial disappears, and I see things as they are in great strong masses: the buttons are lost, but the garment remains; the garment is lost, but the sitter remains; the sitter is lost, but the shadow remains; the shadow is lost, but the picture remains. And *that* night cannot efface from the painter's imagination."[38]

In the end, *Whistler's Mother* falls short of approaching Adrian Stokes's ideal of integration. Stokes has nothing to say about Whistler in his collected writings, but my guess is that he would not have liked the picture. I return to Klein's idea that extreme idealization contains its opposite: that which is exalted is also hated and feared. Given the conflicting associations raised by the very word *mother*, it is perhaps no surprise that such a contested subject would produce a contested painting. In the end the contradictions of the picture, its oscillation between sentimentality and abstraction, are not resolved. It is not that the painting is discontinuous, marked by areas of confusion or sharp contrast. Its immediate effect is one of balance and calm. The formal structure that Barr mapped out for us of frames within frames maintains a strong sense of stability, but that very stability seems set up to contain the disquieting aspects of the picture, its ultimate equation of maternity and death. The dark diaphanous curtain that covers a blackened doorway suggests Anna's approaching passage into oblivion.[39] Indeed, the painting is bracketed by the shimmering curtain on one side and by the blankness of a fragment of a hanging picture on the other. And how weird is the body of Anna Whistler. As we move from the extreme clarity of the mother's face, her body dissolves into blackness. Her breasts, arms, feet, and even the uncanny appendage of chair leg become one dark, mysterious form. As we have seen, to accept this strange painting as an unqualified celebration of motherhood, viewers had to ignore much that is troubling about its form. In the curious example of the U.S. postage stamp, the Postal Service had to make it into a different picture. Yet for Barr to read *Whistler's Mother* as a progenitor of abstraction involved an equal act of invention and erasure. But who can blame them? Whistler's painting is caught between a will toward tradition and a will toward abstraction. These two desires are built into Whistler's title: *Arrangement in Grey and Black: Portrait of the Painter's Mother*, which, like the painting, suggests a compromise between competing drives. Such a quality of uneasy stasis is far from Stokes's dream of reconciliation and transcendence.

FIGURE 1.16 *James McNeill Whistler,* Harmony in Grey and Peach
Color, *1872–74, oil on canvas, 76 x 39 ³/₄ in. Courtesy of the Fogg Art
Museum, Harvard University, Art Museums, Bequest of Grenville L.
Winthrop*

Why, then, evoke Stokes at all? Because I feel his terms are useful in thinking about the contradictory aspects of Whistler's form. In my mind, Stokes is less interesting as a guide to quality than he is for considering the conflicts that arise in the making of paintings and how the artist's anxieties and solutions are both conveyed and hidden from the viewer. *Whistler's Mother* is interesting from the Stokesian point of view not because it is successful but because it holds conflicting drives—the longing to merge and a sense of distance—in stasis, without the requisite sense of integration. Yet we sense in the picture the drive for integration and the pressures that threaten it.

Six years after the completion of *Arrangement in Grey and Black: Portrait of the Painter's Mother,* John Ruskin made his famous charge against Whistler "for flinging a pot of paint in the public's face" in the guise of *Nocturne in Black and Gold: The Falling Rocket.* Whistler's painting of his mother figured in the resulting libel trial, where it was part of an exhibition demonstrating his talent.[40] The irony of Ruskin's charge of formlessness is that I feel no artist was more afraid of this aesthetic abyss than Whistler, perhaps because he had approached the edge so often in his *Nocturnes* and portraits. It must have been comforting to have the picture of his mother close at hand. Solid, immovable, and whole, she was his best argument against the alleged immateriality of his painting.

Whistler's ambition was to create a style of effortless depiction, but in truth painting did not come particularly easily to him. For all his bravado he was no virtuoso of the figure in the manner of a Sargent or Cassatt. Depicting hands and faces was a particular challenge. Take the wreck of *Harmony in Grey and Peach Color* (fig. 1.16) in which he summons many of the elements of the portrait of his mother—framed print and dado in the background, the same color tonality. But nothing seems to work, and the figure of the girl becomes a strange, ghostly presence. Even *Arrangement in Grey: Portrait of the Painter* (fig. 1.17), his self-portrait of 1872, which is supposed to be such a bravura demonstration of skill, does not quite look right. By leaving areas unfinished, where the paint is thinly brushed, Whistler perhaps meant to convey alacrity and skill. Sketchiness stands for the immediacy of inspiration. Yet look how awkward and forced the arm and hand are. We can imagine Whistler, painting and scraping, repainting and scraping again, striving to make the brushwork appear unworked. In the end his painting arm, which holds the brushes, seems strangely detached from the body, locked into the frame of the picture as if to hold his hand

FIGURE 1.17 *James McNeill Whistler,* Arrangement in Grey: Portrait of the Painter, *ca. 1872, oil on canvas, 29 ½ x 21 in. Detroit Institute of Arts, Bequest of Henry Glover Stevens in memory of Ellen P. Stevens and Mary M. Stevens*

back from making yet another correction, or from obliterating the image entirely.

I am not arguing that Whistler was incompetent; rather, that the need to render such crucial elements as the hands and faces of his subjects with three-dimensional clarity disturbed his overall sense of a picture's unity and his desire for a decorative harmony that would have been equivalent to music. Yet to eliminate the human subject entirely, as he seems to want to do when he calls his paintings "Arrangements," was to abandon what was still for him, and, I would add, for Ruskin, the center of the artistic tradition. In struggling to reconcile competing desires his pictures were always in danger of collapsing into formlessness. The scraped ground of a botched and empty canvas: many commissions ended up precisely this way. Perhaps this is the true meaning of the fragment of a picture that hangs on the wall to the right of his mother. It is the specter of the empty picture and the death of inspiration. Whistler avoided such a disaster in *Arrangement in Grey and Black: Portrait of the Painter's Mother,* producing a work of art that assured his continuing fame. Anna Whistler was right: at such moments of crisis the artist needs his mother. To the degree that the mother's embrace is restored and distanced in painting's invitation, so do we all.

2 Picasso in Pollock

The continuing prestige of Whistler's *Nocturne in Black and Gold: The Falling Rocket* in the annals of art history is undoubtedly due to its family resemblance to the drip paintings of Jackson Pollock. Pollock's work, more than Whistler's, suggests Ruskin's description of throwing a pot of paint. But when Pollock himself described his peculiar painting method, it was less in terms of an outward gesture to an imagined audience than as a means of getting into his picture. In a statement prepared for the first and only issue of *Possibilities,* Pollock declared: "When I am *in* my painting, I'm not aware of what I am doing. It is only after a sort of 'get acquainted' period that I see what I have been about. I have no fears about making changes, destroying the image, etc., because the painting has a life of its own. I try to let it come through. It is only when I lose contact with the painting that the result is a mess. Otherwise there is a pure harmony, an easy give and take, and the painting comes out well."[1]

The text might account for the presence of the handprints in *Number 1A, 1948* (fig. 2.1). The artist's hand makes the painting, even as it is a part of the painting; it marks and it leaves its mark. The handprints are surrogates for the artist himself, or the traces he leaves behind as he disappears into the canvas.

But why would anyone want to be in there? Why would anyone want to be surrounded by a web of spattered enamel, a shifting screen that provides neither the security of fixed points of reference nor the freedom of unobstructed vision? However accustomed we have become in our position outside of Pollock's paintings, looking in, we may be uncomfortable, imagining Pollock's supposed stance: inside looking out.

If there is an *in*, what constitutes *out* for Pollock? Ostensibly, it is a manner of applying paint. Out is to continue to use an easel and brushes: "My painting does not come from the

FIGURE 2.1 *Jackson Pollock*, Number 1A, 1948, *1948, oil and enamel on unprimed canvas, 68 x 104 in. The Museum of Modern Art, New York. Purchase*

easel. . . . On the floor I am more at ease. I feel nearer, more a part of the painting, since this way I can walk around it, work from the four sides and literally be *in* the painting."[2] But change in technique is only the means of the movement. The rejection of the easel does not in itself propel Pollock into his painting. In his statement he admits that even when "dripping" onto his canvas laid out on the floor, he may lose contact with the work. The result, he tells us, "is a mess." But what does this mess look like? The implied necessity of Pollock's move into the painting, combined with the pressure felt to fall back out, gives the entire project the anxious quality of escape—but again, escape from what?

I would like to explore the possibility that Pollock's escape is at least in part an escape from influence, an attempt to move away from what is not the self into the self. Harold Bloom developed a theory of literary interpretation centered on what he calls the "anxiety of influence." As I wrote in the introduction, I am wary of Bloom's totalizing approach to the question of artistic creation and competition. His theories, however, are of use in understanding the practices of certain visual artists: Jackson Pollock is one of them.[3] According to Bloom, the artist's rela-

tionship to a "strong precursor" (or precursors) is one of receptiveness and resistance, taking and trying not to take. Here influence has a special meaning. It is not the sum of borrowing that appears in a body of work but a dynamic struggle between the artist and his or her master. Influence is both the means and the obstacle to individualized expression: the means, in that without a received set of forms and a context to put them in, expression itself would be impossible; the obstacle, in that these forms are necessarily not the artist's own. The strength of the artist's voice is dependent on his ability to rework (Bloom would say misread) the master's style, reinterpreting it, so that it appears to emanate from the later artist's own powers. If we agree that one of the functions of art for the modern artist has been the projection of the self onto an object, influence—insofar as it comes from outside the self—is interference. But the artist cannot generate his art from nothing. He needs influence, even as the child needs his parents. To put it another way, the more an artist finds what he wants to say in another artist's work, the less he is able to say himself. In this way the "love" of the artist for the work of his teacher may be ambivalent, involving both attraction and a longing for escape.[4]

Pollock's struggle with Picasso appears overtly in his work. I think this struggle provides part of an explanation for his radical departure from figuration in 1947 and his rejection of the traditional tools of the artist's craft. I do not deny the significance of other artists in shaping Pollock's development: he borrowed from Masson, Miró, Benton, and Mata, as well as from the art of so-called primitive cultures. His paintings and sketches from the 1930s and early 1940s owe a tremendous debt to the Mexican muralists David Siqueiros and José Orozco.[5] Yet, as William Rubin has discussed, Picasso is the crucial example, the Oedipal father, he emulated and tried to surpass.[6] Lee Krasner, Pollock's wife, offered this account of Pollock's rivalry with Picasso: "There's no question that he admired Picasso and at the same time competed with him, wanted to go past him. . . . I remember one time I heard something fall and then Jackson yelling, 'God damn it, that guy missed nothing!' I went to see what had happened. Jackson was staring; and on the floor, where he had thrown it, was a book of Picasso's work."[7]

But Krasner's story only ratifies what is often embarrassingly apparent in Pollock's work prior to 1947. Picasso's line, composition, even particular trademark motifs—masks, bulls, horses—show up in Pollock's art from 1938 through 1946. Often we may regret that the repression is not strong enough. Picasso's influence is so pervasive in these years and

appears in so many forms that it is difficult to characterize specifically. At one moment it is blatantly declared, as in *Don Quixote,* or somewhat reworked, as in *Two,* or almost completely hidden, as in *Night Mist.* The problem is compounded by the nature of the art to which Pollock responds. Although the complexly ordered constructions of classic Cubism certainly inform his work, Pollock is particularly drawn to the moments of difficulty and confusion in Picasso's practice, to his work of the first years in which Cubism was formulated, and to his diffuse and peculiar production of the late 1920s and 1930s. What was Pollock's attitude toward Picasso's art, especially the more controversial art of the 1930s and early 1940s, and how did it compare to the general response among American critics?

November 1939 marked the opening of the exhibit *Picasso: Forty Years of His Art* at the Museum of Modern Art in New York City.[8] Over 350 works, drawn from all periods of his career, were included. Although Pollock certainly did not need the retrospective to become familiar with Picasso's work (New York had been bombarded with Picasso exhibits at various galleries all through the 1930s, and Alfred Barr had included his work in virtually every show at the Museum of Modern Art, regardless of the theme),[9] the exhibit provided a chance to take stock of Picasso's total output. It does not seem coincidental that about this time Picasso's art takes hold of Pollock. Given the extraordinary quality of the show and Picasso's enormous prestige, generally heightened by the political impact of *Guernica* (its message underscored by the beginning of World War II), the critics were surprisingly ambivalent. Edward Jewell began his review in the *New York Times* with a parody of Gertrude Stein's study of Picasso, published that year: "Now we have Picasso and now that we have Picasso what are we going to do about Picasso now that we have him?" Despite the satirical tone, the question is taken seriously and pursued: "Of course, in a sense this was not the first time the great question: What to do about Picasso? had presented itself as in earnest quest of an answer. But it began to be asked with a new earnestness because the people who went to the preview . . . realized now that evasion would be no longer possible."[10]

Jewell himself is uncertain of an answer to his own question. Although he is certain of Picasso's position as "a fermenting, galvanizing force," he is unable to make any sense out of the most recent work. Jewell's discomfort is not unique, or so the title of an article in *Art Digest* would indicate: "NEW YORK CRITICS COLDLY REVALUE THE ART OF PICASSO, ZEUS OF PARIS."[11] The key word is "revalue," for clearly the

response was taken to contain a new element, an irritation with the work not expected by the staff of *Art Digest*. Although Picasso is certainly accepted into the canon of modern masters, aspects of his career worry the critics cited in the article. According to *Art Digest*, Jewell is joined by the critics Jerome Klein, who is also disturbed by the recent work, and Margaret Bruening, who remarks that "incredible as it seems he does at times become ensnared in his own formula; he is wayward and even malicious; he likes the enigmatic often merely because it is only enigmatic; at times he becomes sadly sentimental." *Art Digest* undoubtedly exaggerates and simplifies the diversity of the critical response—for example, it overemphasizes Jewell's acerbic comments, yet the exaggeration is a reaction to a real sense of uneasiness among the reviewers. In a rather mundane profile in the *New York Times*, Anita Brenner calls Picasso the most "famous and fashionable modernist alive today." He is taken to be the European master par excellence because, as Brenner claims, "he has drawn upon the whole accumulation of human experience in the arts, lifting many an idea from his contemporaries, too: so that the sum total of his work represents all modern art more completely than any other man's." But although he is given the dubious title "Mississippi of the Moderns," his "multiplicity of styles" is "bewildering."[12] Alfred Frankfurter, of *Art News*, begins his review of the retrospective with two evocations of the artist—Picasso the charlatan and Picasso the genius—and concludes somewhat predictably that he is a little of both.[13] The newspaper critics are distinctly uncomfortable with the leaps in Picasso's practice, the changes in his figuration, his peculiar reworking of historical styles, his oscillation between public and private symbolism. It is not so much Picasso's formal radicalism that is the problem as the inconsistencies of his style and his propensity for self-aggrandizement. Repeatedly the critics wonder how serious Picasso's art is, how committed he is to any particular strand of modernism. The doubts of the journalists are sharp in contrast to the extravagant claims made for Picasso's art two years earlier by John Graham, the painter and critic: "Picasso's paintings have the same ease of access to the unconscious as have primitive artists—plus a conscious intelligence. . . . No artist ever had greater vision or insight into the origins of plastic form and their ultimate logical destination than Picasso. . . . He delved into the deepest recesses of the unconscious, where lies a full record of all past racial wisdom."[14]

Graham was an early admirer and friend of Pollock, whom we know had read with care and approval Graham's "Primitive Art and Picasso,"

from which this quote is drawn.[15] Given Pollock's brief remarks later about the source of his own art in the unconscious,[16] he probably would have been drawn to Graham's reading (whatever he might have thought of its hyperbole). But the problem for Pollock is that Graham leaves no place for followers. If Picasso has already delved into the deepest recesses of the unconscious, what is there left for Pollock to do? Can we interpret Graham to suggest that Picasso's unconscious is different from other artists' and therefore contains different material? But then what is meant by the phrase "racial wisdom," with its implication of a collective unconscious that Picasso has somehow already tapped?

Robert Goldwater, later a prominent member of "The Club," an informal association of Abstract Expressionists and their art-world supporters, provides a more profound reading of Picasso's art, one that tries to account for its failures and its achievements in the 1930s. Goldwater agrees with the popular critics in wondering whether there are any constants in Picasso's production. For Goldwater, Picasso maintains "a constant spirit of torment, a constant feeling not that the individual work is incomplete, but that its import and expression are bursting the bounds of its forms. . . . Picasso's pictures tend to fill and overfill their frames, to touch at all possible points." He continues: "[Picasso's] recurring revolutions are an attempt to avoid the development of a manner, of a style, of a formula, which would destroy the struggling balance between form and expression. . . . Picasso, in common with other contemporary artists, has been denied a tradition within which to work. . . . Given neither ordered subjects nor a general ideal which is external to him and which he can take for granted, the modern artist must literally go through difficult contortions in order to express things drawn entirely from himself."

Goldwater ends pessimistically for the young artist hoping to use Picasso's painting as a basis for a personal style. Although he implies that Picasso's difficulties are characteristic of modernism, his solutions are considered dead ends. Goldwater asserts that because Picasso's art "consists so largely of 'transformations' of which he [Picasso] speaks, changes which are as much psychological as formal, another artist cannot begin at the point at which Picasso ends." By "psychological," Goldwater means personal, drawn from the self. Other artists cannot use Picasso's solutions because they already bear the master's distinctive mark. But why should the master-pupil relationship break down so particularly in the case of Picasso and his followers? Why should not the student be able to remake Picasso, just as Picasso remade his precur-

sors? Goldwater hints at an answer, though he does not follow up on his suggestion. Earlier he asserts that Picasso's "contortions" are in part a result of his technical heritage and his knowledge of historic styles. Too much knowledge means that for Picasso "direct, unallusive statement has become particularly difficult, and he finds it doubly hard and doubly important to avoid banality and repetition." A few sentences later Goldwater comments that it is therefore "inevitable that an expression should seem to have to be already exhausted when it is still mysterious to others, and so a 'period' lasts for a very short time."[17] The real problem is not that Picasso's solutions are too personal to be used by his students but that they almost immediately become unusable for Picasso. It seems that Picasso's failure to found a "school" is in part a failure to define a stable practice, an art that is coherent in its progressions, open to reuse and variation both for Picasso and his students.

If Pollock had read Goldwater's article, he would have refused its warning. Yet Pollock's art was involved in exactly the kind of contortions Goldwater felt characterized Picasso's art in the 1930s. Picasso's personal statement in the catalogue to the 1939 retrospective might have given Pollock a clue as to how to proceed. Certainly he presented American artists in general with powerful assertions about painting, assertions to test and react against, when he declared that "there is no abstract art. You must always start with something. Afterward you can remove all traces of reality. There's no danger then, anyway, because the idea of the object will have left an indelible mark. It is what started the artist off, excited his ideas, stirred up his emotions. Ideas and emotions will in the end be prisoners in his work. Whatever they do, they can't escape from the picture. They form an integral part of it even when their presence is no longer discernible."[18]

Here Picasso seems to be launching into an attack on a certain kind of abstract painting and its theory, one that claims to be nonfigurative, even nonrepresentational, but it becomes clear later in the text that he is actually describing the process the image undergoes in his own work. He continues:

Everything appears to us in the guise of a "figure." Even in metaphysics ideas are expressed by means of symbolic "figures." See how ridiculous it is then to think of painting without figuration. Do you think it concerns me that a particular picture of mine represents two people? Though these two people once existed for me, they exist no longer. The "vision" of them gave me a preliminary emotion:

then little by little their actual presences became blurred; they developed into a fiction and then disappeared altogether or rather they were transformed into all kinds of problems. They are no longer two people, you see, but forms and colors; forms and colors that have taken on, meanwhile, the *idea* of two people and preserve the vibration of their life.[19]

Picasso moves away from the initial vision—"though [they] once existed for me, they exist no longer"—but this movement away amounts to a return. The process of going beyond the image and the object it represents, negating it, yields an expression of its essential quality, "the vibration of [its] life." "Blurring" and the eventual disappearance of the two figures, Picasso tells us, results in their essential preservation in form.

Pollock's attempt in 1947 to deny the inevitability of figuration and thus to prove Picasso wrong comes only after he first took on Picasso's project of trying to make figuration work. Pollock shares with Picasso a sense that figuration's existence in modern painting depends paradoxically on a denial of figuration. Pollock's often quoted statement that he had decided to "veil the image"[20] in his painting is a variation of Picasso's description of abstraction as a process of "blurring," of "destructions." Both artists ultimately claim that art reveals by hiding. Pollock insists on the "veil," even as he asserts that his paintings come from, and presumably express, the unconscious. Significantly, this claim does correspond to the psychoanalytic account of how the unconscious makes its appearance in consciousness, the clues it sends out through the mechanism of repression.[21] Just as repression does not eliminate the dangerous content, instead merely disguising it so that it can exist in consciousness, painting does away with the initial image, only to preserve the essence of the image, the aspect that made it attractive. If Pollock's initial images belong to Picasso, this process holds out the hope of wresting them free through a repression, or veiling, that will convert them into Pollock's property.

From the beginning Pollock's use of Picasso is characterized by an element of critique, an unwillingness to swallow him whole or be swallowed. Pollock seems to consider *Guernica* (fig. 2.2) the most powerful painting by Picasso; he returns to it repeatedly in the period from 1939 to 1946. It is latent in Pollock's condensation of fragments of human and animal figures in the triangle at the center of the strange *Man, Bull, Bird* (fig. 2.3), and it is clearly manifest in a group of sketches from the same period. Perhaps because the sketches were private, and not meant

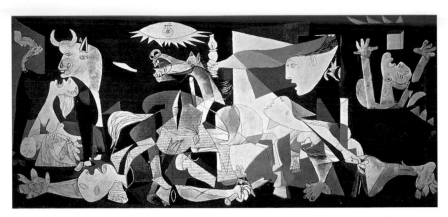

FIGURE 2.2 *Pablo Picasso,* Guernica, *1937, oil on canvas, 137 ½ x 305 ¾ in. Museo Nacional Centro de Arte Reina Sofia*

FIGURE 2.3 *Jackson Pollock,* Man, Bull, Bird, *ca. 1939, oil on canvas, 24 x 36 in. The Anschutz Collection*

to be exhibited, quotations from *Guernica* appear undisguised. In the drawing *Untitled No. 582* (fig. 2.4), the head of a woman at the right center of Picasso's *Guernica* has been converted by Pollock into the image of a single scream, her tongue a dagger point. With her open mouth and outstretched arms, she is a composite of the mother and child (at the far left) and the gesturing man (at the far right) of *Guernica*.

FIGURE 2.4 *Jackson Pollock,* Untitled (No. 582), *ca. 1939–42, pen and brown ink on paper, 13 ⅛ x 10 ⅜ in.*

What was the attraction of *Guernica*? Why do its forms reappear in Pollock's art so frequently? In this work Picasso took on the problem of making a coherent social statement on a public scale. For Pollock, *Guernica* may have been a model for reconciling his earliest artistic influences—the social realism of his teacher, Thomas Benton, and the political radicalism of the Mexican muralists Diego Rivera, Orozco, and Siqueiros—with European modernism. *Guernica* appeared to signal Picasso's move out of the studio and into the forum of public action. Above all, it joined the attempt by the Mexican and American muralists to revive the tradition of history painting that modernism had abandoned. And it did so on a heroic scale and with a confidence of means that was equivalent to the bravado of a Rivera or Benton. Yet even though *Guernica* was undoubtedly a powerful solution to one of the early difficulties of Pollock's art, it, too, received a mixed reaction from the critics, who questioned precisely its success in reconciling history painting with modernism (that is, the language of post-Cubism). A constant of much of the writing about *Guernica* at the time, whether positive or negative, is the mention of a dichotomy between Picasso's technique, his restrained palette and the flattened forms, and his subject, the brutal bombing of a small town. Vernon Clark writes in "The *Guernica Mural*: Picasso and Social Protest": "We are immediately struck, when we examine the *Guernica* by the strange lack of relationship between the subject and the method of presenting it. This, of course, rep-

resents nothing new in Picasso's career; such a lack of harmony between the technique and content appears consistently throughout his painting. The artist has apparently set a limit upon his feelings and upon the intensity of his expression beyond which he has arbitrarily forbidden himself to go."[22]

He concludes that in *Guernica* "Picasso has needed to resort to the most drastic muting methods, the most remote allusions, the most involved de-emotionalizing mechanics to attain the balance and tranquility on which he believes the aesthetic sovereignty of the artist depends." Not surprisingly, Robert Goldwater admires precisely this distancing of the horror in *Guernica*. He wrote that it is "one of the few modern murals which keeps its scale throughout, and it is in grisaille because in color its impact would have been bearable only at a tremendous distance."[23] But Charles Lindstrom puts the question in the most pragmatic terms in an explanatory label provided for the painting when it was exhibited in San Francisco: "The modern painter of war . . . must of necessity recast the horror of his subject so that the mind will not recoil from the shock. The artist must clearly remove the scene from the field of actuality so that the spectator is not too fearful to extend his sympathy to the anguished drama."[24]

But had Picasso gone too far in the work of distancing, allowing the viewer an easy exit from the subject entirely? If so, was this trap intrinsic to the larger project of a revitalized figuration?

Pollock's reworking of *Guernica* centers on the element of distance that was so important to the critics. Significantly, he turns for help to Picasso's sketches for the painting. For example, the presence of the horse in Pollock's drawing *Untitled No. 582* examined above, points us in the direction of a sketch by Picasso that appeared in the 1939 retrospective in which the mother, child, and horse of *Guernica* are drawn on the same page (fig. 2.5).[25] The *Guernica* sketches have none of the elegance and stability of the final mural. They offered Pollock the chance to retrace Picasso's steps in formulating his composition. Pollock's reworking of Picasso's rough and immediate sketches may be the equivalent of searching for the place where *Guernica* went wrong, when the process of removing the horror from the composition went too far. The ambivalence of Pollock's attraction to *Guernica* and the rest of Picasso's work is more explicit in the paintings of the same period. In *Masqued Image* (fig. 2.6) Pollock experiments with one of Picasso's central themes, the face as mask. The gaping mouth at the top again recalls *Guernica*, now reconceived in heavy, overworked impasto. But the basic

FIGURE 2.5 *Pablo Picasso,* Horse and Woman with Dead Child, *1937, graphite on paper, 9 ½ x 17 ⅞ in.*

composition is closer to Picasso's famous *Girl Before a Mirror* (fig. 2.7). Pollock and Picasso give us very different kinds of masks: Pollock, the mask as inner state, the unconscious self made conscious; Picasso, the mask as outer show, the vain makeup implied by the mirror. But there are striking formal similarities. Like Picasso, Pollock wants to constrain his figuration within the bounds of a limited space. Like Picasso, he creates a confrontation between two sides of the canvas. But whereas Picasso flirts with the purely decorative, Pollock continually resists the logic of pattern making. In *Girl Before a Mirror,* Picasso seems to delight in converting the female body into geometry, geometry repeated by the mirror (the traditional surrogate for the artist), in the same way the wallpaper behind the figure repeats the diamonds in its pattern. In contrast, Pollock's faces do not fall into elegant arrangements; instead they push against one another. We sense Pollock's searching for a way to handle painting that would be an equivalent to the actual violence of the process of abstraction, the way it converts the world into fragments and planes of color. It is as if Pollock was suggesting that Picasso had not gone far enough in his self-named work of "destruction," reworking the world too easily in schemes that leave the real world untouched. For Pollock, impasto and crude handling become the means for reconciling subject matter with form.

In these early works we can sense Pollock not only relying on *Guernica* but also trying to go back to Picasso's beginnings. A painting like *Moon Woman* (fig. 2.8) is trying to do to Picasso what *Les Demoiselles*

FIGURE 2.6 *Jackson Pollock,* Masqued Image, *ca. 1938–41, oil on canvas, 40 x 24 ⅛ in. The Fort Worth Art Museum purchase, made possible by a grant from the Anne Burnette and Charles Tandy Foundation*

FIGURE 2.7 *Pablo Picasso,* Girl Before a Mirror, *1932, oil on canvas, 64 x 51 ¼ in. The Museum of Modern Art, New York. Gift of Mrs. Simon Guggenheim*

d'Avignon did to Cézanne. Just as Picasso purposely exaggerated the obvious awkwardness of Cézanne's bathers, Pollock takes Picasso's monstrous women and tries to make them even more grotesque. In the same way, Pollock's *Moon Woman* is both an homage and a challenge to Picasso. Picasso's *Seated Woman* (fig. 2.9) may have been Pollock's starting point. Pollock's paraphrase of a Picasso face is so obvious that the picture approaches parody. Pollock adopts a crude version of the heavy black lines that Picasso uses to define his figure, but his painting does not do the same work. We get no sense of Picasso's bravura brush stroke, nor the feeling that the line is really there to define the woman's body. Where the shapes in Picasso's paintings are carefully individualized and separated, Pollock allows body and background to merge. The assertiveness of Pollock's brush stroke suggests that he is trying to make his forms more concrete, yet this is contradicted by the Moon Woman's diffusion into the background of the canvas. The indeterminacy of the space she inhabits is matched by the painting's uneasy balance between elegant abstraction evidenced in the woman's Picassoesque mouth and nose and the purposely rough handling of the paint. The problem for Pollock is that it is hard to outplay Picasso at his own game. At times Picasso constrained his temperament through the use of a consciously decorative style, perhaps out of fear that without the equipment of flat pattern and sensuous colors his art would be in danger of collapsing into stridency and false horror; at other times, however, he draws close

FIGURE 2.8 *Jackson Pollock,* Moon Woman, *1942, oil on canvas, 69 x 43 ¹/₆ in. The Peggy Guggenheim Collection, Venice, Solomon R. Guggenheim Foundation, New York*

FIGURE 2.9 *Pablo Picasso*, Seated Woman, *1927, oil on wood, 51 ¹/₈ x 38 ¹/₄ in.*
Museum of Modern Art, New York. James Thrall Soby Bequest

to the edge. The attributes of sensuous line and bright color only add to the horror of the subject's gaping tooth-filled mouth in his well-known *Seated Bather*. The floral pattern and brilliant handling of paint lure us into this orifice, this vaginal opening, tempting and repellent at once. In this way, Picasso can use his facility to upset our expectations, making the expression more perplexing and frightening through the peculiar displacement of subject and style.

Perhaps Pollock's most profound attempt to come to terms with Picasso's art directly is reflected in two paintings from 1946, *The Child Proceeds* (fig. 2.10) and *White Angel* (fig. 2.11). The peculiar hiding and reemergence of Picasso's influence seem to suggest that Pollock cannot conceive of figuration without Picasso. He admits as much in these two canvases. Here, I think for the first time, we see Pollock actually trying to paint full-bodied Picasso paintings, almost as if he were the master. Pollock does not take a single element of Picasso's style and exaggerate its implications, nor does he fight with Picasso's method of abstracting the figures' bodies. The vaguely maternal figure on the left in *The Child Proceeds*, for example, is very much like a Picasso statue *Standing Woman*, while the apparently female figure recalls Picasso's method of figuration in *The Three Dancers* (fig. 2.12). It does not seem coincidental to me that Pollock reproduces Picasso's images most exactly in two pictures that concern parents. *The Child Proceeds* depicts a couple locked in some sort of sexual embrace that simultaneously produces the fetus in the womb of the "female" figure (Pollock consistently combines gender characteristics, perhaps alluding to the notion of the artist as both male and female, father and mother). Again in *White Angel* we observe two figures; one male, the other vaguely female. The woman on the right seems to have a kind of fetus in her womb, but instead of being made up of swirling brush strokes the embryo is indicated by a series of sign-like lines and dots. I think Pollock's meaning is related to his adoption of Picasso style. These paintings are about origins, the artist as child and his relationship to his parents. Pollock's origin is in Picasso, and so his parents take on Picasso's shape, or the shape of his art. The hope of these paintings is really the hope of the last ten years: that by trying to do the work of the parent, the child will proceed. Working back to origins is also Pollock's intent in the great paintings of the next four years, the drip paintings. But here Pollock attempts a return to the primal origins of art, as if trying to discover what it would be like to paint the very first painting. In striving to divest himself of Picasso's influence, and that of the European modernism he represents, Pollock appears

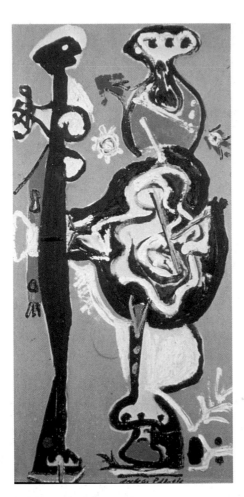

to find it necessary to try and throw off all influence. In the years between 1938 and 1946, Pollock had mirrored what Goldwater called Picasso's "contortions," trying to find a distinctive mode of figuration—though figuration always returned Pollock to Picasso. The result was that instead of making the unconscious visible, or representing the self, Pollock appeared to be merely imitating, distorting, or hiding other art. In doing away with figuration (not merely veiling it, as Pollock claimed), he could seem to do away with Picasso and the great tradition he represented.

Picasso's reputation after the war may have had something to do with both Pollock's admiring acceptance of the Spaniard's influence in 1946 and his violent rejection of it in 1947. The ambivalent tone of American critics in 1939, undoubtedly conditioned by a fear of anything that

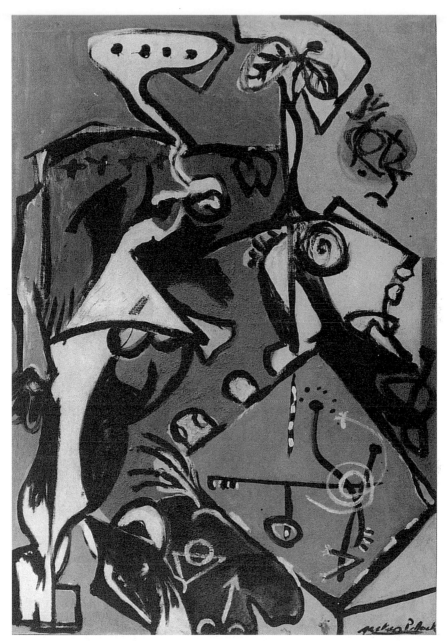

FIGURE 2.11 *Jackson Pollock,* White Angel, *c. 1946, oil, enamel, and sand on canvas,*
43 ½ x 29 ⅝ in.

FIGURE 2.12 *Pablo Picasso, The Three Dancers, 1925, oil on canvas, 88 5/8 x 55 7/8 in. Tate Gallery, London*

came out of the troubled European continent, was replaced by almost universal adulation. As Barr noted in the greatly expanded catalogue of the retrospective published in 1946, Picasso's presence in Paris during the Occupation, during which he supposedly risked torture at the hands of the Nazis, converted this controversial painter into a saint.[26] He became a symbol for the survival of Western culture. How could Pollock follow this artist? His solution is to seem not to follow Picasso at all, to repudiate Picasso's premise that art without figuration is impossible. In the end the drip paintings not only do away with Picasso's figuration, but they abandon all his trappings and the trappings of the tradition Picasso had come to embody. Pollock's rejection of materials bought in the local art store is a rejection of the easel and brushes of the master and his tradition, even as it is an attempt to re-create what it might have been like to be the first artist. It returns Pollock to the cave, to a time when paint was any colored liquid at hand, the canvas was a wall, and brushes were the tools of everyday life. The handprints actually connect

Number 1A, 1948 explicitly to such prehistoric paintings as those at Pech-Merle. In negating the practice of his precursor, Pollock seeks to negate all precursors, as if endeavoring to be the first artist to paint a picture entirely from within himself. I think this is behind the peculiar appeal that the title *Number 1* had for Pollock (as T. J. Clark points out, he used it four times in three years).[27]

There is an unavoidable paradox in Pollock's radical attempt at priority. To produce a representation of the self that owed its existence to no other, he had to eradicate all traditional means of projecting the self onto the canvas. It is no longer the figures or objects and their relationship on the canvas that are the surrogates for the self but the entire field, the painting alone. In willfully confusing the self with his creation, Pollock, the Abstract Expressionist par excellence, disrupts an essential premise of expressionist art—namely, that its purpose is to represent the artist's emotional state. Representation by definition requires a separation between that which is represented and that which does the representation, between the self and its object. This separateness is different from Pollock's claim that he has actually became one with his painting. In this way, Pollock's stance *in* the painting is both triumphant and terrifying. It is triumphant because Pollock has made the move into the painting seemingly by his own power, terrifying because it undermines the position of the artist in relationship to his or her art.

In chapter one we saw how for one modernist, Adrian Stokes, the goal of art was both integration and autonomy. Stokes was both drawn to what he called the merging kind of art, for which Pollock's pictures could stand as a model, and frightened by its deathlike limitlessness. And so he insisted that the great work of art holds its distance. Remember that for Stokes painting was the preeminent medium precisely because it is created through a process by which the artist is separated from the canvas by the length of the brush. But Pollock had seemed to do away with brushes, or that was the story.[28] He had willfully placed himself in the canvas. Now that Pollock is actually in the painting, how does he get *out?* How does he extract himself from the painting and so judge it, make changes, and produce other works of art? Now that he has produced the first painting, what will the second look like?

It is the problem of positioning himself in relationship to his paintings that occupies Pollock after the initial move inside them. How can he get out yet not be where he was just before going in? This problem may provide a partial explanation for Pollock's performance in Hans

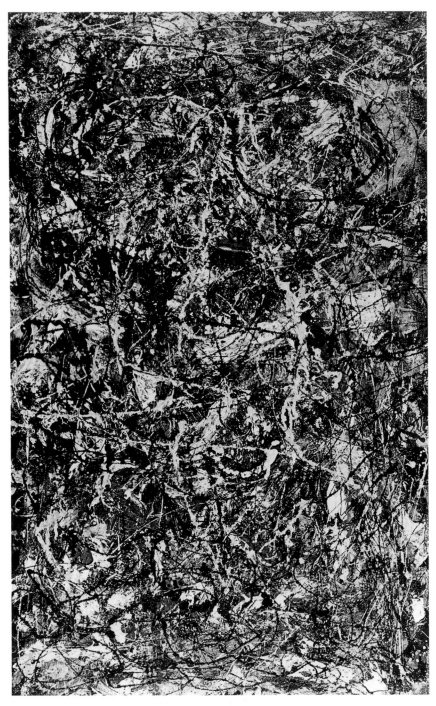

FIGURE 2.13 *Jackson Pollock,* Full Fathom Five, *1947, oil on canvas with nails, tacks, buttons, key, coins, cigarettes, matches, etc., 50 ⅞ x 30 ⅛ in. The Museum of Modern Art, New York. Gift of Peggy Guggenheim*

Namuth's films and photographs.[29] What could be gained by making a supposedly private process public? Significantly, it was Picasso who called for such a record in his 1935 statement: "It would be very interesting to preserve photographically, not the stages, but the metamorphoses of picture. Possibly one might then discover the path followed by the brain in materializing a dream."[30] But being filmed was not just another example of Pollock following Picasso's suggestions. Clearly, Pollock believed his performance was important to the understanding of his work. Perhaps he hoped that Namuth's documentary would make clear both to him and to his audience the difference between Pollock and a Pollock, between the artist and the object he makes. The result was the opposite. The very action of painting became confused with the painting itself.

Pollock's difficulty in deciding where the painting stops and where the artist begins is mirrored, I think, in his problem of deciding where to crop the canvas, where the painting must stop. It might also explain the constant question put to Krasner: "Is it a Painting?" as well as his fear of putting a signature on his work.[31] It is no wonder that the signature haunts Pollock, along with the cutting of the canvas, because its finality puts an end to the process of making the first painting. The presence of the signature automatically calls for a new painting, the next step, even as it signals the shipping off of bits and pieces of the artist out into the world. And so when the crucial separation between the artist and what he makes breaks down, the problems multiply and elements of the practice that were once taken for granted take on strange significance. The attempt to escape from influence by throwing out so many of the accessories of the Western artist brings with it the cost of heightened uncertainty about what remains. The rationale for the entire project of expression of the self in a two-dimensional surface becomes suspect. The pressure of Pollock's questioning undermines even the medium itself. Why should the canvas stop? Why a signature? Why a two-dimensional surface? Why paint?

Built into the title of one of the first and most celebrated of his drip paintings, *Full Fathom Five* (fig. 2.13), is a desire for a less anxious relationship to the art of the past. Pollock's hope was that in the end the veil would in fact reveal. The disguise would express the essential subject, or that which it had only been a symbol for, the unconscious. In this way, Picasso's influence would not be eradicated but saved just under the surface of a transparent veil, and so Pollock might escape from the father and be one with the father at the same time. This dream of

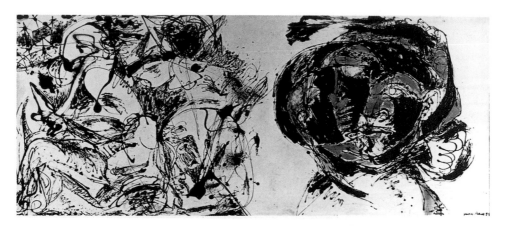

FIGURE 2.14 *Jackson Pollock*, Portrait and a Dream, *1953, enamel on canvas, 58 ⅛ x 134 ¼ in. Dallas Museum of Art, Gift of Mr. And Mrs. Algur H. Meadows and the Meadows Foundation Incorporated*

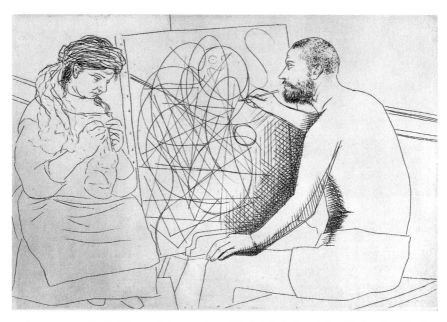

FIGURE 2.15 *Pablo Picasso*, Painter with a Model Knitting (*plate IV from* Le Chef d'Oeuvre Inconnu *by Honoré de Balzac; Paris, Ambrois Vollard, Éditeur, 1931), 1927, etching, 7 ⁹/₁₆ x 10 ¹⁵/₁₆ in. The Museum of Modern Art, New York. The Louis E. Stern Collection*

reconciliation is contained in Ariel's song from Shakespeare's *The Tempest,* the source of the title *Full Fathom Five:*

> Full fadom five thy father lies;
> Of his bones are coral made;
> Those are pearls that were his eyes:
> Nothing of him that doth fade,
> But doth suffer a sea-change
> Into something rich and strange.[32]

The song envisions the death of the father as a painless transformation. Rather than portray an anxious struggle, like the storm that introduces *The Tempest,* it suggests quiet erosion that salvages what it reworks. Extraordinary paintings *do* follow *Full Fathom Five,* rich and strange images, like the ocean in their expansiveness and sense of release. But the father has completely disappeared, no longer available to serve as the source of Pollock's art. In 1950 the Italian art critic Bruno Alfieri summed up the attitude of the next generation of artists: "Compared to Pollock, Picasso . . . who for some decades had troubled the sleep of his colleagues with the everlasting nightmare of his destructive undertakings, becomes a quiet conformist, a painter of the past."[33]

Pollock's *Portrait and a Dream* (fig. 2.14), one of his last paintings, is an attempt to reengage Picasso. The painting is split in half, on one side a clear depiction of a face, on the other a more typical Pollock abstraction (with only the vaguest hints of figuration). Pollock tries to join us outside the work. He tries to hold on to what he knows is his—the web—even as he tries to maintain a sense of his existence apart from the object he creates. He wants to look at what he has done and so move on. Simultaneously he is declaring the connection of his painting to the unconscious—portrait is the dream. Unfortunately, the old problem reemerges and the master comes back too fully. Pollock's tactic had been tried before by Picasso (when he too was facing a crisis in his work) in his print *Painter with a Model Knitting* (fig. 2.15). Given Pollock's past dependence on Picasso's figuration, it is no surprise that the face of *Portrait and a Dream* is a nervous version of a Picasso mask. But it is a shock to see how closely Pollock's dream resembles the drawing on Picasso's easel in the print. Somehow, the escape, carried out at great risks, ends in a return.

3 Staged Artist

Sally Mann's *Immediate Family*

I began by focusing on the theme of the artist's mother. But what if the artist and the mother are one? Sally Mann's fame is based on the novelty of her project of photographing her three children, Emmett, Jessie, and Virginia, in situations of vulnerability and awkwardness. These photographs have compelled certain viewers to raise the issue of abuse, while others have seen in her art an honest representation of the sensuality, pain, and wonder of childhood. *Wet Bed, 1987* is one of the most controversial of her pictures.* It shows her youngest daughter, Virginia, naked and seemingly asleep, lying on a urine-soaked bed. Janet Malcolm describes the picture at length in the *New York Review of Books:*

> Mann's Virginia is the embodiment of invulnerable defenselessness: What harm can befall this beautiful, trusting child? But as we follow the photographer/mother's gaze and look down with her on the sleeping little girl, we feel her mother's fear. We take in the heavy darkness that frames the whiteness of the child's bed, out of which the image of the sleeping cherub emerges like a hallucinatory vision, and, above all, we are transfixed by the large pale stain that spreads from the child's body over the tautly fitted sheet. The stain is yet another insignia of Blakean innocence, another attribute of the time of life when nothing has yet happened to seriously disturb a child's blameless instinctuality. But the stain is also an augury of Blakean experience. It foretells the time when the child will have to be broken of its habit of trust in the world's benevolence.

Malcolm follows with a statement of what she believes is Mann's purpose: "Sally Mann's project has been to document the anger, disappointment, shame, confusion, insecurity that in

*Attempts to obtain permission to reproduce photographs by Sally Mann were unsuccessful. Unless otherwise noted, those photographs discussed here can be seen in Mann's book *Immediate Family* (New York: Aperture, 1992).

every child attach to the twenty-year-long crisis of growing up. She stalks and waits for, and sometimes stages, the moments that other parents and photographers may prefer not to see. That this anatomy of childhood's discontents is drawn in a paradisal Southern summer landscape, and that the family in which the children are growing up is as enlightened, permissive, and affectionate as a family can be, only adds to its power and authenticity."[1]

Other critics agree. Malcolm Jones writes in *Newsweek* that Mann captures her children's "gumption and independence. Whatever contrivance is behind the images, her meticulous chronicle so enhances our appreciation of the mysteries of childhood that it is an accomplishment beyond caveat."[2] Reynolds Price, in the afterword to *Immediate Family*, Mann's 1992 compilation of photographs of her children, writes that "these loving, fearful, trustworthy and profound pictures explore the nature of family love, *maternal* love and child response; and they do so from new yet ancient grounds."[3]

Much of the writing on Sally Mann proceeds from a similar premise: that her work is about what it is to be a child or that it explores the nature of the mother-child relationship. Her vision of childhood is deemed authentic, particularly in contrast to the typical amateur snapshots of smiling kids around the picnic table. She gives us the child's moments of happiness, but also the boredom, release, humiliation, and sadism. Mann herself encourages such responses: "We hope they tell truths, but truths 'told slant,' just as Emily Dickinson commanded. We are spinning a story of what it is to grow up. It is a complicated story and sometimes we try to take on the grand themes: anger, love, death, sensuality, and beauty."[4]

Mann cleverly hedges her bets. By hoping that her photographs tell the truth, she introduces the idea that they are documents. In fact they have been referred to as diaries. Yet she says that she and her children are actually "spinning a story," making fiction that tells only "the truth told slant."

I would like to begin with the proposition that Mann's *Immediate Family* is not about the truth of childhood at all. That is, we will not find in these pictures proof that children are sexual, or that children are innocent, or that growing up is wonderful or miserable (or even that it is both).[5] Neither will we be able to arrive at the truth of Mann's relationship to her children from looking at her pictures. I think it is far more productive to think about *Immediate Family* as a work of art that stages the coming into being of an artist. It is the work through which Mann

finds her voice and fame, even as it attempts a kind of explanation for how such a voice might be found. If it is about children at all, it is not about childhood in general but about what it is to be a child of an artist, and what it is to be a child who grows to become an artist. From the beginning Mann confuses the two by insisting that her children are her collaborators and that they even edit which pictures are to be shown. To follow her logic, Emmett, Jessie, and Virginia are not merely passive models but artists in their own right, working with their mother to produce the *Immediate Family*. This confusion of roles is of course built into the biological relationship of mother and child. The two are bound by genetic code and at one point shared the same body.

Photographing might be a way to re-create the process of giving birth. In much of the art-historical debate about objectification and photography, the camera is conceived as a phallic instrument, but it can easily be seen as vaginal or womblike, a box with a hole. Mann herself said, "Good photographs are like the eggs in the ovary, an artist is allowed only so many."[6] Mann's lens brings her children back into the body of her camera, reproducing them again, not as living beings but as works of art.

It is not new to see the process of art-making as a kind of giving birth. One can argue that male artists are driven by womb envy, the act of making art substituting for childbirth. Mann, however, is both a mother and an artist who makes pictures of her own children. If there is a substitution going on in her work, it is not about making children out of art but about making her children into art. Traditionally, childbearing and rearing have been seen as a hindrance to becoming an artist. Mann says that when she had her first baby, she was afraid that she might lose her identity as a photographer. "I felt that I had to work twice as hard to prove that I wasn't turning into a housewife. I forced myself to take pictures even a day or two after they were born so as not to get caught in some kind of trap."[7] But the way out of the trap was not just to take twice as many photographs but to take pictures of the very children who originally threatened her ability to be an artist.

The photograph *The Ditch, 1987* enacts the process. Mann's son Emmett appears to be playing in the mud (such scatological play suggests the primitive sources of art-making in the child's fascination with his own feces). Yet he is not so much playing as posing, crouched in a narrow canal that pours out from the wide lake behind. As Anne Higonnet suggests, the image seems staged to suggest Emmett's emergence from the birth canal.[8] This rebirth is another kind of staging. Emmett per-

forms for the crowd of swimmers who stand around him. Their faces are cropped so that they lose a sense of individuality; they become surrogates for the viewers of the photograph itself. And so Mann converts Emmett's coming into being into her own performance, and his audience becomes the audience of art.

We might also think about *Wet Bed* as an allegory of art-making. The artist-child dreams and from her body come fluids that create a shape on the clean white surface of her bed, an elemental abstract image. But to resolve this photograph into a benign allegory of creation is to miss Mann's aggression. Her goal is to shock. In *Immediate Family, Wet Bed* appears directly across from the *Terrible Picture, 1989,* in which Virginia seems to be dead, hanging from a tree. Such a juxtaposition suggests to me that Mann's ambitions are high and that she intends to scandalize and reap the rewards of such notoriety in the manner of Robert Mapplethorpe. Indeed, *Wet Bed* could be seen as fusing two of Mapplethorpe's most controversial subjects: his images of naked children, for example, *Jessie McBride,* and his focus on the erotics of urination, for example, *Jim and Tom, Sausalito.* It may seem outrageous to compare Mann's photograph of her lovely child with Mapplethorpe's photograph of a man pissing into the mouth of his friend, but does not the comparison point to the danger of Mann's picture, the way it allies the extraordinary beauty and desirability of her daughter with the stream of urine?

The stain on the bed itself looks very much like one of Warhol's purposely scandalous *Oxidation Paintings.*[9] Warhol created the pictures by having young men urinate on a canvases that had been primed with copper paint. Elsewhere I have discussed Warhol's odd experiment in terms of a tradition of twentieth-century scatology, Duchamp's *Fountain* being a founding example and the paintings of Pollock, alias Jack the Dripper, another.[10] These male artists unknowingly had re-created Freud's imagined competition between prehistoric men described in *Civilization and Its Discontents.* Freud claimed that such men delighted in comparing their potency and the strengths of their urinary streams by seeing which of them could best put out the fire. Civilization began when they agree to save the fire instead of putting it out. According to Freud, woman, "because her anatomy made it impossible for her to yield to [the] temptation" of putting the fire out, was "appointed guardian of the fire."[11] In this sense Duchamp and Pollock, as well as Mapplethorpe, Warhol, and Serrano, reject Freud's conception of civilization as one of restraint and purposely evoke a precivilized state. I

FIGURE 3.1 *Alfred Stieglitz*, Photographic Journal of a Baby, *The Photographic Times, vol. 34, no. 1 (January 1902)*

called these artists "bad boys of modern art—metaphorical bed wetters all." But here we have a bed wetter who is a girl. Sally Mann marks out her own territory, and in so doing proves Freud wrong in thinking that the competition of peeing on the fire is a purely male affair.

I have suggested that *Wet Bed* is an erotic image. A repeated theme of several of the articles on Mann is that she risks arrest because of her pictures of nude children. In fact, Mann has benefited from the titillation of potential illegality but has never actually had to face a legal challenge. [12] Perhaps, because there is an assumption that the mother-child relationship is chaste, Mann is shielded from the charge of being erotically invested in her pictures of her children. In general the attacks on Mann concerning the morality of her images differ greatly from the outrage against the art of Mapplethorpe. Critics attack Mapplethorpe's images of men engaging in homosexual acts because of their imagined effect on the viewer. They are thought to be instruments of corruption and solicitation. These critics are unconcerned about the well-being of the gay men in Mapplethorpe's pictures, possibly because, unlike children, they are responsible for their own actions. In the case of Mann, the concern is not what her photographs do to the viewer but what they do to her subjects, her own children. In shifting the attention to the psychic health of Mann's children, critics raise terrors other than the ill effects of pornography.

Looming over the controversy raised by Mann's image is the specter of child abuse. The critics fear that Mann's camera is exposing children to psychic damage, though no reviewer specifies how being made over into photographs will hurt her children. We have to look elsewhere in the culture to flesh out their anxiety. Some six months after *Immediate Family* was published, a novel by Kathryn Harrison appeared entitled *Exposure*.[13] The book tells the story of a father who makes his reputation by photographing his daughter as she grows up. Like Mann, the father takes pictures of his daughter nude and as if she were dead. Unlike Mann, he continues to photograph his child long after she reaches puberty, when she is not aware of his presence, even as she masturbates or has sex with her boyfriend. The father's photographic voyeurism results in a body of photographs good enough to justify a retrospective at the Museum of Modern Art but also in an emotionally damaged woman who is a kleptomaniac and repeatedly attempts suicide.

If Kathryn Harrison was unaware of Sally Mann's work when she wrote her novel, she may have known of Alfred Stieglitz's *Photographic Journal of a Baby* (fig. 3.1). Stieglitz photographed his daughter, who co-

FIGURE 3.2 *Alfred Stieglitz, Katherine, 1905, photogravure, 8 5/16 x 6 5/9 in. The Metropolitan Museum of Art, Gift of J. B. Newmann, 1958 (58.577.22)*

incidentally is named Katherine (Kitty), for several years—from her birth in 1898 until 1902 and then occasionally later.[14] He published several of these pictures in a scrapbook format. Consciously artless, these pictures anticipate the snapshot aesthetic of the postmodern period. Indeed, many of the pictures seem so banal in recording the day-to-day events of an infant that it is difficult to make out Stieglitz's aesthetic intention. In focusing on key events in a baby's life, like learning to walk, he may have been trying to capture the early stages of child development. Later pictures of Kitty seem far more artistic. The most interesting of these, *Katherine* (fig. 3.2), suggests her frustration with being forced to stand still for the camera. She glares fixedly at the camera. The cartoon of a maid with a large knife in her hand on the wall behind her makes explicit her annoyance. Why did Stieglitz abandon the *Photographic Journal of a Baby*? Perhaps his obsession in making his child pose upset his wife, Emmy Obemeyer, or perhaps he could not find a way to make aesthetic sense of the *Journal* project. Unlike his photographs of O'Keeffe, these snapshots are hardly distinguishable from the great mass of snapshots that were made by every adoring parent.

Kitty undoubtedly suffered from her parents' unhappy marriage, which effectively ended when Stieglitz left Emmy for O'Keeffe in 1918.

In 1923, as her parents were in the process of getting a divorce, Kitty gave birth to her own child, whereupon she fell into a postpartum depression and succumbed to schizophrenia.[15] It would be ridiculous to tie Kitty's illness to Stieglitz's early attempts to make her over into his art. Their unhappy relationship, however, could easily have inspired the theme of Hamilton's novel of a daughter made mad by a father's photographs.

A more disturbing fantasy about the result of a parent's voyeurism is the cult film *Peeping Tom,* a favorite of film theorists. Appearing in 1960, the same year as *Psycho,* its perverse and violent story so upset the British critics that it destroyed the career of its director, Michael Powell. The subject of *Peeping Tom* is Mark, a mass-murderer who simultaneously kills and films his victims, using the camera's tripod as a weapon. The murderer's violent acts and compulsion to record them are rooted in his father's habit of studying him as a small boy, filming his every action as he grew up. Early on in the movie we are shown one of the home movies in which Mark's father places a lizard next to the eight-year-old boy's head in order to film his reaction of terror. His father's abusive voyeurism turns his son into an artist of exacting standards who never feels his films of his murdered victims are perfect enough, hence his compulsion to keep on murdering and filming.

Perversely, Powell himself plays the father and casts his own son as the young Mark. Powell remembered the filming of the scene mentioned above: "In the final scene he got frightened, to everybody's embarrassment, including his own. I felt like a murderer, deservedly. Needless to say, I used the scene in the film. If my son had lizard complexes late in life, it will be my fault."[16]

By filming his son, Powell is guilty of the same crime as the film's sadistic father. His guilt makes him feel like a murderer, that is, he identifies with both the fictional Mark and his father. It is as if Powell were compelled to act out his own conception of the artist as both victim and perpetrator of a voyeuristic and narcissistic art.

In these times of working parents, we think of child neglect as a matter of not paying enough attention to a child. But the fathers of *Exposure* and *Peeping Tom* devote too much attention to their children. Sadly, this holding of the gaze of the parent does not bestow self-worth. Instead the children suffer ego loss; they grow up feeling unloved and unlovable. In the case of *Exposure* the daughter believes that by virtue of getting older, she inevitably lost her father's interest. In both *Exposure* and *Peeping Tom,* looking through the camera is conceived as distancing or even obliterating parental love. The omnipotent father of *Peeping*

Tom goes out of his way to humiliate his son and to capture that humiliation on film. Yet the father's work is not meant for public exposure. In contrast, the daughter in *Exposure* is humiliated twice, first by posing for the pictures and then by their exhibition. Above all, *Exposure* and *Peeping Tom* conceive photographing and filming children as acts of parental narcissism.

Here it is important to stop a moment and reconsider my argument. I want to make it clear that I am not investigating the terms of Mann's relationship to her children. I do not mean to suggest that Mann's practice of photographing her children will produce the schizophrenia of Stieglitz's daughter, nor the kleptomania of the daughter in *Exposure,* nor the monster of *Peeping Tom.* Just as we cannot know what it would be like to be Mann's children, we cannot and should not predict the effect of their being their mother's subject. Rather, I take Mann at her word in that she is "spinning stories." One of those stories is the artist's origin in self-love. Mann's fascination with water and its illusive reflections encourage thinking about the artist's vanity and the myth of Narcissus. In *Emmett, Jessie, and Virginia, 1990,* the lake seems to completely surround the children. The water's mirroring of their image is a metaphor for the photographic process itself, even as the pool suggests the chemicals that reveal the image on paper. The blackness of the water and sky set off her children's beautiful bodies. But since Mann is the mother of her subjects, her camera's loving look is in some sense a desire for herself. The lake is a metaphor for Mann's photographic technique, but it also is the pool in which Narcissus became entranced by his own image.

Looking at Mann's remarkably beautiful children in *Immediate Family,* charming even when covered with blood or Popsicle drippings, I cannot help thinking that they have the exquisite features and lithe bodies of child movie stars. Indeed, the phenomenon of the stage parent, mothers and fathers who live vicariously through their children's performances, may be closer to the story of the *Immediate Family* than the violence of *Exposure* or *Peeping Tom.* When I began work on this chapter, I imagined that it would be a relatively easy job to investigate the psychological and social role of the stage parent. Although our culture invests an enormous amount of psychic energy in stories of the controlling and grasping parents behind the success of such child performers as Brooke Shields, Elizabeth Taylor, and Michael Jackson, careful studies of the phenomenon are surprisingly scarce. However, the larger issue the phenomenon of the stage parent raises—that is, the use of the

child as an object of the parent's narcissism—is the subject of the work of Alice Miller, the enormously influential child psychologist.

The story of the making of *Immediate Family* could almost be a case study out of Miller's *Drama of the Gifted Child.* The very title of her work suggests theater, as if the relationship of parent to child she critiques were a work of art, albeit a flawed and repetitious one. Miller's interest is not children who have been physically abused or who have grown up in situations of extreme deprivation but rather those who have in some sense been loved too much or improperly. I introduce Miller here not as an expert who has the key to unlock Mann's work but because her writing is yet another story that we tell ourselves about the role of the narcissistic parent in the development of the creative child. Indeed, Miller describes the dysfunctional parent as if beginning a fairy tale: "There was a *mother* [Miller includes a footnote stating that the gender of the actual caregiver is not important] who at the core was emotionally insecure and who depended for her equilibrium on her child's behavior in a particular way." In response, the child develops "an amazing ability to perceive and respond intuitively, that is unconsciously, to this need of the mother, or of both parents."[17] The child becomes a kind of artist or actor, performing in order to be loved. Miller actually uses a well-known artist's life as an example of parental exploitation. According to Miller, Henry Moore "massaged his mother's back with an oil to soothe her rheumatism. Reading this suddenly threw light for me on Moore's sculptures: the great, reclining women with the tiny heads—I could now see in them the mother through the small boy's eyes, with the head high above, in diminishing perspective, and the back close before him and enormously enlarged."[18]

The parent's narcissistic love produces the ambitious and creative individual, but one who is forever unhappy and insecure. The gifted child will "do well, even excellently, in everything they undertake; they are admired and envied; they are successful whenever they care to be—but behind all this lurks depression, a feeling of emptiness and self-alienation, and a sense that their life has no meaning. These dark feelings will come to the fore as soon as the drug of grandiosity fails, as soon as they are not 'on top,' not definitely the 'superstar,' or whenever they suddenly get the feeling they have failed to live up to some ideal image. . . . Then they are plagued by anxiety or deep feelings of guilt and shame."[19]

Miller's account fits perfectly the popular view of the modern alienated artist, driven by ambition, yet unable to match the achievements of

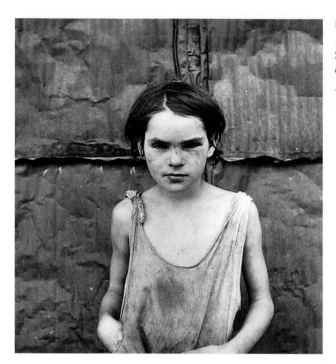

FIGURE 3.3 *Dorothea Lange,* Damaged Child, Shacktown, Elm Grove, Oklahoma, *1936, gelatin silver print, Library of Congress, FSA Collections*

past generations of masters. Miller's story might also be Mann's and her children's. Take Mann's description of how she happened to take the picture *The Perfect Tomato,*[20] in which Jessie dances nude on a picnic table like a ballerina: "It's like she stepped down from heaven and I could see that foot going down. I swung the camera—I'd been taking another picture—just put the film in and shot."[21] Mann recalls that she was about to take a different picture. Perhaps she was focusing on Virginia, or Emmett was posing. But Jessie acted in such a way as to seize her attention. This supposedly heaven-sent photograph was a matter of Jessie learning from her mother what makes a good performance. Instead of some sort of romantic notion of childhood imagination out of which the adult artist springs, we see the creative child imitating adult movements, taking on the poses the parent wants to see. Indeed, in the photograph Jessie dances on the table as if it were a stage and her parents and sister were the audience. What could be more artificial and prescribed than the ballerina's pose? In other pictures the children take on poses of earlier canonical works by Julia Margaret Cameron, Dorothea Lange, and Edward Weston. For example, Mann's *Damaged Child, 1984* reenacts Lange's photograph of a battered girl (fig. 3.3),

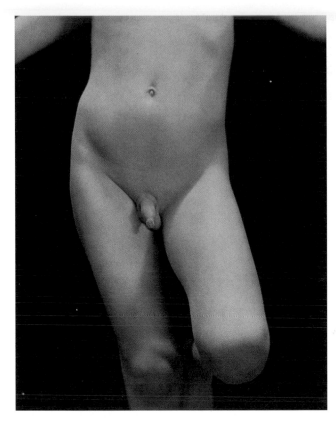

FIGURE 3.4 *Edward Weston,* Neil, 1925, *1925, gelatin silver print, 7 x 6 ½ in. Collection Center for Creative Photography, The University of Arizona, Tucson*

and *Popsicle Drip, 1985* is a reworking of Weston's famous images of his son Neil's naked torso (fig. 3.4). The bloodlike liquid that finds its way down Emmett's stomach and legs in *Popsicle Drip, 1985* undermines Weston's distant classicism, insisting that the child's body is tangibly present. The eye is emphatically drawn to Emmett's genital region—the very area that we as grown-ups are not supposed to pay attention to. *Popsicle Drips, 1985* can be viewed as an example of Mann herself performing for her ideal parent, Weston, in a way analogous to Jessie's performing for Mann in *Perfect Tomato.* Mere imitation of Weston's subject and form, however, is not enough, and so the need for an act of iconoclasm. Mann purposely dirties Weston's imagery, as if making a terrible scratch across his negative. In this way she can imitate his style and remake his subject without seeming to be under the thrall of his influence.

I have read *Perfect Tomato* as a perfect example of the child artist acting out for the demanding parent. But it could be read in exactly the opposite way. Instead of interpreting it as the story of the "bad mother"

who gets her child to perform for love and attention, it might record Jessie as being, in Miller's words, "the person she really is at any given time."[22] In the introduction to *Immediate Family*, Mann describes her pictures in precisely these terms, as if she were aware of Miller's work. She emphasizes her children's autonomy, their ability to make decisions in the process of taking the pictures, and their right to decide which pictures are exhibited: "They have been involved in the creative process since infancy. At times, it is difficult to say exactly who makes the pictures."[23] In an interview in the *Village Voice* she says that when they model for her in the summer, "they're allowed a measure of freedom that I don't think very many children enjoy."[24] That freedom is expressed in *Immediate Family* by nudity. The children are free from the confines of clothes and therefore, supposedly, from the societal inhibitions that clothing stands for. At the same time, in several pictures they seem very much their own persons, able to take care of themselves. Such autonomy is expressed by *Emmett, Jessie and Virginia, 1989*, which serves as the cover of *Immediate Family*. In contrast to the quality of vulnerability that Janet Malcolm found in *Wet Bed*, here Mann's children take a confident pose, their eyes looking directly and sullenly back at their mother's camera.

Even as Mann emphasizes the collaborative nature of her project and her children's self-expression, she often resorts to telling the story of her own childhood as a kind of defense of any embarrassment her work might cause her children. In her introduction to *Immediate Family*, she states, "As a family, we were simply different." This difference was undoubtedly due not only to her parents' avowed atheism in the midst of a devout community but also to her father's eccentric art: he fashioned phalluses and placed them in the garden for neighbors to see and once made a snake out of petrified dog feces. She includes photographs of this "whimsical art" in *Immediate Family* as if they provide the origins of her own craft. Given Mann's emphasis on the role of her father in her upbringing, it is perhaps surprising that her husband, Larry Mann, is not featured more prominently in *Immediate Family*. Mann would undoubtedly say that he was at work and therefore did not figure in his children's summer daytime activities. But another explanation is that in her photographic world she takes for herself the role her own father played; it is Mann's eccentricities that determine the children's fate.

In a conference on censorship, Mann claimed that her children were only undergoing the same experience she had had: "Like my children

today, I wore no clothes until kindergarten interfered with my feral life, a life of freedom not only from clothes but from constraint of any kind, limited only by the boundaries of our property."[25] If playing in the nude or having to sit outside in the hallway during Bible class because her parents were atheists was embarrassing, such humiliation produced "character." In the end, Mann's defense of her eccentricity is that old chestnut, if it was good enough for me, it is good enough for them: "And so I answer . . . that my children will survive our idiosyncrasies, just as I survived those of my parents."[26] But this survival is the survival of the child who is marked to become an artist. Mann says of her children that "their life is full and their perception so rare and true and the love that they are surrounded with so complete that these children, if they were here in this room, would exert much the same force as Wallace Steven's jar: taking dominion, they create their own confident reality."[27] Mann's description of her children as coming into themselves is conflated with her perception of an existing work of art, Steven's poem.[28] Their supposed "dominion" is prescribed by a preexisting aesthetic model. In her fantasy of her children as transcendent beings, Mann is close to Miller's dream of a childhood nurtured by unselfish love and unlimited creative self-discovery. Whether Mann's love is selfish or not, it produces a creative voice that demands to be heard and loved in its own right. Neither Mann nor Miller acknowledges that no matter how ideal the upbringing, the child's voice is inevitably also the voice of the parent.

I have emphasized the ways Mann's children act out or are posed so that they become the subject of photographs that are worth taking and exhibiting. But I have said relatively little about one of the aspects that makes her pictures interesting: they are perverse in the manner that we have come to expect of much post–World War II high-art photography, a perversity that creates notoriety and controversy. In Mann's introduction, her children's gifts that come "like the touch of an angel's wing" are linked to her father's scatological sculpture of a snake, the creature that tempted Eve. It is the very duality of innocence and sin that so often provides the shock of her art.

Immediate Family alternates images of her children absorbed in the common pleasures of reading the comics or blowing bubbles with pictures in which they face the camera directly, touching their bodies in ways that seem calculated to elicit the desires of grown-ups. For example, *Virginia at 3* shows Mann's child completely naked, staring at the viewer while she plays with her left nipple. Or Jessie looks up at the

camera from the leaf-strewn ground, fondling her breast in the suggestively titled *Dirty Jessie*. Alongside these seductive pictures are photographs staged to imply some kind of violence or danger. *Virginia Asleep* shows Mann's youngest child lying unconscious in a field next to a group of sacks, each one about the size of a child's body. By her head are some broken branches, perhaps intended to make the viewer wonder if they have been used to beat her. We are left to imagine that murder has taken place, or is about to, and that Virginia's lifeless body will end up in one of the sacks.

As with the work of Mapplethorpe, the threat of censorship only enhances Mann's fame and the pleasures of her photographs. Also as in Mapplethorpe's art, potentially shocking subject matter is conveyed in prints of extraordinary formal beauty and technical expertise. The richness of Mann's prints, with their glossy blacks and glistening light effects, undermines the potential horror of her subject. And so instead of being repelled by pictures that raise issues of child abuse and child pornography, the viewer is seduced by the elegance of Mann's craft.

I end with the most notorious of Mann's images, *Hayhook, 1989*, the photograph that the *New York Times* would not print (though it has been reproduced often enough in other places). It shows Jessie completely naked and hanging from a hook as if she were a piece of meat. The strangeness of the scene is increased by the fact that several adults ignore her bizarre pose. According to Mann, this image was not staged but occurred when she was "just waiting for something interesting to happen."[29] Jessie's and Virginia's poses recall Titian's *Flaying of Marsyas* (fig. 3.5), in which Marsyas, hanging from a tree, is being flayed alive for having dared boast that he is the greatest musician, greater than Apollo himself. Marsyas's fate has been seen to stand for the suffering and self-emulation necessary to attain artistic perfection. Or it can be read in more obvious ways as the inevitable destruction of artistic pretentiousness and egotism. Both readings are built into *Hayhook*. It is both about the sacrifices needed to make art, as demonstrated by Jessie's physical effort and vulnerability, and about the artist's powerful need for recognition that generates her strange performance. A more contemporary reference is Andres Serrano's *Heaven and Hell* (fig. 3.6) of 1984, with its shocking juxtaposition of a tied-up nude woman and a cardinal. It is typical of Mann to merge allusions to the high-art tradition with references to postmodernism or to the scandalous content of tabloid newspapers.

The uncanniness and aesthetic elegance of *Hayhook* mark Mann's

FIGURE 3.5 *Titian,* The Flaying of Marsyas, *1575–76, oil on canvas, 83 ½ x 81 ½ in. Archbishop's Palace, Kromeriz, Czech Republic*

FIGURE 3.6 *Andres Serrano,* Heaven and Hell, *1984, cibachrome, silicone, plexiglass, wood frame, 40 x 60 in. Courtesy Paula Cooper Gallery, New York*

confident entrance into the history of the art. But there is a quality of desperation in the picture. Both mother and daughter are straining to get our attention. The allegedly natural exhibitionism of children that is often evoked as a defense of *Immediate Family*'s erotic content becomes Mann's own exhibitionism. She knows that the audience for modern art, like the grown-ups in *Hayhook* who are uninterested in Jessie's performance, requires increasingly potent seductions. Mann's children are little modern artists, expressing their individuality in ever more exaggerated and shocking poses. Mann and her children have learned well how to hang on the museum wall, and they join the immediate family of Diane Arbus, Robert Mapplethorpe, Garry Winogrand, and others. Becoming a late twentieth-century artist, surviving parental idiosyncrasies and the weight of the photographic tradition, requires performing, unself-consciously, perversity and familial disjunction. The irony is that the "original" expression of the child-artist is so thoroughly a copy of the parent-artist. In this sense, Mann's pictures of her children say less about the nature of families than they do about the belatedness of art at the end of the century.

Autonomy

4 The Hands of the Artist
Alfred Stieglitz's Photographs of Georgia O'Keeffe

Several people feel I have photographed God. Maybe.
—Alfred Stieglitz

*Unless I can feel God in the palm of my hand, unless my touch is sensitive
enough, then God does not exist for me. I have always believed that.*
—Alfred Stieglitz

I have suggested how an artist's portrait of his mother might
be both an act of love and a declaration of self-
importance equivalent to the most grandiose self-portrait.
Art-historical literature is rich with discussions of how
artists have attempted to elevate their status through their
own image. If fame is the purpose, however, it is perhaps best to
have someone else make your portrait. Almost never commis-
sioned, portraits of artists are created because of the supposedly
intrinsic interest of the subject: the creative genius replaces reli-
gious, historical, and political personages as the hero of modern
society. Such pictures flatter their subject but also suggest a
shared agenda, a collaborative effort that spans mediums.

In New York between the wars, the artist's portrait was a fa-
vorite mode of the modernists, who were in one way or an-
other associated with Alfred Stieglitz. Six of Charles Demuth's
poster portraits were of members of the Stieglitz circle: Arthur
Dove, Charles Duncan, Marsden Hartley, John Marin, Georgia
O'Keeffe, and William Carlos Williams.[1] Rather than like-
nesses, the poster portraits were emblematic, composed of ref-
erences to their subject's professions and interests. For exam-
ple, the most famous of the group, *I Saw the Figure 5 in Gold*
(fig. 4.1), portrays William Carlos Williams by imaging one of
his poems, which describes a red fire engine. These abstract

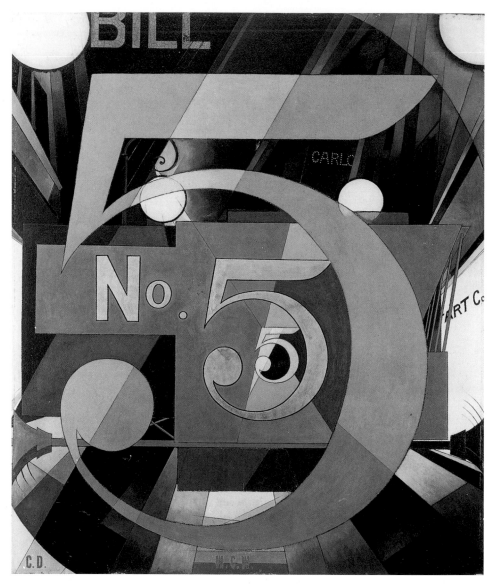

FIGURE 4.1 *Charles Demuth,* I Saw the Figure Five in Gold, *1928, oil on composition board, 36 x 29 ¾ in. The Metropolitan Museum of Art, The Alfred Stieglitz Collection, 1949 (49.59.1)*

portraits were Demuth's bid to alter the view of his art as somehow marginal while at the same time contributing to Stieglitz's obsessive boosterism of the cause of modern art, or perhaps more exactly the cause of Stieglitz's brand of modern art. Demuth's gambit—to enhance the prestige of his own art by depicting other well-known artists—is a familiar one in modern art. In this way Demuth equates his painting not only with the work of other visual artists like Marin and O'Keeffe but also with the poetry of Williams. But I should be clear that the self-advertisement involved in Demuth's project was not meant to appeal to a mass audience. The very need to decode the posters suggests an insider language that acted to cement a sense of group solidarity.

The sense of an elite community of artists drawn together by a shared code is an essential quality of the many portraits of artists by Florine Stettheimer. Stettheimer, even more than Demuth, seemed unconcerned with widespread fame. For example, she repeatedly refused Alfred Stieglitz's offers to give her a one-person show. Rather than be famous and sell a lot of pictures, she seemed to covet an elite reputation. Instead of being known by everyone, she wanted to be known by those who were in the know.[2] Even such an ambitious and seemingly overtly public painting as the *Cathedrals of Art* (fig. 4.2) depicts the art world as if it were a private party. The painting's mix of allegorical figures and art-world celebrities gives the proceedings the flavor of a costume ball where people look like works of art, and works of art look like people. The masquerade suggests exactly the contrast of public and private, display and hiding, that permeates this and all of her best pictures. The party is big enough to include the artists Charles Demuth, Alfred Stieglitz, and Pavel Tchelitchew; the critics Henry McBride and Monroe Wheeler; and the museum professionals Alfred Barr, Francis Taylor, and Juliana Force. But it is small enough to exclude other prominent figures like Georgia O'Keeffe and John Marin.[3] Through such imagery, Stettheimer was able to maintain a reputation among those in the art community whom she felt counted most. Even after her death, her work continued to be a kind of public secret, a sign of elite knowledge, so that when the young curator Henry Geldzahler wanted to impress Andy Warhol on first meeting, he mentioned her name.[4]

Stieglitz is an important figure in *Cathedrals of Art*. He stands almost at the center of the composition, ascending the templelike steps of the Metropolitan Museum of Art, as if he were the high priest of art. But he is also the subject of his own Stettheimer portrait (fig. 4.3). Although Stieglitz was in his sixties when she made the picture, he looks like a

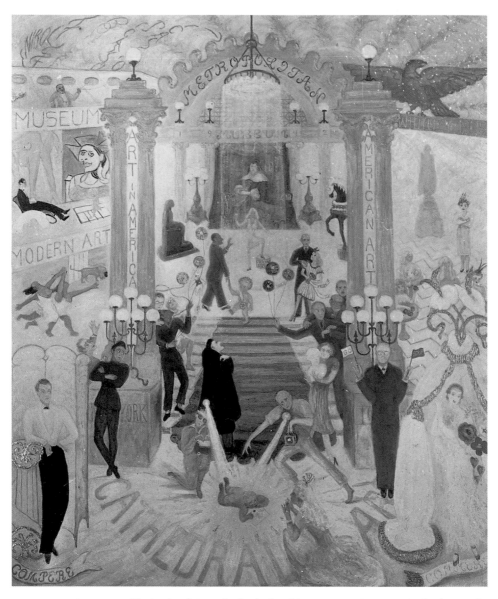

FIGURE 4.2 *Florine Stettheimer,* Cathedrals of Art, *1942, oil on canvas, 60 ¼ x 50 ¼ in. The Metropolitan Museum of Art, Gift of Ettie Stettheimer, 1953 (53.24.1)*

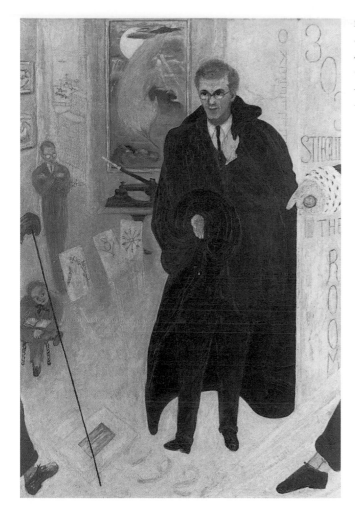

FIGURE 4.3 *Florine Stettheimer,* Portrait of Alfred Stieglitz, *1928, oil on canvas, 38 x 25 ½ in. Fisk University Galleries, Nashville, Tennessee*

young man. Inscribed on the right of the picture are the words "THE ROOM," and "303," a reference to Stieglitz's Intimate Gallery. The portrait is not a literal depiction but a composite of Stieglitz's various aesthetic and promotional activities. Included in the portrait is a tiny image of Arthur Dove reading a book. Dove is childlike, protected by the looming Stieglitz, who watches over his career. The names of Stieglitz's other charges—Hartley, Marin, and O'Keeffe—appear on cards in the background, along with a picture of Stieglitz's summer home at Lake George. Demuth, identified only by his hand and cane, enters from the left, while the baron de Meyer enters on the right. Their presence both

in and *out* of the picture suggests that neither artist was a permanent member of Stieglitz's stable.[5]

In both the portrait and *Cathedrals of Art,* Stieglitz is costumed in a somewhat dated black cape. He has a self-important and slightly crazed look. But flattery was not as important to him as being the center of attention. He seemed to believe that there was no such thing as bad publicity, going so far as to reprint in *Camera Work* negative reviews of the artists he represented alongside the good ones. And supposedly he did not mind when Francis Picabia caricatured him as a camera with sagging bellows in *Ici, c'est ici Stieglitz* (fig. 4.4).[6] Despite the prominence given to the words "fois" and "amour"—faith and love—the implication of the limp camera was that Stieglitz's inspiration was flagging. Perhaps he took the very intensity of Picabia's derision as a sign of his potency. After all, such Oedipal pranks were to be expected from the children of a strong father.

The network of literary and visual associations that are so essential to the portraits of both Stettheimer and Demuth mirror Stieglitz's general strategy for selling his stable of artists and for raising the prestige of photography. Stieglitz, who abhorred the idea of commercial portraiture, had no qualms about making pictures of the artists in his circle. Portraits of Demuth, Hartley, Marin and, above all, O'Keeffe were meant to transcend mere likenesses to become images of creativity itself. He encouraged his artists to write about one another, so that an exhibition of O'Keeffe's paintings would be accompanied by a Hartley essay, or Strand would write a review of the latest Marin show. Demuth's and Stettheimer's portraits, along with the caricatures by Marius De Zayas and Picabia, contributed to the sense of an aesthetic community in an atmosphere deemed hostile to modern art.

The very abstract form of Demuth's poster portraits, so different from his still lifes of flowers and fruit, suggests the Stieglitz circle's disdain for what most Americans would have considered a proper likeness. Their parodic use of advertising is an attack on traditional concepts of aesthetic beauty. Of course, what is advertised by Demuth's posters is a new elite, a clique of painters and poets dedicated to modern forms of expression and redefined standards of conduct. It is precisely through such projects as Demuth's that the Stieglitz circle was packaged as a circle. At best there was something splendid about the way Demuth and his friends imaged themselves into a community, convincing the art world and one another of the importance of their project; at worst, the circle became merely circular, each member scratch-

FIGURE 4.4 *Francis Picabia,* Ici, c'est ici Stieglitz, *1915, pen, and red and black ink, 29 ⅞ x 20 in. The Metropolitan Museum of Art, The Alfred Stieglitz Collection, 1949 (49.70.14)*

ing another's back. Sometimes it is hard to tell the difference between supposed artistic judgment and self-flattery. When William Carlos Williams deemed Demuth's portrait of him, *I Saw the Figure 5 in Gold,* the most distinguished American painting he had seen in years, we cannot help feeling that his praise had something to do with the subject.[7]

Strangely missing from the list of artists that Demuth depicted in the poster portraits is the figure that should be at the center of the series: Stieglitz himself. Perhaps Demuth felt that Stieglitz's importance in the careers of the individual artists in the series was so evident that it did not need to be literal. Or perhaps this was his revenge for Stieglitz's unwillingness to support his work wholeheartedly. Earlier still, we can think of the series of poster portraits in its entirety as a kind of homage to Stieglitz and his circle. Stieglitz, more than anyone in America, realized that artistic reputations are made not merely through the quality of works of art in themselves but through the complex networks that exist among artists, dealers, collectors, and a broader public. Stieglitz was as much an art strategist as an artist. He loved to tell people of his childhood propensity to change the rules of games. According to Herbert J. Seligmann, Stieglitz "told of having played a game called parcheesi as a child. After a time, becoming tired of the game, he would in-

vent new rules, constituting a new game to be played on the parcheesi board, the other children gladly following his leadership."[8] In another conversation he talked of regrets at not entering "big business," a "game" he could have played "as he was playing now, in the same spirit in which he had invented new rules for parcheesi as a child."[9] But if the game was the establishment and support of an indigenous American art that so many others were playing, how had Stieglitz changed the rules and what were the stakes?

The change of rules was the insertion of photography into the mix. Stieglitz's exhibition of advanced European painting, his promotion of a select group of American painters and photographers, and his publications all have their roots in what he called his "fight" to establish photography as a valid art form. At precisely the point when Stieglitz reached a mature style, his photographic production fell off. Sarah Greenough notes that "with the exception of the years 1910 and 1915, he made very few photographs between the formation of the Photo-Secession in 1902 and the close of 291 in 1917."[10] It was not so much that he "neglected his own work," as Greenough put it (these years include the creation of some of his most famous pictures, including *Steerage*), but that his work moved beyond the scope of the darkroom. He realized that the artistic value of photography could not be established by the intrinsic quality of his pictures, no matter how superb. He would have to act on the larger context of photography's place, or lack of place, in the art world. For all of Stieglitz's romantic belief in inherent genius, he seemed to realize that reputation was a matter of setting up relationships and making comparisons, framing an image of himself and his chosen medium. Stieglitz's sense that fame was based on the construction and relationship of representations is already embodied in one of his earliest photographs. Stieglitz reported: "One of the first pictures I made was of a series of portraits, pinned to a drawing board, that Ernst Encke, a Berlin photographer, had made of me. Ernst was the brother of Fedor Encke, the painter who had lived with our family in New York."[11] Stieglitz's self-portrait is made up of another artist's pictures of him, placed in such a way that the resulting portrait is really many portraits, so many faces staring across, above, or below, as if to size one another up. Rather than presenting a romantic image of introspection in which the camera focuses on deep penetrating eyes that stand in for the soul, the assemblage of photos conveys the artist as he appears to others. That appearance is unstable. He can sport a moustache or add a beard, don monk's garb or put on a sheik's turban.

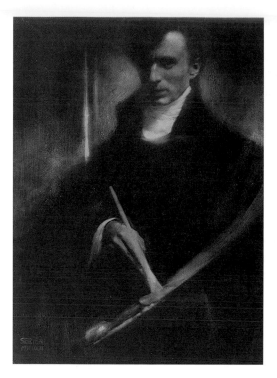

FIGURE 4.5 *Edward Steichen,* Self-Portrait with Brush and Palette, *1902, gum-bichromate print, 10 ½ x 7 ¾ in. The Art Institute of Chicago, Alfred Stieglitz Collection (1949.823)*

Already in 1883 Stieglitz sensed that being an artist is a matter of performances, whereby he could manipulate and reconfigure his public selves.

In describing his self-portrait, Stieglitz says that the pictures of him are seen against a drawing board and were made by a photographer whose brother was a painter. Photography is placed in a context that establishes it as a relative of painting, but perhaps only a poor relation. Stieglitz's construction refuses to evoke the tradition of painted self-portraits that his friend Edward Steichen would uphold, palette in hand as if he were a painter who happened to take pictures (fig. 4.5). The overlapping of small photos, informally pinned to a cheap drawing board, builds into the picture a sense of the casualness with which we treat snapshots, not the reverence given painted images. This strange self-portrait is Stieglitz's first attempt to think about the status of the photographer in terms of the relationship between images and contexts. Yet the results are insubstantial. Are we to conclude that the artist is nothing more than the sum of all the photographs taken of him? Is photography as an art form defined merely by all the photographs ever taken?

The sheer quantity of photographs in the world haunted Stieglitz. He wrote that "the placing in the hands of the general public a means of making pictures with but little labor and requiring less knowledge has of necessity been followed by the production of millions of photographs. It is due to this fatal facility that photography as a picture-making medium has fallen into disrepute in so many quarters."[12] "Fatal facility" was his term for new ease of picture taking and developing, so that virtually anyone could snap a photo. That photographs were mechanically made undermined photography's aesthetic pretensions. It suggested that these unmediated images of reality could be produced by virtually anyone with the right equipment. Stieglitz wanted to reassert specialization and craft into the medium. He argued that to take great photographs involved enormous patience, labor, and skill. Just because photographers relied on a machine rather than on their hands did not mean their work was unartistic or unmediated. He quoted the photographer and critic P. H. Emerson, who admitted that painting required greater technique than photography but who believed that "the greatest thoughts have been expressed by means of the simplest technique, writing."[13] By citing Emerson, Stieglitz suggests that photography is as much like writing as it is like painting.

Stieglitz's image *Sunlight and Shadows, Paula, Berlin* (fig. 4.6) seems constructed to illustrate the point. As Rosalind Krauss has pointed out, the picture "could almost be called a catalogue of self-definition: an elaborate construction through which we are shown what, in its very nature, a photograph *is*."[14] Paula sits in a small dark room lit by a window on the left. The space, with its shuttered light, suggests the inside of a camera. On the wall and on the table are photographs, including duplicates of the same print. Once again, Stieglitz is photographing photographs, even as he reminds us that duplication is the business of photography.

Krauss identifies *Paula* with Stieglitz's attempt to establish photography's "autonomous status as an art." She asserts that "it is only artists, or more precisely specific works of art, that make something a medium."[15] But artists cannot will a medium into existence; they can only assert its power in relation to other mediums that are already well established. Stieglitz's strategy was to insert art photography into preestablished aesthetic categories. In her discussion of the self-reflexive qualities of *Paula*, Krauss fails to remark on the fact that Paula is not contemplating a photograph or taking a picture; she is writing. In other words, Stieglitz makes in the photograph the comparison he sought to emphasize

in his essay. Stieglitz takes a grab bag of rather sentimental elements—dramatic chiaroscuro, a valentine and birdcage, pictures of landscapes, and Paula herself, in elegant finery, all devices a bad photographer might use to evoke artiness—and creates a parable about photography. He insists that it is a medium akin to writing: writing with light. Indeed, the light that streams across the shutters of the room and through the shutter of the camera writes the image.

Focusing on writing, or the self-reflexive nature of *Paula*, should not blind us to the fact that the picture still looks like a certain kind of painting. Compare it with Vermeer's *Girl Reading a Letter* (fig. 4.7).[16] In any case the argument of *Paula* for photography, if we can call it that, occurs in a limited domain, the darkroom of the few who at the turn of the century cared about photography as an aesthetic practice.

For the most part Stieglitz had made his claims for photography as an art within the limited scope of amateur photographic societies. But with the founding of *Camera Work* and his own gallery he turned his ambitions to the larger art world. If the galleries and museums of New York would not allow photography in as an equal, why not create a new art establishment that would be more welcoming? Working closely with Edward Steichen, who scouted works by the avant-garde in Europe, Stieglitz presented the first American exhibitions of the works of Constantin Brancuși, Pablo Picasso, and Auguste Rodin, as well as of African art. According to Sarah Greenough, Stieglitz's hope was that by showing what he called "anti-photographic" art by avant-garde painters and sculptors he would better secure the unique aesthetic function of photography. In contrast to abstractions by Picasso, for example, photography becomes the preeminent medium of the real; in fact photography supposedly frees the other arts from mimesis.[17] But there was a more pedestrian side to exhibiting the European avant-garde. By showing painting and sculpture in a space and a magazine originally created for the camera, photography was made not just the equal of other forms of advanced art but their host: it led the way. In this context the small size of Stieglitz's galleries was significant. Whether because of financial considerations or modesty, the smallness of 291, and later the Intimate Gallery and An American Place, meant that the kind of work shown was not much larger than photographs. Significantly, Stieglitz had a propensity for showing drawings and watercolors. Photographs figured as yet other works of art on paper.[18] His two favorite painters, Marin and O'Keeffe, were first represented by their works on paper. Stieglitz featured not Rodin's sculptures but his intimate watercolors;

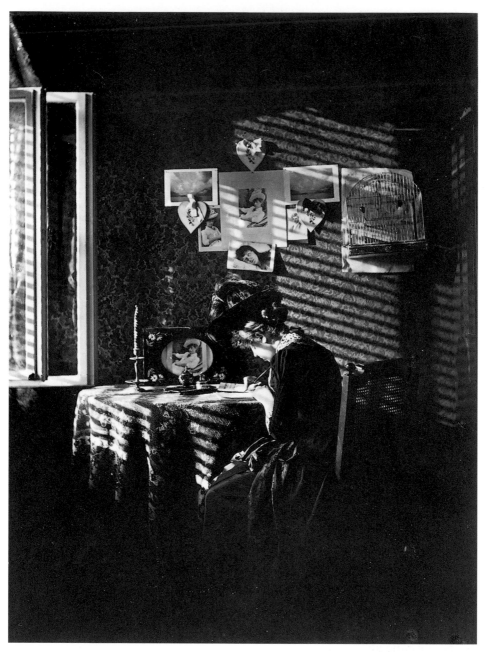

FIGURE 4.6 *Alfred Stieglitz,* Paula, Berlin, *1889, Contact print on azo, dry plate,*
8 ⅞ x 6 ½ in. The Museum of Modern Art, New York

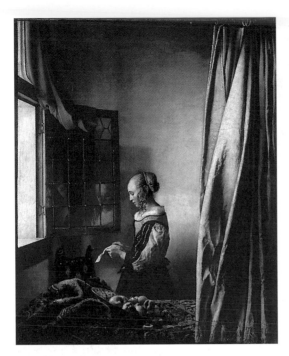

FIGURE 4.7 *Johannes Vermeer,* Girl Reading a Letter at an Open Window, *ca. 1659, oil on canvas, 32 ⁵/₈ x 25 ³/₈ in. Gemälde-galerie, Alte Meister, Dresden*

Cézanne's watercolors were exhibited as well. *Camera Work* became the ultimate level playing field since, no matter what the medium or size of the work of art, in reproduction it would share the same format as the photograph. Indeed, the photogravure method used for the reproductions in the magazine was far more sensitive to photographic images than to paintings.

We can see in the exhibitions at 291 the roots of the institutionalization not only of photography but also of modern art in general. The simple burlap-covered walls and uncluttered space designed by Steichen in which starkly framed works of art hung along a single line—each picture or sculpture given plenty of room to breathe—was the basic model for almost all future exhibitions of modern art and photography. But if Stieglitz is the prototype for the modern art curator, he is even more so the creator of the myth of the heroic art dealer. He is that person who tirelessly works for the success of the artists he represents, never worrying about sales, and who in the end has his taste vindicated by the judgment of history. Stieglitz of course refused the title of dealer. He always insisted that he never made any money in commissions from his artists. Stieglitz's relationship to money was ambivalent at best. He was famous for his disdain of commercial photography, insisting that

true art was above mere commerce. Of course, this was the disdain of a man from a wealthy family who lived off inherited income and never had to stoop to making commercial photographs. Still, Stieglitz believed that the use of photography for advertising and for cheap portraits was a prime reason for its failure to be taken seriously as an art form. Although he was eager to raise money for the artists he represented, he claimed that he had refused large offers for their works of art because he did not think a buyer was worthy; yet he would give paintings away to those who he felt had the right spirit.[19] Nonetheless, it was this anti-dealer who cleverly engineered the sale of a Marin watercolor for six thousand dollars, proving himself the most wily of bargainers.[20] He recognized the relationship between price and artistic prestige, while maintaining the fiction that he was not interested in commercial success. He claimed that the art business was like "a house of prostitution, where women, even virgin girls, were at the command of men with money; money ruled. In an emergency, if all the girls were busy and a man came, with money, in haste, the proprietress of the house could step in and fill the place of one of the girls. But this a picture dealer could never do for an artist."[21] This story is odd because in Stieglitz's case he could fill in. After all, he was both dealer and artist. It is also a strange story given his highly public relationship with O'Keeffe and the type of photographs of her he exhibited. If Stieglitz was the madam of his brothel, what did that make O'Keeffe, the woman he had so blatantly displayed to the world?

What role did his photographs of O'Keeffe have in his fight for the prestige of photography and his attack on the brazen commercialism of American culture? How did they prove that Stieglitz was neither madam nor pimp? Given his fear concerning the commodification of art, why risk bringing his practice so close to another trade that threatened photography's aesthetic status: pornography?

In his essay "Pictorial Photography," Stieglitz struggled to differentiate his work from the millions of pictures he maintained were made by "the ignorant" and "the purely technical." Only great work could be produced "by those who are following photography for the love of it, and not merely for financial reasons." Stieglitz proudly embraced the term *amateur*, writing "an amateur is one who works for love."[22] Love separates the true artist from the technician, the dealer. But given the medium's supposed debasement through advertising and pornography, how does one demonstrate love in photography?

It is precisely as expressions of love that the photographs of O'Keeffe have been read. The nature of Stieglitz and O'Keeffe's relationship has been much discussed. The questions these intimate pictures raise about Stieglitz's exploitation of O'Keeffe and the larger issues of the male gaze are troubling and need to be worked out so that O'Keeffe's contribution to the process is understood. Indeed, as Anne Wagner has suggested in her balanced and insightful discussion of the portraits, they could fruitfully be considered not as a production of Stieglitz alone but as a collaboration.[23] This is particularly true of the exhibition engineered by O'Keeffe in 1978, in which some fifty of the Stieglitz photographs of her were shown at the Metropolitan Museum of Art.[24] But even as O'Keeffe had only just enshrined her "portrait" at the Metropolitan, she sought to distance herself from his works: "When I look over the photographs Stieglitz took of me—some of them more than sixty years ago—I wonder who that person is."[25] I think O'Keeffe's statement is a defense against the seduction of the pictures and the aggression of the act—first Stieglitz's and then her own—of making them public. Nevertheless, I will take her at her word and talk about the pictures in terms of Stieglitz's practice. I will put Stieglitz's relationship to O'Keeffe aside and assume that, in some sense, he meant these photographs to stand as images of love, with all the contradictory meanings the word suggests: loss of self in the other, tenderness, adoration, and passion, as well as extreme egotism, lust, and possessiveness. Yet declaring love for a subject and demonstrating love for the medium are not the same. When Stieglitz declared, "When I make a picture I make love," did he mean he makes love to the subject, the camera, the process of printmaking, or all three?[26]

In a sense I am arguing that O'Keeffe's body was a test, a great opportunity to demonstrate the power and sensitivity of his medium. The photographs of O'Keeffe come at a point when through his exhibition practices and publications Stieglitz had helped put into place an elite audience receptive to the claim that photography was equal to other art forms. But he had yet to create a series of photographs that would compare to the scandalous production of the European avant-garde—works by such artists as Matisse and Picasso—that he featured in *Camera Work*. Of course he was also taking on the great subject of Western art, the female nude, which was understood to be particularly resistant to being made over into photographic art. To talk of the pictures Stieglitz took of the woman he loved as a strategic move may seem overcalculating, but I think that many artists have a fundamental faith that intense de-

sire for a subject will produce work that is paradoxically about the medium itself. The hope is that by finding what one cares most about in the world, the artist will arrive at that which is most important in his or her craft.

To call any of the individual pictures Stieglitz made of O'Keeffe a portrait is, according to his terms, a misnomer. In Stieglitz's conception, the entire series was the portrait. He began photographing O'Keeffe in 1917 and continued doing so until the mid-1930s. The so-called key set in the National Gallery numbers over three hundred unique images, several of which were printed using different techniques. The conceit is that no single image can express the totality of a person: the complexity of an individual might be reflected through multiple viewpoints or through elapsed time. Seriality suggests a work in progress, change, and incompleteness. The end of the project is circumscribed only by the death of its author or its subject. Krauss argues that the crop is a fundamental element of photographic form, in that it insists that the picture is only a small piece of a larger reality. Stieglitz extends the logic of the crop, by insisting that every photograph of O'Keeffe is a fragment.

Even though the series stopped because of death, it has never been seen in its complete form by the public. During Stieglitz's lifetime several of the more erotic pictures were withheld from the public.[27] O'Keeffe selectively continued this practice when she was alive. To this day, the portrait has never been exhibited or published in its entirety. Even if we could imagine such an exhibition, how would it be assembled? Is it best understood in biographical terms, as a charting of the two artists' and lovers' relationship? Should it be seen as registering O'Keeffe's maturation and independence? Within any given year of production, there is an infinite number of ways to assemble the pictures. As mentioned, Stieglitz was horrified by the proliferation of photographs in the world. His careful editing of his own production was therefore a response to photography's profligate nature. Yet the O'Keeffe portrait is big enough to begin to suggest the ways photography might spin out of control. Its very ability to seize multiple moments and multiple aspects of a life raises the very specter of the boundless series that terrified Stieglitz. If one picture cannot do the work of expressing an individual, then how many are sufficient? The dangers of documenting a life in serial fashion had been demonstrated to Stieglitz earlier, when in 1898 he began a project to record his daughter growing up called *Journal of a Baby* (see Chapter 3).[28] The project failed not only because it was too evasive or did not produce interesting pictures but because it suggested

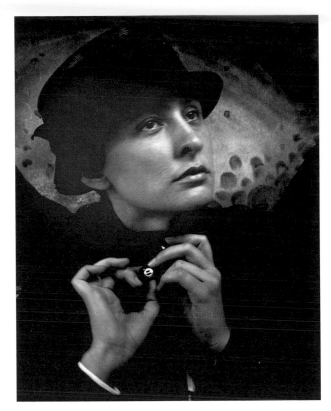

FIGURE 4.8 *Alfred Stieglitz,*
Georgia O'Keeffe: A
Portrait—Head, *1918, silver
gelatin developed-out print
mounted on paper board,
9 ¾ x 7 ¹¹/₁₆ in. National
Gallery of Art, Washington,
D.C., Alfred Stieglitz Collection*

the limitlessness of photography. There seemed no end to the number
of photographs necessary to convey the lengthy process of childhood.
Reproducing a child's life becomes confused with the endless repro-
duction of snapshots. Stieglitz tried not to make the same mistake with
O'Keeffe. Hence there was the need to carefully control the dissemina-
tion of the O'Keeffe portrait. But also the artist had to assert a sense of
containment on the surface of the picture itself. And so the crop be-
comes a sign not just of the fragmentary nature of experience, or of the
act of abstraction, but of the boundary where photography stops.

The woman Stieglitz got onto paper was a painter. Many of his pho-
tographs of O'Keeffe show her with her work. For example, in *Georgia
O'Keeffe: A Portrait—Head* (fig. 4.8), he places O'Keeffe in front of
her charcoal drawing *Special No. 15*. In another photograph, *Georgia
O'Keeffe: A Portrait: Hands and Watercolor, June 4, 1917* (fig. 4.9), he has
O'Keeffe touch one of her drawings, a womblike image from her Blue

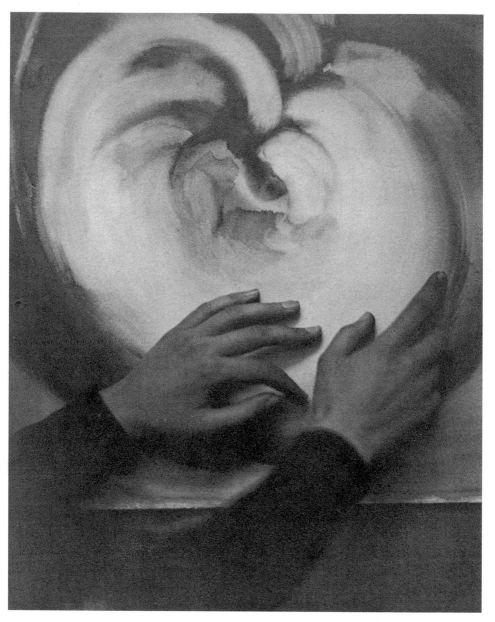

FIGURE 4.9 *Alfred Stieglitz,* Georgia O'Keeffe: A Portrait: Hands and Watercolor, June 4, 1917, *1917, platinum print, 9 ⁵/₈ x 7 ⁵/₈ in. National Gallery of Art, Washington, D.C., Alfred Stieglitz Collection*

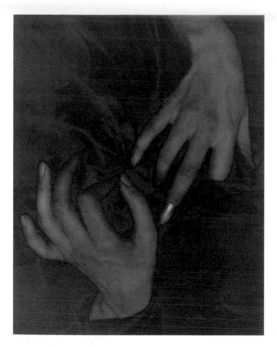

Series.[29] He thereby reveals his desire not just for O'Keeffe's body but also for her medium. Stieglitz's gallery activity made painters something like the guest of the camera, and his journal made modern painting a part of his larger project of camera work. Here Stieglitz's camera seems intent on *possessing* a painter and her craft. He is intent on showing us what she looks like, but also what she does. In one photograph he shows her with her paints. Above all, he is obsessed with depicting her hands. With the exception of her face itself, they are the most frequently photographed subjects of the series.

In this emphasis Stieglitz was evoking a long tradition in which the creative act is centered in the gesture of hands. Surely, Michelangelo's *Creation of Adam* is the most famous. As if in emulation of Michelangelo, El Lissitzky, Stieglitz's contemporary, created a well-known self-portrait in which the artist, compass in hand, takes up the role of God the architect. Most of Stieglitz's photographs of O'Keeffe are not as grandiose as Lissitzky's, but they convey the same message. The artist's creativity is centered in the hands. In several of the pictures O'Keeffe's hands are placed on, or beside, her paintings to emphasize the creative act, but just as often they are allowed to touch her own skin or fiddle with a button. In *Georgia O'Keeffe: A Portrait—Hands and Thimble* (fig. 4.10),

Stieglitz focuses in on O'Keeffe sewing. Perhaps we are meant to equate her art-making with feminine domestic tasks, but such an interpretation would have to ignore the effect of Stieglitz's radical cropping. The hands cease to be attached to a body: indeed they seem like entities in themselves, interacting in a graceful dance. Stieglitz claimed that there was no top or bottom to pictures like these; they could be hung horizontally or vertically.[30] In this way he insisted on the abstractness of his photographs and their distance from the original subject.

Georgia O'Keeffe: A Portrait: Hands and Watercolor, June 4, 1917 is a key picture in the series. We know that O'Keeffe felt that without it the 1978 exhibition would have been incomplete.[31] In it there is a beautiful play between its shallow space and the swirling depth of O'Keeffe's abstraction. Photographic space is purposely flattened out by sandwiching O'Keeffe's hands between the plane of the painting and the plane of the photograph. The picture seems to say that where photographic space is tangible and real, pictorial space is mysterious and infinite. O'Keeffe's hands through the means of Stieglitz's camera magically bridge the gap.

The painting has been described as resembling a womb. Wagner, for example, argues that Stieglitz is suggesting the way that the "artist and her body are identified as one and the same."[32] Another interpretation could be made about the relationship of photography to reproduction. What are the differences and similarities between the camera and the female's power to create life and art? A key meaning of the picture is that the camera is not a machine. The hands that enter the corner of the picture are a surrogate for the photographer's caressing eyes, even as they make Stieglitz's point that photography is handwork. Not only does the hand focus the camera and press the shutter, but it prints the picture. One of the aspects that gets lost in reproduction is the subtle differences from print to print of the same picture. These differences loomed larger when Stieglitz printed the same photograph in different mediums (platinum, palladium, and silver nitrate) and on different papers. Arguably, the platinum and palladium prints are more painterly. And when we compare them to their silver nitrate twins, we become far more aware of the surface. But this is to ignore the image itself. For all of Stieglitz's wish that we become aware of the process of printing as handwork, the photograph of O'Keeffe touching her painting has exactly the opposite effect. We look into the picture, through the surface, to register the touch of fingers on a canvas, not on a photograph. Where O'Keeffe's hands painted the image whose very forms are or-

ganic and imprecise, a machine and a chemical reaction mediated Stieglitz's handwork.

Wagner describes O'Keeffe's hands as only "tentatively" exploring the womblike form of her painting.[33] O'Keeffe's unwillingness to press too closely against her painting may express a disturbing implication of her act. Even as the photograph seems to celebrate the sensuousness of O'Keeffe's body and art, rhyming the two, it violates her picture. Literally, to touch a painting or drawing is to negate its ability to convey an illusion to the person who is doing the touching. In feeling its surface the toucher relegates the picture to dead matter. Indeed, as any conservator knows, putting fingers on a picture endangers its well-being, particularly if the painting's support is paper. By this act O'Keeffe is not just giving her body over to Stieglitz's camera, she is sacrificing the autonomy of her own picture to the needs of his photographic ambition.

A later photograph, *Georgia O'Keeffe: A Portrait—Hand and Wheel,* 1933 (fig. 4.11) shows O'Keeffe's hand stroking the bright hubcap of a car. She had learned to drive in New Mexico, and it was this car that took her away from him.[34] But her gesture has none of the quality of autonomy that we get in the contemporary pictures of her sitting in her car. It seems flirtatious even as it implies that a shiny automobile can be as seductive as a woman's body. In another photograph from the same shoot, O'Keeffe's arm is ornamented with a silver bracelet. Whether Stieglitz meant it or not, the association of an expensive object with her ornamented arm raises the issue of the commodification of women and artists that Stieglitz suggested in his unfortunate brothel analogy. The picture brings to mind advertisements in which beautiful women are used to sell the latest automobiles. Yet we must realize that Stieglitz was an artist who made pictures by touching a machine. Indeed, the wheel of the car makes a good stand-in for the lens of a camera. In pointedly linking the hands of an artist to a machine, Stieglitz hints at the relationship between the creative act and the camera. Technology did not erase handicraft, since it remained subject to the hands' bidding. Stieglitz insisted that developing and printing required intense handwork. In other words, the machine augmented the hand, giving it new powers. The machine might be different from the human form, but it was beautiful in its own right. Whether in the guise of the bright chrome of a car's hubcaps or the lens and shiny dials of a camera, machines can evoke love.

Many of Stieglitz's portraits show O'Keeffe's hands isolated from all other things, as if they were objects of beauty in and of themselves.

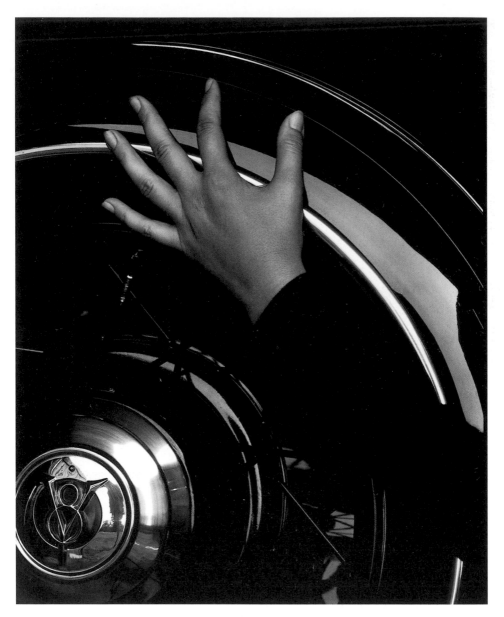

FIGURE 4.11 *Alfred Stieglitz,* Georgia O'Keeffe: A Portrait—Hand and Wheel, *1933, silver gelatin developed-out print, 9 ½ x 7 ⅝ in. National Gallery of Art, Washington, D.C., Alfred Stieglitz Collection*

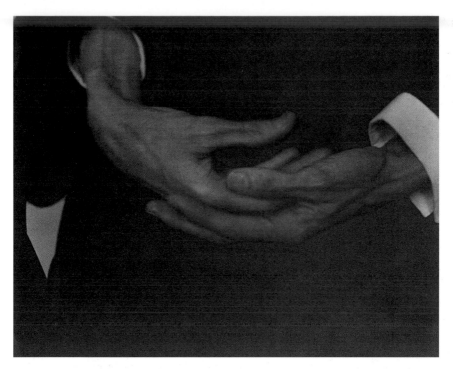

FIGURE 4.12 *Alfred Stieglitz,* Charles Demuth, *1923, platinum or palladium print,*
7 ⅝ x 9 ½ in. National Gallery of Art, Washington, D.C., Alfred Stieglitz Collection

O'Keeffe wrote that her hands had been admired since she was a little
girl.[35] Artists were supposed to have particularly sensitive hands. Inter-
estingly, Demuth was well known for his extraordinary hands. Man Ray
photographed them in isolation, and Stieglitz's half-length portrait of
Demuth, in *Charles Demuth* (fig. 4.12), emphasizes their refinement. Yet
elegant male hands were often taken as a sign not of creativity but of
homosexuality. A friend wrote that Demuth "had very beautiful hands.
I remember that he often sat with one hand drooping from the wrist
and held in front of him like this (striking the pose), his elbow resting
on the arm of a chair."[36] The homosexual's hands supposedly had a
grace indicative not of prowess or potency but of weakness, as implied
in Sherwood Anderson's story "Hands" (1916), whose Wing Biddle-
baum was famous for his "slender expressive fingers, forever active,
forever striving to conceal themselves in his pockets or behind his
back."[37] Wrongly accused of molesting a boy, he spends the rest of his
life trying to hide the secret longing his nervous and beautiful hands

may betray at any moment. As the character George Willard comes to think, "His hands have something to do with his fear of me and of everyone."[38]

In the simplest terms, expressive hands in a man may be a sign of effeminacy. Worse still, they may suggest, as in Anderson's tale, a quality of unfulfilled and uncontrollable desire. By photographing O'Keeffe's hands, Stieglitz safely takes to himself their creative power, their fecundity, without himself appearing feminine or out of control. After all, it is O'Keeffe who fondles her own body or plays with a phallic sculpture. He can seem to desire her body, even possess it, while at the same time remain safely distanced behind the lens. One of the extraordinary qualities of the pictures is the way they oscillate between seeming to be O'Keeffe's hands—feeling, touching, grasping—and the hands of someone just outside the frame. In one such photograph, *Georgia O'Keeffe: A Portrait—Neck* (fig. 4.13), her hands could be perceived as not belonging to O'Keeffe at all but as coming out from the camera to feel her body. Stieglitz and the viewer become O'Keeffe's hands.

For the contemporary critic Lewis Mumford, this was one of the great accomplishments of the photographs. According to Mumford, the act of sex between two lovers was "the most essential demonstration of touchability." Only the "direct sense of touch . . . removes the needs for words and signs and breaks down the formidable distance between object and subject, between thine and mine." Several photographs focus in on the touch of O'Keeffe's fingers on her skin or, perhaps even more tactilely, the play of her fingers on a button or the opening of her dress. For Mumford, Stieglitz had found a way to suggest the blindness of love. Mumford wrote that love was blind in "the way that it often shuts out the outer world in order to concentrate upon the inner stimulus," but "it has the beautiful compensation . . . for it learns to see with its fingertips, and to offset the closed eyes, reacts more quickly with the other available senses in every region of the body." The result is "deeper levels of consciousness." Mumford continues that in the O'Keeffe portrait Stieglitz translated "this world of blind touch into sight."[39] An extraordinary idea, that photography, this ultimate medium of vision, could express blindness.

A comparison with Paul Strand's famous 1916 picture *Blind Woman, New York* (fig. 4.14) immediately comes to mind, in which the word "BLIND" figures so prominently. It was produced in the same year of the first O'Keeffe portraits. Strand's picture makes us think about the power of the camera, its ability to make us see the truth of the city in its

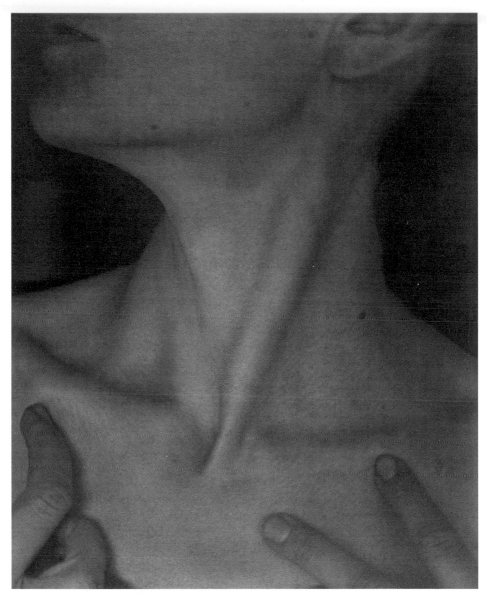

FIGURE 4.13 *Alfred Stieglitz,* Georgia O'Keeffe: A Portrait—Neck, *1921, palladium print, 9 ¼ x 7 ½ in. National Gallery of Art, Washington, D.C., Alfred Stieglitz Collection*

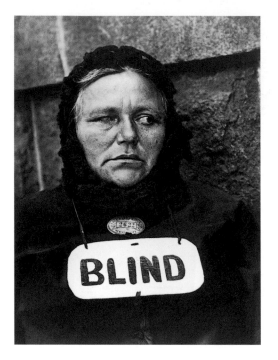

FIGURE 4.14 *Paul Strand,* Blind Woman, New York, *1916, gold chloride-toned gelatin silver print, 12 ⅞ x 9 ¾ in. Yale University Art Gallery. Gift of Michael E. Hoffman*

poverty and misery. But his picture is also about the limits of the camera. Photographic vision does not assure knowledge. Perhaps it merely gives us a new form of blindness. Significantly, the knowledge of the woman's blindness is not conveyed by the appearance of her distorted eyes but by that word itself, which she wears on a sign hanging from her neck. Strand's message seems to be that the camera can tell us only so much. In contrast, Stieglitz's form of blindness bestows on photographic knowledge the verification of touch. As Mumford wrote, "In a part by part revelation of a woman's body, in the isolated presentation of a hand, a breast, a neck, a thigh, a leg, Stieglitz achieved the exact visual equivalent of the report of the hand or the face as it travels over the body of the beloved."[40]

In emphasizing the hands of O'Keeffe, Stieglitz not only seemed to assert his power over her; he also seized for photography one of the powers of modernist painting: the ability to suggest touch. In his essay "Constructing Physicality," Richard Shiff discusses the move of modernist painting toward tactility. According to Shiff, modern painting's "involvement in the tactile" sets up "a metonymic exchange between an artist's or a viewer's human physicality and the material, constructed physicality of an artwork. When we see a picture in terms of its material

references to touch . . . we reorient not only a local pictorial order but also our global sense of how human bodies contact their surroundings; we reconstruct the functioning of the body and its senses, how it relates to the world."[41] Shiff is talking about a kind of painting that calls attention to its own making through brush stroke, fragmentation, and texture. There are obvious differences between Stieglitz's photography and modernist painting as Shiff describes it. For all of Stieglitz's insistence on the uniqueness of each photographic print, awareness of the physicality of the actual photograph is not the prime factor in our appreciation of his images. Indeed, the kind of straight photography Stieglitz championed might be a paradigm of the "transparency" that Shiff says is opposed to the opacity of modernist painting. Yet this is precisely Stieglitz's achievement in the O'Keeffe portraits. Using sharp focus and extreme cropping, Stieglitz achieves the tactile quality Shiff finds in Cézanne's painting, without imitating painterly methods. Shiff writes of a reciprocal exchange between touch and vision so that "touch is figuring vision, and vision is figuring touch."[42] Touch in Stieglitz's photograph is communicated through a kind of performance rather than by the medium itself. Still, in thematizing touch in the O'Keeffe portraits, Stieglitz suggests physicality. At the same time his overall abstraction and fragmentation of O'Keeffe's body undermines the idea that photography was merely an unmediated view of reality.

Stieglitz's attempt at suggesting touch through the highly optical medium of photography provides an interesting example of what Martin Jay calls the modern denigration of vision.[43] Jay traces how, for many twentieth-century artists and philosophers, seeing is dangerous, producing illusions; its pleasures are tinged with guilt. In this sense it is not just money that potentially corrupts photography but its supposed plagiarism of reality. The camera's image of the naked body is particularly suspect in this scheme. The erotic photograph is always in danger of becoming mere fetish, an empty substitution. The pleasure it arouses is purely mechanical, a matter of staging, light, and optics.

Stieglitz's hope was that touch might redeem vision. He proudly placed himself in the tradition of the doubting Thomas. In typically grandiose terms, he supposedly said, "Unless I can feel God in the palm of my hand, unless my touch is sensitive enough, then God does not exist for me. I have always believed that."[44] Here, however, the point was not to establish the existence of God but that of O'Keeffe. Although we will never know the truth of Stieglitz and O'Keeffe's relationship, what we can sense in his O'Keeffe portrait is desire—for O'Keeffe's body and art—

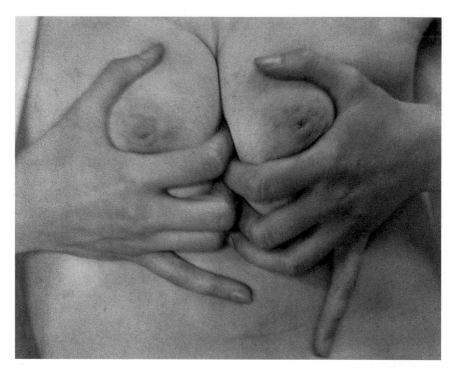

FIGURE 4.15 *Alfred Stieglitz,* Georgia O'Keeffe: A Portrait—Hands and Breasts, *1919, palladium print, 7 ½ x 9 in. National Gallery of Art, Washington, D.C., Alfred Stieglitz Collection*

as well as a confirmation that both were real and were his. The obsessive character of Stieglitz's cumulative portrait of O'Keeffe suggests that he never was completely sure of this. Probably the most disturbing of the pictures is a group in which O'Keeffe's hands clutch her breasts (fig. 4.15). These images are hard to make sense of; in them, O'Keeffe's figure seems rubbery and awkward. The famous photograph of O'Keeffe's torso (fig. 4.16), in which her robe is open to reveal her genital area, may seem at first more shocking. In the torso photograph, however, O'Keeffe's body retains its coherence and elegant line. This stasis is lost when she grabs at her breasts, as if the appendages of her body were at war. Is O'Keeffe exploring her body in a masturbatory performance—feeling pain as well as pleasure at her own touch—or are her hands acting out Stieglitz's fantasy of possession?

This fantasy is made overt in another photograph from 1919 (fig. 4.17). It shows O'Keeffe's hands holding the small phallic sculpture en-

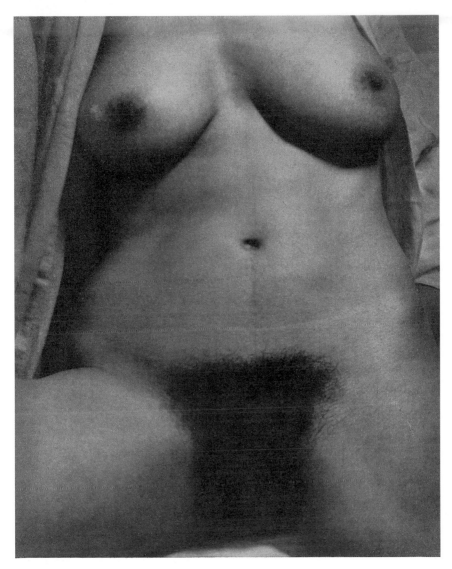

FIGURE 4.16 *Alfred Stieglitz,* Georgia O'Keeffe: A Portrait—Torso, *1918, palladium print, 9 ½ x 7 ⅛ in. National Gallery of Art, Washington, D.C., Alfred Stieglitz Collection*

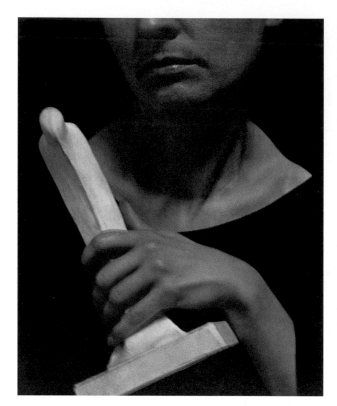

FIGURE 4.17 *Alfred Stieglitz,* Georgia O'Keeffe: A Portrait—Sculpture, *1920, palladium print, 9 ⅝ x 7 ⅝ in. National Gallery of Art, Washington, D.C., Alfred Stieglitz Collection*

titled *Abstraction,* which she had made in 1916. The implication is that, in holding it, O'Keeffe is fondling the genitals of the photographer. We could take this image to be a sign of her debasement or of her power. After all, she fashioned the sculpture, and she is taking the phallus to herself. Or perhaps what Stieglitz and O'Keeffe are really doing is playing with the very idea that the artist's masculinity is somehow located in his genitals. The possibility emerges that this image is satiric when we compare it with another photograph of her touching this same phallic sculpture with her feet (fig. 4.18). Whether O'Keeffe fondles herself, or her sculpture, touch is a matter of subjugation and power, flirtation and flattery, pleasure and pain. Touch caresses, but it also hurts; it holds, but it may also fail to hold on to its object.

Thinking about the entire series of more than three hundred photographs, I am left not with a sense that they encompass "everything important in human development, identity and interaction," as one writer improbably claims.[45] Rather, the cumulative portrait's fragmentation,

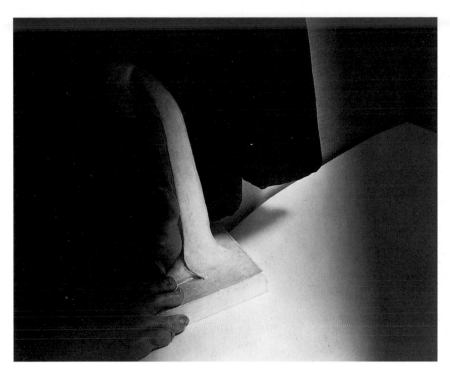

FIGURE 4.18 *Alfred Stieglitz,* Georgia O'Keeffe: A Portrait—Feet and Sculpture, *1918, silver gelatin developed-out print, 7 ³⁄₈ x 9 ¹⁄₈ in. National Gallery of Art, Washington, D.C., Alfred Stieglitz Collection*

exacerbated by its peculiar exhibition history, in which many of the most powerful photographs have been censored or repressed, conveys to me the unbounded quality of desire. For all of Stieglitz's attempts to bring his subject in close, to feel O'Keeffe in the palm of his hand, his camera still *holds* her at a distance: the crop and the inescapable flatness of the photographic surface has this effect. In the end, Stieglitz's pictures of O'Keeffe are less eloquent in conveying touch than a sense that the love object is untouchable. It is always just beyond the grasp of the hands of the artist.

5 Woman without Men
O'Keeffe's Spaces

I wanted to make it my house, but I'll tell you the dirt resists you. It is very hard to make the earth your own.
—Georgia O'Keeffe

According to Roxana Robinson, Georgia O'Keeffe's ascendancy and Alfred Stieglitz's final decline in the art world was marked by O'Keeffe's retrospective at the Museum of Modern Art (MoMA) in 1946: "From now on, his artists' works would be exhibited by strangers, hung and lit according to other people's standards, and shown to audiences that he could not screen."[1] Yet O'Keeffe's entrance into the pantheon of modernist masters was not universally hailed. Clement Greenberg disdainfully wrote of the retrospective that it brought together "opposed extremes of hygiene and scatology" that the museum's curators had confused for modern art. According to Greenberg, O'Keeffe's "pseudo-modern" art is simultaneously too public—he complains about its "popularity"—and too private: it "has less to do with art than with private worship and the embellishments of private fetishes with secret and arbitrary meanings."[2] Anne Wagner attributes Greenberg's scorn to his embarrassment in the face of O'Keeffe's disturbing representation of the "body and its absence." She effectively argues that O'Keeffe's flowers negotiate the "polarities of gender" even as they oscillate between modes of abstraction and figuration.[3] In this chapter I take Greenberg at his word and examine three sites in which O'Keeffe had to think about hygiene and scatology: the women's powder room of Radio City Music Hall, the exercise room of the Elizabeth Arden Salon, and her Abiquiu home. She never completed the first; all we know of it is from a few scattered letters and biographies. The second was effectively dismantled when O'Keeffe's mural was sold. The

third is in the process of being made over into a historic house and so is not quite as it would have been in her lifetime. Powder room, beauty salon, and home, all are coded feminine. Although very modern, they are abject in terms of the usual aspirations of high modernist art.[4] All three share a curious play between privacy and publicity, escape and display, helplessness and power. These issues are central not only to her own practice but to the modernist concept of the autonomous work of art and the autonomous artist.

In the previous essay I mentioned O'Keeffe's sense of dislocation when she viewed Stieglitz's photographs of her. If it was hard for her to recognize herself in his portrait, then what would she make of her current media image and the vast industry that has cropped up around her art and life? New biographies of O'Keeffe are an almost annual publishing event. Her pictures are ubiquitous on calendars, mouse pads, coasters, and shopping bags. Her *Red Poppy* painting alone has been reproduced 156 million times in the form of a 1996 U.S. postage stamp. Such numbers overwhelm the usual statistics cited in discussions of the multiple in the so-called age of mechanical reproduction.

It would be a simple matter to lay this vulgarization of O'Keeffe's life and artistic legacy at the door of her various promoters and exploiters, in particular her husband and dealer, Alfred Stieglitz (the two married in 1924). Yet the evidence suggests that O'Keeffe, for all her protests, was intent on achieving widespread fame. Her work strikes me as designed to be reproduced. Consider the painting *Red Poppy*, which makes a fine postage stamp (fig. 5.1). Unlike the case of the *Whistler's Mother* stamp, discussed in Chapter 1, the U.S. Postal Service felt no need to crop or augment O'Keeffe's picture. It was simply made very small. But the designer, Margaret Bauer, claims that "as tiny as the flower appears on the stamp, the image is still very striking."[5]

This miniaturization is ironic given O'Keeffe's usual process of enlargement. *Red Poppy* is a perfect example of her method. She brings us in close, eliminating all signs of the flower's background and stem. Because the blossom comes to fill the entire foreground, it seems very large, no matter what the size of the actual canvas. In fact it is not necessarily because O'Keeffe enlarges her flowers that they seem huge. *Red Poppy* is actually a tiny picture, measuring just seven by nine inches, not all that much bigger than an actual poppy bloom. But because she removes points of reference, it is impossible to gauge scale. Her pictures reproduce well because they lack scale and tend to be flat.

O'Keeffe herself did not seem overly concerned with the question of

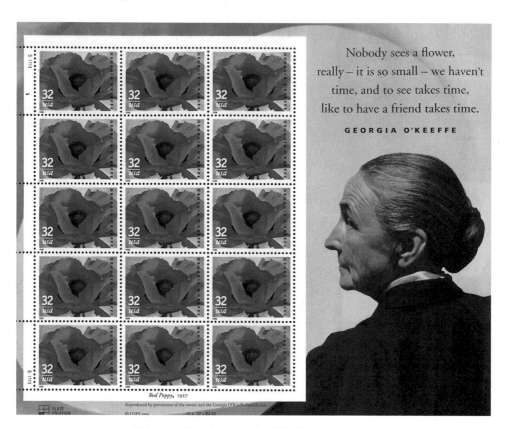

Nobody sees a flower,
really – it is so small – we haven't
time, and to see takes time,
like to have a friend takes time.

GEORGIA O'KEEFFE

Red Poppy, 1927

FIGURE 5.1 *U.S. Postal Service, Georgia O'Keeffe stamp, 1996*

a reproduction's fidelity to the original. During the mid-1970s, in the process of looking at proofs of the 1976 Viking monograph of her work, she insisted that it was not so important that the plates accurately render the colors of the original paintings as that they "feel right."[6] What I see as the peculiar flaws of her techniques—namely, the sometimes chalky surface and a certain lack of interest in varying the size and texture of brush strokes as they describe different objects—do not appear in the reproductions. Certainly, subtlety of color and touch is lost in the plates, but the uniformity of the glossy paper's surface itself reinforces the power of O'Keeffe's shapes. And so in a large coffee-table book, or on the corner of an envelope, or as the picture of the month on a calendar, or on a coaster, her images have impact.

Given the popularity of O'Keeffe's work, it is now hard to imagine a time when she, at least, thought her work was not seen enough. She often expressed directly, and by implication, the desire to be properly no-

ticed, or, that is, to have her work noticed. In this context her famous pronouncement—"one rarely takes the time to really see a flower. I have painted what each flower is to me and I have painted it big enough so that others would see what I see"—is both a cliché about modern inattentiveness and a call to pay attention to her work.[7] In another quotation, she spoke about the genesis of one of her best-known paintings, *Cow's Skull: Red, White, and Blue* (fig. 5.2): "As I was working I thought of the city men I had been seeing in the East. They talked so often of writing the Great American Novel—the Great American Play—the Great American Poetry. . . . So as I painted along on my cow's skull on blue I thought to myself, 'I'll make it an American painting. They will not think it great with the red stripes down the sides—Red, White and Blue—but they will notice it.'"[8]

O'Keeffe insists that the painting was something of a joke. In general she went out of her way to deflate interpretations of her skull paintings that made too much of their morbid implications.[9] Yet surely by the logic of her own explanation the skull functions as a vanitas symbol, implying that the ambitions of a male-dominated art world are ultimately absurd. The irony is that even as O'Keeffe seeks to negate the ambitions of the men, she is making her own bid to produce the Great American Work of Art.

The picture's effect is not satirical but iconic. The skull, with its long horns, against the black vertical post, forms a great crucifix. The red, white, and blue bands of the background juxtapose this symbol of Christianity with the symbol of the nation, the American flag. But any possible flag waving engendered by this juxtaposition is negated by the terror of the skull itself. The great horns and long nose seem phallic, even as the crack and opening in the center have a vaginal connotation. Under the influence of the Surrealists Salvador Dali and Max Ernst, who were obsessed with images of castration, O'Keeffe fashioned a vagina dentata.

O'Keeffe's efforts to make a joke out of *Cow's Skull: Red, White, and Blue* seem to me to be a defense against its overly portentous tone. The picture makes its claim to be the Great American Painting by layering highly evocative imagery. Like a coatrack, which the skull on the post also resembles, the picture invites us to hang various associations on it. Does O'Keeffe mean to suggest the deep spiritualism of the West, or is she mocking its religious intolerance? Is she exposing the vanity of male ambition, or rivaling it? Is this a painting about death, or, as she insisted, is it expressive of the liveliness of nature even in decay? The con-

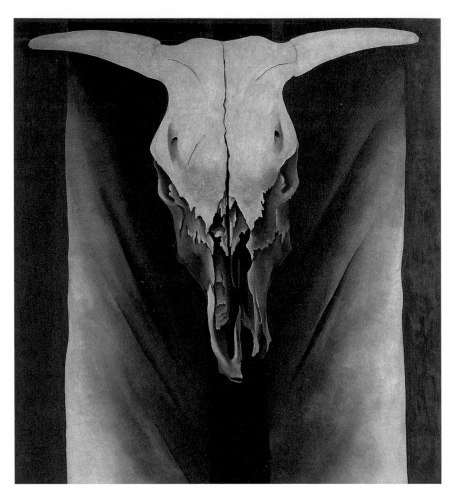

FIGURE 5.2 *Georgia O'Keeffe,* Cow's Skull: Red, White, and Blue, *1931, oil on canvas, 39 ⅞ x 35 ⅞ in. The Metropolitan Museum of Art, The Alfred Stieglitz Collection, 1949 (52.203)*

notations of this imagery do not necessarily add up, or they contradict one another. Whatever we decide is the picture's ultimate meaning, the extreme simplicity of the format creates a picture that stands out from a great distance. It is an image easily remembered, even as its iconic subject matter is gauged to create a range of powerful responses.

If the painting can be read as a phallus-vulva, as a crucifix, or as a ghoulish flag (something like a pirate's skull and crossbones), still the strongest association is with the human face itself. O'Keeffe did very few portraits, and she rarely depicted literal bodies. Yet her skull paint-

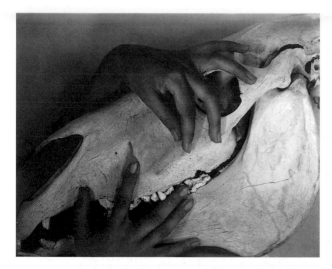

FIGURE 5.3 *Alfred Stieglitz,* Georgia O'Keeffe: A Portrait—Hands and Bones, *1930, silver gelatin developed-out print, 7 ¹/₂ x 9 ¹/₂ in. National Gallery of Art, Washington, D.C., Alfred Stieglitz Collection*

ings directly evoke facial features. In *Cow's Skull: Red, White, and Blue,* the two great sockets of the skull seem to stare back at the viewer. We might conclude that O'Keeffe's strategy for getting noticed was to make a picture that seems to notice us.

Cow's Skull: Red, White, and Blue was created at a crucial juncture in O'Keeffe's career. Although it was actually painted in 1931 at the Stieglitz compound in Lake George, New York, the skull itself was part of a shipment of bones she brought back from New Mexico. It therefore celebrates the discovery of the southwest as the next great theme of her art.[10] Given O'Keeffe's increasingly rocky relationship to Stieglitz, the skull motif may have a double meaning. It stands for New Mexico, where O'Keeffe would much rather have been. But I believe her turn to a subject so evocative of death relates to Stieglitz's age and the souring of their relationship. In 1931 he was sixty-seven, O'Keeffe only forty-four. Three years earlier he had had intense palpitations that may have been a heart attack.[11] Prior to O'Keeffe painting *Cow Skull: Red, White, and Blue,* Stieglitz had made photographs of O'Keeffe fondling the long snout of a horse's skull (fig. 5.3). I think they allude to his mortality and the increasingly apparent disparity in their ages and health. These photographs are simultaneously erotic and self-mocking. O'Keeffe's hands make intimate contact with the skull, but it is only lifeless bone. Stieglitz's influence on O'Keeffe was fading: distance (Stieglitz was never to go to New Mexico) and the possibility of marital infidelity were taking their toll.[12]

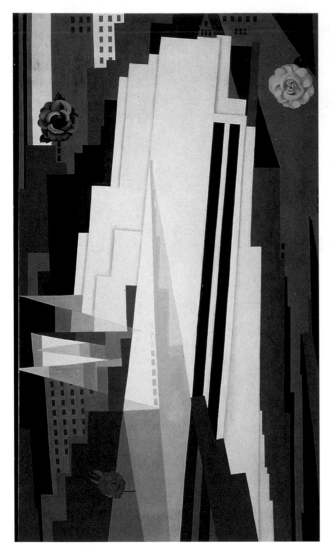

FIGURE 5.4 *Georgia O'Keeffe,* Cityscape with Roses (Manhattan), *1932, oil on canvas, 84 x 48 in. Smithsonian American Art Museum, gift of the Georgia O'Keeffe Foundation*

RADIO CITY MUSIC HALL

Given the heightened tensions in their relationship, which I sense reflected in both artists' work, it is no surprise that the two had a major disagreement over O'Keeffe's career in 1932. They differed specifically about whether she should accept the commission to decorate one of the women's lounges at Radio City Music Hall. The story begins when she submitted work for an exhibition at MoMA. Feeling that modernist artists were being left behind in the rush to adorn major public buildings with murals, the museum sponsored a competition, inviting Amer-

FIGURE 5.5 *Georgia O'Keeffe,*
City Night, *1926, oil on canvas,*
48 x 30 in. Minneapolis Institute of
Arts, gift of the Regis Corporation,
Mr. and Mrs. W. John Driscoll, The
Beim Foundation, The Larsen Fund,
and by Public Subscription

ican artists to submit projects. The building of Rockefeller Center was the most important impetus for the exhibit. MoMA wanted to encourage the planners, and particularly those responsible for Radio City Music Hall, to commission murals by American artists. Selected artists, including O'Keeffe, were given six weeks to execute a sketch and a full-size panel.[13] Her submission, *Manhattan* (figs. 5.4, 5.6), fused two motifs she had painted often during the 1920s: skyscrapers and flowers. The full-scale panel, however, was considerably flatter and more consciously decorative than her skyscraper canvases of the twenties. Anna Chave suggests that O'Keeffe was clearly playing to the museum's preference for cubism and abstraction.[14] In fact, the mural project is no more abstract than several of O'Keeffe's earlier skyscraper paintings. In *City Night* of 1926 (fig. 5.5), for example, the windows have been eliminated, and the buildings look like minimalist slabs. These monumental three-dimensional forms are replaced in *Manhattan* by shapes that could have been constructed of cut paper. The flowers float incongruously on the surface of the image, almost like a collage, and their

FIGURE 5.6 *Georgia O'Keeffe*, Manhattan (study for mural), *1932, oil on canvas, about 21 x 48 in. Location unknown*

presence acts as a signature. Whether O'Keeffe liked it or not, flowers were the subject for which she was known. They provide the only element of originality in a version of a skyline more pedestrian than her earlier skyscraper paintings. In her mural design, a certain modishness, the jazzy dance of art deco graphics, enters her work, as if she were gesturing not so much to the MoMA's curators, or to the art critics, but directly to those responsible for the Radio City Music Hall program.

The very superficiality of O'Keeffe's mural scheme may have been a response to a growing consensus among her critics that her work was primarily concerned with interior female states. One of the great themes of the vast literature on O'Keeffe has been her ambivalence about her public reputation and her desire to protect herself from misreadings of her art. Art historians, including Anna Chave, Barbara Buhler Lynes, and Anne Wagner, have analyzed in depth the erotically charged critical responses to O'Keeffe's work, written in the 1920s by mostly male authors.[15] For Paul Rosenfeld, her paintings "bring before one the outline of a whole universe, a full course of life: mysterious cycles of birth and reproduction and death expressed through the terms of a woman's body."[16] Lewis Mumford agreed, claiming that O'Keeffe "has beautified the sense of what it is to be a woman," by finding "a language for experiences that are otherwise too intimate to be shared."[17] Throughout her career O'Keeffe repeatedly voiced her displeasure with overly eroticized readings of her paintings.[18] The stylishness and frankly decorative patterning of her skyscraper mural might best be seen as an attempt to refute the view that her art was embarrassingly

personal. Unlike her easel paintings of skyscrapers, the buildings in the mural are so compressed that there is little sense of the cavernous space between structures that Chave reads so much into. The small flowers that act as her signature motif are also oddly flat, closed to the interpretations that see in her lilies, irises, and poppies metaphors for the female body.

Whatever we ultimately think of O'Keeffe's mural project for the Museum of Modern Art, it did get the attention of Donald Deskey, who was responsible for overseeing the decorative program of the Radio City Music Hall.[19] In 1932 Deskey offered O'Keeffe the standard fee of fifteen hundred dollars, which was below the price for one of her typical easel paintings, to decorate one of the four women's lounges in the theater. She agreed without Stieglitz's knowledge. When he found out, he was furious and tried, as her agent, first to cancel the contract and then to get O'Keeffe's fee raised. Deskey insisted on the original agreement, and O'Keeffe went ahead with the project without Stieglitz's blessing. But when it was time to begin painting the mural, there was a problem with the way the canvas was adhering to the wall because the plaster had not properly set. O'Keeffe reported, "I came to town to start on that job but the plaster is wet—not ready for the canvas—so I've told them I am not going to do it—they say I am—so there we are. I am in a sulk because I want to do it but I cant [sic] if the plaster isn't dry. . . . It causes much disturbance about this part of town."[20] Reportedly, the next day Stieglitz called Deskey to announce that O'Keeffe was suffering from a "nervous breakdown" and would have to be released from her contract.[21] Deskey replaced O'Keeffe with Yasuo Kuniyoshi, who quickly finished the project with a giant flower and plant motif that is strongly O'Keeffean in manner (fig. 5.7).

Biographies of O'Keeffe stress Stieglitz's irrational interference in trying to block the mural commission. He went so far as to enlist his coterie of followers, including the critic Ralph Flint, to talk O'Keeffe out of the commission.[22] Such bullying may be reprehensible, but can Stieglitz and company be forgiven for thinking that a women's powder room might not be the most auspicious place for O'Keeffe's ambitions? And why, one wonders, did O'Keeffe accept this project in the first place?

I believe that the powder room commission was both attractive and repellent to O'Keeffe, because it made concrete the terms of her critical fame and marginalization, that is, her status as a *woman* artist. As early as 1929 O'Keeffe had written that she longed "to paint something for a particular place—and paint it *Big*."[23] The Radio City Music Hall commis-

sion appeared to offer not only an opportunity to work large but also a chance to extend her audience from modernist sympathizers to the masses, who were thought to be the ideal audience for the mural movement that was sweeping the United States. In many respects, however, the Radio City Music Hall project was severely limiting from the start. O'Keeffe's murals for the lounge would certainly have been big, but they would have been only quasi-public, available solely to the women who used the lounge and not to the male population. This in itself would not necessarily have been a bad thing. We can imagine O'Keeffe delighting in finding a way to circumvent the very men she claimed to mock with *Cow's Skull: Red, White, and Blue*. More troubling is the status of the location, an anteroom to the toilets where women relieve themselves during intermission.

Public bathrooms can be sites of anxiety. They are feared as breeding grounds for diseases. Certain restrooms—usually in remote or little-used locations—have been conducive for anonymous homosexual encounters. The very possibility of being "cruised" in such a location is threatening to certain men.[24] And some women, too, are wary of public facilities, because they were raised to think it was "unladylike" to use them. According to Alexander Kira, whose *Bathroom* is among the few serious studies devoted to the history and design of toilets, women's fear of using public facilities and the resulting need to "hold it in" accounted for a higher incidence of bladder infection among women than men in the early 1970s, when his book was published.[25] We can only guess that the same would have been true for the earlier period. He also writes about women's use of various excuses to cover up the need to use the facilities. Among the most popular is the phrase "I need to powder my nose." As Kira points out, the private function of using the toilet may be disguised through a group activity: "As if on cue, one finds all the ladies excusing themselves to go off to the 'rest room.' While this pattern undoubtedly has other elements involved such as comparing notes about their respective dates or their luncheon partners, plans for the evening, and so on, it is also a fairly effective privacy device, used by women of all ages in all circumstances. It operates by obscuring the identity of any particular individual and removes the burden of being the one who had to go do you know what."[26]

Curiously, the public restroom, which Kira suggests is a site of feminine unease, has also been seen as a place of women's power. In Hollywood movies or on the Broadway stage, the bathroom was not a place to relieve the bowels but an arena to plot and talk about men. It was trans-

FIGURE 5.7 *Yasuo Kuniyoshi, mural in women's powder room, 1932. Radio City Music Hall, New York*

formed from a place of potential embarrassment to a site of conspiracy. A perfect example is Clare Boothe's play, and later film, *The Women* of 1936, the final scene of which is set in a powder room (another scene takes place in Elizabeth Arden's exercise room, which was decorated by O'Keeffe the very same year the play premiered).[27]

The Women was notable because its cast was exclusively female. But such a seemingly feminist act merely hides an antifeminist message, namely, that women must forgive their husband's transgressions and stay married. Scenes in which the principal characters gossip about and fight over men move the plot along. It culminates with the heroine, Mary, recapturing her wayward husband. The play ends when Mary's rival, Crystal, declares, "You're just a cat, like all the rest of us!" and Mary replies, "Well, I've had two years to sharpen my claws."[28] In other words, for a woman to be successful in love, she must learn how to catfight. The women of *The Women* act out the comedy in settings that, like the Radio City Music Hall powder room, are either for women only or coded as feminine. The power of these women, exercised for the most part

FIGURE 5.8 *Henry Billings, mural in women's powder room, 1932. Radio City Music Hall, New York*

through the spreading of rumors, is located outside the public realm of business and politics, the men's world. From the quasi-public spaces of the beauty parlor, the dress salon, the exercise room, and the bathroom, they exert power over men through deceit and manipulation.

It is precisely this conception that inspired a mural for another women's powder room, this one on the third mezzanine of Radio City (fig. 5.8), directly above O'Keeffe's site. Henry Billings depicts two female leopards lurking among classical ruins. The implication is that women are seductive and elegant like large cats; they are essentially decadent, bringing down civilization itself. Deskey himself took responsibility for the powder room on the first mezzanine and completely covered the polygonally shaped space with mirrors (fig. 5.9), so that reflections were infinitely repeated. According to this conception, women are all surface and vanity, their bodies made over into an endless series of duplications. Contrast this with Witold Gordon's mural for the men's lounge (fig. 5.10), where the walls are decorated with maps of the world (complete with a cartoon version of the rape of Europa). In Gordon's

FIGURE 5.9 *Donald Deskey, Polygon women's powder room, 1932. Radio City Music Hall, New York*

conception the power of men is explicit: they control the earth. Though such control is undermined by prowling female leopards in Billings's mural in the women's room.

Stuart Davis's mural for the main male lounge on the ground floor, *Men Without Women* (fig. 5.11), is a direct response to the perceived threat of female decadence. His abstraction incorporates several overtly phallic objects, including a cigar and a gas pump. For Davis the bathroom is obviously a place of exhibitionism and competition. Lee Edelman has written about the peculiar fact that men urinate in semi-public positions at urinals, whereas women urinate in private. This difference is a matter not merely of anatomy but of different attitudes about the genitals, so that the penis is to be exhibited but the vulva and the anus are to be kept hidden.[29] Significantly the phallic objects in Davis's mural—cigar, pipe, barber's pole, gas pump, matches—are juxtaposed with things that suggest masculine competition and games of chance, such as a playing card, horse, motorcar, and sailboat. It is

FIGURE 5.10 *Witold Gordon, mural in men's first mezzanine lounge, 1932. Radio City Music Hall, New York, Donald Deskey Collection, Cooper-Hewitt, National Design Museum, Smithsonian Institution*

FIGURE 5.11 *Stuart Davis,* Mural (Men Without Women), *1932, oil on canvas, 128 7/8 x 203 7/8 in. The Museum of Modern Art, New York. Gift of Radio City Music Hall Corporation*

no surprise that Davis's phallic imagery has not inspired elaborate discussions of the male body similar to those elicited by O'Keeffe's flowers. Like the urinals in the bathroom, symbols of masculinity are accepted as public posture rather than interior states.

Davis's title, *Men Without Women,* is derived from a book of short stories by Ernest Hemingway.[30] On the face of it Davis's mural has little to do with these stories, most of which are set in Europe. Yet both the stories and the mural focus on stereotypically masculine themes. In contrast to Davis's jazzy and cheerful juxtaposition of images drawn from advertising and popular culture, Hemingway's book is intensely dark, its characters doomed. The opening story, for example, concerns an aged bullfighter who is fatally gored. This work is not so much a celebration of masculinity as a rumination about the inability of men to live up to their expectations in their masculine roles. Perhaps the mural's bravado is a defense against Hemingway's pervasive theme: the fear of impotence. But if masculinity is threatened in Davis's worldview, it is not by the failure to perform but by the possibility of female competition. Davis suggested that the title of the mural was a direct response to

FIGURE 5.12 *Georgia O'Keeffe,* Jimson Weed (Miracle Flower), *1936, oil on linen, 70 x 83 ½ in. Indianapolis Museum of Art, Gift of Eli Lilly and Company*

the encroachment of women into previously male domains; it implied that the public bathroom was one of the few places left in modern society where men could be by themselves without female intrusion. As Davis commented, "The flappers have taken over. . . . But they couldn't get into the Men's Room to see my murals."[31] He clearly exaggerated the increasing power of women in the overwhelming patriarchal society of 1930s America. Davis's quip nonetheless points to an interesting aspect of the Radio City Music Hall commissions: once finished, neither O'Keeffe's nor Davis's powder room would be available to the other sex.

O'Keeffe accepted the commission as part of her search for a popular audience. Yet built into the project was the reality that only women, in the most female of spaces, would see it. And then no one—neither

man nor woman—saw it, because it was never begun. Because no sketch remains, what follows is mere speculation about her possible plans for the space. My point in such speculation is to relate O'Keeffe's characteristic motif and style to this curious commission. After all, Deskey hired her because of what he knew of her work and its associations.

One possibility is that she would have repeated the jazzy motif of *Manhattan* despite the lackluster response of the critics to the MoMA exhibition. Yet because of the later mural she did for the Elizabeth Arden Salon, and the paintings that Kuniyoshi actually executed in the space, my guess is that O'Keeffe would have reprised flowers in the murals, perhaps the camellias she used in *Manhattan* or the jimsonweeds that were among her favorite subjects in the 1930s. Perhaps the motif would have looked something like the enormous *Jimson Weed* (fig. 5.12) that she later executed to decorate the exercise rooms of the Elizabeth Arden Salon. *Jimson Weed* was similar to her canvas *The White Flower* of 1932, painted the same year she designed the Radio City Music Hall mural.[32] In *Jimson Weed* four enormous jimsonweed blossoms and their leaves fill the center of the image. They are seen against a light-blue mottled background and a partly clouded sky.

Jimson Weed was a rectangular canvas that was placed in the Arden Salon and later removed. The Music Hall commission would have involved fitting the flowers around wall fixtures, including several large mirrors. The vine of the jimsonweed motif would have lent itself to being twined around these elements. We can guess that O'Keeffe might have taken the vine down to the floor, just as Kuniyoshi did with his floral arrangements in the final decorative scheme. In fact, it is tempting to think that Kuniyoshi was privy to a sketch by O'Keeffe—if one ever existed.[33] Kuniyoshi's colors are more muted and his forms vaguer than O'Keeffe's, but the enormous blossoms that fill the room seem to be an homage to her paintings.

Had O'Keeffe done the mural, my guess is that the effect would probably have been more graphically striking than Kuniyoshi's. As it appears in the later Arden mural, O'Keeffe's flower, although ostensibly a common vine, is baroque and luxurious. The white trumpets of jimsonweed painted on an enormous scale would have been as theatrical as Radio City Music Hall itself. The choice of this particular weed is telling. Although the flower has a seductive elegance, it belongs to the deadly nightshade family. Merely touching it can cause a rash. Indeed, cattle and sheep grazing on the vine can die, and thereby be transformed into O'Keeffe's favorite skull motif.[34] Her "miracle flower," as it

was also called, is therefore both beautiful and deadly, a flower that must be held at a distance.[35]

Whatever O'Keeffe's plan for the powder room, her mural would have shared the walls with a series of round makeup mirrors. This design would have juxtaposed the act of women *painting* their faces and the creation of a woman painter.[36] It is the connection between O'Keeffe's characteristic motif of flowers and women preparing their toilet that is so troubling to me. Would not this alternation of flowers and mirrors literalize the most essential readings of O'Keeffe's paintings? We can imagine women at these mirrors preparing themselves to be the very objects of the overheated imaginings that were such a staple of the largely male accounts of O'Keeffe's art. Yet this very literalizing of the feminine might have worked to counter the insistent reading of her painting as interior. By putting her flower motifs to such purely decorative purposes, O'Keeffe would have rejected all the readings that stressed the intimate nature of her expression. Instead she would have made her flowers all surface, as superficial, in a sense, as the mirrors that reveal only the outward visage of women. The deadly nature of the jimsonweed would have augmented this insistence on surface and distance.

In 1927 O'Keeffe wrote Waldo Frank that she wanted to make an exhibition of work that would be "so magnificently vulgar that all the people who have liked what I have been doing would stop speaking to me."[37] By vulgar, I think she meant popular and commercial, for these were precisely the terms that Stieglitz and his circle claimed most to despise. Vulgar meant reinstating the public nature of her art—turning the readings away from the question of her interior and her body. But, as Wagner suggests, vulgar also implies making the private uncomfortably public. Wagner writes: "What would it be like to overturn . . . the (un)comfortable decorum governing one's place in the world? To elect painting the site of the upset is to ensure that it occur in a space simultaneously public and personal."[38] It seems to me that the powder room commission fulfilled all these meanings of vulgar for O'Keeffe, including upsetting her greatest defender.

Stieglitz rightly took her acceptance of the powder room commission as an attack on his coterie's conception of her art as an intense personal expression of what it meant to be a woman. Indeed, as the Intimate Gallery, the name of his exhibition space from 1925 to 1929, conveys, Stieglitz believed that art was a form of private communication that, paradoxically, goes on in public. His space was a place to enact the "Di-

rect Point of Contact between Public and Artist," free from commercial dealings.[39] O'Keeffe's project threatened to create a send-up of the very concept of an Intimate Gallery. With the powder room, and the later Arden commission, intimacy was in danger of being made over into the privacy of bodily functions; the purity of Stieglitz's uncluttered space into the cleanliness of the washroom; the exulted communication between artist and sensitive audience into the gossip of women before their mirrors. Stieglitz should have appreciated the joke. After all, he had photographed the notorious 1917 *Fountain* of Marcel Duchamp, alias R. Mutt, soon after it had been rejected from the Salon of Independent Artists.[40] Duchamp's urinal threatened to convert the space of the art exhibition into a bathroom. O'Keeffe's mural might do the opposite, confusing the bathroom with the art gallery.

Thinking about O'Keeffe's mural decoration for Radio City is a frustrating game of "what if." My guess is that she abandoned the project because she could not find a way of actually making the space her own, which she had said all along was her goal. Initially the powder room commission might have offered her the opportunity not only to declare her independence from Stieglitz but also to make an aggressive public statement that differed from masculine bravado. Upon contemplation, however, and probably under the intense pressure of Stieglitz, she lost faith in her ability to shift the parameters that were built into the powder room. In a sense the walls were spoiled long before the canvas started to peel off. In painting the mural, O'Keeffe would have been faced yet again with a set of preconceived conceptions of the supposed powers and weaknesses of women. Abject and glamorous at once, the women's powder room of Radio City Music Hall too neatly mirrored her own marginalized position as the Great American Woman Artist of the New York art world.

In 1937, Stieglitz's worst nightmare was confirmed by a puff piece in *Town & Country* publicizing the new exercise room of Elizabeth Arden's beauty salon.[41] In the photographic illustrations that accompany the article (fig. 5.13), three women dance, nymphlike, in front of mirrors that reflect O'Keeffe's mural, which she finished in 1936. Just above is a reproduction of the painting, flanked by curtains. The photograph is tilted, as if the picture itself were taking part in the dance. The copy reads: "BEAUTY IS FUN. . . . Georgia O'Keeffe's painting . . . dominates the yellow and white splendor reflected in the many mirrors of this latest in exercise floors. Here, in a day when the ponderous solidity of a Juno is as outmoded as a Model-T Ford, and a slim, lithe figure as nec-

essary as a lovely face, Miss Arden has assembled the ways and means." Coincidentally, the *Town & Country* blurb on the O'Keeffe mural faces an advertisement for a bathroom that "everyone admires."

Town & Country, with its fashionable covers designed by the likes of Max Ernst and Raoul Dufy, its glossy photographs of the houses of the rich, and its advertisements for beauty products and bathroom fixtures, seems far removed from Stieglitz's supposed ideal of an art removed from commerce. Still, O'Keeffe's *Jimson Weed* displays the kind of exhibitionism that we take for granted in the Davis mural. Femininity is now a matter of public display, all surfaces mingled with the masquerade of fashion. Indeed, O'Keeffe's own phrase, "magnificently vulgar," seems apt in describing *Jimson Weed* in place. Given the aggressively decorative

quality of the Arden project, it is hard to revert to the rhetoric of Lewis Mumford and other critics and talk about "experiences that are otherwise too intimate to be shared." Ironically, the Arden commission, which makes O'Keeffe's work seem so popular and superficial, was executed with Stieglitz's blessings. Presumably the high fee of ten thousand dollars that he negotiated from Arden cleansed the project of its seeming degradation.[42]

In completing the canvas for the Arden Salon, O'Keeffe demonstrated that she could work big and on commission. But her success here doesn't contradict my reading of the Radio City Music fiasco. The terms of the contract were different, and Arden agreed to a much larger fee than Deskey had. More important, O'Keeffe did not have to paint the picture in place, and it was not made to fit into a larger decorative scheme. It is just a large picture whose frame is essential for maintaining a fiction that the space and the image are separate. The picture of women exercising in front of the painting suggests how difficult it is to maintain that fiction. Nevertheless, because of the framing, it became a simple matter to move the painting to a museum wall, where it eventually found its way.

ABIQUIU

O'Keeffe's miserable experience trying to decorate a major public space in New York during the 1930s makes her permanent move to New Mexico more understandable. She claimed that she had "wanted to do a room for so long" but that "experimenting so publicly is a bit precarious in every way."[43] Fresh from the disaster at Radio City Music Hall, she told Russell Vernon Hunter that she would paint a mural on the kitchen wall at Lake George. She wrote, "I have a fever to do a room."[44] Such a private setting might have been the best place to experiment on a large scale. But she never executed this mural either, perhaps because she did not feel at home at Lake George. It was only in New Mexico that she had the opportunity to create literally her own room. At Abiquiu it was no longer a matter of decorating a wall but of fashioning an entire environment.

From the time O'Keeffe began living in her Abiquiu home in 1949, it became her sanctuary and a place of pilgrimage for a select group of admirers, journalists, and photographers. In magazine spreads and coffee-table books, the house was imaged as if it were a temple. O'Keeffe's home in Abiquiu (fig. 5.14) is a masterpiece. Yet it was not designed by a single author, and it was in every way a hybrid: part restoration of the

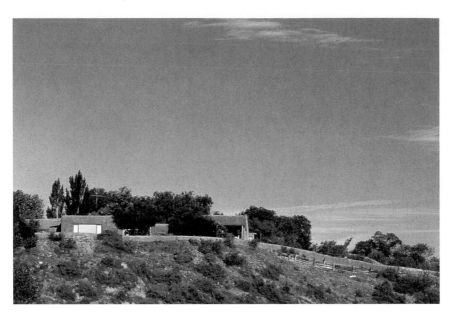

FIGURE 5.14 *O'Keeffe house, Abiquiu, New Mexico, 1995. Collection of the Georgia O'Keeffe Foundation*

original nineteenth-century adobe plan, part new construction. When O'Keeffe bought the property, she found a building in ruins, many of the rooms existing only as the footprints of their foundations. From 1946 to 1949 the house was rebuilt under the supervision of her assistant, Maria Chabot.[45] Because O'Keeffe was so busy dealing with Stieglitz's estate in New York City (Stieglitz died in 1946), she gave Chabot wide rein in the design and execution of her home and studio.[46] Yet in the end the house and its furnishings were made for and represent O'Keeffe's sensibility. The basic hacienda plan of the original house was maintained, but walls were torn down to expand certain rooms, and other structures were added. Plate-glass windows were inserted into thick adobe walls. O'Keeffe furnished the rooms with carefully chosen pieces by Charles Eames, Eero Saarinen, and Mies van der Rohe (fig. 5.15) to set off the austere packed-dirt floors, kiva fireplaces, and built-in adobe benches.[47]

In renovating her home, O'Keeffe and Chabot were probably thinking about the adobe houses of others in her circle of artists and writers who, in the first half of the twentieth century, had begun to move to New Mexico. O'Keeffe had stayed at Mabel Dodge Luhan's compound in Taos, called Los Gallos, and she surely knew the nearby house of the

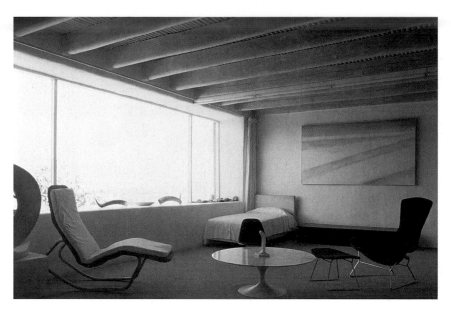

FIGURE 5.15 *O'Keeffe house, studio, Abiquiu, New Mexico, 1995. Collection of the Georgia O'Keeffe Foundation*

artists Ernest and Mary Blumenschein. As Wanda Corn suggests, Luhan was an important model for O'Keeffe in that she provided a "social and intellectual space that a woman created and ran according to her own desires."[48] Luhan's complex, now a bed-and-breakfast, was an agglomeration of native and European influences. Rather than follow a hacienda plan, it employs a two-story stepped-up elevation that gestures to the architecture of the nearby Taos pueblo.[49] From the outside, the big glass windows of the second-floor bedroom suggest a modernist interior, though Luhan decorated eclectically with French and Italian furniture. There is little sense of a remote retreat. Luhan, who loved to entertain, wanted the main dining room to evoke the Villa Curonia, her residence in Italy. The emphasis at Los Gallos was on comfort, but also on public presence, as evoked by "The Big Room," the name given to the main lounge.[50]

The Blumenschein house is a bit closer in spirit to O'Keeffe's home— both are based on a hacienda plan, and both have a large studio for painting. Like O'Keeffe, the Blumenscheins introduced many windows to bring in light. Unlike O'Keeffe, however, they installed wood flooring over the dirt base and furnished with antiques. Even though the

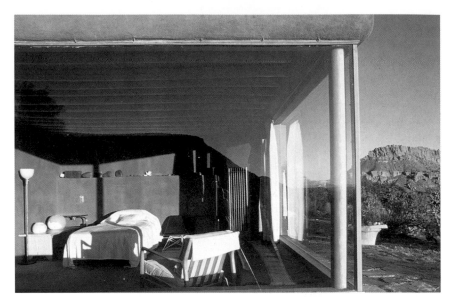

FIGURE 5.16 *O'Keeffe house, bedroom, Abiquiu, New Mexico, 1995. Collection of the Georgia O'Keeffe Foundation*

Blumenscheins did not decorate in an ostentatious manner, their home would have seemed positively cluttered in comparison to O'Keeffe's. It does not seem particularly designed. Rather, like most homes, it feels as if it came into being over time, in response to the changing circumstances and interests of its occupants.[51] Mabel Dodge Luhan's house, like O'Keeffe's, was an expression of its owner's ambitions and tastes. But it seems more improvised, its harmony a result of forcing different styles to coexist rather than to merge. In contrast, O'Keeffe's home suggests a highly unified aesthetic conception. Initially Chabot worried that the opposite would be the case: "The trouble is: you want a native house with modern windows—water—lights: and that means a kind of structure that really isn't native. So the native is all sort of a sham—or else the modernism is really a farce. It is hard to do a hybrid."[52]

Yet because of Chabot's sensitivity to O'Keeffe's aesthetic, which she gleaned through their time together and through her paintings, the modern and the old work beautifully together in the Abiquiu house. There is a continuity of form between the native (the packed dirt floors, the viga ceilings) and the new (the plate-glass windows, the machine-made furniture). For all its origins in indigenous architecture, it seems neither archaeological nor nostalgic. Its feel is resolutely modern.

Chabot wrote to O'Keeffe about a party where she "met a dozen

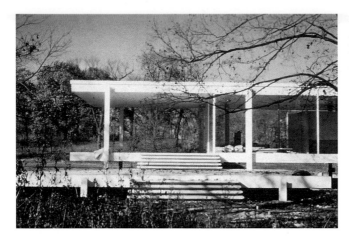

FIGURE 5.17 *Ludwig Mies van der Rohe,* Farnsworth house, *Piano, Illinois, 1945–51*

young architects it seemed to me. . . . Talking to them I realized that I wasn't anything of the kind, had none of their information—none of their art."[53] In another letter she derided "the kind of rigidity that results when a man builds with his mind and a piece of paper."[54] Yet O'Keeffe and Chabot were influenced by the work of contemporary architects. Mies van der Rohe was surely the inspiration for the corner glass walls of O'Keeffe's bedroom (fig. 5.16), which provide wonderful views of the canyon, mountains, and the road to Española, below. The immense glass windows, long horizontal expanse, and minimal furniture of her studio give it a Miesian feel. A glass coffee table by Mies, a thick sheet suspended over chrome legs, is the major piece in the living room. Ornament is minimal: simple muslin is used as bedcovers, and bare lightbulbs provide illumination.

The Abiquiu "restoration" was planned just after Mies began to design his famous Farnsworth house (fig. 5.17), a model of which was exhibited at the MoMA in 1947. Mies's goal in designing this house was to "let the outside in." He later said that "through the glass walls of the Farnsworth House, [nature] gains a more profound significance than if viewed from outside. This way more is said about nature—it becomes a part of the larger whole."[55] In the same way, the great windows of O'Keeffe's bedroom and studio frame the landscape. The outside is let into the Abiquiu house not only through its windows but also by leaving one of the major rooms roofless, in effect creating two interior patios. Two of Mies's ideals, "freedom of open spaces" and contemplation of nature, are embodied in the Abiquiu program of expanding rooms and increasing fenestration.

Significantly, the Farnsworth house, like the Abiquiu compound, was built for a single, middle-aged professional woman. Such patrons are rare in the history of modern architecture. As Alice T. Friedman writes, Mies used Edith Farnsworth's lack of a family as an excuse to eliminate almost all vestiges of domestic privacy from his design. Unfortunately, the Farnsworth house was a place not only to see out of but also to look into—to the eventual horror of Edith Farnsworth, who found that she could never feel free from the prying eyes of strangers. Because Chabot saw her role as anticipating O'Keeffe's desires, she was far more sensitive to her needs than Mies was to Farnsworth's. Yet like Farnsworth's, O'Keeffe's house was not built with traditional ideas of feminine domesticity in mind. O'Keeffe had no children to accommodate. Significantly, the bedroom is located not off the living room but off the studio; work is placed at the center of basic existence. Yet the kitchen and dining areas of the house are almost as crucial.

Long before the Abiquiu project was begun, Stieglitz mused about what kind of house O'Keeffe might build. Rather than imagining a house devoid of the signs of domesticity, he claimed it would be furnished only with kitchen furniture, "made as sensitively as O'Keeffe made her paintings."[56] Here Stieglitz is allying O'Keeffe to the best functionalist dogma of the Bauhaus, but by summoning up the kitchen he gave a decisively feminine cast to her functionalism. Of course, the kitchen is the place where domesticity is work, but it is work for the home. The kitchen, with its pots, pans, mixing tools, and jars of spices, and the artist's studio, with its brushes, palette knives, and paints, are really not that far apart. In the Abiquiu compound, the kitchen and the studio are separate, but the movement from one to the other does not feel abrupt. Domestic living and artwork merge. Even O'Keeffe's bathroom is more like a passageway between spaces than a separate room.

I have emphasized the Miesian aspects of O'Keeffe's home, yet in many ways the house is anti-Miesian. Just before O'Keeffe bought the property, she made a pilgrimage to the architectural studio of Frank Lloyd Wright in Wisconsin.[57] The general antistructural quality of the adobe style, the way clay walls wrap around the interior and seamlessly join the floor, could stand as exemplary for Wright's famous concept of plasticity. As Vincent Scully has written, Wright advocated an architecture in which all the elements of the house would be integrated.[58] He sought to hide signs of traditional post-and-beam construction in an effort to create flow between the various parts of the building. Many of the rooms in O'Keeffe's house are perfect illustrations of Wright's con-

cept. The so-called Indian room almost seems like a cave. The transition from floor to wall is gradual; both are made of earth. A *banco,* a long bench or bed that is attached to the wall and also made of earth, further diffuses the disjunction between interior elements. In general, with the exception of a steel column in the Miesian bedroom and the vigas in the ceiling, structural elements are not a major element. Nontraditional supporting beams were used in order to fit plate-glass windows into the kitchen and studio, but they were not declared, as they would have been in a building by Mies. He and his followers might have deeply admired the purity and functionality of adobe architecture, but the Miesian thing to do in Abiquiu would have been to tear down the adobe and place a glass box there instead. The central aesthetic of using indigenous forms in a modern way is also Wrightian. Yet Wright surely would not have left anything of the original structure either. He would have eradicated the adobe house to make a Wrightian adobe-like house. O'Keeffe and Chabot were not modern architects in this sense; architecture was not their primary means of expression. In assimilating modern elements within adobe forms, leaving certain Pueblo-Spanish elements intact while altering or obliterating others, they suggested an architectural aesthetic of adaptation and appropriation that is contrary to modernist architects' push to remake the old in their own image. If O'Keeffe's house is profoundly modernist in spirit, it is so in terms of painting; this is a modern painter's house.

THE DOOR

According to O'Keeffe, what attracted her to the Abiquiu compound was not its architectural spaces but its potential as a motif for a painting. She was drawn to its simple black patio door: "Oh I never thought of the view, I knew it was a good place but you didn't find anything like that door in any other place and I thought that door was something that I had to have."[59] A door is flat and framed like a painting. It is an opening onto space, but it is not a space in and of itself. Unlike a window, it usually cannot be seen through. In its flatness and opacity, its framed objectness, it is like a modernist painting. Indeed, it became the inspiration for several of O'Keeffe's most abstract paintings, one of the earliest of which dates from 1948. *In the Patio II* (fig. 5.18) is divided into three bands of color, with a simple black square in the center. A strip of light blue represents the sky. The wall is a dark yellow ocher, and the packed dirt of the patio floor a lighter tone of the same color. Wall and floor meet in a line that curves out at the lower left. This ir-

FIGURE 5.18 *Georgia O'Keeffe*, In the Patio II, *1948, 18 x 30 in. Georgia O'Keeffe Museum, New Mexico*

regularity conveys the handmade character of the adobe wall. However, the fact that the doorway is set back from this line suggests that the dark ocher shape represents both the wall and its shadow cast on the floor below. This merging of shadow and wall flattens the image. The only sign of depth is the area at the bottom of the door. O'Keeffe has bowed the bottom edge of the door slightly outward, as if the ground were slightly lower at that point, and she has added just a hint of gray to suggest reflected light on the floor.

If it were not for the title, *In the Patio II*, the picture would be hard to decipher as a specific place. One of O'Keeffe's operating procedures was to scan her environment for evocative subjects that could be read as pattern and geometry, and as real things. The door is a perfect example of such a subject. In a series of paintings from the early 1950s she continued to paint the door front on, or from an extremely foreshortened angle on the side. In *Patio with Black Door, 1955* (fig. 5.19), the foreshortened angle seems to introduce a heightened sense of three dimensions, but close cropping, and the extreme perspective, flatten the painting. As a series, the pictures of the patio door oscillate between flatness and depth, clarity and indistinctness, abstraction and depiction. O'Keeffe

FIGURE 5.19 *Georgia O'Keeffe,* Patio with Black Door, *1955, oil on canvas, 40 x 30 in. The Museum of Fine Arts, Boston, gift of the William H. Lane Foundation, 1990*

seems to be testing the points at which a shape suggests an object "out there" and still registers as a shape.

The Abiquiu door was not the first passageway to interest O'Keeffe. Large black doorways are major elements in paintings like the 1932 *White Canadian Barn, No. 2* (fig. 5.20).[60] Here the wall of a barn is interrupted by two enormous black rectangles that read both as simple openings—voids—and as shed doors. In the 1929 *Lake George Window* (fig. 5.21), O'Keeffe looks at a door through a window. This painting could stand as a rumination on the question of the relationship of painting to windows on the world. Famously, Greenberg suggested that premodernist paintings were akin to windows, in that they provided illusions of three-dimensional spaces.[61] For Greenberg, and the school of formalist critics that he led, such holing through of the picture

FIGURE 5.20 *Georgia O'Keeffe,* White Canadian Barn, No. 2, *1932, oil on canvas, 12 x 30 in. The Metropolitan Museum of Art, The Alfred Stieglitz Collection, 1949 (64.310)*

plane distracted from the picture as picture. O'Keeffe wants to have it both ways. She seems to say, yes, a painting is, and is not, like a window. It is flat, but it is capable of presenting a three-dimensional world. We seem to look through, rather than at, certain kinds of paintings. Yet what her painted window reveals is not an open space but a door, which itself contains a blank window. Her window and door open back onto themselves. The illusionistic conceit of looking through the picture at something else leads us back to what we originally were looking at, a painted and framed rectangle: a door, a window, and finally a picture.

The patio door resonated for O'Keeffe in another sense. It is no coincidence that she found this motif during a key transition in her life. O'Keeffe was in negotiation for the Abiquiu house in the last days of 1945. The imminent transfer of ownership at the beginning of a new year gives the sale a mythic importance, a sense of an ending and a beginning. For some time now, she had been spending longer periods of time away from her husband. By New Year's Eve, 1945, Stieglitz was eighty-one and in poor health. He died on July 14, 1946. O'Keeffe actually moved into the Abiquiu house in 1949, after Stieglitz's complicated estate was settled. The door figures in her paintings as a passageway. As Sharyn R. Udall writes, "Doors are certainly a metaphor for moving between realms" in O'Keeffe's paintings.[62] Specifically, the Abiquiu door symbolized for her the break with old commitments and the finding of autonomy as a person and an artist.

The Abiquiu house was not the first space that O'Keeffe owned. In 1940 she purchased her summer retreat at Ghost Ranch, which is down

FIGURE 5.21 *Georgia O'Keeffe*, Lake George Window, *1929, 40 x 30 in. The Museum of Modern Art, New York. Acquired through the Richard D. Brixey Bequest*

the road from Abiquiu. The Ghost Ranch house is also adobe and follows the hacienda plan. It was a base for painting campaigns in the surrounding country. Although it provided the isolation and the landscape she craved, it lacked self-sufficiency and protection from the environment. The house in Abiquiu came with all-important water rights, which meant that she could have a vegetable garden, freeing her from trips to Española and Santa Fe for produce. Despite O'Keeffe's great admiration for the Abiquiu door, she probably would not have bought the house had it not come with those water rights.[63]

The Ghost Ranch house was a summer retreat, her version of Stieglitz's compound at Lake George. In contrast, the house at Abiquiu was the first real home in which she felt completely independent. For much of O'Keeffe's career before World War II, she lived in other people's spaces, in Stieglitz's cramped apartment in New York City, at his family's

compound at Lake George, or on property lent to her by Arthur Pack in New Mexico. It was only when she purchased the houses at Ghost Ranch and then at Abiquiu that she began to create a space where she could live and work as she wished.

Ghost Ranch is located in the valley, at the foot of the mountains and cliffs that O'Keeffe loved to paint. It is *in* the landscape. In contrast, the Abiquiu house is a place to look *out* at the landscape; yet, O'Keeffe claimed not to be drawn to this aspect of the home. Significantly, the door she loved so much is in an interior court. This patio, and the so-called "Roofless Room," allowed her to be outside but completely protected by the thick adobe walls. Everything about the house suggests protection. On the town side, high walls keep out the curious. The house sits on the corner of the mesa above the road to Española, like a lookout post or small fort. It seems completely immune to intruders and in command of the surrounding valley below: a perfect setting for the general who owned the house until 1902. It was also an ideal site for a new kind of artist who, though remote from the centers of modernity, maintained close connections to the art market. O'Keeffe's retreat is not that of the hermit who casts aside worldly fortune but of the famous artist who needs an idyllic setting in order to continue to make art. And it was O'Keeffe's fame, her ability to communicate to a large public and sell her work to increasingly affluent collectors, which allowed her autonomy.

Of course, such autonomy was illusory. As remote as Abiquiu seems, it is only a short drive from Los Alamos, the very epicenter of the modern world in the 1940s. It turns out that O'Keeffe had a bomb shelter constructed at Abiquiu, just in case. It seems a bit deflating to think of this woman, who publicly projected an image of stoic wisdom and grace, privately trying to stave off Armageddon. And yet there is something about the entire Abiquiu complex that speaks of self-preservation and the fragility of her independence. Even her own house frustrated her attempts at control: "I wanted to make it *my* house, but I'll tell you the dirt resists you. It is very hard to make the earth your own."[64]

Through her Abiquiu home, elegant and spare, crowning the mesa like a classical temple on an acropolis, O'Keeffe seems to have fulfilled a modernist fantasy of autonomy and aesthetic purity, a merger of art and nature. Ironically, this achievement was built on the success of paintings whose modernist credentials have been suspect. Even her most abstract paintings had their origins in figurative motifs, though this fact alone should not exclude her from being thought of as a mod-

ernist painter. After all, Picasso himself insisted on the false dichotomy between abstraction and figuration.[65] Rather, the too public display of her work on calendars and postage stamps has impeded the supposedly private function of contemplation and reflection that is central to the modernist conception of the purity of the work of art. Or to put it another way, her work seems to offer little resistance to the various pedestrian uses to which it has been put. I return to Greenberg's two terms for O'Keeffe's false modernism, hygiene and scatology, with their chauvinist implication that women's work is cleaning up filth. I do not think we can deny that O'Keeffe's house and her paintings of the New Mexican landscape tidy up the messiness of modern life. After 1940 she seems little interested in, as Wagner puts it, upsetting "the (un)comfortable decorum governing one's place in the world."

Greenberg's fears, however, are really not about O'Keeffe's art. Rather he is concerned that modernism itself, its abstractness and flatness, its code of less is more, might be reduced to a mere tidying up of the popular and the vulgar. It is not that kitsch is a bad version of the avant-garde, as he liked to claim, but that the avant-garde might be merely a good version of kitsch. Or, more troubling still, it might not be possible to tell the two apart. He complained that "many experts—some of them on the museum's [MoMA's] own staff—identify the opposed extremes of hygiene and scatology with modern art, but the particular experts at the museum should have had at least enough sophistication to keep them apart."[66] But the experts should be forgiven. The clean is always becoming dirty, the pure impure, or vice versa.

Certainly O'Keeffe herself would reject such modernist tropes as pure and impure. They too easily mirror the terms used to canonize and denigrate women. She knew firsthand what it was like to be labeled pure and impure at once, high priestess and adulteress: these were roles she played defending the cause of modernism for Stieglitz. In the end the "magnificent vulgarity" of her paintings and the intimations of transcendence of her home are inseparable. Perhaps this is true of modernism as well; there is no hygiene without scatology, no avant-garde without kitsch, just as there is no public without private. Robert Penn Warren, speaking in 1942 on the modernist desire for pure poetry, insisted that even the purest poems incorporated the vulgar and the pedestrian and that there was no clear separation between the everyday and the poetic. Pure poems have to "mar themselves with cacophonies, jagged rhythms, ugly words and ugly thoughts, colloqui-

alisms, clichés, sterile technical terms, head work and argument, self-contradictions, cleverness, irony, realism—all things which call us back to the world of prose and imperfection."[67] Through such internal contrast and resistance, this was how the poem creates "a movement . . . through complication toward simplicity of effect." It forges the "context of its own creation. . . . It must, as Coleridge puts it, make the reader 'an active creative being.'"[68]

The Radio City Music Hall project had ended with the seeming impossibility of O'Keeffe making over a public space so that it was her room exclusively. She did, however, fashion her own space in Abiquiu, but in the course of her many years there she made it quasi-public by welcoming the camera and the press. This ostensibly private space became the backdrop of a documentary for public television in 1977 and the subject of an article in *Architectural Digest* in July 1981, the cover of which featured her favorite door, the door that provided her with a face onto the world and a mask behind which she could hide. It is therefore the perfect metaphor for O'Keeffe's uncanny ability to be famous and endlessly photographed, and yet to convey a sense of absolute privacy. And so a site of potential feminine subjection, the home, is made over into a sign of the artist's success and power. From this home O'Keeffe seemed to put her mark on everything surveyed. In the tourist brochures, Abiquiu, Sante Fe, and Taos, New Mexico, all became O'Keeffe country. Surely this was room enough for any artist's ambition.

6 A Rake Progresses
David Hockney and Late Modernist Painting

For Georgia O'Keeffe, finding the ideal place to make art involved leaving the home she and Stieglitz had made and establishing a new life in a region of the United States, New Mexico, that was so different from New York City that it might as well have been a foreign country. Such acts of expatriatism could almost be said to be a necessary condition of being a modern artist. Often it is a matter of leaving one's native country for the reigning center of the art world: Paris in the first half of the twentieth century, New York City in the second half. Or, as in the case of O'Keeffe, success enables the artist to seek out a home that is far from such aesthetic epicenters and therefore free of the distractions of society. But when an artist is young, he or she usually wants to be where the action is. In the case of David Hockney in the early 1960s, the action seemed to be in America.

A Rake's Progress, a suite of sixteen prints completed in 1963, recounts Hockney's first trip to the United States and the role it played in the artist's imagined rise and fall. But before launching into a discussion of this early series that traces the trajectory of the modern artist's career, I need to own up to my ambivalence about Hockney's work. This ambivalence is allegorized for me by one of his wittiest paintings, *Play within a Play* (fig. 6.1). Hockney describes the picture in this way: "It uses Domenchino's idea of a very shallow space with a picture on a tapestry that has illusion and you don't know whether the illusion is real or not, because it has this border round it. You're playing so many games, and they are visual. . . . The figure is a portrait of John Kasmin. . . . Now it seemed appropriate to trap him in this small space between art and life (the sheet of glass is real

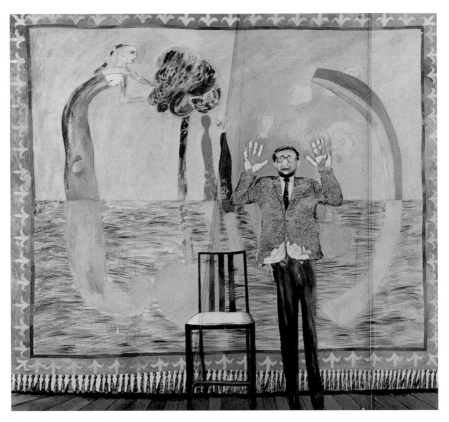

FIGURE 6.1 *David Hockney,* Play within a Play, *1963, oil on canvas and plexiglass, 72 x 78 in. Private collection*

and where his hands or clothes touch they are painted on the surface of the glass)."[1] The picture *plays* on the idea of the primacy of the picture plane, even as its illusionism violates that same plane.[2] The incorporation of a pane of reflective glass is a pun on "self-reflexivity," the modernist concept that art should be about the making of art. Hockney insists that figuration—what he calls depiction—is as capable of investigating the nature of the medium as is abstraction. John Kasmin is Hockney's art dealer. Although Hockney likes and admires him personally, the painting is mocking. It pokes fun at the dealers, collectors, and, I might add, art historians who, unlike the artist, experience art from the outside.

But *Play within a Play* has another association that is made transparent in the film *A Bigger Splash,* the 1974 quasi-documentary based on

Hockney's life. The movie re-creates *Play within a Play* so that Kasmin is shown literally outside a window with his face pressed against the glass looking in. He resembles a poor man not invited to a rich person's party, or a Peeping Tom. At its worst, Hockney's art often makes me feel this way. It presents a world of chic wealth and pleasure that the unlucky and ordinary cannot know. If I do find myself wanting to be a member of that elite company, I feel guilty for the superficiality of my desires.

Although Hockney has made many pictures that I wish I had painted, and at times has lived the life I wish I could live, I am worried by a quality of superficiality in his work. Max Horkheimer and Theodor Adorno have written that our culture provides us with goods and experiences that we know to be empty—but we want them anyway: "The triumph of advertising in the culture industry is that consumers feel compelled to buy and use its products even though they see through them." Like Clement Greenberg, Horkheimer and Adorno are particularly disturbed by the way advertising replaces love and passion with the merely hygienic: "The most intimate reactions of human beings have been so thoroughly reified that the idea of anything specific to themselves now persists only as an utterly abstract notion: personality scarcely signifies anything more than shining white teeth and freedom from body odor and emotions."[3] Such a culture is often Hockney's subject and target. He is obsessed by images of showers and swimming pools. He contrasts their severe geometry with the beautiful bodies of young men in a vision of modernity that is elegant and desirable, but also strangely sterile. Hockney consciously converts the most vulgar aspirations of American society, such as the desire for the perfect bathroom or the biggest swimming pool, into paintings that in their formal construction refer to color-field abstraction. The implication is that there may not be much difference between high modernism and conspicuous consumption. Hockney is well aware that the same people who own the most expensive consumer objects are also the patrons for advanced art, including his own. Hockney's *Beverly Hills Housewife* (fig. 6.2) suggests that living in a house in the style of Mies van der Rohe or owning the right piece of minimalist sculpture does not ensure spiritual or moral depth. Indeed, this portrait of a California collector, with its hard edges and bright surfaces, suggests that the pursuit of high modernist purism might degenerate into superficial style. The two nonmodernist touches in *Beverly Hills Housewife*, the deer head and the zebra fabric on the lounge chair, recall a time when film moguls flaunted their wealth by

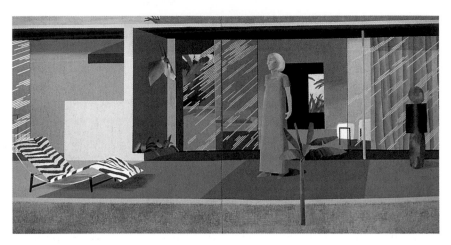

FIGURE 6.2 *David Hockney,* Beverly Hills Housewife, *1966, acrylic on canvas, 72 x 144 in. Private collection*

building ornate mansions in Beverly Hills. These kitschy elements suggest continuity between an earlier ostentation and a 1960s highbrow conception of good taste. And so as I worry about the emptiness of Hockney's paintings, I also worry about the failures of modernism.

The seduction of American consumer culture and its possible corrupting effects are at the center of David Hockney's *A Rake's Progress.* Hockney based the prints on William Hogarth's series of paintings and engravings titled *The Rake's Progress,* done in 1734–35. Hogarth's dissipated "rake," who squanders his inheritance and ends up in the madhouse, becomes Hockney himself, and Hogarth's morality tale the story of Hockney's first encounter with the United States. Hockney said, "When I came back I decided to do *A Rake's Progress* because this was a way of telling a story about New York and my experiences and everything."[4] Here I follow Hockney's lead, in that I take *A Rake's Progress* to be biographical. I am well aware, however, that it is not a literal transcription of Hockney's experience. The young man with the big head and wired-rimmed glasses who appears repeatedly in the series is and is not the author. For simplicity's sake, I will refer to this character as Hockney, but he is also the fictitious rake of Hockney's imagination.

Hockney remembered that his initial impetus to travel to America came from "a sexual point of view." "I'd seen American *Physique Pictorial* magazines which I found when I first came to London. And they were

full of what I thought were very beautiful bodies, American, and I thought, very nice, that's the real thing. The art I didn't care about."[5]

Physique Pictorial was the most successful gay publication of the fifties and sixties. Founded and run by Bob Mizer, its ostensible purpose was to focus on bodybuilding, but by the early 1960s *Physique Pictorial* had become increasingly brazen in posing seminude men together suggestively in such settings as the shower and the gym. Hockney actually used a picture (fig. 6.3) from *Physique Magazine* as the source for *Boy About to Take a Shower* (fig. 6.4), which was done just after he completed *A Rake's Progress*.[6] His use of the photograph is indicative of the allure the magazine exerted on gay men during a period when overt homosexual imagery was relatively rare. To the young English artist, *Physique Pictorial* seemed to offer up the possibility that America was a space of hedonistic freedom where beautiful straight-looking boys openly expressed their affection in direct physical relationships.[7]

Hockney began including homosexual themes in his canvases as early as 1961, while he was still a student at the Royal Academy of Art. Although he had yet to visit the United States, his attempts to express his desire for men were filtered through his admiration for an American, the poet Walt Whitman. According to Hockney, his first serious painting was *Adhesiveness* (fig. 6.5), the title of which was derived from Whitman's term for intimacy between two men. But where Whitman was somewhat vague about the nature of such intimacy, the painting is explicit. Two crudely painted figures fit together like a jigsaw puzzle, to suggest, in Hockney's words, the "69 position," in which a couple perform oral sex on each other.[8] The painting recalls crude images of fellatio in the manner of graffiti on bathroom walls. And as with graffiti, Hockney includes actual writing, using Whitman's private code of numbers to refer to lovers, "4.8" stands for "DH" and "23.23" stands for "WW."[9] In a fantasy of sexual and aesthetic union, the bodies of the painter and poet interlock, they become one.

We 2 Boys Together Clinging (fig. 6.6) is also about a Whitmanic adhesiveness, the merging of two kindred souls. Its title is borrowed from a poem in Whitman's *Leaves of Grass*. The cartoon quality of the figures gives the picture a humorous quality that belies the sense of desperation embodied in the boys' attempt to keep together. Hockney recalled that he was struck at the time by a news story about two boys perilously clinging to a cliff. Hockney describes the phallic protrusions on the two figures as "tentacles" that "help keep the bodies close together."[10] Perhaps because of the cultural interdictions against homosexuality, the

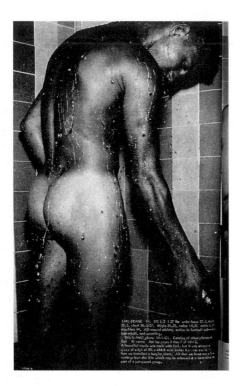

two men are under pressure to separate. In this context the word "never" scrawled above the couple refers to a line of Whitman's poem: "One the other never leaving," in that the boys want to stay together. But it also suggests the prohibition against homosexuality that, along with the tensions of any intense relationship, might sunder their connection. Or as Kenneth E. Silver has written, "'Never' between the mouths of the boys suggests that Hockney's ode may be to love desperately desired rather than blissfully achieved."[11]

What is remarkable about Hockney's practice is not the gay content per se (Marsden Hartley and Jasper Johns also used Whitman as a gay hero)[12] but his frankness in acknowledging its presence. Discovering homosexual subject matter in Hockney's paintings is not a matter of guesswork. Hockney himself declares it to be the subject: "They were partly propaganda of something I felt hadn't been propagandized, especially among students, as a subject: homosexuality. I felt it should be done. Nobody else would use it as a subject, but because it was a part of me it was a subject that I could treat humorously."[13] *Adhesiveness* and *We 2 Boys Together Clinging* were made at a time when Hockney was still

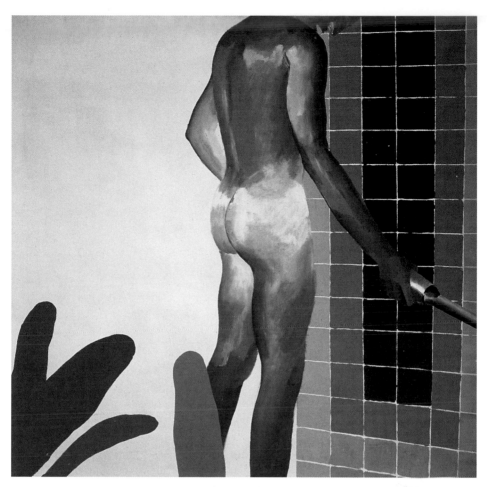

FIGURE 6.4 *David Hockney,* Boy About to Take a Shower, *1964, acrylic on canvas, 36 x 36 in. World Co. Ltd, Kobe, Japan*

at art school, trying to find a way to paint figuratively. He claimed that his fellow students were all painting like Abstract Expressionists and that only R. B. Kitaj was encouraging him to paint figuratively. This radical subject matter negated the conservative implications of figurative art and gave paintings that might seem otherwise traditional a flavor of scandal. Yet the gay theme was never mentioned directly by Hockney's early critics. It could not be talked about, at least not in print.

Hockney talked about the steady stream of visitors to the cubicle in which he painted at the Royal College of Art and his wish to get their

FIGURE 6.5 *David Hockney,* Adhesiveness, *1960, oil on board, 50 x 40 in.*

attention. He became "conscious . . . that I was being cheeky and bold, and that's what one should do, I thought, be slightly cheeky, although I'm a bit shy."[14] Despite his supposed shyness, Hockney used an image from *Physique Magazine* as the subject for his diploma painting when he graduated. He caused quite a stir at the graduation by wearing a gold lamé jacket, not exactly the costume of a shy man. A photograph of Hockney posing in front of *Life Painting for a Diploma* suggests his ambition (fig. 6.7). His whole demeanor is confident or, as he says, cheeky. By touching the shoulders of the life figure, his own stake in the homoerotic content of the picture is made explicit. Students were expected to demonstrate at graduation knowledge of anatomy, hence the inclusion of the skeleton in the painting. According to Hockney, the correctly drawn skeleton was less about his skill as a draftsman than about the lifelessness of the school's instructional method.

FIGURE 6.6 *David Hockney*, We 2 Boys Together Clinging, *1961, oil on board,
48 x 60 in. The Arts Council of Britain*

In the play between the skeleton, the beautiful athletic body, and the
body of the artist himself, Hockney sets up a series of relationships that
he repeated in many of his images of the 1960s. Painting provides the
way for the artist to possess the beautiful boy. But that boy is always dis-
tant, always a beautiful body just out of reach. As I wrote in my discus-
sion of Stieglitz's portrait of O'Keeffe, actually touching a painting
negates its illusionism. Hockney might seem to put his hand on the
body of the love object, but he is actually only making contact with the
dead surface of his canvas.

As stated earlier, Hockney's trip to America was driven by his desire
to make physical contact with the real boys of *Physique Magazine*. The
first plate of Hockney's *A Rake's Progress*, entitled *The Arrival* (fig. 6.8),
shows the artist being whisked to New York as if on a magic carpet. The
carpet itself is made up of violent scribbles, suggesting the kind of Ab-
stract Expressionist painting Hockney invariably associated with the
United States. In this sense, he could be said to be trampling on

FIGURE 6.7 *David Hockney in front of his painting,* Life Painting for a Diploma, *1962 (photograph published in* Town, *September 1962)*

FIGURE 6.8 *David Hockney,* A Rake's Progress: "The Arrival," *1961–63, etching and aquatint, 11 ¹⁵/₁₆ x 15 ⁷/₈ in. Yale Center for British Art, Paul Mellon Fund*

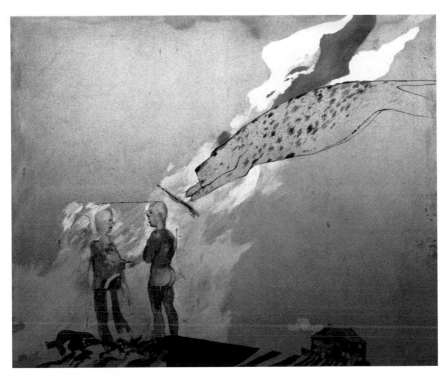

FIGURE 6.9 *David Hockney,* Picture Emphasizing Stillness, *1962, oil and Letraset on canvas, 60 x 72 in.*

Abstract Expressionist ground, as he makes his triumphant and figural arrival in New York City.

The words "Flying Tiger," written across the top left corner, refer to the cheap charter flight that made the trip possible. But they also suggest the large cat that leaps out of the sky in *Picture Emphasizing Stillness* (fig. 6.9). That painting has been taken to be a demonstration of the static nature of painting, since the men are in no danger from the leopard. Because the picture is merely a depiction, the leopard will remain frozen in midleap.[15] Yet the beast strikes after all, not in a literal sense, but in the erotic encounter between the two men. Likewise the Flying Tiger in *The Arrival* propels Hockney's sexual awakening, setting the artist down before the phallic Empire State Building, a potent symbol for the "sexual point of view" and the beautiful men that Hockney said drew him to the States. The Empire State Building forms a couple with another, more modernist skyscraper whose phallic top bends in the direction of the artist, as if bowing in welcome.

Just as Hockney could be said to trump Hogarth, by doubling the

number of prints in his *Rake,* he augments Hogarth's black-and-white engraved format with color. Each print includes an area that is printed with red ink. Hockney does not mention this use of red in his autobiography, nor does he reproduce the work in color. In comparison to his sophisticated use of color in his later prints and paintings, his application in *A Rake's Progress* of a single hue seems crude.[16] Because the red areas are discreet and relatively small, the effect is less of coloring in than of augmenting certain themes. In general, I think red in the series stands for passion as well as for the devilish temptations of the United States that lure the rake. But in some cases Hockney uses red simply to represent the sun. In the first print, he does both. The red blotches above Hockney's head express his excitement about arriving in the land of *Physique Pictorial,* but the circular red bands to the right of the blotches also coalesce into an image of the sun, perhaps as seen through the smog of New York City.

The second print, *Receiving the Inheritance* (fig. 6.10), suggests approaching fame and the money it brings, thereby fulfilling Hockney's erotic fantasy of the United States. It shows the artist selling his prints to William Lieberman, who was then a curator at the MoMA. On the table can be made out Hockney's etching entitled *Myself and My Heroes,* which includes the image of Walt Whitman. The sale had a galvanizing effect on Hockney, vindicating the direction of his work. It signaled his real *arrival* as a professional artist whose work was now worthy of a great museum. The money from the sale provided the opportunity to extend his trip and to seek out distinctly American experiences. In *Meeting the Good People* (fig. 6.11), he visits the monuments of Washington, D.C. The Lincoln Memorial looms much larger than those of Jefferson and Washington. Hockney's image of the statue of Lincoln is oddly animated and informal, as if Lincoln were alive. Although most of the sculpture is in shadow, there is a lighter quality in the area of his genitals. Of course, Lincoln was the adored hero of Hockney's hero, Whitman, and so Lincoln takes on a more corporeal and erotic form than does the tiny Jefferson.

Hockney goes to Madison Square Garden to hear gospel singing in *The Gospel Singing (Good People) (Madison Square Garden)* (fig. 6.12). In focusing on Lincoln and black spirituals, he is surely aligning himself with the burgeoning civil rights movement. Yet he refuses to separate politics from erotic pleasure. The gospel singer has both a halo and an exaggerated bosom; the spiritual is literally conveyed through her body. Her "hallelujahs" float up to a small group of people who appear to in-

FIGURE 6.10 *David Hockney,* A Rake's Progress: *"Receiving the Inheritance," 1961–63, etching and aquatint, 11 ¹⁵/₁₆ x 15 ⁷/₈ in. Yale Center for British Art, Paul Mellon Fund*

FIGURE 6.11 *David Hockney,* A Rake's Progress: *"Meeting the Good People (Washington)," 1961–63, etching and aquatint, 11 ¹⁵/₁₆ x 15 ⁷/₈ in. Yale Center for British Art, Paul Mellon Fund*

FIGURE 6.12 *David Hockney,* A Rake's Progress: *"The Gospel Singing (Good People) (Madison Square Garden)," 1961–63, etching and aquatint, 11 ¹⁵/₁₆ x 15 ⁷/₈ in. Yale Center for British Art, Paul Mellon Fund*

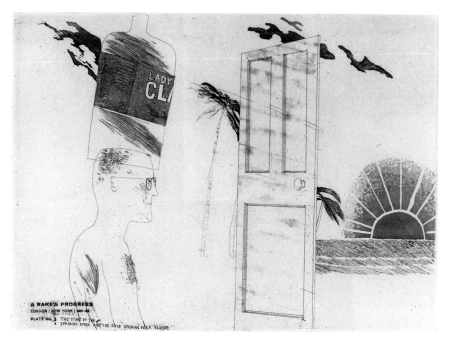

FIGURE 6.13 *David Hockney,* A Rake's Progress: "The Start of the Spending Spree and the Door Opening for a Blonde," *1961–63, etching and aquatint, 11 ¹⁵/₁₆ x 15 ⁷/₈ in. Yale Center for British Art, Paul Mellon Fund*

habit the sky. This top of the print is designated heaven, but it takes on the hellish color of red. The spiritual and the hedonistic merge, both in the singer's impassioned song and in the message "God is love" that is written on the ties of three figures in the foreground.

Lieberman's purchase also effected a personal transformation: "I got about two hundred dollars which was a lot of money for me, and I bought a suit, an American suit, and bleached my hair."[17] Hence *The Start of the Spending Spree and the Door Opening for a Blonde* (fig. 6.13). Hockney's alter ego stands before a door on the other side of which are the palm trees and the red sun of California. Even though at this point Hockney had not been to the West Coast, from Hollywood movies he imagines it to be the real America.

Balanced on the head of the artist is a bottle of Lady Clairol hair color, which he used to dye his hair blond. Simon Faulkner discusses how Hockney's bleached hair and stylish clothes helped catapult him into the London Sixties Swingers scene.[18] It certainly marked him as a

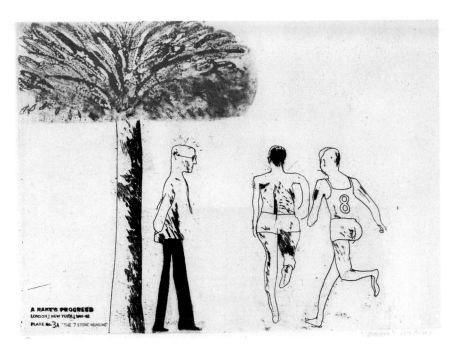

FIGURE 6.14 *David Hockney,* A Rake's Progress: "The 7-Stone Weakling," *1961–63, etching and aquatint, 11 ¹⁵/₁₆ x 15 ⁷/₈ in. Yale Center for British Art, Paul Mellon Fund*

Baudelairean dandy, a man who remakes himself as a work of art. By dyeing his hair, Hockney was literally applying color to his own body, painting himself. Like Baudelaire's hero of the "Painter of Modern Life," the Hockney figure in the *A Rake's Progress* is something of a flâneur: "For the perfect flâneur, for the passionate spectator, it is an immense joy to set up house in the heart of the multitude, amid the ebb and flow of movement, in the midst of the fugitive and the infinite. To be away from home and yet to feel oneself everywhere at home; to see the world, to be at the centre of the world, and yet to remain hidden from the world." Throughout the series Hockney's stand-in is depicted observing, from the wings, contemporary American culture as if detached from it. His task as an artist is to experience the various pleasures that America seemed to offer—nightclubs, sex, and drink. He becomes a rake, but unlike Hogarth's infamous hero, he always remains outside himself. He is, as Baudelaire writes, "an 'I' with an insatiable appetite for the 'non-I'."[19]

Hockney probably associated being blond with being American. Becoming a blond was the first step in the long process of Hockney becoming an expatriate in that very California setting that lies on the

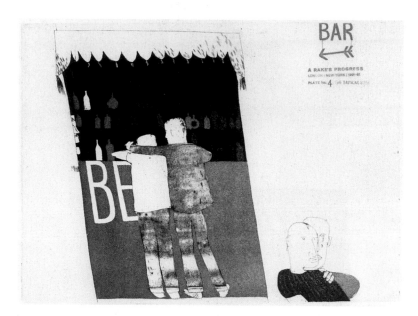

FIGURE 6.15 *David Hockney,* A Rake's Progress: "The Drinking Scene,"
*1961–63, etching and aquatint, 11 ¹⁵/₁₆ x 15 ⁷/₈ in. Yale Center for British Art,
Paul Mellon Fund*

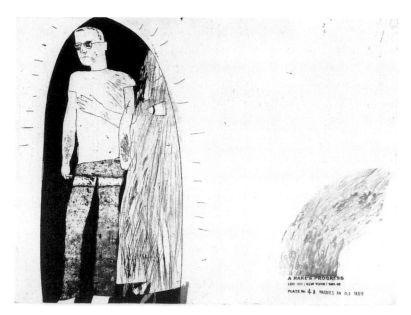

FIGURE 6.16 *David Hockney,* A Rake's Progress: "Marries an Old Maid,"
*1961–63, etching and aquatint, 11 ¹⁵/₁₆ x 15 ⁷/₈ in. Yale Center for British Art,
Paul Mellon Fund*

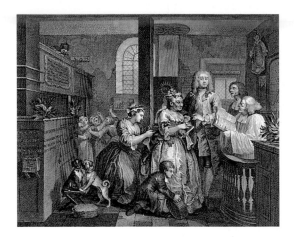

FIGURE 6.17 *William Hogarth,* The Rake's Progress: "He Marries," *1735, engraving, 14 x 16 in. Yale Center for British Art, Paul Mellon Collection*

other side of the doorway of *The Start of the Spending Spree and the Door Opens for a Blonde.* Nevertheless, dyeing his hair does not make Hockney into an American jock. In *The 7-Stone Weakling* (fig. 6.14) the artist looks longingly at two male runners in a park. He stands next to a palm tree. Its red leaves—rendered in a liquid aquatint—shoot out at the top like a geyser. The tree's burst of red leaves suggests Hockney's desire for the men who pass him by. There is still an enormous distance between the artist and the beautiful athletic males he admires.

 The Drinking Scene (fig. 6.15) takes place in a gay bar. Two men with their backs to us stand at a bar—one has his arm over the shoulder of the other. The mustached bartender's face peers out from a corner, somewhat sinisterly. Their bodies obscure a word that begins with the letters "BE," suggesting both "beer" and "be," the idea that in comparison to the repressive atmosphere of England, gay men could simply *be* in New York. Hockney remembers that "the life of the city was very stimulating, the gay bars—there weren't many in those days; it was a marvellously lively society. I was utterly thrilled by it, all the time I was excited by it. The fact that you could watch television at three in the morning, and go out and the bars would still be open. I thought it was marvellous."[20] Yet not everyone seems to be enjoying himself in the drinking scene. In the foreground a man appears to be crying, as he pulls a male companion to him. Are they about to break up? The unhappiness of couples is the subject of *Marries an Old Maid* (fig. 6.16), an image of the artist marrying, a replay of the story of Hogarth's rake, who casts his lot with an "old maid" in order to pay off his debts (fig. 6.17). In Hockney's print the move into a dark doorway with the obscured figure may be

less an allusion to Hogarth's theme of financial desperation than to the prevalence in the United States and England of using a wife as a veil, or "beard," to hide homosexuality. As if to express the frustration of the groom, red scratches have been applied to the right. In this way figures 6.15 and 6.16 suggest two sides of gay life in the early sixties: the bars filled with men seeking sexual companionship at night, and their closeted existence during the day.

The next three prints, *The Election Campaign (With Dark Message)* (fig. 6.18), *Viewing a Prison Scene* (fig. 6.19), and *Death in Harlem* (fig. 6.20), focus on the signs of racial and economic oppression in the United States. Hockney shows himself at an election, at a prison, and at a deathbed in Harlem. According to Peter Adam, the "dark message" is merely that the bars had to be closed on Election Day.[21] But it also refers to the empty rhetoric of political debate, suggested by the "etc. etc. etc. etc. etc. etc. etc. etc. etc. etc." that accompanies the politician's words entreating the electorate to vote. In the prison scene, we see a disembodied arm on the left cuffed to a headless jailer. Hockney watches, powerless to intervene, because his own arms and legs have been severed from his body. In the distance can be made out a prisoner. His number, "12345678," suggests an infinite series, as if everyone is in danger of being rounded up by the police. Hockney, now just a head on the right, looks away from the casket of *Death in Harlem,* as if he cannot bare to witness the funeral. The three prints taken as a group present the dark side of American life. Their bleakness contrasts with the earlier images that celebrate American freedom. The young Hockney, an adamant pacifist, was undoubtedly dismayed by the violence and prejudice of American life. He was shocked by the disparity between wealth and poverty: "New York was quite a different city then. Really much more elegant than it is now. . . . Yet in the Bowery there were people sleeping on the street. . . . Now you never saw that in England." Indeed, he credits the presence of so much private wealth and public squalor with giving him the idea of emulating Hogarth: "I saw this and I thought this is like eighteenth-century London. . . . It's Hogarthian."[22]

He soon discovers that in the United States financial success is illusory. In *The Wallet Begins to Empty* (fig. 6.21) the artist begins his descent down a staircase as his cash begins to run out. A woman, who recalls the gospel singer, and a man, who looks like Lincoln, stand at the top of the stairs, with the Washington Monument in the background. Like the archangel casting out Adam and Eve from Paradise, they point Hockney down the stairs. *Disintegration* (fig. 6.22) depicts Hockney staring at

FIGURE 6.18 *David Hockney, A Rake's Progress: "The Election Campaign (With Dark Message)," 1961–63, etching and aquatint, 11 ¹⁵/₁₆ x 15 ⅞ in. Yale Center for British Art, Paul Mellon Fund*

FIGURE 6.19 *David Hockney, A Rake's Progress: "Viewing a Prison Scene," 1961–63, etching and aquatint, 11 ¹⁵/₁₆ x 15 ⅞ in. Yale Center for British Art, Paul Mellon Fund*

FIGURE 6.20 *David Hockney, A Rake's Progress: "Death in Harlem," 1961–63, etching and aquatint, 11 ¹⁵/₁₆ x 15 ⅞ in. Yale Center for British Art, Paul Mellon Fund*

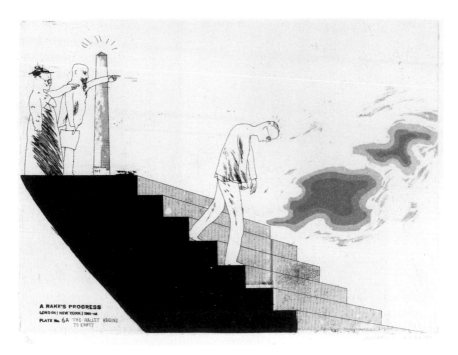

FIGURE 6.21 *David Hockney,* A Rake's Progress: "The Wallet Begins to Empty," *1961–63, etching and aquatint, 11 15/16 x 15 7/8 in. Yale Center for British Art, Paul Mellon Fund*

a billboard for Bellows Blended Whiskey showing a liquor glass super-imposed against a five-dollar sign. Out of his head comes a blotchy red balloon, and his nose has detached from his body. Is this the effect of too much alcohol on Hockney's brain, or is it because he cannot afford a drink? In the next print Hockney is *Cast Aside* (fig. 6.23): a giant hand throws Hockney into the mouth of a giant snake, symbol of lust and sin. Finally he tumbles down the stairs and out of the series in *Meeting the Other People* (fig. 6.24). If Hockey has fallen from Paradise, at least he seems to have tumbled into a young man. The odd potted plant at the foot of the stairs suggests that Hockney's precipitous decline should not be thought of in terms of the extremes of Hogarth's rake's madness. Rather he has fallen into the blandness of middle-class American life, where people are the creatures of mass media. The ultimate fall is anonymity and standardization. He is therefore nowhere to be found in the final print, *Bedlam* (fig. 6.25), unless he has joined the row of youths plugged into their radios like so many automatons awaiting their mas-ter's orders. Although the slogan on their T-shirts, "I Swing to WABC,"

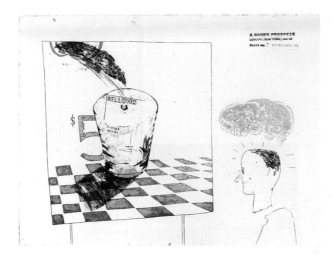

FIGURE 6.22 *David Hockney, A Rake's Progress: "Disintegration," 1961–63, etching and aquatint, 11 ¹⁵/₁₆ x 15 ⁷/₈ in. Yale Center for British Art, Paul Mellon Fund*

promises liberation, their cookie-cutter dress is an acerbic comment on the ultimate conformity and emptiness of American culture.

The art historian T. J. Clark has written on the difficulty of artists and art historians of his generation of the 1960s and 1970s to come to terms with Abstract Expressionism and to make this "moment of high achievement part of the past."[23] Perhaps Clark, along with Michael Fried and Rosalind Krauss, has so far been unable to, in Freudian terms, productively mourn the passing of Pollock and company or to resolve their ambivalent relationship to the legacy of Clement Greenberg. But I think for artists and critics of the 1980s and 1990s—my generation—Pop Art is the great problem, the great obsession. We are haunted not so much by art failures as by art successes. We are worried not by the causes of the collapse of the Popular Front in the thirties, or why so many Abstract Expressionists drank themselves to death, but by what to make of the ostentatious spectacle of artists' careers of the Pop and post-Pop periods. Even as we admire Pop Art's flaunting of conventions—its embracing of the popular, its camping and, in the case of Warhol and Hockney, its bringing into the art gallery and the museum blatant images of homosexuality—we may be embarrassed by its collusion with the establishment it mocks. The problem is that the subversive quality of so much of 1960s art—I am thinking of Warhol's practice as well as Hockney's—seemingly goes hand in hand with reveling in a network of wealth and power, the specter of "selling out." In this context, the theme of "A Rake's Progress" has particular significance. William Hogarth's original version was meant to serve as a warning to

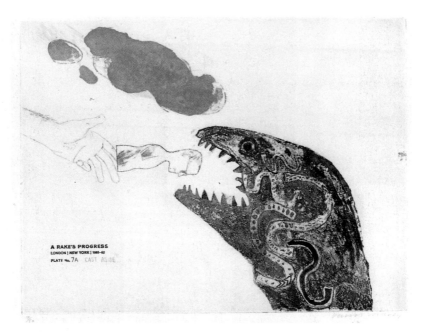

FIGURE 6.23 *David Hockney,* A Rake's Progress: "Cast Aside," *1961–63, etching and aquatint, 11 ¹⁵/₁₆ x 15 ⅞ in. Yale Center for British Art, Paul Mellon Fund*

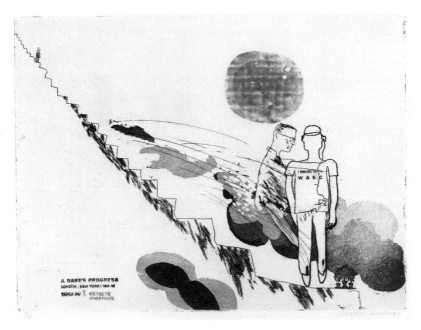

FIGURE 6.24 *David Hockney,* A Rake's Progress: "Meeting the Other People," *1961–63, etching and aquatint, 11 ¹⁵/₁₆ x 15 ⅞ in. Yale Center for British Art, Paul Mellon Fund*

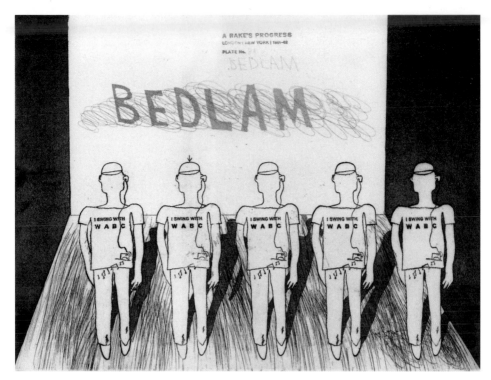

FIGURE 6.25 *David Hockney,* A Rake's Progress: "Bedlam," *1961–63, etching and aquatint, 11 ¹⁵/₁₆ x 15 ⁷/₈ in. Yale Center for British Art, Paul Mellon Fund*

the young that laziness and hedonism lead inevitably to poverty and even madness. The moral grounding of Hockney's retelling of the story is considerably less certain. Where Hogarth would have us avoid the rake's progress, Hockney sees it as a necessary adventure, the artist's rite of passage. It is as if Hockney were reading through the surface of Hogarth's moralizing. For although the rake ends badly, the energy and thrill of Hogarth's prints are expressed by the very revelry the series is supposed to denounce. In Hogarth's world evil is far more fascinating than good. Indeed, throughout the modern period artists have ignored Hogarth's warning and instead have explored the underworld as a source of subject matter and as a means to test the dominant cultural boundaries of behavior and standards of taste. Clandestine behavior of all varieties—homosexuality, prostitution, drug addiction, alcoholism—have been key subjects of the twentieth-century avant-garde. But the representation of transgressive behavior is not equivalent to abandoning a moral stance.

Although Hockney celebrates the sin of homosexuality as allowing for new possibilities of loving, he does not completely abandon Hogarth's lesson. Hockney's "A Rake's Progress" is particularly attuned to the sixties' obsession with idealism and the danger of moral decay. The so-called counterculture movement may have promised sexual liberation, but it still advocated an idealistic moral code. The commandment "Thou shall not sell out" is one of the great legacies of the 1960s. It is a commandment that, given the varied temptations of American culture, is almost impossible to obey. Hockney's *A Rake's Progress* can be read as a sixties allegory of the corruption of success.

Where Hogarth's rake is a scoundrel to begin with, Hockney's rake begins as a kind of innocent with angel wings. Cartoonish, with his big head, glasses, and puny body, he seems powerless before a seductive and corrupting culture. Paradoxically, the knowledge of the New York City gay subculture and the mechanism of artistic fame that he needs to become himself, to "be," are the very things that threaten his selfhood and cause his disintegration. The form of the prints, their mixture of crude drawing style and ultrasophisticated abstract composition, mirrors Hockney's ambivalence about the acquisition of artistic skill and therefore commercial success. In these prints Hockney seems to worry that progress, his coming to be as an artist and a person, might also be a kind of decline.

Is Hockney really a rake? Does he lose his moral stance with fame? His autobiography *David Hockney by David Hockney* includes two stories that point in different directions. In 1968 he was stopped by British Customs, which seized some male nudist magazines that he needed for his art. Hockney protested: "You've picked the wrong person this morning; I'm not just a little businessman who's not going to say a word. I'm going to fight you."[24] Hockney enlisted the help of the venerable art historian Kenneth Clark with the intention of pursuing the case in the English courts, no matter what the publicity. In the story we have the sense of an artist who not only represents homosexuality but is willing to enter the legal arena to defend the circulation of gay images. No gay liberationist, he is nevertheless tired of being oppressed and is willing to fight that oppression.

Unfortunately that Hockney was no "little businessman" also gave him the opportunity to become an oppressor. In 1965, the year his first New York show sold out, Hockney met a "ravishingly beautiful boy." He remembered that "it seemed unfair that I should meet him just as I had

FIGURE 6.26 *David Hockney,* Bob, "France," *1965, pencil and crayon, 19 x 22 ³/₄ in.*

to leave [for England]." And so Hockney paid for his ticket to cross the ocean with him, but he quickly tired of his company because, as he put it, "he was very dumb; really very dumb." "There is a drawing, called *Bob, "France"* (fig. 6.26), of a marvelous beautiful pink bottom, and that's all he had in his favor. . . . But he's dead now; he died later on."[25] Hockney reports that the youth became a go-go dancer and then overdosed on drugs. Despite Hockney's tone of regret, we sense an unconscious delight in being able to treat beautiful boys with the callousness previously reserved for female models. What is chilling about the story is the way Hockney seems not to share in any responsibility for the boy's decline. This is not surprising given the propensity at that time for letting things just happen. Warhol assumed the ultimate deadpan pose, unwilling or unable to intercede while most of his "superstars" disintegrated.

It is to Hockney's credit that contained within his pictures of beautiful boys lounging by pools or waking in expensive hotel rooms is a quality of emptiness. Yet we need to remember that a new honesty about homosexuality does not add up to new power structures and social relationships. Paul Melia has noticed the parallels between Hockney's images of nude men and Gauguin's pictures of Tahiti. Melia suggests that Hockney effectively "colonizes" Los Angeles as if it were "an outpost of Empire" and its beautiful male inhabitants were equivalent to Gauguin's Tahitian natives.[26] Is Hockney's repeated depiction of young men lying stomach down, their buttocks seemingly awaiting penetration, any different from the objectification of women's bodies that is a staple of the Western tradition? I feel Melia underestimates the ways homosexuality disturbs the typical male-female relationship by making the male both active subject and passive object of the gaze. Still, Hockney seems

less interested in rethinking the gendered dynamics of the exchange between the viewer and viewed than in extending the range of pleasures that are visible in the culture.

Part of the fantasy of *A Rake's Progress* had come true. Hockney became rich and famous. In fact the sale of the series gave Hockney the freedom to move to California. Hockney reports that he was offered the "staggering amount" of five thousand pounds for an edition of fifty, which was paid to him in installments. By 1971 his work and life were considered of sufficient interest that Jack Hazan and David Mingay suggested making a film based on Hockney's life. They were not interested in making a popular movie in the style of *Lust for Life,* in which famous actors portray artists. Nor did they want merely to interview Hockney or to have him demonstrate his technique for the camera, as Jackson Pollock had done for Hans Namuth. They called the traditional documentary process "opportunistic," because it used "the best bits of film that the filmmakers happen to hit when the cameras are running and put together after the event." Hazan and Mingay instead convinced Hockney and his friends to act out a story based loosely on their own lives. They not only "reconstructed" events for *A Bigger Splash,* they invented scenes, making use of "real" people who acted out "fantasies or hypotheses about the characters which were thought up by the director."[27] Hockney was never scripted, but his friends were.[28] For example, Peter Schlesinger, a young artist, simulates sex with a straight actor provided by the filmmakers. Later he was flown to California to film the scenes in which he swims naked in a pool.[29] Without knowing it, Hazan and Mingay were pioneers in the new hybrid of docudramas and reenactment so popular in Hollywood (I think of Joan Rivers starring in the story of her husband's suicide in a television film, or of Howard Stern playing himself in *Private Parts*).

Long before postmodernism declared identity to be a masquerade, *A Bigger Splash* had Hockney perform himself. Hazan and Mingay claimed that this always happens in documentaries. Certainly, Pollock was performing when he dripped for Namuth. A particularly staged moment in the Pollock film occurs when the camera is placed under a piece of glass as the artist hurls paint onto its surface. In this way we become the surface of Pollock's canvas. Namuth wanted us to feel privy to a highly private activity, but given the location of the camera just under his dripping brush, Pollock had to be aware of the filming all the time.

Whether or not Pollock is faking for the camera in Namuth's docu-

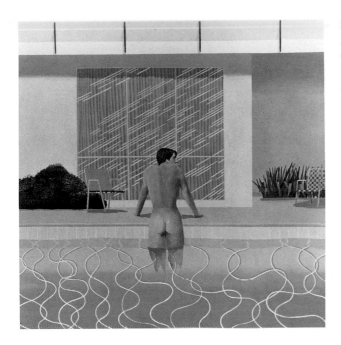

FIGURE 6.27 *David Hockney,* Peter Getting Out of Nick's Pool, *1966, acrylic on canvas, 84 x 84 in. Walker Art Gallery, Liverpool*

mentary, the activity of painting is the film's main subject. It tells us little about Pollock's private life. The opposite is true of *A Bigger Splash.* Although there are moments when Hockney paints or photographs, much of the film concentrates on his relationship with Peter Schlesinger. Hockney's difficulty in completing a portrait of Peter, entitled *Portrait of an Artist,* parallels his breakup with the artist. The movie includes several scenes of Schlesinger nude, including one in which he has sex with another man. It also includes routine scenes of day-to-day life. For example, we watch Hockney take a shower. The filmmakers particularly delight in re-creating actual paintings. In a memorable sequence, Schlesinger rises out of the pool as if *Peter Getting out of Nick's Pool* (fig. 6.27) has come to life. Peter walks from the pool into a re-creation of Hockney's *Beverly Hills Housewife,* where the owner is improbably dusting her stuffed stag head.

The effect of these tableaux vivants is to undermine the aesthetic distance between a painting and what it depicts. When the film was released, Hockney was disturbed by it because of distortions of fact and because it forced him to revisit a painful period in his life.[30] But perhaps also disturbing to him was the film's confusion of painting with reality, which undermined Hockney's careful attempt to balance depiction with abstraction. Alan Woods writes: "Hockney's early work

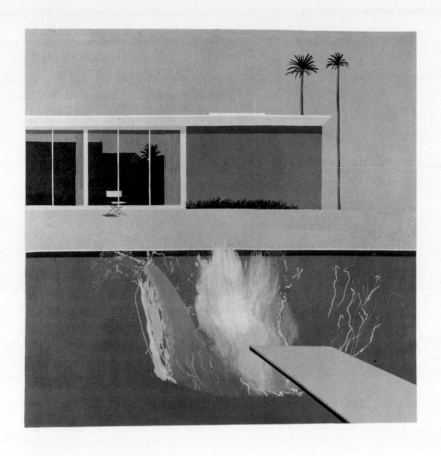

FIGURE 6.28 *David Hockney,* A Bigger Splash, *1967, acrylic on canvas, 96 x 96 in. Tate Gallery, London*

involves a whole range of formal and rhetorical devices which insist that we are first and foremost looking at pictures of the world and not at the world itself." Yet, as Woods continues, "To consider the distance between images and the world is also to confirm and examine a connection, to acknowledge the necessity for painting of a world outside and around the practice of painting."[31] But the film's subtle message was that this distinction between the depicted world and the real world had been muddied as Hockney's style became increasingly more dependent on photography and photographic ways of seeing.

Perhaps the most scandalous moment in *A Bigger Splash* is not the

scene when two naked men kiss and rub against each other but the recording of Hockney projecting a photograph onto a canvas in order to complete *Portrait of an Artist.* Instead of Namuth's heroic Pollock, who is pure expression, pure imagination, we are given the Pop artist, dependent on snapshots and mechanical means for his inspiration. Promiscuity in *A Bigger Splash* is not so much a matter of Peter cheating on David, or three boys having sex in a pool, but of the weird confusion of real and unreal, photography and painting, film and life. Although Hockney does paint and draw pictures in the movie, the great moment in which he finishes *Portrait of an Artist* looks fake. He takes brush to canvas, but very little paint seems to go on the picture: instead of lip-synching, it's pretty much brush-synching.

The film's title, *A Bigger Splash,* was of course taken from Hockney's own 1967 painting (fig. 6.28). Given the central role of the painting *Portrait of an Artist* in the film's "story," it seems an odd choice. Yet the title works on many levels. The film devotes many scenes to attractive young men diving into pools, literally making big splashes. But the title also suggests ambition, and *A Bigger Splash* has been seen as one of the key paintings of Hockney's career. The format of the painting *A Bigger Splash* is a square, divided into simple horizontal bands of the swimming pool, house, and sky. The diving board juts out from the corner, creating the only major diagonal in the picture. The irregular lines of the splash itself break the stark geometric configuration of the picture. This contrast of forms—the tracery of water against the hard edges of architecture—is like the abrupt sound of a figure hitting still water in an otherwise quiet day.

According to Hockney, the title was a means to differentiate the picture from two earlier splash paintings, *The Little Splash* and *The Splash.* But I think he had much more in mind. He commented on the picture's relationship to figuration and abstraction. On one level, the painting "could be considered figurative in the sense that there was a figure who's just gone under the water. . . . But if you take away the chair, for instance, and the reflection in the glass, it becomes much more abstract." In fact, the picture began as a color-field painting made up of stark bands: "It was just about a striped painting" upon which Hockney painted buildings and the splash itself.[32] If Hockney was knowingly making use of contemporary color-field painting, he was also responding to an earlier generation of Abstract Expressionists. Above all, I think he had in mind Pollock, whose works could be said to be made up of big splashes of paint.

Pollock believed that he had veiled the figure, as if under the skin of drips was a human body. In contrast, Hockney applied the traces of figuration on top of abstract elements. The hope was not to embed figuration in abstraction but to disengage it from the allover field, to pull it out of the water. The poignancy of Hockney's *A Bigger Splash* is that the figure is not fully there. It is suggested only by the splash it leaves behind. Like the leopard in *Picture Emphasizing Stillness* that cannot move because it is only a depiction, the figure will never emerge out of the blue rectangle.

Kenneth Silver ties *A Bigger Splash* to Brueghel's *The Fall of Icarus*, another work in which the key subject disappears under the water. But Icarus does not dive; he falls. His story is the ultimate tale of failed ambition, of being brought down for flying too close to the sun. Hockney's *A Bigger Splash* is also about failure, or at least diminished aspirations. Even as Hockney uses satire to assert his superiority over contemporary abstract painters, he suggests how limited the field of painting has become. Silver writes of *A Bigger Splash*, and of Hockney's California paintings in general, that they capture "an ideal world of classic calm and order that, in a typically American way, is at once attainable, banal, and tremendously alluring."[33] Hockney makes his mark, or "splash," by painting the pools and lawns of the owners of expensive modern art, the very people who own paintings by the Abstract Expressionists. Yet even as he undermines the pretensions of an avant-garde that thought it could transcend its bourgeois patronage, he does not find for himself an alternative means of transcendence. His vision remains banal, even if, as Silver says, it is alluring. There is something always slightly tawdry in Hockney's vision of elegant pools and glass houses. Their unreality has less the feel of modern arcadias in the mode of Matisse or Picasso and more the quality of glossy layouts in *Architectural Digest* and *House and Garden*. Of course, Hockney, like many of his Pop contemporaries, makes no pretenses of his art being resistant to such contexts.

In the film *A Bigger Splash*, Henry Geldzahler was "cast" as a worldly figure who lures Hockney away from more stable surroundings in London, telling him that in New York he can paint and nightclub. Hazan and Mingay see Geldzahler, the curator of twentieth-century art at the Metropolitan Museum and Hockney's best friend, as something of a devil, given to picking up young boys and distracting Hockney from his real work. Hockney saw Geldzahler in more maternal terms. Hockney wrote that in order to get right the one-point perspective of the painting

Henry Geldzahler and Christopher Scott (fig. 6.29), "To draw the floor I laid tapes from the vanishing point, which is about two inches above Henry's head, to the bottom of the canvas. At one point in the work there were twenty or thirty tapes radiating from his head. . . . It looked like an incredible radiant glow from a halo round his head, with an angel in a raincoat visiting him."[34] But if *Henry Geldzahler and Christopher Scott* is an annunciation, with Henry the Virgin Mary and his lover Christopher the Angel Gabriel, what is being announced? The birth of a new Christ, that is, the coming into being of the mature artist, Hockney himself.

Significantly, Geldzahler appears again in a key painting in which Hockney attempts to establish his relationship to the Old Masters, *Looking at Pictures on a Screen* (fig. 6.30). There is a conscious seriousness to this work, a new sense of Hockney's ambitions. By 1977, when the painting was finished, Hockney had achieved enormous financial success and fame. Only forty years old, he had already been honored by a retrospective at the Whitechapel Art Gallery in London, and the Musée des Arts Décoratifs in Paris. Yet by his own admission, he felt dissatisfied with the direction of his work. He also felt "quite removed" from contemporary art, and from conceptual art in particular, which was the prevailing movement in New York at that time. He wrote, "That period— 1973—was very disturbing for me; I had been struggling with paintings, like the one of *George Lawson and Wayne Sleep,* which I eventually abandoned. There was something wrong in what I was doing, which I have . . . described as the trap of naturalism."[35] One solution was to experiment in different mediums. In the 1970s Hockney begin to work extensively in photography and set design (fittingly, his first major opera production was Stravinsky's *The Rake's Progress*). He spent considerable time in Paris, perhaps seeking sanctuary in the old center of modernism. He writes about spending long hours in Brancuşi's studio or of repeatedly visiting the Musée d'Art Moderne. His pictures increasingly focus on the process of picture making, as his subject matter decreasingly deals with the erotics of the male figure.

Looking at Pictures on a Screen encapsulates Hockney's change of direction in the 1970s. It is a transitional work to the degree that it is in a highly naturalist mode. That naturalism, however, does not describe spaces of pop consumerism or the elegant rich. Instead we are in the artist's own studio. Geldzahler is taken out of the earlier context of a gay marriage or travel companion and is given his professional role as tastemaker and art historian. He gazes at Hockney's choices from London's National Gallery, which, through the medium of reproduction,

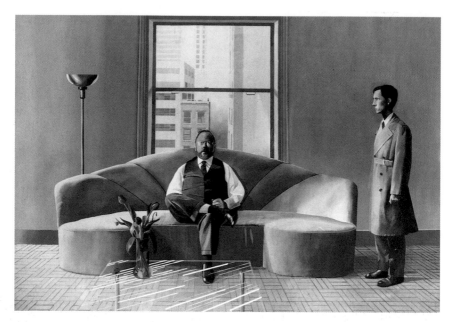

FIGURE 6.29 *David Hockney,* Henry Geldzahler and Christopher Scott, *1969, acrylic on canvas, 84 x 120 in.*

are no longer in the museum but in Hockney's studio.[36] Hockney's choices are hardly inspired. They are all canonical. He is emphatically insisting on the great masters and linking his own painting to this revered tradition. On another level, the picture is a witty comment on the way art historians look at pictures, that is, usually in reproduction or as slides projected onto a screen. But where most artists decry this reliance on reproduction, Hockney felt it heightened the power of the work of art. It is at this time that Hockney became obsessed with commercial reproduction, looking for ways of producing works of art that are geared to new mediums like the copy and fax machine.

Yet even as *Looking at Pictures on a Screen* attempts to raise the prestige of Hockney's art by equating his work with that of the great masters, the picture has the opposite effect on that tradition itself. In comparison to the splendor of Geldzahler in elegant clothing and the bright colors of the studio, the pictures on the screen look rather insubstantial. There is a curious move away from the painting's ostensible subject, looking at pictures, to the idea of sensibility and style. The painting seems to say that the self is defined by taste, the pictures and objects one likes. Like postcards pinned to a bulletin board, these things are interchangeable. When you are bored with the selection, you purchase new ones. Iden-

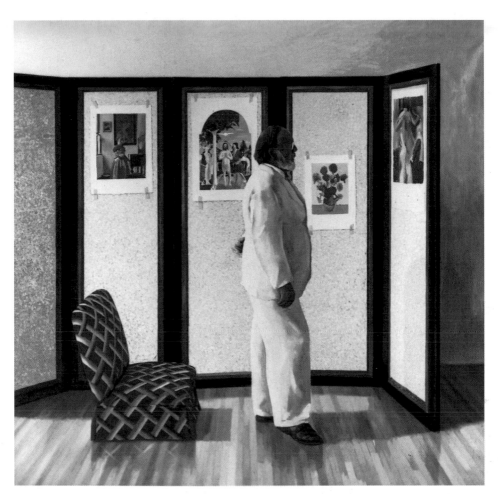

FIGURE 6.30 *David Hockney,* Looking at Pictures on a Screen*, 1977, oil on canvas, 74 x 74 in.*

tity is a matter not of inner states but of consumerism and the glossy surface of the reproduction.

However, I don't think this is the intended message of *Looking at Pictures on a Screen*. Rather, Hockney is insisting on his seriousness by placing his so-called art of depiction in its proper history. The diverse works that have followed this painting have focused on important problems of space that are part of the great tradition of painting. Paradoxically, this concern with weighty questions of perspective, reproduction, and abstraction has meant retreating to some extent from two qualities that made his work seem so original and interesting to some—its frank

depiction of homosexual life and its elegant illusionism. Hockney's second book of memoirs is called *That's the Way I See It.* Whereas his first book, *David Hockney by David Hockney,* emphasized the role of the self in his work, with numerous personal anecdotes, the later book puts far more stress on Hockney's viewpoint and the meaning of his work. Hockney believes that in his abstractions and his photo-collages he has taken up Picasso's Cubist exploration of space and that he is approaching a new concept of subjective perspective. Arguably, this cerebral exploration does not chasten Hockney's pictures; rather it channels the erotic into his desire for the practice of his chosen master, Picasso. After all, it was Picasso's Classic Period of the 1920s that had inspired Hockney's naturalist contour pen-and-ink drawings of male nudes that were a staple of his art in the 1960s. But now Picasso was influencing his move away from such meticulous depictions of reality.

Hockney's obsession with Picasso is confronted directly in his *Artist and Model* (fig. 6.31) of 1974. *Artist and Model* is a recasting of Picasso's *Painter with a Model Knitting* (which I discussed in Chapter 2 in relationship to Pollock's work), Picasso here taking the role of the painter, and the naked Hockney the role of his female subject. But it is Picasso who is the real model; it is Picasso who is the source to be learned from.

In exposing his body to Picasso's gaze, Hockney fantasizes about becoming Picasso's lover while drawing attention to the erotic component built into the teacher-student relationship. The art historian Gert Schiff refers to the "Socratic Eros implied in Hockney's depiction of his discipleship." Yet Schiff also suggests that Hockney's nudity is a kind of return to "prelapsarian innocence" so that he can take in Picasso's influence "unencumbered by the trammels of (pictorial) convention, a pure receptacle for the spirit of Picasso, his 'model.'"[37] But surely Hockney's nudity is no sign of grace. It is the message of *A Rake's Progress* that innocence, at least for the modern artists, is not sustainable. Everything about Hockney's witty reinterpretation of Picasso suggests a knowing (even too knowing) sophistication. There can be no question of forgetting conventions and beginning afresh. Nor can Hockney simply become Picasso reincarnated. It may be Hockney's fantasy to seduce his imagined master so that artist and model become one. But the picture itself negates this desire in its oddly stiff poses. The picture seems more a face-off than a friendly meeting between two intimates.

Surprisingly, given Hockney's adoration for Picasso and his obsession with Cubism, several of Hockney's most ambitious paintings of the last decade seem as much about Matisse's color as about Picasso's space.

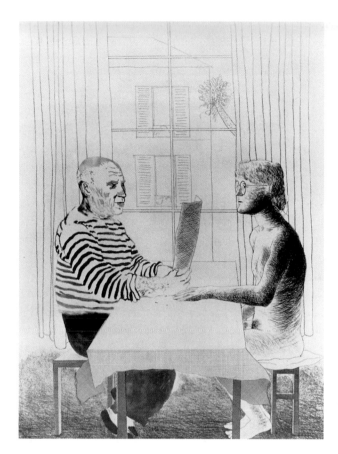

FIGURE 6.31 *David Hockney, Artist and Model, 1974, etching, 32 x 24 in.*

Perhaps like Tintoretto, who was said to wed the color of Titian with the drawing of Michelangelo, Hockney's ambition is to marry Matisse and Picasso (this would surely have been the gay marriage of the century). Formal influences aside, what is striking about Hockney's late style is its frequent abstractness. The geometric forms of his "Very New Paintings," as in *The Seventeenth V.N. Painting* (fig. 6.32) do not obviously refer to any real space. He thinks of them as "inner landscapes." Some of them have numbers like the typical color-field paintings of the sixties that Hockney use to satirize. In such paintings the Rake seems to have found his way out of Bedlam by embracing the very abstraction he once sought to escape. Hockney is no longer interested in insisting on the way a style of illusion or "depiction" might also be capable of demonstrating the essential nature of painting. Indeed, he shares Picasso's belief that there is no difference between depiction and abstraction. Nor

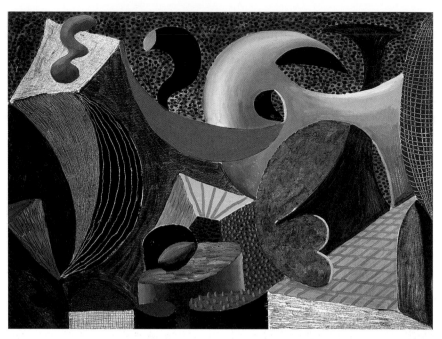

FIGURE 6.32 *David Hockney,* The Seventeenth V.N. Painting, *1992, oil on canvas, 36 x 48 in.*

does he find it necessary to, as he put it when he was younger, "propagandize" homosexuality. In these paintings he does not renounce pleasure. Their intense colors are deeply hedonistic, but such hedonism is not tied to a particular sexual identity or politics. That is not to say that the pictures have somehow become closeted or that abstraction itself is somehow a heterosexual language. Hockney's paintings continue to respond to his own domestic surroundings—the courtyard and interior of his home—and the surrounding landscape. In this way they always reflect the vision of a gay man. The very absence of the figure may have an important content in terms of what it means to be a homosexual in the age of AIDS. By leaving out the naked boys of earlier work, Hockney may be coming to terms with his increasing isolation owing not only to his increasing deafness but also to the loss of so many close friends to AIDS and other illnesses.

If we think of the first half of Hockney's career as a rake's progress, perhaps the second half should be thought of in terms of the prodigal son. If Hockney had not literally abandoned his parents' England (he continued to spend long periods of time in London throughout his

FIGURE 6.33 *David Hockney,* Garrowby Hill, *1998, oil on canvas, 60 x 76 in.*

career), his art was identified with his adopted home base of Los Angeles and its supposed hedonism. Hockney had never painted pictures of England that were equivalent to his views of California. In 1997, at the behest of a terminally ill friend, Jonathan Silver, Hockney returned to his native Yorkshire. There he created a series of panoramic landscapes that he exhibited under the title "Local Views by a Local Artist for a Local Lad." To my eye the most beautiful of these works is *Garrowby Hill* (fig. 6.33), in which a snakelike road swirls down into a valley of farms. Like *A Bigger Splash,* the geometric patterns of the landscape refer to abstract painting, in this case the *Ocean Park* series of Hockney's fellow Californian Richard Diebenkorn. Indeed, the lavenders, golds, and oranges of *Garrowby Hill* have more to do with bright California light than with the wet atmosphere of Yorkshire.

Where Hockney's paintings of the 1960s, like *A Bigger Splash,* conveyed the superficiality of modern life in the flatness of their planar configuration, *Garrowby Hill* is about depth. Its planes are literally the plains of a bountiful earth. The land replaces the swimming pool. The impending death of Silver, who died before the picture was exhibited,

made Hockney think about his own mortality. And so the picture's most important source is not abstract painting but van Gogh's final pictures of wheat fields in which perspective and the horizon stand for the infinite.

Hockney's trip to England was only a visit; he returned to the United States. As if to insist on his right to represent his adopted country, he exhibited some of the Yorkshire paintings next to multipaneled pictures of the Grand Canyon at the Museum of Fine Arts in Boston in 1998. But if these pictures of the national park are about painting the Great American Landscape, they are also about vertigo, the dizziness of a frighteningly vast space. One of the most difficult effects for an artist to create is a sense of looking down. Because of the nature of one-point perspective, the eye must first travel up the foreground in order to suggest the sensation of looking down at the center. By twisting perspectives in both his panoramas and the "Very New Paintings," Hockney makes the eye travel throughout the pictures so that the experience of looking becomes intensely physical. But there is also a personal meaning to this sensation of visual movement and spatial dislocation. It suggests Hockney's status as an expatriate who is never fully at home in either the United States or England.

I believe the last twenty years of Hockney's career have been devoted to proving that he is not a rake after all, and for all his financial success he has not sold out. The tradition of modernist painting has become a sanctuary of integrity for him. Unfortunately, the formal and thematic ambitions of Hockney's late style have not resonated with the New York art world. Perhaps there is nostalgia for his earlier pictures of naked boys sleeping, showering, or swimming. Or maybe Hockney's formal exploration of vision and space in painting is redundant in the age of simulacra and mass media. After all, his own images of suburban sprinklers and swimming pools had contributed to the Pop undermining of the authority of modernist painting. Some have viewed Hockney's progress out of the bedlam of American consumerism into the embrace of Picasso and the tradition of modernism as a mere retreat. In a weird postmodernist transmutation of values, it is not Hockney the rake but Hockney the high modernist who seems decadent.

Collaborations

7 Famous Artists
Agee and Evans,
Caldwell and Bourke-White

Above all else: in God's name don't think of it as Art.
—James Agee

Artists combine forces for a variety of reasons: to share ideas, to combine diverse mediums, and to promote their careers. Sometimes collaborations come about in response to moments of crisis. For many artists in the 1930s, the widespread unemployment and poverty of the time created reactions that challenged the abilities of a single author. James Agee and Walker Evans's *Let Us Now Praise Famous Men* and Erskine Caldwell and Margaret Bourke-White's *You Have Seen Their Faces* were collaborations born of the desire to document suffering. Through the combination of photographs and text, they wanted to show the human costs of an exploitative system in which the tenant farmers of the South were driven into debt, having to turn over virtually their entire crop to the landowners. But artist collaborations are, by their very nature, fragile and hard to maintain. Caldwell and Bourke-White almost split up in Arkansas after traveling in the South for less than a week. And Evans and Agee almost abandoned *Let Us Now Praise Famous Men* when Agee could not find a way to turn their vivid experiences of three Alabama tenant families into prose.

Let Us Now Praise Famous Men was originally planned as an article for *Fortune* magazine. As Agee put it, the photographer and the writer went to the "middle south" in the summer of 1936 to produce

> an article on cotton tenantry in the United States, in the form of a photographic and verbal record of the daily living and environment of an average white family of tenant farmers. . . .

We found no one family through which the whole of tenantry in that country could be justly represented, but decided that through three we had come to know, our job might with qualified adequacy be done. With the most nearly representative of the three we lived a little less than four weeks, seeing them and the others intimately and constantly. At the end of August, long before we were willing to, we returned into the north and got our work ready.[1]

The families that Agee and Evans chose—the Burroughses, the Tengles, and the Fieldses (in the book they are called Gudger, Ricketts, and Woods to protect their privacy)—were destitute even by the standards of Alabama sharecroppers.[2]

Agee found that he could not write about the deeply private experience of the poor families they lived among as an article for a business magazine. He almost concluded that he could not write about it at all. Indeed, it took him five years of writing, with numerous false starts, hysterical outbreaks, destruction of sections, and the nurturing support of Walker Evans, to get the manuscript into print. When *Let Us Now Praise Famous Men* finally came out, in 1941, it was not particularly well received or understood, in part because of poor timing. The entrance of the United States into World War II and the end of the Depression had replaced the issue of poverty as a central concern in the media; in the first year the book sold hardly six hundred copies. Only when it was republished in the 1960s did it become a big seller and a so-called classic of documentary art.[3] But part of the initial commercial failure had to do with the book's peculiar format, its fragmentary quality, and its modernist suspicion of journalism and illustration.

Margaret Olin writes of James Agee and Walker Evans's *Let Us Now Praise Famous Men* that its union of "two modernist discursive modes: one 'documentary' . . . the other 'artistic' . . . resembles a marriage whose dynamics puzzle, and even disturb, the outsider."[4] Much the same could be said of the relationship of Agee and Evans that spawned the book: their mutual dependence and competitiveness sometimes seems like a marriage in which each partner both needs the other and fears that need. At other times it reminds me of sibling rivalry, or even the relationship of a parent and child. Olin's interest is in what Evans's photographs and Agee's words do to their subjects. She turns to the question of looking back to the viewers. Her goal is to interrogate the collaboration of viewer and viewed, public and private, a process set in motion by Agee and Evans but by no means unique to their practice.

Olin is concerned with "gazes" and what she calls the "privilege of perception," which she finds intrinsic to modernist documentary photography in general. Instead I am interested in what two artists *do to each other* in order to make a single work of art. What were the dynamics that produced the odd hybrid of a book made up of words and photographs created by two talented individuals?

In focusing on the dynamics of collaboration, I am following the lead of Wayne Koestenbaum. Male-male authorship, what Koestenbaum calls "double talk," is both competition and collaboration. Even as it approaches "metaphorical sexual intercourse," it is always denying intimacy. Two artists come together to fulfill some need, "a longing for replenishment and union that invites baroquely sexual interpretation," but that coming together is anxious in its homoeroticism and the mutual loss of autonomy: "Collaborators express homoeroticism and they strive to conceal it."[5] Koestenbaum wishes to establish the "male collaborative text" as a "generic category." I am not sure that the anxious dynamics he finds in such working relationships as Freud and Breuer's, or Pound and Eliot's, hold true for all male-male collaborations, yet his description seems tailor-made to describe the partnership between Agee and Evans.

In many ways *Let Us Now Praise Famous Men* is a collaboration that does not appear to be collaborative at all. Instead of bringing text and writing together in a way that the reader might expect—so that the photographs might seem to illustrate the writing, or the writing might seem to explain the photographs—Agee and Evans decided to keep text and image completely separate. The book is introduced by a series of photographs, without captions or page numbers. As if it were a play, Agee's text is prefaced by a list of "persons and places" that it is not keyed to the photographs. The very of act of reading the book is awkward. Should we concentrate on the writing, or look at the photographs, or flip back and forth trying to find a relationship between the two?

The two artists were envious of one another's medium. Before Evans became a photographer he seriously considered becoming a writer. And in *Let Us Now Praise Famous Men*, Agee insists that he wanted his writing to be like photography: "If I could do it, I'd do no writing at all here. It would be photographs; the rest would be fragments of cloth, bits of cotton, lumps of earth, records of speech, pieces of wood and iron, phials of odors, plates of food and of excrement."[6] Large sections of the book take the form of elaborate lists of objects in the various rooms of the tenant farmers' houses. And he constantly evokes the ap-

paratus of the camera to heighten his descriptions: "The silence of the brightness of this middle morning is increased upon me moment by moment and upon this house, and upon this house the whole of heaven is drawn into one lens; and this house itself, in each of its objects, it, too, is one lens."[7] The tenant farmer's house has itself become a camera, as if the photographic apparatus were the ultimate means of intensifying experience. But the lens is also Agee's eye, or to put it another way, Agee longs to see photographically. At the same time, we must remember that Agee wrote these passages long after the fact, and under the spell of Evans's photographs. Even if Agee is not actually describing Evans's photographs, he wants his long descriptions to approach in accuracy and minutia the technique of Evans's "straight" photography, for which he tended to use a large-format camera, even lighting, and long exposures to achieve optimum clarity.

Agee's attempt to write like the camera involves more than providing the reader with a catalogue of things seen. For him the photograph yields an unmediated projection of the real. He deems looking at photographs a profoundly sensory experience, one that involves seeing before thinking. If Agee is to make writing approach the condition of the image, he has to disrupt its narrative flow, its seeming constructedness. He is always busy disrupting the arrangement of his prose to break the linearity of reading a book from cover to cover. In the preface he instructs "serious readers" to "proceed to the book-proper after finishing the first section of the Preface. A later return will do no harm."[8] We are to listen to his words, and not listen to his words. Yet he tells us that he "intended also that the text be read continuously, as music is listened to or a film watched." How can one read a nearly five-hundred-page book continuously, particularly when its subject is so disturbing and its prose so densely packed with long descriptions?

Agee insists that the text is not so much meant to be read as heard, or rather that it was written "with reading aloud in mind." If Evans's photographs are for the eye, Agee's words are for the ear: the physical sensation, he believes, should take precedence over the process of interpretation and understanding. But then he immediately writes, "That cannot be recommended" and so "variations of tone, pace, shape, and dynamics are here particularly unavailable to the eye alone, and with their loss, a good deal of meaning escapes."[9] "Meaning" has escaped even before the book has begun. Agee wants us close to him, to feel his experience, even as he tells us that experience is already, inevitably, lost. Just as Agee attempts to make his prose photographic, Evans's pho-

tographs, in a sense, approach the condition of writing. The idea that images are experienced instantaneously is fictive. We scan all images for information. It is argued that we read them. We have come to mistrust Agee's idealized conception of Evans's craft as an unmediated presentation of the truth. In fact, James C. Curtis and Sheila Grannen have demonstrated that Evans moved furniture and objects around to produce his carefully composed and elegantly Spartan photographs of the tenant farmers' homes.[10] But even if we agree that looking at a photograph is fundamentally different from reading a text, and if we acknowledge Evans's desire to produce pictures that seem free of the bias that is embedded in written statements, Evans's assembling of his photographs in a progression yields a narrative. Although they by no means tell a consistently linear story, the photographs begin with people, then move on to their possessions and their environment. In an orderly fashion, Evans focuses first on the family and house of the Burroughses, then of the Fieldses, and finally of the Tengles.

There is a suggestion that the tenant families' lives are bounded by the ruthless power of capital, represented in the opening image of the landowner (fig. 7.1), and by the local government's acquiescence to that power, as represented in the final image of the pathetic mayor's office (fig. 7.2). The picture of the landowner is testament to Evans's subtlety. There is nothing in the image that shouts out his corruption. His expression is flat—he doesn't quite smile. More telling is the relative luxury of his somewhat rumpled sports jacket, seersucker pants, laundered shirt, and tie. His jacket curves out at the stomach indicating that the landowner is well fed. We know from the negative that Evans cropped the picture for publication so that the man fills the frame, effectively increasing the landowner's quality of control and emphasizing his paunch. His corpulent body is far more representative of power than the tiny two-story building that serves as city hall. The puddles of water in the foreground and the collapsing buildings in the background suggest the inability of Moundville, Alabama, to conjure up a sense of community. Yet on the second floor one can make out bars on the windows: the mayor's office was probably also the town jail. No matter how ineffective the civic spirit, the penal system still operates if a farmer gets drunk or gets so desperate that he is forced to steal.

A literary urge in the ordering of the photographs is much more pronounced in the later edition of *Let Us Now Praise Famous Men*, which has far more photographs. Not enough has been made of Evans's transformation of *Let Us Now Praise Famous Men* for the 1960 edition. In

FIGURE 7.1 *Walker Evans,* Landlord, *1936, Courtesy of the Library of Congress*

FIGURE 7.2 *Walker Evans,* Mayor's Office, Moundville, Alabama, *1936, Courtesy of the Library of Congress*

analyses of the biographies, Evans has been portrayed as the acquiescent and modest partner in the collaboration. The simple clarity and sparseness of his photographs, which have no captions, play against the excessiveness of Agee's prose. If there is anxiety about the dynamics of the pairing, it seems to be all in the text. But after Agee's death, Evans not only doubled the number of photographs for the new edition but removed a few images that had been in the original and reordered the reassembled group. He also added his own introduction, thus effectively breaking the silence of his photographs.

Adding photographs, though providing us many more memorable images to ponder, does not improve the book. The original thirty-one were both numerous enough to convey the richness of the subject and few enough to be fixed in our minds. Agee himself noted that "the photographs are not illustrative. They, and the text, are coequal, mutually independent, and fully collaborative."[11] But doesn't adding more photographs disrupt this balance?

In the original, Evans introduced only one break in the sequence. In general the group is more cohesive and direct. The later edition is broken into four sequences. The landowner is still at the beginning, but there are more images of the three families. As Alan Trachtenberg has pointed out to me, the move in the first section (the Burroughses) from the father and mother to the bed and then to their children is carefully orchestrated to suggest Agee's theme of the erotics of the family. From part three to part four a cinematic transition takes place in which a family driving to town is followed by images of the town itself (they are actually pictures of many different southern towns). In general the later edition brings to the mix more images of work as well as images of African Americans relaxing in front of storefronts. The final picture, that of a newly covered grave, perhaps of a child (fig. 7.3), ends the photographic cycle with an image of mortality and protest.[12] If it is a premature death, it is no doubt due to the horrendous conditions of tenant farming that is the book's theme. It corresponds to Agee's concluding description of a graveyard. Agee's description of the grave of a little girl leads to a reverie on separation from the beloved families he has described and to the hope of a final reunion in death: "It is not likely for her; it is not likely for any of you, my beloved, whose poor lives I have already so betrayed, and should you see these things so astounded, so destroyed, I dread to dare that I shall ever look into your dear eyes again: and soon, quite soon now, in two years, in five, in forty, it will all be over, and one by one we shall all be drawn into the planet beside one another."[13]

FIGURE 7.3 *Walker Evans, A Child's Grave, 1936, Courtesy of the Library of Congress*

Concluding the later edition with a photograph of a grave is an example of Evans's concerted effort to include pictures that correspond to Agee's text. For example, Agee writes at length about clothing, including shoes, which are among the family's most valued possessions. And so Evans includes a photograph of shoes (fig. 7.4), which brings to mind van Gogh's famous paintings of the same subject.

But even if we welcome the additional photographs that are so wonderful on their own terms, Evans's written introduction is disruptive of the purpose of the original collaboration. After all, Evans was supposed to photograph, and Agee was supposed to write. Agee himself had asked us to ignore his own opening words. Evans's essay, short as it is, puts another buffer between the photographs and Agee's text, even as it sets the whole project into a comfortable past. And so Agee appears first not in his own words but as Evans remembers him. The 1988 edition further disrupts the original collaboration by providing yet another preface by John Hershey. The convention of the biographical essay sadly normalizes the entire production.

We see in the form, or forms, of the collaboration of Agee and Evans a coming together: each artist wants his work to approach the condition of the other; and a breaking apart: the artists keep their mediums separate. Agee describes scenes that mirror this quality of closeness and distance. He constantly reminds us of his desire for physical contact with his subjects, but that desire is always frustrated. He tells us early on of an embarrassing episode in which he managed to frighten a black couple by running after them to inquire about getting a key to a locked-up church that Evans wanted to photograph. Agee had forgotten what it meant for a white man to run after blacks in the south: "The least I could have done was to throw myself flat on my face and embrace and kiss their feet. That impulse took hold of me so powerfully, from my whole body, not by thought, that I caught myself from doing it exactly and as scarcely as you snatch yourself from jumping from a sheer height: here, with the realization that it would have frightened them still worse (to say nothing of me) and would have been still less explicable; so that I stood and looked into their eyes and loved them, and wished to God I was dead."[14]

Later, Agee describes in great detail his longing for a union with the daughter of his hosts: "I had such tenderness and such gratitude toward her that while she spoke I very strongly, as something steadier than an 'impulse,' wanted in answer to take her large body in my arms and smooth the damp hair back from her forehead and to kiss and comfort and shelter her like a child, and I can swear that I now as then almost believe that in that moment she would have so well understood this, and so purely and quietly met it, that now as then I only wish to God I had done it." Agee does not touch her but "instead the most I did was

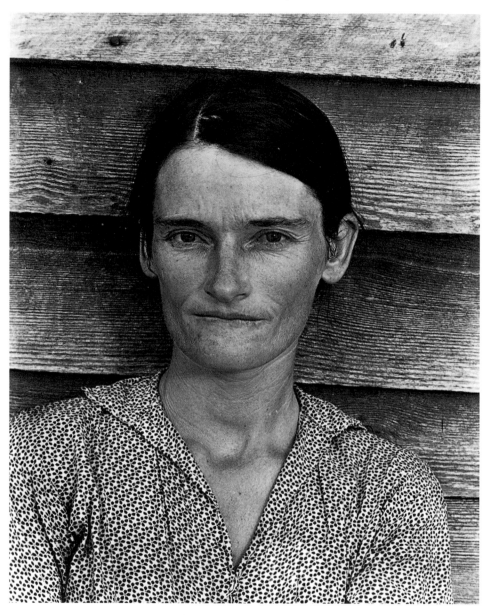

FIGURE 7.5 *Walker Evans,* Allie Mae Burroughs, *1936, Courtesy of the Library of Congress*

to stand facing her, and to keep looking into her eyes."[15] This is the viewpoint that Evans gives us in his portraits of the women of the tenant families. We feel in them Agee's sense of longing and restraint. For example, Evans takes an extreme close-up of Mrs. Allie Mae Burroughs (fig. 7.5). The camera looks into her eyes, sensing her humanity and dignity. Yet the uncanny clarity of Evans's technique actually undermines the connection between viewer and viewed. If the sharpness of detail convinces us that the subject is real and present, this same clarity is also off-putting. It is as if Evans has photographed his subjects in a vacuum, and the moisture and dust of atmosphere that tie all things to one another have been eliminated. A similar paradox is set up by the picture's flatness. The compressed space brings the subject up close. Evans wants to dispense with the polite distance people maintain between themselves. But movement toward Allie Mae is emphatically checked by the role of the frame, buttressed by horizontal lines of the clapboarding, so that the picture plane is always secure.

Evans's cropping results in an oscillation between closeness and distance. For example, in the touching photograph of Laura Minnie Lee Tengle (fig. 7.6) he forces us to focus on her beautiful face. Her enormous eyes and her intelligent expression seduce us. She clutches the arm of a sibling, as if worried by the attention of Evans, though the rest of the body of her protector is cropped out. The mere fragment of an arm, and the pattern of the dress worn by the grown-up behind, ab-

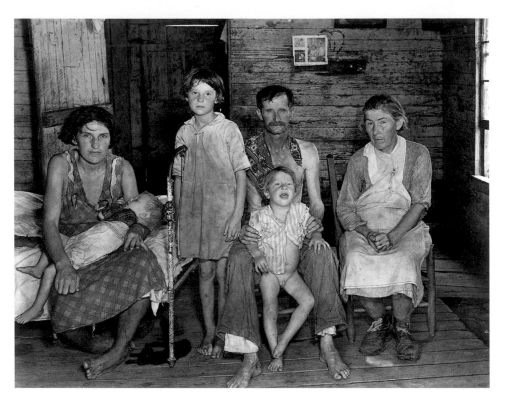

FIGURE 7.7 *Walker Evans,* The Sharecropper's Family, *or* Bud Fields and His Family, *1936, Courtesy of the Library of Congress*

stract the picture, rendering the child's grasp of another human being strangely ineffectual.

Evans refrains from such overt cropping in the most famous photograph in the book, *The Sharecropper's Family* (fig. 7.7), which focuses on the Fields family, but it too is about distance. From the start we are made aware of the gulf between the camera and the subject. Each figure takes a pose; all try to look their best. Evans makes no attempt to feign spontaneity. The separateness of the principal characters in the composition is reinforced by Evans's balanced composition, which is classical in feeling. The horizontal lines of the boards, wall, and floor provide the backdrop to the friezelike assembly of figures. The standing girl creates a triangle of the group. Particularly elegant is the way the doorway frames the standing girl, even as the slats of the open door frame her mother. The bare feet of the family members are remarkably lively, as if this part of the body were immune to posing. The grandmother is the only one to wear footgear—very old shoes indeed. That she wears them

at all only highlights the others' lack of shoes. With the exception of the two infants, everyone looks directly at the camera. They may have been told not to smile, nor to do anything special, and so their faces are not easy to read. Still, their expressions are not blank. The girl seems impatient; the mother hunches her shoulders, as if to hold herself still. The grandmother seems inquisitive, the father amused, the half-naked boy excited. The baby sleeps.

Arguably, a distancing between photographer and subject is built into the documentary process. More disturbing is the discontinuity between the family members. The mother reveals no interest in the baby in her lap (this is no modern day Madonna and Child). She is also separated from her daughter by the bars of the bed frame. The grandmother is even further removed. The line of her shoulders points away from the group, and the back of her chair creates a boundary between her and her son-in-law. The little boy's mouth is open as if he might be saying something, though his demeanor suggests the inarticulate. His father holds him apparently not out of tenderness but to keep him from running off. His naked genitals as well as the family's exposed feet suggest an inability to maintain the decorum of the traditional portrait photograph. This may reflect their innocence, but it certainly indicates the devastation of poverty. It is telling that the girl holds the bed frame almost like a crutch. This does not appear to be a family whose struggle against poverty makes them closer or stronger. Such familial discontinuity is surely a result of the brutality Evans witnessed in their lives. But it was also a projection of the separateness and distance that characterizes human relationships in general, and in particular that of the two collaborative artists. Agee's very claim that the work of photography and text is "mutually independent" but also somehow "collaborative" implies both a drive for separateness and a sense of dependence. They longed for connection between each other and their subjects, but they also wanted autonomy for themselves and their mediums.

The attempt by Agee and Evans to get close to the tenant families reminds us that when we call *Let Us Now Praise Famous Men* a collaboration, we should not forget the participation of the tenant farmers they were representing. These people were not passive objects to be photographed and described. Both Agee and Evans knew that these families were affected by their presence. Evans used a thirty-five-millimeter camera for preliminary shots, partially to help the families relax and get used to being photographed. But allowing subjects to strike their own poses is not equivalent to the partnership of equals that was struck be-

tween Agee and Evans. Evans later said that although they explained to the families what they were doing "with some sympathy" and "with some respect," they gave them money: "We bought them, in a way. That sounds more corrupt than it was meant to be. We went into their houses as paying guests, and we told them what we were doing, and we sort of paid them for that. Good money."[16] Despite Evans's statement, it seems likely that only the Burroughs family was paid, and only for room and board.[17] Later, somewhat defensively, Evans insisted that "the motive is strong," and that "there's no malevolence in it and there's no deception in it."[18]

Agee was far more worried by the potentially exploitative act of invading the privacy of the families. He begins the book by calling the project "curious, not to say obscene and thoroughly terrifying."[19] But if their work was obscene, it is in part due to Agee's introjection of his own sexual urges into the text. It is impossible to ignore the weirdly sexual component of Agee's attitude toward the families, which seems so inappropriate given the stated goal of documenting their exploitation and unhappiness. Even when he is alone in the Burroughses' house, his heated imagination reminds him of his "hot early puberty" when he masturbated in his grandfather's home: "At length I took off all my clothes, lay along the cold counterpanes of every bed, planted my obscenities in the cold hearts of every mirror in foreknowledge, what unseen words and acts lurked ambushed in those deep white seas before the innocent fixtures of a lady's hair: I permitted nothing to escape the fingering of my senses nor the insulting of the cold reptilian fury of the terror of lone desire which was upon me."[20]

Agee continues by insisting that while in the tenant farmer's house "it is not entirely otherwise," he feels "no open sexual desire" but rather "the quietly triumphant vigilance of the extended senses before an intricate task of surgery." Why then evoke the image of masturbation at all? Throughout the book, Agee introduces such seemingly inappropriate erotic thoughts, only to distance them. These scandalous confessions intensify the physical sense of existing with these families in their environment. In the end, Agee is not content with merely describing their physical world. He wants us to know what it is like to be in his skin. We sense Agee's body constantly intruding into the process of description, as if he were not fully in control of his senses or his actions. This is the very opposite of photography's disembodied sight as conveyed by Evans's lens. Yes, Evans's pictures give us vivid bodies, arguably more vivid than Agee's confusing text. But there is little sense of the body of

the photographer, what it feels like to hold the camera and push the shutter—the embarrassment, which Agee is so good at conveying, of looking into the eyes of another human being and having that glance returned, without the distancing effect of the frame.[21] In so emphatically inserting his own psyche into the text, Agee was effectively inventing the so-called new journalism that was to become a staple of American documentary efforts in the 1960s. Agee refused the possibility of a disembodied objectivity, perhaps because this is what he imagined was the role of photography in the collaboration.

Koestenbaum writes that "men who collaborate engage in a metaphorical sexual intercourse, and the text they balance between them is alternately the child of their sexual union, and a shared woman."[22] If *Let Us Now Praise Famous Men* is a child of the Agee and Evans collaboration as a whole, it becomes so in part by providing extraordinary portraits of, and ruminations about, children—from the images of the sons and daughter of Floyd and Allie Mae Burroughs to that of a child's grave. On another level *Let Us Now Praise Famous Men* could be said to treat the three families generally as having a kind of childlike vulnerability. According to Agee they are an "undefended and appallingly damaged group of human beings."[23] Because they are powerless, they do not share responsibility for the corruption of a materialistic society. Poverty itself exempts the farmers from the decadence of consumerism. Their world is meager, but it is pure because of this meagerness. In Evans's photographs the austerity of their living quarters is meant to reveal this untouched quality. Ironically, the very alleviation of poverty, which the farmers surely desire, might threaten to disrupt this unspoiled vision.

Yet if the images of children are among the most poignant in the book, Agee and Evans do not want to infantilize the families. In fact, in Evans's photographs Floyd and Allie Mae Burroughs take on the characteristics of ideal parents, particularly in contrast to the landowner, the symbolic bad father. The landowner is not obviously evil, but he seems uncomfortably stiff and disconnected as he faces the camera. Both Allie Mae and Floyd Burroughs look relaxed, and this sense of comfort imbues their faces with intelligence and selfhood, or, as Agee put it, with "individual, antiauthoritative human consciousness."[24] The linear geometry of Evans's characteristic background enhances, through contrast, the irregular and soft outlines of the human face and body. Such geometry is not merely a foil, however. It suggests the ordering mind of both the photographer and his subject. And if Evans tidied

up the Burroughses' house in his photographs of interiors, the purpose was not just to make an elegant picture but to convey how even in abject poverty, the Burroughses were capable of creating a dignified environment.

The opening images of the Burroughses, parents and children, in the first edition gives way to the picture of the bed and its connotations of the erotic origins of the family. This subtle allusion is as close as Evans gets to Agee's heated text in which sexual desire and the family romance loom large. Indeed, just as Koestenbaum predicts, Agee's text includes a fantasy of the sharing of a woman between the collaborators: "If only Emma [Mary Fields, sister of Allie Mae Burroughs] could spend her last few days alive having a gigantic good time in bed with George [Floyd Burroughs, Allie Mae's husband] . . . and with Walker and with me, whom she is curious about and attracted to, and who are at the same moment tangible and friendly and not at all to be feared." It is not clear whether Agee is imagining each man taking turns with Mary alone or a sexual triangle.[25] The latent homosexuality of Agee's fantasy is, however, quickly replaced by an image of hostility and competition: "Not one of us would be capable of trusting ourselves to it unless beyond any doubt each knew all the others to be thus capable: and even then how crazily the conditioned and inferior parts of each of our beings would rush in, and take revenge."[26] This fantasy of seeming to desire his collaborator through the body of another woman parallels Agee's desire to possess Evans's craft. Just as sexual fantasy gives way to images of reprisal, photography, which Agee initially set up as an ideal medium, becomes demonic. Agee describes the camera at the end of the book as a monstrous instrument of power: "Walker setting up the terrible structure of the tripod crested by the black square heavy head, dangerous as that of a hunchback, of the camera; stooping beneath cloak and cloud of wicked cloth, and twisting buttons; a witchcraft preparing, colder than keenest ice, and incalculably cruel."[27] Agee's desire for his collaborator's tool is transformed into fear. Agee ends up worrying that Evans will end up besting him and make precisely the kind of contact with his subject he longs for.

Agee's envy and fear of his collaborator erupts in his account of a crisis during a trip to Birmingham with Evans to escape for a few days from the wrenching poverty of the tenant families. Agee splits up with Evans on the trip: "Twenty-four hours of every day for weeks now I had been in the company of another person. . . . I knew now how much greater the strain had been than I had been able, while under it, to re-

alize; for I have never known more complete pleasure and relief at be-
ing alone." He longs for physical companionship with a woman, imag-
ining sex with a prostitute ("a piece of tail") but realizes that he "will be
good for nothing."[28] Instead of opting for sex he decides to return to
the tenant families but runs his car off the road as he is headed back.
But this accident and the equivalent *ditching* of Evans free him to cre-
ate. He cements his relationship with the families, but now without
Evans, even apologizing for what he believes was the invasion of their
privacy by Evans's camera.

Agee's car accident seems overly determined. The great trauma of his
childhood was the premature death of his father in an automobile and
the subsequent breakdown of his family home. Now a mishap with a car
brings him to a new family who takes him in and provides the subject for
his writing. It is as if he had magically reversed the tragic narrative of his
unhappy childhood. Instead of an accident destroying his family, it re-
stores the shattered family unit, if only briefly. In this sense, Agee's ob-
sessive musings about sexuality are less the signs of a predatory adult
than an attempt to relive the sensation of his growing up and sexual
awakening. But Agee was no longer a child, and his thinking about sex
is infused with self-analysis and heavily influenced by Freudian concepts
of the family. For all his idealizing of the Burroughses, he cannot think
about them in terms that are free from the family romance or without
projecting his incestuous desires onto his subject.

Agee finds his bearings only when Evans has left the scene.[29] The col-
laboration of *Let Us Now Praise Famous Men* could be said to begin only
when the collaborators have separated. At least that is what the text sug-
gests. But in fact, Evans returns to take the pictures of the families.
Agee not only used these pictures as inspiration, but for the next five
years he relied on Evans's friendship and encouragement to finish writ-
ing the book. It is likely that without Evans's prodding, the book never
would have been finished.

I have suggested that the collaboration of *Let Us Now Praise Famous Men*
was a personal competition between Agee and Evans, but it was also a
rivalry in quite another sense. At about the same time James Agee and
Walker Evans were living with three tenant families in Alabama, Erskine
Caldwell and Margaret Bourke-White were traveling throughout the
South documenting poverty for *You Have Seen Their Faces,* which they
published in 1937. Given the similarity of their projects, both of which
documented the conditions of the rural South through photography

and writing, it was inevitable that the two books would be compared—and Agee knew it. He included in the appendix of *Let Us Now Praise Famous Men* an abridged version of a *New York Post* article in which May Cameron discusses Margaret Bourke-White's clothes: "'You can't possibly miss her,' Miss Bourke-White's secretary told me, 'because she's wearing the reddest coat in the world.' A superior red coat, Miss Bourke-White called it, and such fun. It was designed for her by Howard Greer, and if you're as little up on your movie magazines as I am, I'd better explain that the Greer label is some pumpkins. You'd find it, if you could look, in the more glamorous gowns of Dietrich and, among others, Hepburn."[30] Agee clearly reprinted the review to suggest Bourke-White's superficiality and the distance between her glamorous life and the poverty she photographed. But despite Agee's attempt to denigrate Caldwell and Bourke-White, the fact is they finished the project four years before the publication of *Let Us Now Praise Famous Men*. *You Have Seen Their Faces* was enormously successful, gaining critical acclaim and a wide audience.[31]

Agee's dismissal of Bourke-White was not due solely to her work on *You Have Seen Their Faces*. It turns out that Agee himself had worked with Bourke-White, or at least his prose and her photographs had appeared side by side. Two years before embarking for the South with Evans, Agee had written a report on the dust bowl for *Fortune* that was illustrated with photographs by Bourke-White. Agee was unhappy with her pictures, however, which he found too picturesque and aesthetic.[32] This reaction is surprising, given that Agee's writing is sentimental and arty. For example, he writes of the dead cattle that appear in one of Bourke-White's pictures (fig. 7.8): "Quietly a cow has relaxed into death. Instantly her sisters close like circling water above a sinking stone, briefly to mourn her. Watch well, and seriously, these faces. And seriously recall that noble motet . . . 'Daughters of Jerusalem, weep not for yourselves but for your children, and for your children's children.'"[33]

Whatever we may think of the ultimate quality of this photo story, the investigations of rural poverty by Agee and Evans, and Bourke-White and Caldwell, were anticipated by the earlier Agee and Bourke-White pairing. Its failure may have been attributed to the writer's and author's ignorance of their subject and to the fact that neither had ever worked with the other. Both *Let Us Now Praise Famous Men* and *You Have Seen Their Faces* were a direct response to the kind of superficial journalistic approach exemplified by the drought article. Rather than a photographer and reporter being sent to a disaster with orders to provide as

"TO WHAT GREEN ALTAR, O MYSTERIOUS PRIEST, LEAD'ST THOU THAT HEIFER LOWING TO THE SKIES"
... the poem continues, questioning, "And all her silken flanks with garlands dressed?" The starved flanks to the lower right are silken because they have been skinned—all but the gasping head—for what little money there was in the hide. To the lower left: a vulture, a hog, or the blessed sun has disclosed Nature's bright ultimate garlands. Above: quietly a cow has relaxed into death. Instantly her sisters close like circling water above a sinking stone, briefly to mourn her. Watch well, and seriously, these faces. And seriously recall that noble motet which begins: *Plorate, filiae Israel* . . . "Daughters of Jerusalem, weep not for yourselves but for your children, and for your children's children . . ."

· 79 ·

quickly as possible a story and pictures for a magazine article, both sets of collaborators had a long enough period to learn about their subjects in depth. The photographer was not merely to provide illustrations, and the writer captions; together the two were to work as a team.

In a sense Agee was right: just as Caldwell and Bourke-White were very different from Agee and Evans, *You Have Seen Their Faces* is distinct from *Let Us Now Praise Famous Men*. Erskine Caldwell, the best-selling author of *Tobacco Road* and *God's Little Acre*, shared none of Agee's ambivalence about "spying" on the poor. After all, he had grown up in the region and had already brought the experience of southern rural poverty to the attention of a general public by way of his enormously popular novels. And Bourke-White, the lead photographer for *Fortune*, was almost as well known as Caldwell. When Henry Luce created *Life*, a picture by Bourke-White of Fort Peck Dam, in Montana, was chosen for

the inaugural cover.[34] In contrast to the retiring and modest Evans, who had a small reputation in high-art circles, Bourke-White was famous—perhaps the most famous photographer of the period. Caldwell and Bourke-White joined forces with the express intention of reaching a wider audience. Although Caldwell initially had his doubts about Bourke-White's sincerity, he agreed to work with her precisely because her photographs had mass appeal.

If there is a sexual component to Agee and Evans's collaboration, it was certainly beneath the surface, a kind of unstated tension between the two artists. From the beginning of the collaboration between Caldwell and Bourke-White, however, there was a conscious fear, at least on the part of Caldwell's wife, that sex would invade the relationship. And so when Caldwell and Bourke-White drove South, Caldwell's secretary accompanied them as a kind of chaperone. The collaboration did not begin well. Caldwell did not seem to like Bourke-White. He was annoyed by the quantity of luggage she needed and her complaints about lodgings. Early on he decided that the two simply could not work together, and so he had it out with Bourke-White and called the whole thing off. This is how Bourke-White tells the story in her memoirs: "I tried desperately to tell him how much this meant to me, this opportunity to do something worthwhile, but I wasn't making much sense, because, of course, I was crying. Then suddenly something very unexpected happened. He fell in love with me. From then onward, everything worked out beautifully."[35]

Caldwell's version of the story is somewhat different. He claimed that she somehow got him to visit her in her room, where he found her half-naked in bed:

> I soon saw Margaret in bed with the covering tossed aside in the balmy air of the summer evening. With gradually increasing vision in the dim light, I was soon aware that she was partially clothed in a very thin garment. . . . Ever since starting on our tour, I had been constantly impressed by Margaret's enticingly lissome figure and her provocative femininity. However, I was not prepared to find myself in a hotel room with her by invitation.
>
> "And now that you're here," Margaret said, "you can sit down so we can talk for a little while."[36]

It appears they did more than just talk. Whatever version of the story we accept, the erotic nature of their union is clear. The sexual relationship of the two protagonists appears to have been a necessary component

in the success of their project. Their love ensured that, as Bourke-White claims, "everything worked out beautifully." They eventually married.

Bourke-White and Caldwell's union produced a collaborative work that was less conflicted than that of Agee and Evans. Pictures are organized into four groups within the text. Unlike the unidentified photos in *Let Us Now Praise Famous Men,* each carries a caption. Although her pictures open the book, Bourke-White is given second billing. On the other hand, Caldwell does not encroach on Bourke-White's territory. In contrast to Agee's attempt to write photographically by including elaborate descriptive passages, Caldwell never describes what people and things look like; his writing is proscriptive rather than descriptive. He allows Bourke-White's pictures to do this. Bourke-White's presence is introduced at the end of the book when she describes her photographic technique: "Most of the interiors were taken with Panchro-press film; some with Super-Sensitive Panchromatic, which is also quite satisfactory with flashes. For outside work Super-Sensitive Panchromatic was employed throughout."[37] Bourke-White's concerns with problems of lighting and film have been cited by William Stott as evidence of her superficiality and her indifference to the plight of her subjects.[38] What Stott ignores is that Bourke-White's professional tone anticipates and counters the kind of chauvinistic dismissal of women artists epitomized by the suggestion at the end of *Let Us Now Praise Famous Men* that she was interested only in clothes. In emphasizing the mechanical elements of her craft, Bourke-White is also trying to insist on the objectivity of her photographs and to stress her professionalism. Both Bourke-White and Caldwell avoid a sense of their personal stake in their subjects. Unlike *Let Us Now Praise Famous Men, You Have Seen Their Faces* contains no personal revelations.

Bourke-White's images are far more stagy than Evans's more formal treatments. Evans's subject usually poses in front of a stark rectilinear background or in a tightly compressed space. Bourke-White is far more likely to emphasize the diagonal, by photographing from below or above her subject, thereby suggesting more space. Because of Bourke-White's use of a flash, which increases contrast, and of faster film, which adds graininess, her pictures never have the clarity and tonal range of Evans's. This difference is exaggerated in the printing, because *You Have Seen Their Faces* has a larger format, and so its pictures are blown up.

Evans uses architecture to frame figures, or it becomes a subject of interest in and of itself, almost as if it were a character with human dimensions. He makes a portrait of a cabin or a general store. Bourke-

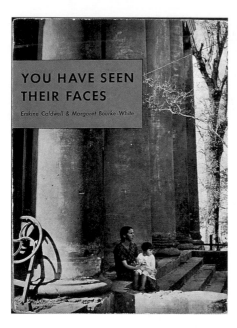

FIGURE 7.9 *Cover from Erskine Caldwell and Margaret Bourke-White,* You Have Seen Their Faces *(New York: Modern Age Books, 1937; reprinted by the University of Georgia Press, 1995)*

White, however, includes few pictures that do not include a human figure. She likes to use architectural elements in a more obviously narrative way than Evans. For example, on the cover of *You Have Seen Their Faces* (fig. 7.9) a mother and daughter are dwarfed by columns on the porch of an old plantation mansion in Clinton, Louisiana, that, according to a caption, has been converted into a multifamily house. The columns are crumbling, symbols of a decayed system of exploitation that predates the Civil War and is at the root of the South's terrible poverty.

The woman on the cover of *You Have Seen Their Faces* looks defeated by her environment. In contrast, the first Bourke-White image, *Elbow Creek, Arkansas* (fig. 7.10), shows a boy plowing, from a perspective that makes him look like a young giant. Comparing this image with others, of older men and women made feeble by illness and starvation, reinforces the text's message that the future of the South is in the hands of its younger generation: "The young people still have strong bodies and the will to succeed. They can change the agricultural system that broke the bodies and wills of their parents. . . . The young people, the boys and girls, the young men and women . . . have the power in themselves to fight against any system that attempts to break their bodies and spirits as it did their parents."[39] Rather than depend on extreme clarity of detail, in the documentary style of Evans, Bourke-White uses high con-

FIGURE 7.10 *Margaret Bourke-White,* Elbow Creek, Arkansas, *1936, from Erskine Caldwell and Margaret Bourke-White,* You Have Seen Their Faces *(New York: Modern Age Books, 1937; reprinted by the University of Georgia Press, 1995)*

ELBOW CREEK, ARKANSAS. "My father doesn hire any field hands, or sharecroppers. He makes a lot of cotton, about sixty bales a year. Me and my brother stay home from school to work for him."

trast to accentuate the three-dimensionality of her subjects. The diagonal of the plow in *Elbow Creek, Arkansas,* combined with the extreme foreshortening and intense sculptural shadows, makes the boy seem to push across the picture as if in a movie.

Throughout the book Bourke-White makes use of cinematic techniques to involve the viewer. To simulate movement, in *Summerside, Georgia* (fig. 7.11) she uses three separate frames to show a child eating watermelon. This same device appears later in her pictures of a church sermon in College Grove, Tennessee. But the relationship to movies is not merely a matter of simulating motion. She also mimics the pace of film, with its abrupt shifts in angles and its alternations among close-up,

FIGURE 7.11
Margaret Bourke-White, Summerside, Georgia, *1936, from Erskine Caldwell and Margaret Bourke-White*, You Have Seen Their Faces *(New York: Modern Age Books, 1937; reprinted by the University of Georgia Press, 1995)*

SUMMERSIDE, GEORGIA. "My daddy grows me all the watermelons I can eat."

HARRISBURG, ARKANSAS. "Five months of school a year is all I'm in favor of, because I need my children at home to help work the farm."

FIGURE 7.12 *Margaret Bourke-White*, Harrisburg, Arkansas, *1936, from Erskine Caldwell and Margaret Bourke-White*, You Have Seen Their Faces *(New York: Modern Age Books, 1937; reprinted by the University of Georgia Press, 1995)*

full-body, and panoramic shots. Her high vantage point in *Harrisburg, Arkansas* (fig. 7.12), a photo of schoolchildren at their desks, suggests a movie camera panning over a scene.

Where Evans is suspicious of sentimental associations, Bourke-White is more than willing to pose a mother and baby like a Madonna and Child altarpiece, thereby imparting holiness. She will have none of Evans's sense of respectful distance. She wants her photographs to leap out at us and evoke an intense emotional response. But for all the cinematic drama and occasional sentimentality of her photographs, Bourke-White avoids idealizing the environment of poverty as Evans's do. In particular, she is sensitive to the ways the modern media have completely invaded the spaces of the South. Bourke-White was fascinated by farmers' use of newspapers and magazines to cover cracks in the walls. She had the "uneasy feeling" that she might find one of her own advertisements used this way. The stark spaces of Evans's photographs are elegant in comparison to the clutter of Bourke-White's pictures of shacks, where photos and newspaper become wallpaper and insulation (fig. 7.13). These images advertising "magic pain-killers and Buttercup Snuff," as well as makeup, clothing, and automobiles, reflect the intrusion of the modern commercial world into the lives of the rural poor.[40] Evans also incorporated advertising in his pictures. His photographs of torn movie posters are famous, and *Let Us Now Praise Famous Men* includes a few pictures in which cheap commercial calendars are pinned to the wall (the later edition includes advertising on storefronts). Yet for the most part the photographs of *Let Us Now Praise Famous Men* project living conditions that in their very poverty and backwardness have been spared the vulgarity of the mass media. To put it another way, in Evans's photographs, the commercial holds its place. And when it is central, the photographer's poetic sense transfigures it, reminding the viewer of a cubist collage. Bourke-White's pictures suggest that the poor would like to own the things that are in the advertisements. When they cannot have them, they use photographs to dream. Her anxiety about seeing her own pictures plastered to the wall is due to her sense of complicity in the creation of desires that she knows will probably never be satisfied.

Unlike Evans, Bourke-White has no compunction about showing ugly people and the truly horrific effects of poverty. For example, in *Sweetfern, Arkansas* (fig. 7.14) we are forced to look at an old woman with an enormous goiter. If the girl of *McDaniel, Georgia* (fig. 7.15) is not physically misshapen in a literal sense, she appears so in Bourke-

FIGURE 7.13 *Margaret Bourke-White*, East Feliciana Parrish, Louisiana, *1936, from Erskine Caldwell and Margaret Bourke-White*, You Have Seen Their Faces *(New York: Modern Age Books, 1937; reprinted by the University of Georgia Press, 1995)*

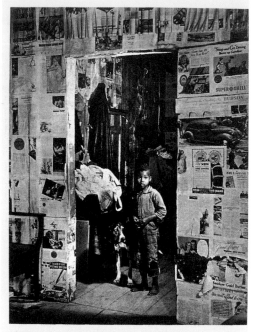

EAST FELICIANA PARISH, LOUISIANA. "Blackie ain't good for nothing, he's just an old hound dog."

FIGURE 7.14 *Margaret Bourke-White*, Sweetfern, Arkansas, *1936, from Erskine Caldwell and Margaret Bourke-White*, You Have Seen Their Faces *(New York: Modern Age Books, 1937; reprinted by the University of Georgia Press, 1995)*

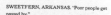

SWEETFERN, ARKANSAS. "Poor people get passed by."

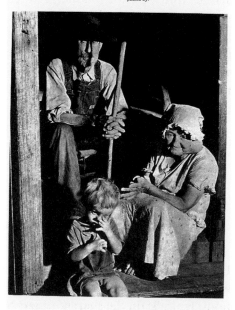

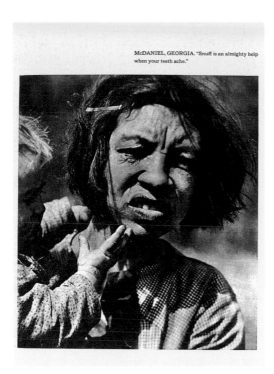

McDANIEL, GEORGIA. "Snuff is an almighty help when your teeth ache."

FIGURE 7.15 *Margaret Bourke-White*, McDaniel, Georgia, *1936, from Erskine Caldwell and Margaret Bourke-White,* You Have Seen Their Faces *(New York: Modern Age Books, 1937; reprinted by the University of Georgia Press, 1995)*

White's photograph. Erskine Caldwell's text is equally inelegant and direct. In contrast to the obsessive way Agee worries about the process of writing and his project's status as art ("Above all else: in God's name don't think of it as Art"),[41] Caldwell does not inject an elaborate discussion of the process of his documentary effort. *You Have Seen Their Faces* reads like a political manifesto. He is angry and certain of his knowledge of his people's misfortune:

> The South has always been shoved around like a country cousin. It buys mill-ends and wears hand-me-downs. It sits at second-table and is fed short rations. It is the place where the ordinary will do, where the makeshift is good enough. It is the dogtown on the other side of the railroad tracks that smells so badly every time the wind changes. It is the Southern Extremity of America, the Empire of the Sun, the Cotton States; it is the Deep South, Down South; it is The South."[42]

He discusses at length the ways sharecropping approaches slavery. Caldwell has none of Agee's compunction about suggesting political solutions. He calls on the sharecroppers to take collective action, convinced

that the only way they can improve their situation is by demanding a fair wage for their work. He concludes that the "youth of the South can succeed where their mothers and fathers failed if they will refuse to raise another man's cotton while hungry and in rags."[43]

Another major difference between the two books is the emphasis on race. A key premise of Agee and Evans's book was that they had lived intimately with their subjects, yet they did not include a black family; the white population would never have tolerated two white northerners living in the home of an African American family.[44] Caldwell and Bourke-White made no pretense of such intimacy, and so they were free to consider the plight of both whites and blacks. Certainly race relationships remain a crucial element of *Let Us Now Praise Famous Men,* as evidenced by Agee's encounter with the black couple, but they remain peripheral to the story of the three white families.

Race, however, is at the center of *You Have Seen Their Faces.* Caldwell writes: "The Negro tenant farmer is the descendant of the slave. For generations he has lived in mortal fear of the white boss in the cotton country. He has seen his women violated and his children humiliated. He himself has been discriminated against, cheated, whipped, and held forcibly in an inferior position. Every white face he sees is a reminder of his brother's mutilations, burning, and death at the stake. He has no recourse to law, because he is denied the right of trial before his peers."[45]

Images of African Americans are not segregated within a section of the book. They are dispersed throughout, making it clear that the problem of sharecropping concerns both whites and blacks all over the South. Indeed, Caldwell claims that because of the inequality of the southern legal system, landowners were better able to control the African American population. As a result, many white tenant farmers were forced to give up growing cotton. Caldwell writes: "The landowner in the rich plantation country wants a man who can be subjected to his will by means of fear and intimidation. . . . The Negro tenant farmer on a plantation is still a slave."[46] If Caldwell is right, then Agee and Evans's decision to focus on three white families is hardly "adequate," as Agee claimed, to convey the totality of tenant farming.

Bourke-White takes some of her most memorable pictures in a black church. Her images of the intense religious fervor of a preacher and his congregation, in which "getting religion is like putting money in the bank," are a counterpoint to Caldwell's attack on the churches for silently condoning the tenant system.[47] And if Caldwell ultimately blames racism on the exploitation of the landowners, he is harsh in his

criticism of the white sharecroppers who use African Americans as scapegoats for their problems. Yet Caldwell and Bourke-White's emphasis on blacks is still influenced by racist stereotypes. A particularly embarrassing caption above an image of an African American mother from Ocelot, Georgia, reads: "I got more children now than I know what to do with, but they keep coming along like watermelons in the summertime."[48] Nicholas Natanson has noted that "Bourke-White's black subjects, to a much greater extent than her whites, fall into the pathetic category. Consider the physical positions in which blacks appear in *You Have Seen Their Faces*. Lying, sprawling, crouching, kneeling, huddling blacks are everywhere." And Natanson contrasts the "lurid" exaggerated depiction of the African American service with the relative "dignity" of Bourke-White's representation of a fundamentalist white service.[49]

Caldwell and Bourke-White share none of Agee and Evans's compunction about invading the privacy of the poor. In contrast to Evans's supposed practice of taking his portrait photographs only when his subjects were ready, Bourke-White was proud of her use of surprise: "Sometimes I would set up the camera in a corner of the rooms, sit some distance away from it with a remote control in my hand, and watch our people while Mr. Caldwell talked with them. It might be an hour before their faces or gestures gave us what we were trying to express, but the instant it occurred the scene was imprisoned on a sheet of film before they knew what had happened."[50] Bourke-White's use of the word "imprisoned" seems unintentionally ironic given both the book's famous pictures of chain gangs (fig. 7.16) and its leftist rhetoric.

Arguably, whether the photographer surprises her subject or waits until the person is ready does not fundamentally alter the power relationship embodied in the documentary stance. Nevertheless, critics have had a hard time justifying another of Caldwell's and Bourke-White's practices; they made up quotations for their subjects. For example, above an image of an African American farmhand, *Porter, Arkansas* (fig. 7.17), they wrote: "We got seventy-five cents a day in the cotton field last year, and a whipping if we didn't stay and work. I hear they say we'll get a dollar a day this year." The stereotyping of the lives of their subjects into pithy statements is at times demeaning. But given Caldwell's status as a playwright, I am not sure why inventing quotations per se should be considered such a terrible thing. In fact, Bourke-White was actually proud that she was able to help her successful playwright-lover invent monologues for the southern poor. This act of putting words into the mouths of their subjects may seem to cancel out their claim to

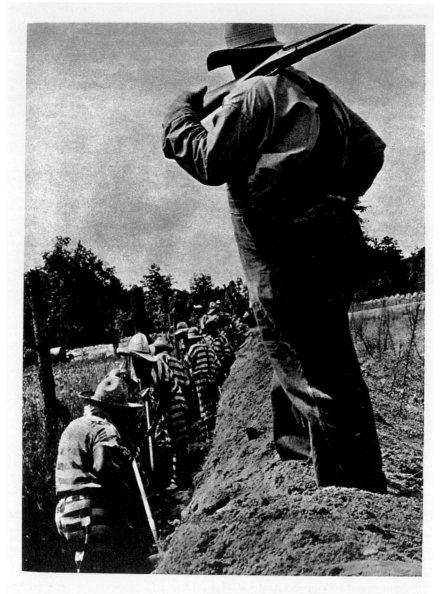

HOOD'S CHAPEL, GEORGIA. "The gang goes out in the morning and the gang comes back at night, and in the meanwhile a lot of sweat is shed."

FIGURE 7.16 *Margaret Bourke-White,* Hood's Chapel, Georgia, *1936, from Erskine Caldwell and Margaret Bourke-White,* You Have Seen Their Faces *(New York: Modern Age Books, 1937; reprinted by the University of Georgia Press, 1995)*

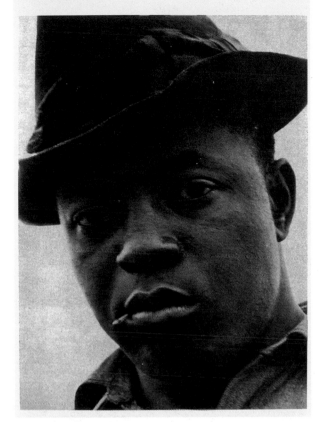

PORTER, ARKANSAS: "We got seventy-five cents a day in the cotton field last year, and a whipping if we didn't stay and work. I hear them say we'll get a dollar a day this year."

FIGURE 7.17 *Margaret Bourke-White,* Porter, Arkansas, *1936, from Erskine Caldwell and Margaret Bourke-White,* You Have Seen Their Faces *(New York: Modern Age Books, 1937; reprinted by the University of Georgia Press, 1995)*

truth in this documentary project, a claim that we have come to believe is always suspect, yet it is in keeping with their method of doing whatever was necessary to get their message across in the most obvious way possible.

I have tried to demonstrate that Agee and Evans's collaboration fits neatly into the pattern Koestenbaum observed in key male-male partnerships. In his *Double Talk,* Koestenbaum has little to say about the dynamics of male-female collaboration. Perhaps he avoids the subject because it so often reflects the familiar pattern of suppressed differences, the woman playing a subsidiary role to produce a supposed unity of expression. On the face of it, *You Have Seen Their Faces* does not seem to be an exception. I have suggested that photographs and text do not seem

discontinuous, as they do in *Let Us Now Praise Famous Men,* and that very unity is a result of Bourke-White's seeming subordination in the project. Reading Caldwell's text, one has little awareness of Bourke-White's role. The use of fabricated captions may be seen as a further denigration of the capability of her photographs to speak for themselves. Yet in another sense, Bourke-White's photos could be said to overwhelm the book. As one of the inventors of the photo magazine, she knew how to hold the attention of a mass audience with images that were graphic and vivid. No matter how interesting Caldwell's text, the average reader of the book inevitably scans the photographs long before reading the text (if it is read at all).[51] For this reason, Agee was wise to separate his writing completely from the photographs and thus avoid the inevitable comparisons. Agee always knew that his words could not compete with Evans's images.

It is tempting to generalize from these two instances of collaboration. But in the end they perhaps reveal less about the typical dynamics of male-male and male-female relationships than they do about the need to collaborate. Most histories of twentieth-century art emphasize heroic individuals who struggle alone in the studio. To collaborate is to leave the studio and find fulfillment in the practice of another artist. There is a strong erotic component in this process. For good or bad, collaborations seem to reenact the family romance in some way. As we collaborate, in spite of ourselves, we become lovers, or parent and child, or siblings. But for all the competitive aspects that threaten or fuel its success, the act of collaboration is about the wish not to compete. These photo-text collaborations are attempts to disrupt the conception of artistic creation as the expression of an individual genius whose stature is always measured against the production of another genius. The ostensible goal of both collaborations was not even to make "great art" but to change the world. Above all, the work that resulted from these two affiliations was an attempt to avoid the egocentric and produce something of communal value. Ironically, it is not the plight of their subjects but the art of Agee, Evans, Caldwell, and Bourke-White that we remember. In spite of their wishes, we end up praising or damning famous artists.

8 The Bombing of Basquiat

The collaboration of James Agee and Walker Evans was driven by a desire to dispense with ego. The problems of the Depression were too vast and pressing for the artist to insist on individualized expression, at least that was the initial idea behind their working together. But collaboration can just as easily come out of a need to augment ego: combining forces as a means to validate a rising career or as a chance to recharge flagging inspiration. In this case collaboration suggests the complex negotiations of two companies joining forces to market a new product for which neither owns an exclusive patent. The relationship will last only as long as there are profits to be made. This seemed to be the terms of the collaborative paintings of Jean-Michel Basquiat and Andy Warhol when they were first shown in New York City in 1985. But just as the reputed selflessness of the Agee and Evans working relationship turned out to be only half true, the cynical view of the Basquiat-Warhol collaboration as a kind of corporate merger is too flat and limiting. Despite the disparity in age and experience—Warhol was born in 1928, Basquiat in 1960—both artists got more and less than than they bargained for from the collaboration; both seemed far more emotionally invested in the relationship than their public stance let on. Warhol, at least, was dazzled and terrified by his new friend and soon-to-be collaborator, or so his 1982 portrait of Jean-Michel suggests (fig. 8.1). In this extraordinary picture, a screen print based on a Polaroid photo of Basquiat's face has been layered onto the field of one of Warhol's *Oxidation Paintings* (fig. 8.2). The result combines Warhol's standard portrait format of celebrities and socialites with the oxidation technique in which a male urinates on a copper field, producing a so-called "piss painting." The urine stains now take the place of the typical multicolored brush strokes that were applied to the ground of Warhol's soci-

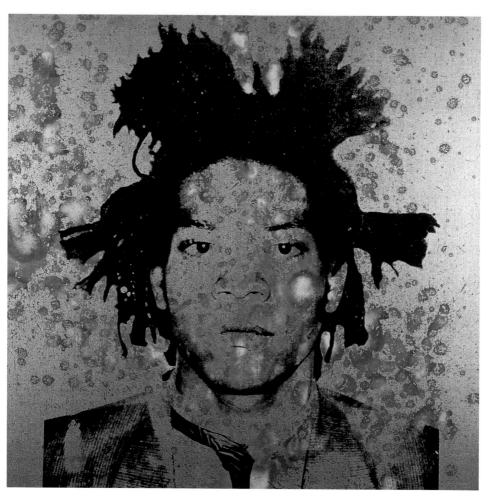

FIGURE 8.1 *Andy Warhol,* Jean-Michel Basquiat, *1982, oxidized silkscreen on canvas, 40 x 40 in. Andy Warhol Museum, Pittsburgh*

ety portraits by his assistants. Warhol's usual oxidation process provides only the trace of a performance in which young men put their genitals to work for Warhol. The *Oxidation Paintings* are like the stained sheets of an erotic encounter. The boys who "painted" the pictures remain anonymous, their bodies nowhere to be found in the final work of art. But in *Jean-Michel Basquiat* the pisser is given a face, that of a beautiful young man who has just begun to make a name for himself. Basquiat's head against the lustrous copper background recalls Warhol's earlier *Gold Marilyn Monroe* (fig. 8.3). Unlike Monroe's face, Basquiat's fills the entire image, his dreadlocks flaring like the rays of the sun. He is a new Apollo.

FIGURE 8.2 *Andy Warhol,* Oxidation Painting, *1978, oxidized metallic on canvas, The Andy Warhol Foundation, Inc./Art Resource, N.Y., location not indicated*

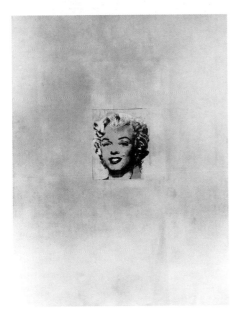

FIGURE 8.3 *Andy Warhol,* Gold Marilyn Monroe, *1962, synthetic polymer paint, silkscreen, and oil on canvas, 83 ¼ x 57 in. The Museum of Modern Art, New York. Gift of Philip Johnson*

My reading of the portrait makes the questionable assumption that Basquiat actually urinated on the ground of his own portrait, but that is what the juxtaposition of the photograph and the oxidation technique implies. The "pisser" is named. Basquiat is no anonymous Warhol assistant, no Factory hanger-on; his evacuations *mark* his arrival as a newly famous artist in his own right.

But on second thought perhaps the stains are really Warhol's, no matter who made them. Warhol was the author. In thinking of them as

Warhol's stains, their spray across the surface of the picture suggests to me less pools of urine than the scatter shot of semen aimed at Basquiat's head. Basquiat becomes yet another object of Warhol's erotic fantasies. He is not unlike the male leads of Warhol's films *Blow Job* and *My Hustler*.[1]

The portrait can be seen as a celebration of an aesthetic act that transfigures the basest material or as a trace of masturbatory release. As such it perfectly embodies the two-headed quality of fame itself. It bestows recognition—to paraphrase Jonathan Flatley's discussion of Warhol's portraits, it "gives good face"—and it withholds recognition, it defaces.[2] For if Warhol's oxidized painting is iconic, making of Basquiat a young glittering god, it is also iconoclastic, desecrating Basquiat's image. It reflects the moment when Basquiat made his *big splash* on the scene, a time when he had the power to work alchemy on the basest materials: "I was writing gold on all this stuff, and I made all this money right afterward."[3] But in Warhol's portrait Basquiat's splendor is already *stained,* as if predicting that his presence will succumb to the process of oxidation. Gold will return to excrement.

This chapter might easily have been entitled "The Uses and Abuses of Jean-Michel Basquiat." My purpose is to consider the ways in which the artist and his work were exploited by artists and critics during his lifetime and after his death at the age of twenty-seven in 1988. The themes of my book—fame and its costs, collaboration and competition, ambition and abjection, the artist's image in film and photography—fit Basquiat's career almost too neatly. Sadly, the doomed trajectory of *A Rake's Progress* that was only imagined by David Hockney seems to have been the very stuff of Basquiat's life and death. After his death critics frequently commented on the dramatic potential of his rise and fall. Indeed, it was not long before Basquiat's life made it to the screen. Julian Schnabel's 1996 film *Basquiat* was less a coming to terms with its subject than a self-portrait of Schnabel. But Schnabel's film was only the most grandiose of the various attempts to make use of Basquiat's life and art. In a certain sense the continuing exploitation of Basquiat's career is a sign of its success and continued relevance. No critic, including myself, is exempt from using Basquiat for his or her own purposes. Even the crucial act of correcting the prejudice latent in the mainstream critical response to Basquiat's art involves the remaking of Basquiat to suit a particular viewpoint. For example, bell hooks rightly rebukes the "Eurocentric" gaze that sees in Basquiat's work only "those aspects that mimic familiar white Western traditions." But in so doing she invents a

"more inclusive" viewer who is "better able to see the dynamism springing from the convergence, contact and conflict of varied traditions." Hooks not only calls into being this ideal audience, she idealizes Basquiat's work so that it is seen as a site of resistance to the "Eurocentric gaze that commodifies, appropriates and celebrates." In the process of denouncing the racism of white critics she skirts dangerously toward her own version of racial essentialism by claiming that Basquiat had "distinct connections to a cultural and ancestral memory that linked him directly to 'primitive' traditions." She herself admits that her assessment of Basquiat is no disinterested memory of the actual artist or work (if such a thing were possible) but a "re-membering." She attempts to salvage Basquiat from the *dismemberment* of the critics, even as it enlists Basquiat into her membership. My point is not to disagree with hooks but to point out the creative aspects of her interpretive act. Such subjectivity is inevitable because, as she herself says, Basquiat's work "confronts different eyes in different ways."[4]

Basquiat frequently obscures words on his canvases by crossing them out, covering them up, or purposely misspelling them. In *Charles the First* (fig. 8.4), for example, the word *young* is crossed out while the word *their* is misspelled. This misspelling and canceling out is the perfect metaphor for the interpretative process itself. Miswriting suggests misreading, Harold Bloom's term for the concept of influence whereby younger artists find their voice by creatively misunderstanding the work of their teachers. But such creative mistakes are not the exclusive province of artists; all interpretations are misreadings. If crossing out is conducive to misreading, it is also a form of emphasis. Basquiat claimed that by obscuring words he made the viewer pay more attention to them.[5] Miscommunication becomes the very condition of significance and meaning. In this sense, even Robert Hughes's attempt to cross out Basquiat's achievement—he entitled his obituary for Basquiat "Requiem for a Featherweight"—ends up reinscribing its significance by the very vehemence of his attack.[6]

In painting one phrase over another or striking a line through a word, Basquiat was also mimicking public graffiti in which alternate words are scrawled over signs. Often the word that is written over the sign is the nickname, or "tag," of the graffiti artist. Norman Mailer quotes a street artist who claimed that "the name was the faith of graffiti"; the goal of graffiti was to "hit" an object with your name. Mailer writes: "For now your name is over their name, over the subway manufacturer, the Transit Authority, the city administration. Your presence is

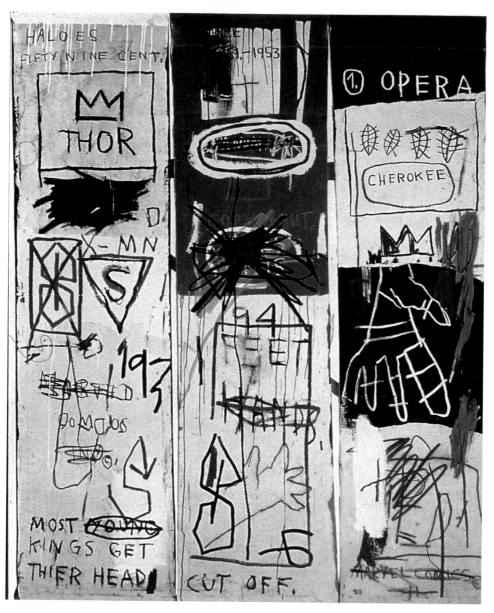

FIGURE 8.4 *Jean-Michel Basquiat,* Charles the First, *1982, acrylic and oil paint stick on canvas (three panels), 78 x 62 ¼ in.*

on their presence, your alias hangs over their scene."[7] But often the graffiti artist's own name gets, as Rene Ricard puts it, "bombed over" by subsequent tags so that the signature of a single author eventually becomes a confusion of names and jumbled phrases.[8]

I am particularly interested in what might be called the bombing of Basquiat, the writing of one name over another: Basquiat writing his name over Warhol's, Warhol and Schnabel writing their names over Basquiat's, the critics writing their names everywhere over everything.

Rene Ricard's "Radiant Child," published in *Art Forum* in 1981, was the first extensive discussion of Basquiat's work. The "radiant child" refers to Keith Haring's signature baby motif, but for Ricard it was also a symbol for a new group of artists that included not only Haring but Basquiat and Judy Rifka. These artists frequented the Mudd and Pyramid clubs and participated in such exhibitions as the "Times Square Show" and "New York/New Wave" and in group shows at various East Village art galleries. His essay singles out Basquiat's work because it had made the transition from the street—Basquiat with Al Diaz had formed the graffiti duo SAMO—to the art gallery. Ricard writes of Basquiat's pictures that "there is observable history in his work. His touch has spontaneous erudition that comforts one as the expected does."[9] Later he claims that "if Cy Twombly and Jean Dubuffet had a baby and gave it up for adoption, it would be Jean-Michel."[10]

What is surprising about Ricard's promotion of Basquiat in "The Radiant Child" is not his interpretations of works of art per se but the peculiar way he integrates his assessment with a larger discussion of fame. Interspersed throughout the piece is the repeated question, "Where is Taki?" (Taki was a graffiti artist whose tag was ubiquitous on the subways and streets of New York City in the early 1970s but who then disappeared.) The suggestion is that street art is fleeting. Although graffiti art is about creating a name, it is by definition ephemeral unless the artist finds a way to move from the street to the gallery, as did Haring and Basquiat. Ricard's discussion of fame moves from the question of the street artist to that of the critic and the audience. The theme of the fickleness of fame is replaced by the anxiety of failing to recognize a masterpiece. He claims that everyone wants to get on the "van Gogh Boat": "No one wants to be part of a generation that ignores another van Gogh."[11] The implication is that the next van Goghs are the artists selected by Ricard. The essay concludes in an ecstatic call for self-recognition: "We are that radiant child and have spent our lives defending that little baby, constructing an adult around it to pro-

tect it from the unlisted signals of forces we have no control over. We are that little baby, the radiant child, and our name, what we are to become, is outside us."

Ricard's assessment of artists' work is replaced by the search for a name, which he takes to be the original purpose of graffiti. Paradoxically, becoming an outward name allows the artist to be true to his or her inner child. Ricard dispenses with the romantic notion that public reputation and private persona are different; finding a public name is finding the self. It is only through fame that the artist can survive: "I think about how one must become the iconic representation of oneself if one is to outlast the vague definite indifference of the world." The model for this journey of self-discovery through notoriety is the critic himself. He ends by declaring, "We must become 'Judy Rifka' or 'Jean-Michel' the way I became 'Rene Ricard.'"[12] Rene Ricard became *Rene Ricard* precisely by naming his preferred artists, Jean-Michel among others.

In "Radiant Child" Ricard suggests a publicity stunt to a young artist whose "climb was on." This artist (whom Ricard refuses to name) stopped by to deliver a small painting for which he was asking fifty dollars. He insults Ricard by mentioning that he is going to give Andy Warhol a picture for free. Ricard offers him advice: "Don't give him the picture. Kids do that. Trade. That's what real artists do with each other. Since Andy's a press junkie, and I see you're getting the taste call up page six of the *Post* and get a photographer to the Factory. . . . You both get your picture in the paper, Andy comes off looking like friend of youth, you get a press clipping, and it's gravy for all parties."[13]

In proposing this scheme, Ricard must have known of Basquiat's early attempts to get Warhol's attention. In 1978, Basquiat, who was then only eighteen, waylaid Warhol at a restaurant and got him to buy some painted postcards, though they did not become friends until 1982, when Basquiat's career was already established. It seems Ricard's idea of true reciprocity between Warhol and a young artist had to await Basquiat's own fame. And rather than trade a preexisting work, they trade images of each other—they do each other's portraits.

Warhol mentions in his diary that the art dealer Bruno Bischofberger brought Basquiat for lunch on October 4, 1982. Warhol snapped a Polaroid, perhaps the basis for his oxidation portrait of Basquiat, discussed above. Basquiat rushed home and returned two hours later with *Dos Cabezas* (fig. 8.5). Instead of being a portrait of Warhol by himself, it shows the two artists together. Warhol, in essence, becomes part of Bas-

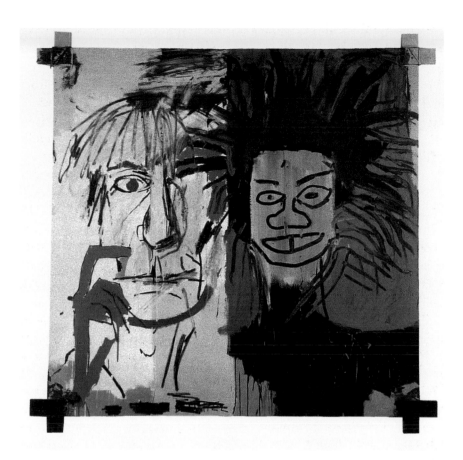

FIGURE 8.5 *Jean-Michel Basquiat, Dos Cabezas, 1984, acrylic and oil paint stick on canvas with exposed wood supports and twine, 60 ½ x 61 in. Collection of Mr. and Mrs. Thomas E. Worrell, Jr.*

quiat's self-portrait. When Warhol first saw *Dos Cabezas* he was amazed at how quickly the picture had been made: "Within two hours a painting was back, still wet, of him and me together. And I mean, just getting to Christie Street must have taken an hour. He told me his assistant painted it."[14] It seems unlikely that Basquiat had actually had one of his studio assistants make the entire picture. Perhaps it was begun by someone working in his studio and then finished by Basquiat. I believe Basquiat's remark was a sly reference to Warhol's famous practice of getting others to make his art, even as it was a way for Basquiat to brag that he was successful enough to have his own studio assistants. Basquiat was making the most Warholian of gestures by undermining the authorial

authenticity of his own painting. At this lunch there was also a discussion of money. Warhol remembered that Basquiat tried to give him back forty dollars for his early act of buying postcards from him. Warhol records in his *Diaries* that he was "embarrassed" and refused the repayment but adds that he thought he had actually given Basquiat more money.[15] Their relationship began around issues of borrowings and exchanges, and the act of mutual portraiture has the flavor of a reckoning of accounts.

A sense of two artists approaching each other but holding each other at a distance is embodied in the two-part structure of *Dos Cabezas*. Warhol is on the left, Basquiat on the right. The self-portrait component is rendered in Basquiat's characteristic manner. Its directness and lack of finish suggests the drawing of children or the sketchiness of street graffiti. Basquiat conveys his eyes, nose, and mouth schematically. That we are able to read it as a self-portrait at all is due not to any attempt at likeness but to the signlike quality of the dreadlocks. An undifferentiated blue background and emphatic outline further flatten the image.

Basquiat does the very opposite in the half devoted to Warhol. He works at a likeness, using shadows to convey the specificity of Warhol's nose and mouth. Basquiat's depiction of Warhol's hand in front of his face is based on Warhol's self-portrait of 1966 (fig. 8.6). How do we account for this foray into illusionistic portraiture? Perhaps likeness is meant as a gesture of respect—an attempt to seduce the senior artist by offering him his own image. Surely Warhol's very face is a kind of sign, a stand-in not so much for a person but for a mechanism of fame that Basquiat wants to get close to. But if Basquiat positions himself with Warhol, he also positions himself against Warhol by shifting styles of depiction. Basquiat's body, for example, is painted black, whereas Warhol is almost entirely white. In addition, the manner in which Warhol is depicted relates to the Western tradition of figuration. To put it in the simplest terms, a famous white artist is represented as literally white and in a style associated with a predominantly white European tradition of painting.

The contrast of modes of representations in *Dos Cabezas* has the effect of drawing attention to Basquiat's so-called primitivism. I do not need to dwell here on all the problematic meanings of the word *primitive*. It is enough to note that various modes of representations—those of Africans, Native Americans, children, the insane, and so on—have, at different times and for different purposes, been grouped under the

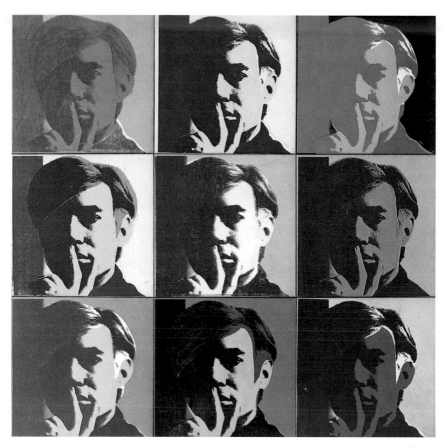

FIGURE 8.6 *Andy Warhol,* Self-Portrait, *1966, silkscreen ink on synthetic polymer paint on nine canvases, 67 ⁵/₈ x 67 ⁵/₈ in. The Museum of Modern Art, New York. Gift of Philip Johnson*

rubric of primitive. For much of the twentieth century, mainstream critics have ignored differences in forms and functions between, for example, a Native American sand painting and a child's drawings, assuming that such productions were somehow direct expressions of their maker's unconscious. Basquiat's earliest critics did not make the mistake of thinking that his work was itself primitive; rather they insisted that like earlier modernist painters such as Dubuffet, he had tapped primitive sources. Jeanne Silverthorne insists that "Basquiat is no untutored naïve." In fact she is annoyed by what she suggests are the affectations of his "stick-figure primitivism" and "aimless markings."[16] According to Jeffrey Deitch, Basquiat "is hardly a primitive." To the degree that Basquiat is "marvelously intuitive," it is not in his use of street culture or

his "spectral images of shamans and voodoo effigies" but in his "understanding of the language of modern painting." According to Deitch, Basquiat's paintings are "a canvas jungle that harness[es] the traditions of modern art to portray the ecstatic violence of the New York street." In this unfortunate sentence Deitch brings together several words—*jungle, violence, ecstatic, street*—that together add up to a racial stereotype. Regardless of the sophisticated urbanism of Basquiat's imagery, *jungle* is still the word used by Deitch to evoke his work. For Deitch, Basquiat's triumph is not so much his ability to express his blackness but his demonstration of the continuing viability of modernism: "His graft of street culture onto high art is a classic example of how modernism continues to rejuvenate itself."[17]

There is surely something odd about Deitch "grafting" the rejuvenation of modernism onto Basquiat's art. If it is an essentialist construct to see Basquiat as merely offering up an instinctual blackness, it is problematic to effectively homogenize his troubling content by insisting that its sources are to be found in a modernist tradition. Deitch does acknowledge, however, the appeal of Basquiat's paintings for the New York art world. His work became successful at precisely the moment large-scale expressionist painting was making a comeback. Basquiat's street vocabulary, his emphatic references to black culture—his seeming ability to represent the condition of African American men in the United States on a heroic scale—seemed to vindicate the revival of figurative painting. Dick Hebdige has suggested that Basquiat appeared on the scene as "American modernism's first (and last?) officially appointed black savior . . . a messiah for painting suited to the New World in the eighties: a Picasso in blackface."[18] The often private and arcane subject matter of the neoexpressionists, artists like Schnabel, Susan Rothenberg, David Salle and Eric Fischl, could be seen as reactionary, the art world's version of Reagan politics. In reversing the so-called dematerialization of the art object, the new painting seemed to abandon the critique of the commodity that had been central to certain "conceptual" art practices of the seventies. But given Basquiat's subject matter, in which questions of race were confronted directly, his painting could not be so easily dismissed as merely ratifying conservative interests.

Adam Gopnik, of the *New Yorker*, is particularly dismissive of Basquiat's primitivism: "The 'African' masks, the coarse, zappy line, the scarifications, the scribbling intensity: these are not just the primitive clichés of 1984. They are the primitive clichés of 1948—or, for that matter of 1918." But that is exactly the point. Basquiat's pictures are an at-

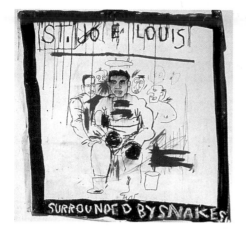

FIGURE 8.7 *Jean-Michel Basquiat*, St. Joe
Louis Surrounded by Snakes, *1982,*
acrylic, oil paintstick, and paper collage on
canvas, 40 x 40 in. Collection of Wojtek Fibak

FIGURE 8.8 *Jean-Michel Basquiat,*
Untitled (Aaron), *1981, ink, crayon,*
and acrylic on paper, 30 x 22 in.
Collection of Larry Warsh

tempt to restore to these clichés something of their original force. What
would happen if African-inspired forms were painted not by a Picasso
or a Dubuffet but by a black man? What if these so-called clichés were
used not to conjure up some fantasy of erotic otherness—Gauguin's
Tahiti natives or Picasso's prostitutes—but African American heroes?
For Gopnik, all that keeps "Basquiat's reputation afloat . . . is a series of
biographical myths."[19] He of course means Basquiat's troubled life and
death. But in fact, Basquiat willed this myth into being by evoking the
"biographical myths" of Charlie Parker, Joe Louis (fig. 8.7), and Hank
Aaron (fig. 8.8). By so doing he was also able to revitalize what to some
critics may be the biggest cliché of all, expressionist painting.

We see Basquiat, in Gopnik's words, building his "reputation" out of
"biographical myths" in one of his most celebrated paintings, *Charles the*
First (see fig. 8.4). Basquiat told Henry Geldzahler that his subject mat-
ter was "royalty, heroism, and the streets," themes that are all repre-
sented in this three-part canvas.[20] Robert Farris Thompson, among oth-
ers, has written on the painting in terms of Basquiat's identification
with its subject, the jazz saxophonist Charlie "Bird" Parker. Its triptych
form suggests an altarpiece; at top center is a small crucifix, and on the
left are the words "haloes fifty nine cent." Basquiat "crowns" his hero
both by association and by literally drawing a crown on the canvas, un-
der which he writes "Thor," the god of thunder. Parker is also honored

by the presence of Superman's insignia, in the middle panel. The street imagery of graffiti-like scrawls and comic-book heroes is combined with sophisticated references to myth and history, in what Thompson calls Basquiat's "self-creolization," which he defines as "being fluent in several languages and knowing how to fuse them to effect."[21]

Charles the First is about Parker's heroic status, his fame as the king of saxophonists. But this fame cuts both ways. The decapitation of Charles the First, king of England, is allied with Parker's death. Scrawled across the bottom corner are the words "most young kings get thier [*sic*] head cut off." The word "young" is circled and scratched out to suggest his premature death, while the misspelled "thier" resembles the sound of "tear," a word associated with mourning and wounds. Disembodied hands appear as the sign of creativity—the playing of an instrument, the painting of a canvas. But their disembodied quality also suggests an amputation, a cutting off of life and art making.

Basquiat did several paintings that referenced Parker, including *CPRKR* and *Horn Players,* thereby inviting critics to make the comparison between the black painter and the black saxophonist. Klaus Kertess writes at length of the parallels between the lives of Basquiat and Parker, noting "the romantic myth of Parker's life, a life lived as spontaneously as his music was composed. Parker was unpredictable, moody, charismatic, obsessed with work, and despite his addiction to heroin . . . had a voracious appetite for food and sex." He also sees a broad stylistic connection to the saxophonist: "Parker's spiky bouquets of sound and his black expressiveness were crucial to Basquiat."[22] Gopnik was infuriated by this equation of Basquiat's and Parker's practice and felt that Basquiat's ersatz primitivism had nothing to do with Parker's "concise dramatic form and lucid classical emotion."[23]

I believe that Gopnik is right to be leery about facile analogies between two very different practices and mediums. After all, what would painted jazz look like? Not like Basquiat's painting, but not like Mondrian's *Broadway Boogie Woogie* either (although I suspect making this standard art-historical association would not trouble Gopnik). What galls Gopnik is not the superficial equation of different mediums and contexts but the very idea that a young painter is being compared to a figure who has been bestowed with the canonical graces of "classicism and lucidity." What is missed is the poignancy of Basquiat's attempt to find a tradition and thereby an identity. Basquiat wants to give his pictorial art an African American lineage that did not seem to be available in the standard histories of modern art. Rightly or wrongly, Basquiat did

not identify with the few African American painters who had met with some establishment success—Romare Bearden, Jacob Lawrence, Bob Thompson, and Henry Ossawa Tanner. But his use of Parker was not merely an act of evoking a name or of drawing a personal parallel to Parker's life. Basquiat was making a claim about the potential expressiveness of painting. Of course, Basquiat's paintings are not literally like Parker's music, but perhaps in their improvisations, their mixture of high-modernist sources and vernacular gestures, their bright, lustrous colors, the tactility of their surface—they might summon up an equivalent vividness. Basquiat's wonderful economy of language is set off by his cacophony of marks, drips, and rubbings. A wordless music like Parker's may not be the most apt analogy (Greg Tate has suggested that Basquiat's art is a kind of painted hip-hop).[24] Yet the Parker connection is not about painting music but about finding a pictorial language that has an equivalent immediacy.

Whether Basquiat's vocabulary of forms appeared new or as a collection of clichés, it did the trick. It brought into being an artistic personality capable of being made over into a myth. Dick Hebdige writes that Basquiat played "his part in the restoration of the canvas-kings whose authority and privileged Truth claims had been seriously eroded by two decades of art theory and practice. . . . Basquiat's function was, in part . . . to keep at bay for a little while longer the unadmitted questions crowded round the edges of the frame."[25] Hebdige's reading suggests the enormous appeal of Basquiat for Julian Schnabel, who was *the* canvas king of the 1980s. Supposedly Basquiat saw Schnabel as the artist to beat in the art world. In 1981 he inquired of Ricard, "So, can you set up a boxing match between me and Schnabel?"[26] Schnabel himself said that Basquiat was competitive with him, relating how Basquiat peed on his staircase in order to "reclaim his territory." The word "reclaim" is an odd choice by Schnabel, since it suggests that Schnabel had stolen artistic priority from Basquiat—when chronologically it was Schnabel who was first on the scene. Yet Schnabel does steal from Basquiat after all. It is Schnabel who guiltily remembers besting Basquiat: "I did something once that I think really hurt his feelings. . . . This guy Rockets Redglare was walking down the street, and I said 'What are you doing?' He said, 'I'm going to Jean-Michel's—he's going to make a painting of me.' I said, 'I'll make a painting of you.' So he came over to my studio."[27]

But this theft is nothing in comparison to the film *Basquiat,* in which Schnabel steals Basquiat's practice.[28] Schnabel *recasts* it so that the name Basquiat merges with the name Schnabel. Even though by all reports,

Schnabel and Basquiat were never terribly close, Schnabel gives his surrogate, Albert Milo, played by Gary Oldman, a major role in Basquiat's life. The imagined presence of Schnabel in the narrative provides an excuse to fill the backgrounds of several scenes with a miniretrospective of his own paintings. Even the film's central metaphor, the image of the heroic surfer riding a huge wave until his eventual crash, is borrowed from Schnabel's autobiography.[29] But more startling is the fact that because Basquiat's estate would not grant permission to use the artist's work, Schnabel and his assistants were forced to make pseudo-Basquiat paintings.[30]

In chapter 2, I compared Jackson Pollock's actively painting a picture in Hans Namuth's documentary with David Hockney's only pretending to paint in *A Bigger Splash*. Both Pollock's and Hockney's acts of painting were clearly staged for the camera, but the fact that the artists played themselves gave the films a certain authenticity. When the actor Jeffrey Wright simulates painting a Basquiat, he is really simulating Schnabel simulating Basquiat. In the film Basquiat is seen as an instinctual genius, a kind of Midas—everything he touches becomes beautiful (he can make a portrait out of maple syrup). When the Milo/Schnabel character first sees Basquiat's studio, his exaggeratedly patronizing tone is meant to signal to the audience his envy. But he should not be envious at all, since he is staring at his own pictures, that is, Schnabel's pictures. The movie's parade of exploitative art-world figures, from Mary Boone to Henry Geldzahler, is meant to stand in contrast to the truth of Basquiat's paintings, though these paintings are fakes.

When I first thought about Schnabel's act of remaking Basquiat's painting, I was amazed by his gall. But in retrospect it suggests a certain suspension of ego, a desire to lose oneself in the other's practice. Just as Basquiat on some level wanted to be Parker, Schnabel wants to be Basquiat. What is involved in making pictures in another painter's style? Unable to literally copy Basquiat's canvases, Schnabel had to learn to make a believable approximation. It must have been a humbling experience. If ever there was an argument for the marvelous touch, design, and color of Basquiat's pictures, it is Schnabel's hollow imitations. In a certain sense Basquiat's pictures had to teach Schnabel how to paint. They became the original to Schnabel's copy. Ironically, the process involves Schnabel in the very kind of postmodernist process of simulacra that his autobiography suggests he despises.[31] Suddenly, instead of asserting the heroism of the creative act, Schnabel finds himself caught in

a Baudrillardian scenario. He is to Basquiat what Sherrie Levine is to Walker Evans, or Mike Bidlo is to Jackson Pollock.

Schnabel was not alone in learning to paint from Basquiat. Andy Warhol had the same experience. Throughout the 1970s, assistants manufactured Warhol's public paintings (at least this was the official story). In this way Warhol was always collaborating. His characteristic contribution was to take the photograph upon which the silk-screen images were based and then to direct assistants, whose degrees of involvement varied, in the final execution of his pictures. But in his collaboration with Jean-Michel Basquiat, the press made a big deal about Warhol actually putting hand to canvas. The collaborative paintings began with Warhol stenciling a logo—for example, "Paramount" or "Amoco"; Basquiat would then paint around and over it. Basquiat described the process in this way: "Andy would start most of the paintings. He would start one and put something very recognizable on it, or a product logo, and then I would sort of deface it. Then I would try to get him to work some more on it, and then I would work some more on it. I would try to get him to do at least two things. He likes to do just one hit, and then have me do all the work after that. . . . We used to paint over each others [*sic*] stuff all the time."[32]

Significantly, Basquiat uses the term "deface" to describe the way he paints on top of Warhol's work. Notice also the word "hit," which is the graffiti artist's term for putting one image on top of another. Basquiat's claims of a reciprocal process, a give-and-take, is touching. He ends by asserting that they both painted over each other's stuff. But this contradicts his complaint that Warhol was reluctant to paint once he had laid down the initial logos, preferring to get Basquiat "to do all the work after that." At least in Basquiat's description, Basquiat pushes the process along, encouraging Warhol to keep painting even as he defaces Warhol's work.

Rather than painting in a new way by collaborating with Basquiat, Warhol was actually painting the way he once had. For their collaboration Warhol resurrected the stencil method he had used to do his first "hand-painted" Pop pictures. The typical logos he passed on for Basquiat's brush in 1984–85, as seen in *Paramount* (fig. 8.9) and *Zenith* (fig. 8.10), must have been very much like the one in *Advertisement* of 1960 (fig. 8.11). Indeed, *Advertisement* looks unfinished because of the odd gaps in the Pepsi logo and the missing letters in the slogans. It is as if Basquiat had been summoned to restore the young Warhol to life and complete his picture.

In another sense Warhol becomes the ultimate tag for Basquiat to

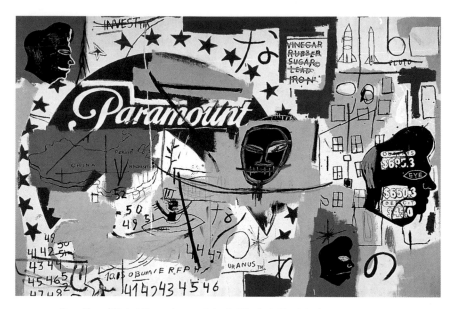

FIGURE 8.9 *Jean-Michel Basquiat and Andy Warhol,* Untitled (Paramount), *1984, acrylic on canvas, 76 ½ x 115 in. Private collection, courtesy Galerie Bruno Bischofberger, Zurich*

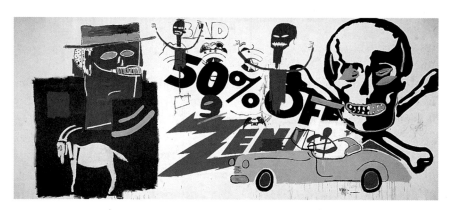

FIGURE 8.10 *Jean-Michel Basquiat and Andy Warhol,* Untitled (Zenith), *1985, acrylic on canvas, 117 ³/₈ x 264 ¹/₁₆ in. Private collection, courtesy Galerie Bruno Bischofberger, Zurich*

FIGURE 8.11 *Andy Warhol, Advertisement, 1960, synthetic polymer paint on canvas, 72 x 54 in. Collection of Dr. Marx, Berlin, on extended loan to the Städtisches Museum Abteiberg, Mönchengladbach*

bomb. By 1984, the year their partnership began, the name Warhol was as much a trademark as Paramount and Mobil. His signature appeared not only on his endless portraits and prints but across the banner of the national magazine *Interview* and on various other media projects. Warhol's use of corporate logos therefore could no longer be seen as subversive. In general his reputation in the mid-1980s was that of a tired artist whose best work was behind him.[33] *The Andy Warhol Diaries*, which were published in 1989, give ample evidence of his anxiety over his loss of fame and status. He was particularly disturbed by the relatively low prices his paintings were bringing at the auction houses, and he is clearly envious of Basquiat's success.

As Trevor Fairbrother notes, "Several new stars, from Haring to Schnabel, would have loved to be part of a two-person collaboration with Warhol, but Basquiat was the partner he chose."[34] In fact, the collaboration originally consisted of Francesco Clemente, Basquiat, and Warhol. This triumvirate, however, was relatively short-lived and was more a matter of shuffling paintings back and forth rather than working together under the same roof. At the same time, Clemente's European elegance and sophistication were not necessarily qualities that Warhol needed. Warhol Factory paintings like the *Skulls* and *The Last Supper* were already overburdened by art-historical allusions. Basquiat's press image as an angry young black painter was the perfect foil to Warhol's apparent blandness (and whiteness), epitomized by the weak-

FIGURE 8.12 *Andy Warhol,* Jean-Michel Basquiat, *1984, synthetic polymer paint on canvas, 113 x 70 in.*

ness of his recent art and his embrace of the establishment through such gestures as the famous Nancy Reagan cover of *Interview.*

Of course there was also a strong erotic component in Warhol's offering himself up to Basquiat. The *Diaries* are full of references to Basquiat's sexual prowess and the size of his genitals, which Warhol attributes to his racial inheritance. He notices, with admiration, Basquiat's erection when he wakes up from afternoon naps.[35] For Warhol, Basquiat was doubly potent: he was a hot painter and a hot body. Warhol's desire suggests important issues about what bell hooks has called "eating the other."[36] Hooks notes with approval the way Basquiat's typically shattered figures refuse the white commodification of the black body: "Commodified, appropriated, made to 'serve' the interests of white masters, the black body as Basquiat shows it is incomplete, not fulfilled, never a full image."[37] But arguably, the commodified black body reemerges in Basquiat's public image, most notably on the cover of the

New York Times magazine in February 1985 and in Warhol's attempt to exploit Basquiat's celebrity.

Warhol's image of Basquiat as Michelangelo's *David* (fig. 8.12) encapsulates these two aspects of Basquiat's figuration. The picture recalls less its original canonical source than the poses of models in *Physique Pictorial* (fig. 8.13) of the 1950s, when Warhol was Basquiat's age. Warhol presents Basquiat as a beautiful athlete who is nevertheless fragmented. Warhol's gaze exalts Basquiat, even as his act of objectification fractures his image. Basquiat is literally made up of several different Polaroids of his body, including a crotch shot in a jock strap. He returns the compliment, though his amusing painting of Warhol as an athlete (fig. 8.14) is more obviously deflating. He mocks Warhol's attempt to stay fit and his much publicized shame about his physical appearance by painting him as a weight lifter whose puny body shows little evidence that the workout is doing much good. Yet in the end, a comparison of the two portraits suggests that it is Basquiat's body that is more exposed, more open to fantasy and desire, and therefore more open to being disfigured.

This comparison of the artists' different body types continues in the posters for the 1985 collaborative exhibition at the Tony Shafrazi Gallery and its celebration at the Palladium (fig. 8.15). Here Warhol and Basquiat take the stance of sparring boxers. The posters are a parody of the fight between the German Max Schmeling and Joe Louis, which raised issues of Aryan supremacy. But this allusion to racial competition does not hide the erotic implications of these images. Why is it that Basquiat's young body is exposed, while Warhol's torso is covered up by a turtleneck sweater? And despite what we would imagine is Warhol's vulnerability in terms of his middle-aged body, it is he who scores the punch.

The boxing posters make explicit the competitive nature of the Basquiat-Warhol partnership, even as they suggest its erotic dimension through their clothed and half-naked bodies. The metaphor was extended in a Basquiat-Warhol collaborative sculpture: *Ten Punching Bags*. Warhol stenciled an image of Jesus Christ borrowed from Leonardo's *Last Supper* on each of the bags. Basquiat then repeatedly applied the word "judge" to each and scattered crude images and letters—a floating figure, a crown, copyright symbols. The allusion to boxing evokes the competitive nature of his collaboration with Warhol. Yet the repeated image of Christ and the word "judge" also imply that the artists themselves are punching bags, martyrs to the critics.

FIGURE 8.13 *Athletic Model Guild,*
"Richard Alan Assumes the David Pose,"
Physique Pictorial, *vol. 5, no. 3, p. 6*

In my earlier discussion of the partnership of Walker Evans and
James Agee, I made liberal use of Wayne Koestenbaum's theorization
of the dynamics of male-to-male collaboration. Koestenbaum holds
that "collaborators express homoeroticism and they strive to conceal
it." Collaboration quickly becomes competition. However, the differ-
ence between the Basquiat-Warhol partnership and those discussed by
Koestenbaum is that there is little attempt to conceal the homoeroti-
cism of the former. By 1982 Warhol's homosexuality was well known,
while Basquiat's notorious success with women made it relatively easy
for him to play, or play at, the role of love object, without any ques-
tioning of his heterosexuality. In this sense their relationship resembles
less Koestenbaum's repressed examples than it does the hustler and
queen of Warhol's films. Thomas Waugh writes: "If the queen is effem-
inate, intense, decked out, oral, desirous, . . . the hustler . . . is butch,
laid-back, stripped bare, taciturn, ambivalent, and 'straight.' The
queen looks, the trade is looked at; she verbalizes and he is spoken to
or about." He continues: "Together, the queen and the trade echo the

FIGURE 8.14 *Jean-Michel Basquiat,* Portrait of Andy Warhol, *1984–85, acrylic on canvas, 90 x 76 in.*

other subject-object pairings of the gay narrative tradition: the dandy and ephebe, the bourgeois and prole, the mentor and protégé, the artist and model, the 'dirty old-john' and the adolescent, the European and the 'Oriental,' and so on."[38] Warhol's fascination with the way Basquiat would nod off at the Factory suggests Waugh's description of the hustler as a passive object of the queen's look. Basquiat becomes yet another masculine "other" in the mold of Warhol's earlier superstar,

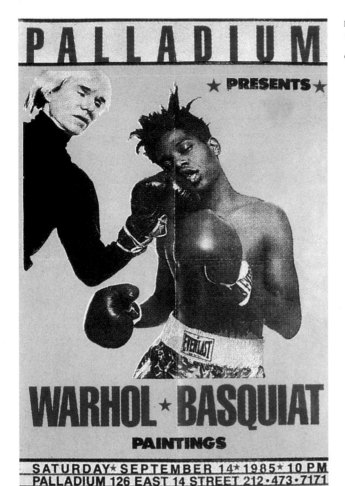

FIGURE 8.15 *Poster for Warhol-Basquiat painting exhibition, 1985*

Joe Dallesandro. Basquiat's role as an ultimate "other" is intensified by his race, so that we can add to Waugh's list of subject-object pairings the roles of master and slave. Indeed, built into Vivian Raynor's condescending description of Basquiat as an art-world mascot, in an article for the *New York Times,* was the implication that the pairing of the established white artist with his young black collaborator had to reproduce racial inequality as well as sexual perversion (she also calls their partnership a "pas de deux").[39]

The painting *Amoco* (fig. 8.16) represents aspects of the dynamics of the Basquiat-Warhol collaboration that I have suggested above. The very trademark "Amoco" may convey a desire for an *amicable* merging. The Amoco gas sign, however, appears alongside that of a major com-

petitor, Mobil, represented by its name and the flying Pegasus. One might interpret the use of different gasoline trademarks as another competition of brand names—those of the two artists. These sign elements were Warhol's most obvious contribution; Basquiat's were more varied. On the left is a large penguinlike figure. He has a black face, and his uniform brings to mind a waiter or some kind of servant. In his hand is a sticklike form with plumes, which suggests a brush, making him the surrogate for Basquiat himself. The phrase "keep frozen" describes the role of the male hustler, who, though the object of heated desire (the flames coming out of the horse's mouth), remains cool to it. Next to the penguin is a symbol derived from the communication codes used by hoboes, which Basquiat adopted as his own (fig. 8.17). He includes its translation: "sucker easy mark."[40] This seems to me to be a reference to Warhol's homosexuality. It says that Warhol is a cocksucker, even as its phallic shape emphasizes Basquiat's masculinity.[41] In this painting Warhol seems to offer up the feminized ground of his stenciled logos to Basquiat's masculine brush, yet in truth there seems to be a reticence on the part of both artists to interact too much. Just as the trademark of Amoco and Mobil remain separate, it is fairly easy to tell the two artists' contributions apart. According to Waugh, the queen is active, while the hustler is passive: "Interacting yes, fucking no. . . . Queen and trade remain separate, never coming together."[42] The picture both ratifies the typical queen-hustler relationship and confuses it. If Basquiat's body were the object of Warhol's desire, it is also true that Warhol's art and reputation were the object of Basquiat's admiration. Basquiat may have at times fulfilled the role of a passive and silent body to Warhol's gaze, but it is Basquiat's brushwork that animates the paintings. Basquiat's art is also full of text; he is not a quiet partner. Nevertheless it is not really clear which of the two artists is the easy mark. Both are adept at *making their mark*.

The initial exhibition of the collaborative paintings was a financial failure; only one painting sold. Criticism was mixed, but the most immediate and public response, Raynor's review in the *New York Times*, was devastating, particularly to Basquiat. Taking her cue from the exhibition poster, she declares, "Warhol, TKO in 16 rounds." Withdrawing her earlier praise of Basquiat's work, she feels that he has "succumbed to the forces that would make him an art world mascot" and has become a "too willing accessory" to "Warhol's manipulations." This initial negative reaction to the collaboration appears to have damaged the two artists' friendship.

FIGURE 8.16 *Jean-Michel Basquiat and Andy Warhol,* Untitled (Amoco), *1984, acrylic on canvas, 120 x 284 ½ in. Private collection, courtesy Galerie Bruno Bischofberger, Zurich*

Bruno Bischofberger, who still owns the bulk of the Basquiat-Warhol paintings, has made a concerted effort to reclaim the collaboration. The deaths of Warhol and Basquiat have increased the interest and value of this series of pictures. The suspicion their collaboration engendered while they were alive has given way to a more positive assessment. José Esteban Muñoz offers a subtle and complex analysis of the work, maintaining that Basquiat "disidentified" with Warhol, that is, he was both influenced by his practice but also managed to distance himself from that influence. Warhol's ambivalent use of the trademark in his Pop paintings points the way for Basquiat's own use of commodity symbols, so that, according to Muñoz, Basquiat is able to "open up a space where a subject can imagine a mode of surviving the nullifying force of consumer capitalism's modes of self." Muñoz is not blind to Warhol's racist impulses or his exploitation of Basquiat, but like the other writers in the anthology *Pop Out,* he idealizes the liberating force of Warhol's queerness, so that it makes up for his sins. Indeed, he describes both artists as "divine creatures who inspired and enabled each other through queer circuits of identifications."[43]

For Muñoz, Warhol's racist entries in his diaries, in which he refers to Basquiat's "b.o." and worries about Basquiat's having his home number because of the young artist's drug addiction,[44] is Warhol's own form of disidentification. In belittling Basquiat through racial stereotypes, Warhol distances himself from his own dependence on Basquiat to revi-

FIGURE 8.17 *Hobo signs from Henry Dreyfuss,* Symbol Sourcebook: An Authoritative Guide to International Graphic Symbols *(New York: Van Nostrand Reinhold Co., 1984)*

talize his art. Yet Warhol's anxieties about Basquiat do not bode well for the equality of their relationship. To be fair, there are other indications in the *Diaries* that Warhol enjoyed Basquiat's attention, was worried about Basquiat's health, and was unhappy when he no longer came around. Basquiat too seemed to care for the older artist. All reports indicate that despite the rift in their friendship at the termination of the exhibition of their collaborative paintings, Basquiat was deeply upset when Warhol died unexpectedly following routine gall bladder surgery in 1987. But to focus on the familial aspects of their relationship—thinking of Warhol as a kind of surrogate father or brother to Basquiat, as Fairbrother wants to—is to ignore Warhol's relentless deadpan stance and his vaunted habit of just letting things happen. I have a hard time thinking about Warhol in fuzzy, nurturing terms. It may be true that his public masquerade of indifference was a cover for a private individual who was capable of affection. But Warhol's personal generosity was always mediated by his public performance of apathy. Indeed, Warhol's oscillation between absence and presence made him the very model of white patronage that objectifies African American athletes and entertainers. At the same time, Basquiat's erratic behavior and his drug

addiction fulfilled Warhol's racist expectations. Both played each other's "other."

In retrospect, the Basquiat-Warhol collaboration might seem like a zero-sum game. Perhaps this is the implication of their picture *Poison* (fig. 8.18) and its skulls. If Basquiat's painting betters Warhol's by seeming fresher and more expressive, that victory was canceled out by Warhol's habit of using other assistants. (Exploiting the work of others was a precisely Warholian gesture. He boasted that he got his best ideas from other people.) We may recognize in Basquiat's line and color the element that animates their partnership, but because of differences in age and status, Basquiat's very vividness becomes part of Warhol's ongoing strategies, his manipulations.

But then again perhaps Basquiat wasn't the "sucker" after all. At least Warhol was not so sure. In the *Diaries* Warhol mentions "Jean-Michel's finding out how you have to be a business, how it all stops being just fun, and then you wonder, What is art? Does it really come out of you or is it a product? It's complicated."[45] Here, Warhol posits himself as the experienced artist who teaches Basquiat about the business of art. But this lesson forces Warhol himself to repeat the most fundamental aesthetic questions (the very ones his own work like the *Brillo Boxes* supposedly rendered invalid).[46] Warhol's answer that "it's complicated" is less an explanation than an admission of the difficulty of answering. Ironically, Warhol turns to Basquiat for a lesson. In the *Diaries* he remembers that Basquiat came over and "painted over a painting that I did, and I don't know if it got better or not."[47]

That Warhol had allowed himself to be effectively painted out by a twenty-four-year-old is fascinating. It recalls de Kooning's modesty in allowing one of his drawings to be erased by Robert Rauschenberg. Rauschenberg's drawing purposely deflated de Kooning's powerful mark, as if all that was left for the younger artist to do was obliterate the older. But given the blankness of Warhol's art, with its own relentless strategies of negation, Warhol's gesture to Basquiat reads like a negation of a negation. That is, it seeks to reverse the Oedipal urge to end painting, as embodied in Rauschenberg's erasure and already threatened by Jackson Pollock's drips. To put it another way, Warhol joined forces with Basquiat with the hopes of learning how to paint again. In this sense, whether the collaborative pictures were successful as paintings is not as important as the fact they were paintings at all. Warhol declared, "Jean-Michel got me into painting differently, and that's a good thing."[48] As a painter myself, I cannot help but take satis-

FIGURE 8.18 *Jean-Michel Basquiat and Andy Warhol,* Untitled (Poison), *1984, acrylic on canvas, location unknown*

faction in the return to painting of an artist who had supposedly summoned its death.

I end with a noncollaborative work of Basquiat from the same time as the Basquiat-Warhol collaboration, an untitled painting on a refrigerator (fig. 8.19). Part of the Basquiat legend was that when he was discovered, he was so poor that he had to paint on found materials. By 1984, however, he surely could have afforded canvas, so the use of the refrigerator may seem affected. But this is not any refrigerator; it is old and covered with precisely the kinds of automobile-related logos that populate the Basquiat-Warhol pictures—logos that suggest a male adolescent's fascination with cars that go fast and win competitions. These typically masculine trademarks of public competitiveness are pasted onto the maternal body of the refrigerator. I am particularly struck that this is a General Electric refrigerator. The GE logo was used by Warhol in several collaborative paintings.[49] Perhaps it is a reference to "Oh, gee," one of Warhol's favorite expressions. This play between the inarticulate expression and the power of the corporate symbol mirrors

FIGURE 8.19 *Jean-Michel Basquiat*, Untitled (Love), *1984, acrylic, oilstick, and paper on refrigerator door, 49 ³/₈ x 30 x 5 in.*

Warhol's ability to be both blank and powerfully present. The refrigerator itself figures as a motif in Warhol's career. The typical objects of his Pop period—Campbell soup, Coca-Cola, Brillo boxes—belong in and around refrigerators. One of Warhol's first Pop paintings, done in 1960, has the title *Icebox* (fig. 8.20), and in 1970 he curated a show at the Museum of Art of the Rhode Island School of Design called *Raid the Icebox*.[50] By making these references, I do not mean to suggest that Basquiat necessarily had Warhol in mind when he painted on this particular refrigerator, only that the refrigerator with its stickers could be taken as a Warholian ground. It was a banal domestic object that was

FIGURE 8.20 *Andy Warhol, Icebox, 1961, oil, ink, and pencil on canvas, 67 x 53 ¹/₈ in. The Menil Collection, Houston*

covered with the trademarks of the commodity culture that was Warhol's great target and comfort. Across this Warholian refrigerator Basquiat painted a patch of green and then scrawled the words "love" in pink, as if painting such a phrase of tenderness could transfigure the icebox. It might warm it up and make it speak of its closed private interior. Basquiat's obsession with trademarks was surely about a desire to, as he put it, "build up a name."[51] And so he was attracted to Warhol, who, more than any other contemporary artist, knew how to convert trademarks into fame. What I think Warhol wanted to learn from Basquiat was how to turn famous names back into feelings, back into a work of art that, like this refrigerator, suggests the possibility of replenishment and the integrity of a private self. That their collaboration in some sense "bombed" does not negate the ultimate value of Basquiat's audacious "love," with its lesson on how to paint if not differently or better, then at least again.

9 Advertisements for the Dead

Eternal duration is promised no more to men's works than to men.
—Marcel Proust

The title *Let Us Now Praise Famous Men* is taken from verse 44 in *Ecclesiasticus*, which is part of the Apocrypha. Agee includes the entire verse at the conclusion of his book. It speaks of "leaders of the people by their counsels" and of great artists "such as found out musical tunes, and recited verses in writing." "All these were honoured in their generations, and were the glory of their times," because, as both Rene Ricard and Norman Mailer would agree, they "left a name behind them." But what of the people who were not famous? *Ecclesiasticus* continues, "And some there be which have no memorial; who are perished, as though they had never been, and are become as though they had never been born."[1]

What follows is an attempt to think about those who have died without leaving a name. My subjects are not fame but obscurity and the role of art in remembering and forgetting the dead. My two examples, the watercolors of my best friend, Marc Lida, and the NAMES Project Quilt, are intensely personal. I cite them not as models for art production in the twenty-first century, nor to castigate what has come before. Rather, their personal resonance for me is a way to abandon the distancing techniques of art-historical description and evaluation so as to make vivid the sensation of loss and the work of remembrance that is my final theme.

"Art is long, life is short," or so we are told. Art bestows immortality on the artist. But what if the artist never becomes famous, and death comes before his or her art is ever known? A cliché has it that a work of art becomes truly valuable only after its creator dies. In truth, it is rare for an artist to achieve posthumous fame after creating in obscurity.[2] Indeed, how could it be other-

wise? How can works of art be known if there is no one to care for them and put them before the public? These are tasks that initially fall on the artist. If lack of fame hinders an artist's life, creating poverty and depriving him or her of the time and space to make art, it can be equally devastating to the works themselves, after the artist's death. Because such art has little monetary value, it may not be properly preserved or documented. After all, galleries rarely have the financial incentive to represent the estate of an artist who failed to win an audience when he or she was alive.

The problem of what becomes of works of art when their maker dies began to haunt me in 1992, when Marc Lida succumbed to AIDS at the age of thirty-four. He was not entirely unsuccessful as an artist. His illustrations were published in the *New York Times* and the *Village Voice*, but he was never able to make a living by selling his art. In part he became a social worker to help people living with HIV/AIDS, because, as he wrote in his application to graduate school, "I have no indication whether I'll ever be able to support myself as an artist."[3] Part of the problem was that he worked in watercolor and made illustrations—two modes usually considered minor in the art world. But if by illustrating he gave up the chance of being represented in the high-art venues of galleries and museums, the great works he chose to illustrate made his work unmarketable among art directors and publishers by virtue of their exalted nature. Until the early part of this century, novels customarily included images, but today fiction is rarely illustrated.

Marc's other great subject, gay nightlife, had a limited commercial audience as well. Paradoxically, to art editors his illustrations seemed too much like high art, whereas to gallery directors they seemed too much like illustration. His line was a bit too crude and expressive to sit passively on the page, his color too variegated to be easily reproduced, and his figures too mannered to fit the needs of advertisers. He might have done children's books, but he was never able to focus on an appropriate story for children. Also there would have been the problem of his overtly gay work. Is it possible for a successful children's illustrator to exhibit pictures of such homosexual nightspots as the Mineshaft (fig. 9.1) or the Saint?

Marc's heart was in making pictures like *Freud Wrestling with Dora's Demons* (fig. 9.2). For him, Dora's analysis was a kind of fairy tale peopled with a beleaguered heroine, a patient, and a courageous hero, the doctor. The watercolor transplants Henry Fuseli's *Nightmare*, an image Freud liked, to the Viennese psychoanalyst's office. Like Fuseli's tor-

FIGURE 9.1 *Marc Lida,* The Mineshaft, *c. 1982, watercolor, 12 ½ x 20 in. Collection of David Lida*

mented female, Dora's head is thrown back, her body splayed across the analyst's couch. In place of Fuseli's incubus, Dora's dreams take the form of the characters of her case study. The humor of the picture is less a matter of its exaggerated gestures than of Lida's irreverence in daring to illustrate such a serious text. Freud, rather than Dora, becomes the target of Lida's absurdity. Dora's nightmares share the same visual space as that of the doctor's office. There is no boundary between real and unreal. Here, the patient-doctor struggle—the so-called talking cure—seems like a dream, or just another fiction. There is no difference between Dora's fantasies and the fantasies of psychoanalysis.

Although Dora's pose is lifted from Fuseli, Lida's real model was the work of the American painter Charles Demuth. One of the things that cemented our friendship when we met in 1972 was our shared love of Demuth's watercolor illustrations of the writings of Emile Zola, Walter Pater, Edgar Allan Poe, and Henry James. Intensifying our pleasure in these well-known works was our knowledge that Demuth had also done private pictures of homosexual bathhouses and sailors having sex with one another. Marc learned from and transformed Demuth's style and took on similar subject matter. Demuth's pictures of avant-garde hangouts, vaudeville theaters, and bathhouses of the period were a model for Lida's extensive recording of bars, discos, and sex clubs of the 1980s.

In 1927 Demuth wrote Alfred Stieglitz that he had been reading Marcel Proust's novel: "So I have joined the others'—not without reser-

FIGURE 9.2 *Marc Lida,*
Freud Wrestling with Dora's
Demons, *1983, watercolor,*
22 x 30 in. Private collection

vations, however. He's too much like myself for me to be able to get a great thrill out if it all,—marvelous, but eight volumes about one personal head-ache is almost unreadable, especially when you have your own head-ache most of the time."[4] Despite his ambivalence, or because of it, Demuth planned to illustrate the "marvelous" opus. He insisted that he needed to do the work in Paris, but he succumbed to his own "personal headache," diabetes, in 1935 and never began the project.[5] And so, in taking on Proust's work Marc was taking up the unfinished project of his chosen master. In bringing Proust and Demuth together through his art, Marc was merging two aspects of his own ambitions, in that throughout his adolescence he had imagined himself a writer. When we first met at the age of fifteen at Buck's Rock, an art camp in New Milford, Connecticut, that catered to the creative children of New York intellectuals, Marc boasted that he had written dozens of plays. I was suitably impressed; only later did I find out that they were very short, with plots borrowed from *I Love Lucy* and movies from the 1930s. It was during our second summer at camp that Marc announced he was reading Proust. Surely, at sixteen he was too young to understand the novel's daring formal invention or to appreciate the significance of its theme of time and memory. Instead, he was reading it for the plot, such as there is, and enjoying Proust's fascination with gossip, particularly his descriptions of clandestine sexual behavior. That summer the melodramas of *All About Eve* and *Gaslight* merged with the sexual exploits of Baron de Charlus; all the while Marc spoke of these fictional characters as if they were living acquaintances.

When Marc was older, he reread Proust with a greater understanding of the novel's stylistic complexity and a heightened awareness of its depiction of homosexuality, prejudice, and illness. In the mid-1980s, he did several sketches based on the novel, but not until 1989 did he begin to work on his Proust series in earnest. It was around this time that he found out he was HIV positive.

The Proust series was exhibited in Marc's lifetime, under fairly modest circumstances. Lida was a student and friend of the well-known children's illustrator Maurice Sendak, who purchased the Proust watercolors and helped arrange for their exhibition at the School of Art of Yale University in 1991. Unfortunately the New York critics did not notice that show. When Marc died the following year, he did not receive an obituary in the *New York Times,* one of the bellwethers of mortal fame. Since his death, his work has for the most part been seen only in group shows. It remains little known outside a small set of friends and colleagues.

At the end of the final section of *Remembrance of Things Past,* Proust insists that art has the power to live on after its author's death: "The cruel law of art is that people die and we ourselves die after exhausting every form of suffering, so that over our heads may grow the grass not of oblivion but of eternal life, the vigorous and luxuriant growth of a true work of art."[6] But a few pages later he remarks, "Eternal duration is promised no more to men's works than to men."[7] In other words, the work of art itself may not endure any longer than its creator. What can I do to ensure that Marc and his work do not disappear? If there was ever a noble use for my training as an art historian, it is to focus attention on the work of my friend and rescue it from oblivion. This discussion provides such an opportunity, but I have another motive for writing about Lida's watercolors that goes beyond that. As reflections of Proust's text, these paintings are about the problem of memory. To confront the work of Lida and Proust is to grapple with the question of how works of art help us, or fail to help us, remember.

Marc died before he had properly prepared his work in terms of titles and dates. I share the blame. In the last months of his life I was uncomfortable discussing anything that might suggest that he was dying.[8] I let the chance pass to interview him about the meanings of his pictures. I also failed to do the most rudimentary job of art-historical scholarship, which is to properly document the work. But in the process of reassembling the text and images I was forced to reconsider the

meaning of the watercolors and their relationship to Proust. I discovered certain aspects of Marc's work that I had not noticed. For example, I had wrongly assumed that the pictures served as an informal homage to Proust; that is, they did not really illustrate the novel in a systematic way. In fact Marc was far more serious about illustrating the complete text than I had imagined. Although he was clearly drawn to dramatic moments of scandal and humor, such as when the unnamed narrator sees two women kissing, or when Baron de Charlus reveals his homosexuality, he was careful to distribute the pictures uniformly throughout the book, as if imagining that his pictures would someday illustrate the novel.

In trying to reconstruct the sequence of the pictures in relationship to the text, I found myself trying to remember my experiences with Marc as well. It was as if I were ritualizing the major theme of Proust and of Marc's series, "The Search for Lost Time," or as it was creatively mistranslated by C. K. Scott Moncrieff, *Remembrance of Things Past.* During the process of rereading, I came upon this famous passage: "And so it is with our own past. It is a labour in vain to attempt to recapture it: all the efforts of our intellect must prove futile. The past is hidden somewhere outside the realm, beyond the reach of intellect, in some material object (in the sensation which that material object will give us) of which we have no inkling. And it depends on chance whether or not we come upon this object before we ourselves die."[9]

It is Proust's conceit that certain pedestrian events, such as tasting a madeleine dipped in herbal tea or stepping on an uneven flagstone, can bring back the past with all the sensations that were felt on the day when the author had first had those experiences. He opposes this complete, almost hallucinogenic memory, to the usual idea of remembrance, which is only a series of conscious recollections: "the truths which the intellect apprehends directly in the world of full and unimpeded light have something less profound, less necessary than those which life communicates to us against our will in an impression which is material because it enters us through the sense but yet has a spiritual meaning which it is possible to extract."[10] Unfortunately we have no control over when these accidents that spur involuntary memories may occur. They may never happen. But even if these sensations do take place, the very moments they bring back will not last. These sensations, no matter how vivid, will be buried again in the past.

The sensations Proust speaks of are so subjective, so highly personal, that they cannot be fully shared. We cannot taste the madeleine or ex-

perience Proust's epiphany. In the end, Proust is presenting us not so much with lost time but with a description of what it might be like to find it. By suggesting that time can be recovered in such a way, however, he is also insisting that it was never really lost, that it stays with us as part of our very being. Time is "embodied," made up of "years past but separated from us."[11] We carry it with us to be restored in brief moments, involuntarily, in key accidental events. Yet in the end it is not chance or random objects that give us a sense of what it is to recapture time; it is Proust's art: "The task was to interpret the given sensations as signs of so many laws and ideas, by trying to think—that is to say, to draw forth from the shadow—what I had merely felt, by trying to convert it into its spiritual equivalent. And this method, which seemed to me the sole method, what was it but the creation of a work of art?"[12]

Proust's descriptions illustrate themselves by creating a picture in our mind. By making Proust's text concrete, illustration runs the risk of providing too much of the materiality and not enough of the elusive "spiritual meaning" that Proust wanted to extract from experience. Yet the very translucency and insubstantiality of Marc's watercolor technique has the effect of describing characters without fixing their corporeal presence. Marc once wrote a description of the illustrations of Maurice Sendak that is also an apt description of his own style: "Though the viewer can make out the subject of the drawings, many of the images seem to be juxtaposed on each other, lending an almost collage-like quality to the pictures. . . . Figures strike operatic, gestural poses; the backgrounds become like stage settings, with the action of the pictures played in the foreground." Lida goes on to comment that these techniques, "which might be used by 20th-century artists for distancing effects—irony, parody or camp . . . engage the viewer, . . . move the viewer, bring him or her into a state of interest, and hopefully, emotional intensity."[13]

Marc's characteristic mode is comic and grotesque. There is little sense of the narrator's inner struggles that make up much of the text. But rather than undercutting Proust's high seriousness, the result is an augmentation of the social and erotic aspects of *Remembrance of Things Past.* Marc reads for moments of both private scandal and public spectacle. And so he begins the series with the scene (fig. 9.3) in which the narrator meets his uncle's mistress, the lady in pink, a famous actress, and impulsively kisses her hand. Rather than show the key moment when the narrator eats a madeleine, thus introducing the major theme of the novel, he instead emphasizes an instant when the narrator learns

FIGURE 9.3 *Marc Lida, The Proust Series: The Lady in Pink, 1989–90, watercolor, 10 ³/₄ x 14 ¹/₂ in. Collection of Maurice Sendak*

something about sexual desire. Taking his lead from Proust himself, Marc makes the narrator in his watercolors a self-portrait. But where Proust's hero is in search of lost time, so that his entire project reads like an extended memory, Marc's alter ego seems in pursuit of experience itself, like David Hockney in *A Rake's Progress*. It is almost as if the novel has come to life around him. Perhaps this is a matter of the different mediums of writing and painting. The watercolors suggest that the action is occurring directly in front of the viewer in the present, whereas the text is written as if the author is recalling events. In general, painting tends toward immediacy—it is about presence—while writing, even when it takes the present tense, always seems mediated by time.

Marc is particularly drawn to the voyeuristic element in Proust's novel. In the second illustration he depicts the narrator as a shadowy figure outside a window, spying on Mlle Vinteuil as she embraces her lesbian lover (fig. 9.4). Later in the series, he shows the narrator looking through a transom window at Charlus and Jupien. This is the moment in which Charlus's and Jupien's masculinity becomes "inverted."[14]

FIGURE 9.4 *Marc Lida,* The Proust Series: Mlle Vinteuil and Her Friend, *1989–90, watercolor, 10 ¼ x 14 ½ in. Collection of Maurice Sendak*

In representing clandestine sexuality, Marc represented his own homosexuality. But perhaps more evocative of Marc's life are the depictions of Swann's terminal illness. He illustrated the key scene in which Swann tells the Duchesse de Guermantes that he is dying (fig. 9.5).

"Very well, give me in one word the reason why you can't come to Italy," the Duchess put it to Swann as she rose to say good-bye to us.

"But my dear lady, it's because I shall have then been dead for several months. According to the doctors I've consulted, by the end of the year the thing I've got—which may, for that matter, carry me off at any moment—won't in any case leave me more than three or four months to live, and even that is a generous estimate."

The Duchess stops for a moment, caught "between two duties as incompatible as getting into her carriage to go out to dinner and showing compassion for a man who was about to die." She decides that the "best way of settling the conflict would be to deny that any existed. 'You're joking,' she said to Swann."[15]

As if the two shared the same disease, Carposi's Sarcoma, Marc painted blotches on Swann's skin. Depicting Swann's conversation with

FIGURE 9.5 *Marc Lida,* The Proust Series: Swann Tells Mme de Guermantes That
He Is Dying, *1989–90, watercolor, 10 ¾ x 14 ½ in. Collection of Maurice Sendak*

the duchess and his later appearance at a reception was a way for him to
represent the difficulty of living with a disease that society would rather
not discuss or see. It must have taken courage to give form to this scene,
knowing that Swann's death sentence was his own fate. The pictures'
glowing colors, and their extraordinary humor, are in stark contrast to
the condition of their making—the onset of a wasting disease that even-
tually left Marc unable to work.

In 1983, years before he learned he was HIV positive, Marc repre-
sented the disease directly in a series entitled *Drawings of Sex and Death*
(fig. 9.6). He placed explicit images of orgies and backroom sex next
to jolly pictures based on song titles. This attempt at a modern-day
dance of death was exhibited in the basement of the Pyramid Club, a
hot spot in the East Village of the early eighties. Lida's intent was to
shock his audience:

> I do think that sex is shocking again, homosexuality in particular, be-
> cause sex is associated with getting sick. Obviously, I am not advocat-

FIGURE 9.6 *Marc Lida*, Drawings of Sex and Death: AIDS #7, *1983, tempera on paper, 36 x 48 in. Collection of David Lida*

ing this kind of sex; there is a certain nostalgia for this kind of sexuality, and it's a different kind of nostalgia than the other paintings, because it's something that I've actually lived through. . . . I think that in the age of AIDS, it is almost distasteful to deal with sex like this, certainly, uncomfortable. I do want to make people uneasy with it because I think sex is fundamentally an uneasy thing and in America people try and prettify it.[16]

Marc claimed to be representing a world he knew well, but the drawings of *Sex and Death,* for all their baroque horror, lack the intensity and humanity of the Proust series. In the Proust watercolors sex and death are still the main themes, but they are mediated through a complex narrative that finds in art precisely the means to hold mortality at bay through the recovery of the past. However distant Proust's life and times are to the age of AIDS, it provided Marc with the means to directly confront his illness. The attempt to shock people by explicitly representing sexual encounters of the earlier series is replaced by the dignity of Swann as he calmly tells the duchess he is dying.

In the end, Marc was unable to finish his Proust watercolors. The illustrations stop at the final two volumes of the series, the very two volumes that Proust himself did not live to see published. One of the earliest

FIGURE 9.7 *Marc Lida,* The Baron During the War, *1985, watercolor, 22 x 30 in. Private collection*

sketches for the series shows Charlus being whipped (fig. 9.7)—one of Marc's favorite scenes in the novel. Yet as he worked on the final series, I think he became increasingly drawn to scenes of people simply meeting. Perhaps he had come to realize that private sexual perversions do not necessarily convey much about one's inner life.

My favorite picture in the series, *Mme. Swann in the Allée des Acacias* (fig. 9.8), is not a particularly dramatic moment in the novel. It illustrates the scene in which the young narrator lifts his hat to Odette: "I was now close to Mme Swann, and I doffed my hat to her with so lavish, so prolonged a gesture that she could not repress a smile."[17] The picture is about the way the common world can be miraculously transformed into diaphanous lavenders and greens through a mere exchange of gestures between human beings. The search for lost time that is the novel's theme is above all an attempt to salvage and heighten such moments.

The Proust watercolors are extraordinarily beautiful, but they are no substitute for Marc's presence. With each year I find it harder and harder to conjure up the friend I knew. As Proust suggested, we cannot summon the past. The most powerful memories come back to us at the

FIGURE 9.8 *Marc Lida,* The Proust Series: Mme Swann in the Allée des Acacias, *1989–90, watercolor, 10 ³/₄ x 14 ½ in. Collection of Maurice Sendak*

most unlikely times and through what might be considered the most trivial experiences—if we are lucky. Despite all the clichés, art is not the place where the essence of a person is encapsulated or lives on. My task as an art historian is to make sure that Marc's work continues to be seen, not because it is a way to keep his memory alive but because it is splendid painting. Although he worked in what some might deem a minor medium, his ambitions were high. He courageously and outrageously took on one of the most admired works of twentieth-century literature. He demonstrated that painting can still take on the great themes, that it can confront questions of death and memory, in a manner that is immediate and pleasurable. Perhaps one day, Proust-like, I will trip on the pavement and find myself carried back to Buck's Rock to hear stories about Lucille Ball or Charlus. Until then, I shall console myself with the joy of looking at Marc Lida's very present paintings.

NAMES

If the reader has made it this far, he or she must have noticed a fallacy in my claim that Marc Lida's work is in danger of becoming ob-

scure. After all, his watercolors are in the collection of the most prestigious children's illustrator in the United States. And by a kind of Stieglitz-like sleight of hand, I have managed to include them in the present book alongside the work of such luminaries as Georgia O'Keeffe, Jackson Pollock, and Walker Evans. In essence, Lida has garnered the very praise that *Ecclesiasticus* tells us is properly bestowed on famous men. The great passage in the verse that speaks of those "who are perished, as though they had never been" is reserved not for such a well-connected artist as Marc Lida, whose works are cherished by the cognoscenti, but for those who have died without leaving a name.

In my discussion of graffiti in relationship to the work of Basquiat and Warhol, I emphasized the importance of the name as a means of exerting the author's existence. Graffiti often takes the form of one name being written on top of another. In much the same manner, the Basquiat-Warhol collaboration involved overwriting one trademark with another. This struggle for recognition was predicted by Rene Ricard's claim that in the art world one must "become the iconic representation of oneself if one is to outlast the vague definite indifference of the world." In Ricard's writing, art making becomes confused with notoriety, since without fame the artist and his or her work disappears. To be anonymous is to have never existed.

The assumption that writing the name is a check on oblivion is not just a matter for artists. It is fundamental to our culture's most ambitious monuments to the dead. The National Vietnam Veterans Memorial, the United States Holocaust Memorial Museum, and the NAMES Project Quilt all involve lists of names. The Vietnam Veterans Memorial, designed by Maya Lin, profoundly influenced the later two. It is made up of two enormous slabs of black granite embedded in the Washington Mall and inscribed with the names of over fifty-eight thousand American military personnel who died or were declared missing in Vietnam.[18] The Holocaust Memorial Museum incorporates names in a more active way. Visitors to the museum are given the number, the name, and a brief biography of a concentration-camp prisoner, in a process that ritualistically reenacts that person's terrible experience.[19] The NAMES Project Quilt (fig. 9.9) incorporates the list in numerous ways: in its panels, which usually include names; in guides that direct viewers to the individual panels that are dedicated to those who have died from complications of AIDS; and in the names read aloud when the panels are displayed. In all of these memorials, the naming of those

FIGURE 9.9 *NAMES Project, AIDS Memorial Quilt, 10 October 1992, Washington, D.C.*

who have died is meant to bestow value on the individual's life, even as the overwhelming quantity of names emphasizes the enormity of the loss. In the end, the sheer number of names (still growing in the case of the Quilt) speaks loudest for the significance of these memorials.

Yet of these three memorials to the dead, only the NAMES Project was created directly by the families and friends of those who died. In this sense it serves more as a cemetery than as a unified memorial, each panel taking the place of a headstone.[20] Even the size and proportions of the individual panels (three feet by six feet) suggest a standard cemetery plot or a coffin. However, where modern cemeteries impose strict guidelines on the format of headstones and plots, the panel makers have few constraints. Although the panels must conform to a given size,

materials are limited only to those that can reasonably be applied to a canvas backing when the panels are joined into larger squares (there are eight panels to each square). These materials may include—among the vast array of possible objects commemorating an individual who has died—traditional quilting fabrics, dolls, car keys, champagne glasses, sequins, tennis shoes, wedding rings, photographs, stuffed animals, and buttons. Where the size and shape of a cemetery headstone is dramatically limited by cost, most of these materials are relatively inexpensive. This extraordinary variety constitutes a critique of the modern cemetery, with its standardized headstones and dull repetition of names and dates.

Since the pyramids, the significance of memorials has been measured by their size. But what makes the Quilt so unusual is not its vastness but its mobility. Selections of panels are constantly being sent around the country to schools, churches, and community groups. According to the official Web site of the NAMES Project, the displays are intended to:

Provide HIV prevention education.

Provide a creative means for remembrance and healing.

Illustrate the enormity of the AIDS epidemic.

Increase public awareness of AIDS.

Raise funds for community-based AIDS service organizations.[21]

Instead of the viewer going to the monument, the Quilt travels to its audience. A conscious effort is made on the part of the project to send out panels that relate to the particular community they are visiting. This quality of mobility bestows the panels with a liveliness that we do not usually associate with memorials to the dead.

Of course, the names of the NAMES Project refer not to the panel makers, or what might be called the Quilt's "artists," but to those who died. The panel makers themselves often remain anonymous. If there is a single name that can be attached to the Quilt, it is Cleve Jones, who came up with the idea in 1985. At the culmination of a candlelight march in San Francisco, he looked up at the side of the Federal Building and saw that mourners had taped cardboard signs bearing the names of people who had died. The wall reminded him of a patchwork quilt: "People stood there for hours reading names. I knew then that we needed a monument, a memorial."[22] Jones and Michael Smith organized a group of sewers to complete the first showing of almost two thousand panels in Washington, D.C., in 1987. Over the years, this core group of volunteers has grown into a large professional foundation

centered in San Francisco, where the Quilt is housed. In addition to the central foundation, there are over fifty chapters of the NAMES Project throughout the country and over thirty international affiliates.[23] The chapters sponsor panel-making workshops and assist the foundation in getting the Quilt to their communities as an AIDS-prevention tool and as a means to raise money for AIDS service organizations.

Unlike the Vietnam Veterans Memorial and the Holocaust Memorial Museum, the NAMES Project Quilt is not permanent or static. It continues to grow as new panels are added. Its enormous size severely limits the opportunities for it to be viewed as a whole. From its first exhibition in 1987, when it comprised 1,920 panels, to its last complete showing in 1996, when the panels numbered more than 40,000, it has been displayed in its entirety only five times. In 1996 it was rumored that the Quilt had become so big that it could never again be shown as a whole.

The sheer size of the Quilt is a crucial aspect of its publicity. The Web site for the NAMES Project tells us that it weighs fifty tons and that the panels, if laid end to end, would extend almost fifty miles. In 1996 the Quilt covered the National Mall from the steps of the U.S. Capitol building to the base of the Washington Monument. The size is meant to stand for the terrible impact of the AIDS crisis; its geometric progression symbolizes the course of the epidemic. According to the Web site, the Quilt represents 20 percent of those who have died of the disease. The statistics are staggering: "The United States reported 641,086 cases and 390,692 deaths according to a Centers for Disease Control and Prevention study as of 12/97." Internationally, "the . . . estimated number is 30.6 million cases, 11,700,000 deaths according to a Joint UN Program Study on HIV/AIDS as of 12/97." Such statistics are meant to shock and thereby mobilize a constructive response, but they also have a numbing effect. In the same way, the size of the Quilt, its sublimity, can be overpowering. Although I was impressed by the overall effect of the Quilt when I saw it in 1996, I found myself overwhelmed when I tried to look at the individual panels. There were too many to take in, and they quickly began to all look the same. In this sense, the NAMES Project Quilt may be most effective not as a whole but in its more typical venue—as fragments of a few large squares displayed to small groups of viewers.

In its seeming boundlessness, the Quilt reminds me of Stieglitz's effort to create an accumulative portrait of Georgia O'Keeffe. Both the O'Keeffe portrait and the Quilt are founded on the idea that no single

image is capable of representing the humanity of its subject. Stieglitz's solution, to make his portrait multifarious and ongoing, implies that a person cannot be subsumed by a single image and that we all change with time. But if one photograph cannot sum up a person, how many are sufficient? Likewise the Quilt's growth eloquently reflects the epidemic's continuing spread, even as its thousands of panels represent the diversity of those who have died. Yet despite the vast number of panels, only a small percentage of those who have died are personified. Even the Quilt's most ardent admirers regret the relatively poor representation of women and people of color, as well as the nationalistic emphasis on American deaths. In this view, the Quilt is not boundless at all but limited by its primarily middle-class American origins.

Cleve Jones's idea in effect did away with the need for a unified design. It is instead an immense collaboration. In my discussion of the partnerships of Agee and Evans, Caldwell and Bourke-White, and Basquiat and Warhol, I tried to point to the competitive tensions that arise out of the collaborative process, at least when only two artists are involved. When collaboration involves a large group, its dynamics change, yet competition and the suppression of difference are crucial factors that have to be worked out in any group effort. At about the same time the NAMES Project was creating the first panels, Gran Fury, another collaborative, was formed in New York City to support the work of ACT UP (AIDS Coalition to Unleash Power).[24] Gran Fury created some of ACT UP's best-known posters, T-shirts, stickers, and buttons, bearing slogans like "MEN: USE CONDOMS OR BEAT IT," and "SEXISM REARS ITS UNPROTECTED HEAD" (fig. 9.10).[25] Gran Fury's confrontational imagery and insistent calls to action were in sharp contrast to the comforting symbolism of the Quilt. Gran Fury's posters were meant to break through the decorum of everyday discourse by prodding the viewer into a response. The collective was strongly influenced by the postmodernist work of Barbara Kruger, who appropriates stock photographs and juxtaposes them with sloganlike messages. Richard Meyer writes, "The collective simulated the glossy look and pithy language of advertising to seduce its audience into dealing with the difficult issues of AIDS transmission, research, funding and government (non)response, issues that might otherwise be avoided or rejected out of hand. In catching viewers off-guard, Gran Fury sought to shock them into a new awareness of—and new activity about—the AIDS crisis."[26] Yet as Douglas Crimp and Adam Ralston insist, its posters and banners were as much a means to

FIGURE 9.10 *Gran Fury,* Sexism Rears Its Unprotected Head, *1988, poster, 16 ⅛ x 10 ⅜ in.*

FIGURE 9.11 *Gran Fury,* Read My Lips (Boys), *1988, poster (also used as a T-shirt), 16 ¾ x 10 ¾ in.*

rally the AIDS movement as to win over the larger population to ACT UP's message: "AIDS activist graphics enunciate AIDS politics to and for all of us in the movement. They suggest slogans (SILENCE = DEATH becomes 'We'll never be silent again'), target opponents (the *New York Times,* President Reagan, Cardinal O'Connor), define positions ('All people with AIDS are innocent'), propose actions ('Boycott Burroughs Wellcome')."[27]

Arguably, the NAMES Project is equally adept at using the methods of advertising, but instead of Gran Fury's and ACT UP's emphatic address of the slogan and the billboard, its rhetoric is domestic and sentimental, more Betty Crocker than Barbara Kruger. Yet some of the individual panels make use of slogans that could easily have been incorporated into a Gran Fury campaign: "I CAME HERE TODAY TO ASK THAT THIS NATION WITH ALL ITS RESOURCES AND COMPASSION

NOT LET MY EPITAPH READ HE DIED OF RED TAPE," or "MY ANGER IS, THAT THE GOVERNMENT FAILED TO EDUCATE US."[28]

Whereas Gran Fury always linked the issue of gay and lesbian liberation with the fight against HIV/AIDS, as in the "READ MY LIPS" poster (fig. 9.11), the NAMES Project Quilt has subsumed the question of sexual identity in a more inclusive message of personal and national loss. The literature that accompanies the Quilt often emphasizes how HIV/AIDS affects the entire population, not just the so-called high-risk groups. In fact the NAMES Project has been accused of closeting the epidemic in the service of gaining mainstream support for dealing with the crisis.[29] This is not to say that the panels suppress homosexuality; the Quilt's individual panels often refer to the sexual identity of their subjects. Despite its encompassing intentions, an informal tour of the panels shows that male names vastly outnumber those of females and that the majority of these men were gay. Reading many of the panels chronologically, noting their references to music, clubs, leather, and drag, is to be given an informal history of gay life in the 1980s and 1990s.

In the end both the NAMES Project and Gran Fury have been enormously successful in raising awareness and in mobilizing support for people living with HIV/AIDS. Often the two have worked in tandem. I remember in 1987 how moved my friends in ACT UP were when they first saw the Quilt, even though some were prepared to denounce it as a passive gesture of mourning. Later, important ACT UP demonstrations were organized around the Quilt's exhibition. At the same time, the Quilt's presence has galvanized political responses. In 1992, on the eve of the presidential election, the supposedly nonpartisan candlelight march that was organized in conjunction with the Quilt's presentation turned into a denunciation of Republican policy in an insistent ACT UP chant of "Shame! Shame! Shame!" in front of the Bush White House.

When critics write about the politics of the NAMES Project Quilt and of Gran Fury, they focus on the content of their work. But there is a political component to their differing models of collaboration. Gran Fury made use of consensus as a decision-making process. Although individual artists in the group were given the task of designing particular posters for specific actions, each design was nonetheless discussed by the group until there was agreement that it worked. In the collective's early years, the design was presented to ACT UP as a whole, where it was often rejected or sent back for revisions. In its most radical form, consensus requires the agreement of all concerned. The idea is to promote an environment in which all voices are equal and accounted for. In practice,

however, not all voices are equal. Some people speak persuasively and have no problem making their feelings clear. It often takes courage to oppose the will of the majority by exerting one's individual veto.

The collaborative process of the NAMES Project Quilt differs completely from the consensus model. Perhaps in its earliest days, the original planning group tried to act democratically, but now the foundation has the structure of a traditional nonprofit corporation, including a director and a hierarchy of workers. Even so, the actual process of making the Quilt is based on an ideal of complete equality. This ideal has its roots in the feminine tradition of the friendship quilt, in which each woman in a quilting group makes a square, adding her name and style to the larger whole.[30] Every panel in the NAMES Quilt is allotted the same amount of space, and, supposedly, every contribution that follows the minimum guidelines is accepted.[31] Discussions and negotiations in the manner of a collective occur only when a collaborative group makes an individual panel.

By harnessing the special skills of its members and editing out through consensus any weak production, Gran Fury maintained a high degree of graphic and aesthetic professionalism. There is no such consistency in the NAMES Project Quilt. The makers of the panels range widely in terms of their skills and sophistication. Many of the panels are the work of talented sewers with a knowledge of complex stitching and traditional bunting. Janet Lewallen, for example, added the name Chuck Morris in tiny plastic red flowers over an unfinished quilt that Morris himself had previously made. According to Cindy Ruskin's *The Quilt: Stories From the NAMES Project*, Morris's hobby had been quilt making. When he died, he had left unfinished the six-by-three-foot section that Lewallen incorporated into his panel.[32]

A particularly beautiful panel (fig. 9.12) is designed using various patterned materials to form an iris that is superimposed on a pink triangle and backed with a green madras-like fabric. Dedicated to David Sindt, it was made by his nephew Andrew Weber, with help from his mother and an artist friend. The different fabrics that make up the petals of the iris relate to aspects of Sindt's life.[33] Panels executed by fashion designers and their studios as part of a special fund-raising project exhibit an even higher level of professionalism and aestheticism.[34]

Just as many panels have been crudely fashioned without the use of a sewing machine, some makers have forgone the use of thread and needle entirely. A large "C," the dates 1983–1987, a verse from the song "You Are My Sunshine," and a brightly rendered landscape are painted

onto a piece of fabric to stand for the life of a child.[35] Indeed, even Cleve Jones, the founder, does not sew. He created the first panel by using stencils to spray-paint the name of his friend Marvin Feldman on a field of pink triangles and Stars of David (fig. 9.13). As long as a panel meets the most modest standards of durability, it will not be turned down.[36]

Focusing on individual panels, however, takes away from one of the distinctive aspects of the Quilt: the joining of unrelated designs into larger squares. Rico Franses insists that the Quilt "flirts with visual chaos" because "the lack of framing devices between individual panels means that it is often difficult to distinguish where one begins and another ends."[37] Although it is true that individual panels tend to blend most with their neighbors when they are grouped by color rather than by the locality from which they are sent, I think Franses overestimates the difficulty of gauging difference. The very first square (fig. 9.14) can be taken as representative of the whole. A bright orange panel with the name Gary Moonert displayed in the upper left corner, along with a shirt from his organization, the Castro Lions, is placed next to a panel with an enormous portrait of Marvin Feldman with his cat. These two vertical panels play against the horizontal orientation of the pairs to the right and below. These panels are organized around the presentation of names in big block letters: Douglas Lowery, Reggie Hightower, Bob Greenwood, and Gary Barnhill. In the case of Reggie Hightower, the arching letters are placed over eighteen equally sized squares; the grid of this single panel echoes the larger grid of the entire project itself. Beneath this panel and to the left is one that reads more like a traditional quilt, in which bands of colors form frames within frames; it bears no obvious signs of commemoration: the abstract pattern is meant to stand for a human presence. This anonymity contrasts with the overt statement of its neighbor, in which the name Simon Guzman stands out in red. A bird soars up from the corner toward this name, as if carrying it to heaven.

A decade later it could be argued that there are no significant changes in terms of panel design. If square 5,200 (fig. 9.15) seems to more unified than square 1, it is not because of any plan of the individual panel makers, but because the NAMES Project has seemingly grouped the panels according to their common use of pinks, lavenders, and reds. The panel in the top left corner, in which "Tommy Friend" is superimposed over a background that spells "love," suggests that using a surname in relationship to HIV/AIDS is still considered dangerous.

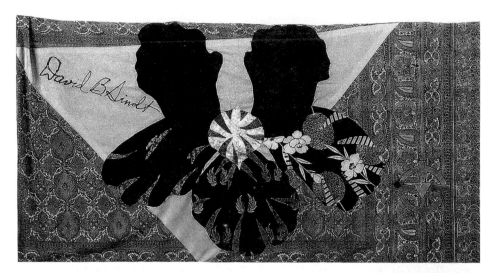

FIGURE 9.12 *The NAMES Project, AIDS Memorial Quilt—David Sindt, 1992.*
Courtesy of the NAMES Project Foundation

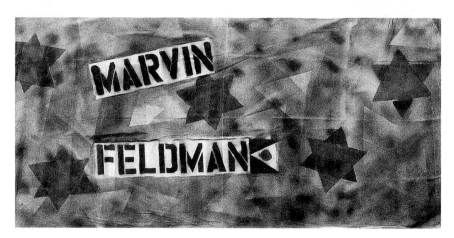

FIGURE 9.13 *The NAMES Project, AIDS Memorial Quilt—Marvin Feldman, 1992.*
Courtesy of the NAMES Project Foundation

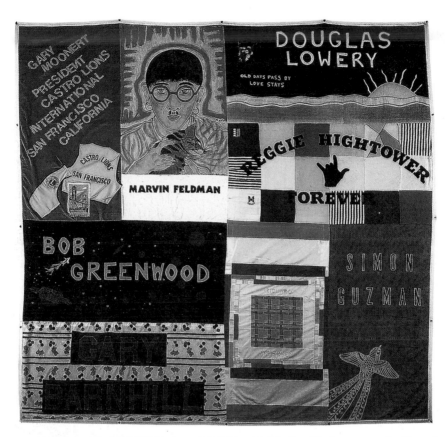

FIGURE 9.14 *The NAMES Project, AIDS Memorial Quilt—Block 1, 1992. Courtesy of the NAMES Project Foundation*

In this square, composed mostly of horizontal panels, six rectangles surround a central pair. In the panels for Thad Onebane and Ronald F. Peart, Jr., the designers have found a means of photographing onto fabric, thereby allowing a more durable way of incorporating pictures of the deceased into the panels. In the lower right panel an image of a butterfly, red ribbon, and heart commemorates not an individual but those who died under the care of the Trinity Hill HIV/AIDS Unit in Hartford, Connecticut.

Aesthetically, one might think of the eight-panel-square format as collage, in that all the panels involve the application of found materials onto flat color grounds. Yet for the most part the panels lack the special discontinuity of classic modernist collages from Picasso to Rauschenberg. In the Cubist tradition of collage, individual elements are frac-

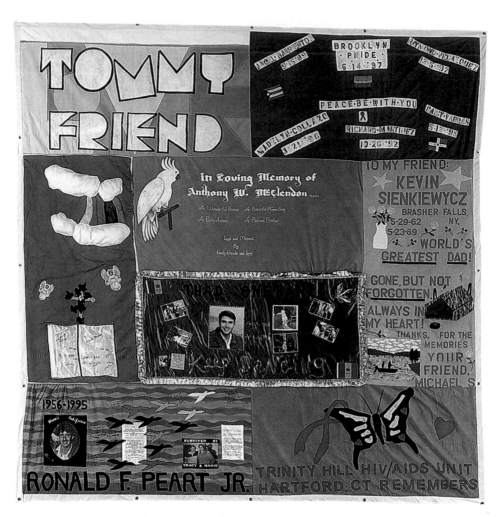

FIGURE 9.15 *The NAMES Project, AIDS Memorial Quilt—Block 5200, 1992.*
Courtesy of the NAMES Project Foundation

tured and original connotations disrupted, even as the fragments are reoriented for the sake of the overall unity of the picture plane. In contrast, the panel makers favor legibility. To the degree that there is overlapping, it is not to create a new kind of spacial organization but to enhance readability. If there is a high-art precedent for the format, it is not in Cubist collage but in the poster portraits of Charles Demuth, which I discussed in Chapter 4. Like Demuth, the panel makers attempt to sum up a person's life using the devices of commercial

signage—bold lettering, bright colors, quotations, and photographs. The most significant means to this end is the name itself, augmented by images and patterns that might set that name off from all the others. When viewed this way, the Quilt is a microcosm of American commercial life. But instead of selling products it asks us to remember people. It is the panel makers' task to figure out how to convert a person into an image that, like a billboard, will hold its own in the cacophony of names. To paraphrase Norman Mailer, the panels are advertisements for the dead.

As advertisements, the panels tend to be more effective when they are simple and bold. Deane Dixon made a minimalist panel for her son Rick (fig. 9.16) that features nothing more than the cut-out letters of his name.[38] It is as if his mother had found a way to redeem the dullest tombstone by making it over into soft white cloth and to revitalize the power of the name through contrast with the chaos of the surrounding panels. Yet other panels are eloquent in the way they attempt to cram in as much material as possible, like a scrapbook. The one dedicated to Thad Onebane in square 5,200 incorporates flags, photographs, the phrase "Keep Dancing," letters, a gold border, and a velvet background. Such attempts to fill a rectangle with as much information as possible hint at desperation. As if to deal with the frustration that panel makers have trying to make a piece of cloth six by three feet stand for a person, the NAMES Project asks for a letter and information from those who submit the panels. These materials have become a vast archive, so that the Quilt has become a means for gathering and recording a significant segment of late twentieth-century history.

Despite the emphasis on names in the Quilt, the panel makers rarely sign their work. Peter Hawkins writes, "It is startling to realize that a memorial on the scale of the NAMES Project Quilt is 'authorless,' having neither designer nor design." Hawkins does give credit to Cleve Jones for the initial idea, but Hawkins notes that Jones "has had no control over how the Quilt would look, either in its parts or in its larger configurations."[39] Yet the formation of the panels into squares is not a random process. Cindy "Gert" McMullen, the Quilt Production Coordinator, and her staff of sewers oversee crucial decisions of placement. When a panel arrives in San Francisco, it is examined for workmanship. Often it has to be carefully resewn before it can be placed alongside the seven other panels to form one large square. What criteria determine how the panels are grouped in squares? Sometimes the decision is determined by origins. A conscious effort is made to group panels by locality, so that in sending the Quilt to a particular chapter, the panels are in essence making a trip home. But sometimes McMullen and her team put together panels because they share a particular color or material. There are squares made up entirely of leather and squares in which blue predominates. The sewing team works hard to accommodate ungainly objects that people sometimes attach to their quilts, ranging from stuffed animals to boas and, in one case, a bowling ball. George Renz, one of the full-time sewers who works with Gert, told me that many of the panels that arrived before the 1996 exhibition in Washington were put together quickly and without great care because panel makers wanted them to be included. He described one quilt in the form of a Christmas tree in which hundreds of pieces had been carefully cut out, as if to be sewn; but the panel maker used glue instead to meet the deadline of the Washington showing. George felt what he called the "panic" of the panel maker to make the deadline. And so he painstakingly sewed the panel himself. In this case, collaboration is not a matter of literally working with another artist but of deducing from the object what it wants to be. Not so much authors, Gert and her sewers are part editors and part conservators.

I was moved by the stories Gert and George told me about their work. Sometimes when the panels are sent for display, Gert goes with them to ensure that they stand up to the wear and tear inherent in being shipped and displayed. During one such trip she spent an enormous amount of time repairing one panel. A woman who lived in the area assisted her. Gert recalled that at one point she sent the woman out to get coffee and thread. When she returned, Gert apologized for being so

brusque. It was then the woman disclosed the reason for her devotion to the project: "You know," she said, "that is my son you're working on." She was so thankful for Gert's hard work on the panel that she gladly undertook the various menial tasks she was assigned. Stories such as this reveal how the individual panels come to embody the people they memorialize. Indeed, there is a tendency among those who work with the panels to think of them as persons. During the elaborate process of preparing for the 1996 exhibition, it was feared that two of the squares had been lost. One had been misplaced by the shipper, who returned it later; the other turned up in Washington when the panels were unloaded. The organizers' sense of relief when they were found was akin to finding lost friends. Michael Bongiorni, Director of Quilt Operations, spoke of these panels as wanting to be found, as if they were alive.[40]

To replace a person with an object may seem regressive. The very form of the NAMES Project Quilt suggests a child's security blanket. Some find the Quilt cloyingly sentimental. Daniel Harris describes it as "kitsch," a term he never defines but which supposedly plays on the emotion of the observer and sells the disease.[41] For Harris, the Quilt reinforces an idea of the ill as childlike victims. The only way to make those who suffer from AIDS palatable is to drape them in Americana. He is particularly disturbed by the commercial ventures associated with its exhibition. As the Quilt has grown, it has become increasingly dependent on a network of corporate and private sponsors, including American Express. Typical of many other grassroots phenomena, success undermines the original effort to circumvent the establishment.

I do not disagree that the individual panels can often be ugly and vulgar. Their language is sometimes closer to mushy greeting cards than to poetry. Crudeness of execution is taken to reflect sincerity. Rarely do the individual panels stand on their own as works of art. Harris writes that "the Quilt is cheapened by nostalgia, the homesickness of an industrial culture for an agrarian one, and our sacramental shroud reeks not of ecclesiastical incense but of the cloying inauthenticity of a shopping mall's Yarn Barn."[42] The sentimental aspects of the Quilt probably account for the fact that although I have lost many close friends to the disease, not one is memorialized in the Quilt, not even Marc Lida. My circle of New York art-world intellectuals and artists has not found in the Quilt an apt expression of mourning. Like Harris, too many of us are embarrassed by the Quilt's seeming commercialism and by having our emotions manipulated. Yet in asserting the old modernist term *kitsch,* Harris seems to regress to an ideal of art free of the taint of

commodity. In attacking the New Age feel-good aspects of the Quilt and its vision of community, he longs for an earlier period in which the dead were honored by what he imagines were restrained "Christian ceremonies." Yet he ignores the extraordinary way in which the quilt tries to reinvent the bland standardization of American funereal practices.

In the end, Harris, like other of its detractors, falls into the trap of thinking of the Quilt as a unified phenomenon. He is dismissive of the "kitschifying effects" of storytelling, but he completely misses the fact that the enormousness of the Quilt undermines traditional concepts of narrative. Wandering among the panels, either as they are stored in a warehouse or as they are displayed on the Mall, one loses any sense of beginning or end. If the panels are like greeting cards, repetitive and crass, the effect of hundreds of squares together is like a great nineteenth-century sampler, vivid and elegant. It is one of the Quilt's most extraordinary accomplishments that it manages to incorporate the most diverse and the most vulgar parts in its overall abstract scheme. In my discussion of O'Keeffe's supposed false modernism, I cited Robert Penn Warren's essay on the role of "impurity" in even the most "pure poem." Arguably, the shopping-mall clichés of the Quilt's individual panels, and the New Age rhetoric of its promoters, only add to the sublimity of the Quilt when it is seen from a distance and coheres into a vast unified field. It has no difficulty holding its own in relationship to the Capitol and the Washington Monument; indeed it connects the two in a manner that is far more emphatic than the Mall's original plan. Yet unlike these enormous stone buildings, the Quilt seems almost immaterial, as though it had brought to the surface the abstraction of the city's original design. From afar it takes on the quality of an ideal geometry projected onto the world rather than that of a hand-sewn blanket made of tangible and sensuous fabric.

Harris denounces the Quilt for its rhetoric of Americana, but he fails to recognize that it taps deeply into the American myth that capitalism and democracy harmonize. Unfurled across the National Mall, the Quilt envisions a national unity composed of equal voices, each with his or her own piece of property. Unfortunately, the AIDS epidemic tells an entirely different story about the United States, one of profound inequalities and prejudice. This obfuscation of the political and economic nature of the epidemic is due to what Aaron Fogel calls its "unconsciously dishonest postmodern mode." For Fogel, the emphasis of the NAMES Project on numbers, to make concrete the enormity of the epidemic, mirrors modern society's use of demographics, reducing in-

dividuals and communities to numbing statistics and polls. He recognizes that for some the Quilt has been celebrated as countering hegemonic concepts of universal narratives through its nomadic deployment and discontinuous panels. But "despite its claims to multiplicity, undecidability, 'nomadology,' and freedom from metanarratives, the blurred demographic has in fact become *the* (allegedly missing) metanarrative."[43] I do not disagree with Fogel's argument. I share his skepticism about postmodernist forms of critique that claim that works of art are able to circumvent hegemony through discontinuity and hybridity. Yet I am not convinced by Fogel's nostalgia for a premodern period in which census taking, as represented by Breughel's famous painting *The Census at Bethlehem,* is freed from such categorization and regimentation, so that "acts of counting are polyphonic and involve consciously irreconcilable historical perspectives." Actually, Fogel is wise enough to suggest that the problem of demographics is not something embedded in the Quilt; rather it is how the culture makes use of numbering and how the Quilt is read in relationship to that use. To some its panels may seem remarkably repetitive and pedestrian. It is part of a narrative that uses enormous numbers to mask the specifics of politics and peoples. Or, perhaps, if one takes the time to read some of the panels for what they tell us about individual lives and their diversity, it may provide precisely Fogel's polyphony. In a sense it all depends on how the grid of the Quilt is perceived. Is it a means to standardization and categorization, that is, in Fogel's terms, "demographically happy," or is it a system for gauging differences? Do its vast panels signal a new sense of community, or is this counting a cultural expression of the use of statistics as a kind of pseudo-knowledge that interferes with meaningful relationships and action?

In the end, the effect of the Quilt is profoundly related to the viewer's position and status. Its meaning changes depending on whether you are a panel maker, a NAMES Project volunteer, or a person with HIV/AIDS imagining your own memorial panel. The Quilt defies its detractors and admirers, because it is more akin to a process than to an object. This sense of an ongoing collaboration, an *unfolding,* is literalized every time the squares are spread out on the Washington Mall. Teams of eight volunteers unfurl each square and turn it into position so that, as Michael Bongiorni put it, "the color erupts" in the sunlight (fig. 9.17). Once the entire Quilt is in place, visitors are able to walk between the squares, as the names of those who have died from complications of AIDS are read aloud. After this event, the Quilt is packed up, only to be

FIGURE 9.17 *Unfurling of the AIDS Memorial Quilt, 10 October 1992, Washington, D.C.*

reassembled in different configurations and contexts. The Quilt continues to change, initiating a vast array of interactions and responses. Inevitably it will stop growing, ideally because a cure will be found and distributed globally to all those who are sick, but more realistically it will be impossible to sustain the project as its size grows ever larger and the public's interest inevitably lags. But even when the last panel is sewn, the Quilt will not become a static monument. There is no single building that could house and display it all at once. Wisely, Marita Sturken thinks about the NAMES Project Quilt as a technology, that is to say, a complex mechanism for coming to terms with mortality. It is not surprising that so many of the attempts to understand the Quilt (including this one) often involve an ambivalent author moving back and forth between its good and bad points. As Sturken writes, the AIDS quilt "is asked . . to represent AIDS and thereby becomes the subject of struggle around who is visible and invisible in the AIDS crisis in the United States and worldwide." She continues: "The AIDS epidemic could not have been memorialized in a traditional way because it is not over and

because it encompasses highly contested notions of what constitutes normalcy, moral behavior, and responsibility."[44]

Perhaps the NAMES Project Quilt is not a work of art at all. One of the panels reads "Is This Art? No! It's Fred Abrams!"[45] I think of Agee's plea: "Above all else: in God's name don't think of it as Art." Certainly the vast majority of its makers would not call themselves artists. Why, then, do I end this book about famous artists with it? If art bestows immortality on the artist, it does so with a cost. As this book informally charts, fame is the result of intense competition, so that each new invention or style seems to erase its predecessor. Indeed, Jean-Michel Basquiat cleverly remade such erasures into his characteristic mode of crossing words out. It seems to me that the NAMES Project suggests another model for art making and for thinking about the history of art. The names on the Quilt do not eradicate or erase; they exist together to represent individuals and community, private memories and public loss. Naming is transfigured into an act of generosity. Sturken writes, "To be moral, say the quilt panels, is to state a name in the face of discrimination; to be responsible, they say, is to care for the dying."[46]

I began this book by remarking on Georgia O'Keeffe's strange feeling of dislocation in relationship to her work. She doesn't know whether it belongs to her, or to Stieglitz, or to the world, and she imagines it destroyed. She is ashamed that she "works for flattery," despite her best efforts to put the words of her teachers aside. A very different artist, Jackson Pollock, was just as anxious. He had found a way into his paintings, only to find that he often fell out of them when they became a "mess." For George Renz of the NAMES Project, the collaborative process has been a way to circumvent such unhappiness. Being both inside and outside of the Quilt feels right. "It is interesting," he told me, "to be seasoned in your craft, at this point in my life, to be an artist . . . and do work that has nothing to do with you." He admitted, though, that the Quilt was not free from ego. "There is a lot of ego in the Quilt— monstrous ego on all levels. . . . I bring my skills, but I don't need to bring my ego." What he had in mind was all the competition and strain that goes into any enormous enterprise or collaboration worth doing. But he also had in mind the very nature of the Quilt in presenting through the name the trace of the person who has died. Still, even as he talked of his anonymity in the process, he spoke of his presence in the Quilt: "I can look at an image of the Quilt at any point, place or time . . . and see myself there, I am part of that dynamic. I don't have to

search out a panel I worked on or a panel for a friend I have made. I just look at the quilt and I know I am there. It's a good feeling."[47] We sense his separation—he doesn't feel that his own ego is on the line— but also his integration, part of what he calls a larger dynamic. He both merges with his work and finds a way to step back from the process and judge his contribution. What we have here is a paraphrase of Adrian Stokes's "invitation" that I discussed in relationship to the theme of the artist's mother in the beginning of this book. We lose ourselves in the ideal work of art, even as we find a sense of autonomy and integration through an engagement with it. Given the fact that the central metaphor of the NAMES Project Quilt is so deeply maternal, this engagement should not be a surprise. What is surprising is that the usual carrier of so much monstrous ego, a name in itself, is transformed by the NAMES Project into a plenitude that embraces the world. The Quilt is no achievement of famous artists; nevertheless it feels to me like great art in its vividness and scope, its ambition and love.

Ecclesiasticus also tells us: "Their bodies are buried in peace; but their name liveth for evermore."

Notes

INTRODUCTION

1. Linda Merrill, *A Pot of Paint: Aesthetics on Trial in Whistler v. Ruskin* (Washington, D.C.: Smithsonian Institution, 1992), 269.
2. Ibid.,136. The original statement appeared in July 1877 in John Ruskin's *Fors Clavigera: Letters to the Workmen and Labourers of Great Britain*, rpt. in *The Works of John Ruskin*, ed. E. T. Cook and Alexander Wedderburn (London: George Allen, 1903–12), vol. 29, p. 160.
3. Merrill, *A Pot of Paint*, 204.
4. Ibid., 173. The original transcript of the trial of *Whistler v. Ruskin* has been lost, but Merrill has painstakingly reconstructed it through the use of contemporary accounts.
5. See Adam Gopnik's discussion of Degas's remark in his "Whistler in the Dark," *New Yorker,* 17 July 1995, 68.
6. Georgia O'Keeffe, letter to Anita Politzer, Columbia, S.C., 11 October 1915; in Jack Cowart, Juan Hamilton, and Sarah Greenough, *Georgia O'Keeffe: Arts and Letters* (Washington, D.C.: National Gallery, 1988), 144–45.
7. Georgia O'Keeffe, letter to Anita Politzer, Columbia, S.C., 20(?) October 1915, *Georgia O'Keeffe: Arts and Letters,* 145–46.
8. Georgia O'Keeffe, letter to Alfred Stieglitz, Charlottesville, Va., 27 July 1916, *Georgia O'Keeffe: Arts and Letters,* 153–54.
9. As rpt. in Francis V. O'Connor, *Jackson Pollock* (New York: Museum of Modern Art, 1967), 40.
10. Vivian Raynor, "Jasper Johns: 'I have attempted to develop my thinking in such a way that the work I've done is not me,'" *Artnews* 72, no. 3 (March 1973): 20–22; rpt. in *Jasper Johns: Writings, Sketchbook Notes, Interviews,* ed. Kirk Varnedoe (New York: Museum of Modern Art, 1996), 145.
11. Jasper Johns, interview with David Sylvester, recorded for the BBC in June 1965; rpt. in *Jasper Johns,* 113.
12. Harold Bloom, *The Anxiety of Influence: A Theory of Poetry* (New York: Oxford University Press, 1973), 11.
13. Dorothy Norman, *Alfred Stieglitz: American Seer* (New York: Aperture, 1973), 10.
14. As quoted in Peter Adam, *David Hockney and His Friends* (London: Absolute Press, 1997), 139.
15. Sigmund Freud, *Introductory Lectures on Psycho-Analysis,* trans. and ed. James Strachey (New York: Norton, 1966), 467–68.
16. Sigmund Freud, *Leonardo da Vinci and a Memory of His Childhood,* trans. Alan Tyson (New York: Norton, 1990).
17. This is based on my memory of Frank Stella in a roundtable discussion at the Yale University Art Gallery in the spring of 1998.

18. See Michel Foucault, *The History of Sexuality: An Introduction*, vol. 1, trans. Richard Howard (New York: Vintage, 1990).

CHAPTER 1: ORIGINS

1. Alice Goldfarb Marquis, *Alfred H. Barr, Jr.: Missionary for the Modern* (Chicago: Contemporary Books, 1989), 111–12.
2. Alfred Barr, *What Is Modern Painting?* (New York: Museum of Modern Art, 1943), 8. I wish to thank Romy Golan for bringing this pamphlet to my attention.
3. For a discussion of the so-called "crisis of masculinity" at the turn of the century and later, see, for example, Michael Kimmel, *Manhood in America: A Cultural History* (New York: Free Press, 1996).
4. Richard Dorment and Margaret F. MacDonald, *James McNeill Whistler* (London: Tate Gallery Publications, 1994), 142.
5. A. C. Swinburne, "Mr. Whistler's Lecture on Art," *Fornightly Review* (June 1888), excerpted as "An Apostasy," in James McNeill Whistler, *The Gentle Art of Making Enemies* (London: William Heinemann, 1892; rpt., New York: Dover, 1967), 252.
6. Marquis, *Barr*, 111. She cites Barr's protest letter to the *New York Times*, 10 May 1934.
7. I want to thank Michel Lobel for pointing out the parallel between Barr's creation of an abstract diagram of the picture and the additions of the Postal Service.
8. Darrel Sewell makes the comparison to Whistler's painting of his mother in the catalogue entry for Tanner's portrait, in Dewey F. Mosby, *Henry Ossawa Tanner* (Philadelphia: Philadelphia Museum of Art, 1991), 142–43.
9. For a discussion of Tanner's complex negotiation of questions of race and identity, see Albert Boime, "Henry Ossawa Tanner's Subversion of Genre," *Art Bulletin* 75, no. 3 (September 1993): 415–42.
10. See Linda Nochlin, *Representing Women* (New York: Thames and Hudson, 1999), 191–92. I want to thank Linda Nochlin for sharing with me an early version of her essay on Cassatt.
11. It is interesting to note that when Mary Cassatt posed for the photographer Theodate Pope in 1903, she assumed a very similar pose, complete with newspaper and spectacles, to the one taken by her mother in *Reading Le Figaro*. The photograph can be seen in the collection of the Hill-Stead Museum, Farmington, Conn. For a reproduction of the photograph, see Nancy Mowll Matthews, ed., *Cassatt: A Retrospective* (n.p.: Hugh Lauter Levin Associates, 1996), 258.
12. Margaret F. MacDonald, "Whistler: The Painting of the 'Mother,'" *Gazette des Beaux-Arts* 85, no. 6 (February 1975): 79.
13. Donald Kuspit, "Representing the Mother: Representing the Unrepresentable?" in Barbara Coller, *The Artist's Mother: Portraits and Homages* (Huntington, N.Y.: Heckscher Museum, 1987), 25.
14. Dorment and MacDonald, *Whistler*, 141. For other possible models, see MacDonald, "Whistler: The Painting of the 'Mother,'" 81–84.
15. See Margaret F. MacDonald and Joy Newton, "The Selling of *Whistler's 'Mother,'" American Legion of Honor* 49, no. 2 (1978): 97–120.

16. Quoted in Margaret MacDonald, "The Whistler Household," in Anna McNeill Whistler, *Whistler's Mother's Cook Book,* ed. Margaret MacDonald (New York: Putnam's, 1979), 29.

17. Anna Whistler to her sister, Kate Palmer, 3 November 1871; rpt. in *Whistler on Art: Selected Letters and Writings of James McNeill Whistler,* ed. Nigel Thorp (Washington, D.C.: Smithsonian Institution Press, 1994), 44–45.

18. MacDonald, "Whistler: The Painting of the 'Mother,'" 84.

19. On Anna's relationship to her son, see Phoebe Lloyd, "Anna Whistler, the Venerable," *Art in America* 72, no. 11 (November 1984): 138–51.

20. Eugene Glynn, "The Critical Writings of Adrian Stokes," *Print Collector's Newsletter* 10, no. 2 (May–June 1979): 60. For a succinct overview of Stokes's theories, see Richard Wollheim's preface to Adrian Stokes, *The Invitation in Art* (London: Tavistock, 1965).

21. Melanie Klein, "A Contribution to the Psychogenesis of Manic-Depressive States" (1934), in *Contributions to Psychoanalysis, 1921–1945,* ed. Ernest Jones (London: Hogarth Press, 1950), 282.

22. Ibid., 284.

23. Stokes's concept of form restoring the ideal child-mother relationship while also allowing for autonomy bears comparison with Julia Kristeva's speculations in "Motherhood According to Giovanni Bellini." For Kristeva, Bellini's art attempts to merge the maternal pre-Oedipal state with the mastery of the father so that Bellini "could share in this both maternal and paternal jouissance. He aspired to become the very space where father and mother meet, only to disappear as parental, psychological, and social figures; a space of unrepresentability toward which all glances nonetheless converge; a primal scene where genitality dissolves sexual identification beyond their given difference" (Julia Kristeva, "Motherhood According to Giovanni Bellini," in *Desire in Language,* ed. Leon S. Roudiez, trans. Thomas Gora, Alice Jardine, and Leons S. Roudiez [New York: Columbia University Press, 1989], 249). Unlike Stokes, however, who concentrates almost exclusively on form, ignoring details of iconography and the artist's life story, Kristeva follows the traditional psychoanalytical approach in evoking Bellini's biography and his narrative content.

As Diane Dillon reminds me, the majority of the feminist literature on the mother focuses on the mother-child relationship rather than on the mother in and of herself. For an overview of such feminist approaches, see Jane Silverman Van Buren, *The Modernist Madonna: Semiotics of the Maternal Metaphor* (Bloomington: University of Indiana, 1989).

24. Adrian Stokes, "Painting and the Inner World" (1963); rpt. in *The Critical Writings of Adrian Stokes III,* ed. Lawrence Gowing (London: Thames and Hudson, 1978), 211.

25. Adrian Stokes, "The Luxury and Necessity of Painting: Three Essays on the Painting of Our Time" (1961); rpt. in *Critical Writings of Adrian Stokes III,* 159.

26. Ibid., 150–51.

27. Ibid., 158.

28. Glynn, "Stokes," 60.

29. Melanie Klein, "Mourning and Its Relation to Manic-Depressive States" (1940), in *Contributions to Psychoanalysis,* 313–14.

30. Adrian Stokes, "The Invitation in Art" (1965); rpt. in *The Critical Writings of Adrian Stokes III*, 266.

31. Melanie Klein, "Envy and Gratitude" (1957), in *Envy and Gratitude and Other Works, 1946–1963* (New York: Delacorte Press/Seymour Lawrence, 1975), 193.

32. Stokes, "The Invitation in Art," 275.

33. Merrill, *A Pot of Paint*, 31.

34. Whistler, *Gentle Art*, 115.

35. Walter L. Strauss, *The Complete Drawings of Albrecht Dürer*, vol. 3: *1510–1519* (New York: Abaris, 1974), 1392–95. The inscription reads: "vnd ist verschiden Im 1514 Jor am erchtag vor der crewtzwochn vm zwey genacht."

36. Hanna Segal, "A Psycho-Analytical Approach to Aesthetics," *New Directions in Psycho-Analysis*, ed. Melanie Klein, Paula Heimann, and R. E. Money-Kyrle (New York: Basic, 1955), 404–5.

37. Adrian Stokes, *Michelangelo: A Study in the Nature of Art* (1955); rpt. in *The Critical Writings of Adrian Stokes III*, 50.

38. Arthur Jerome Eddy, *Recollections and Impressions of J. A. McNeill Whistler* (Philadelphia: Lippincott, 1903), 214.

39. I wish to thank Margaretta Lovell as well as the graduate students of the Art History Department of the University of California, Berkeley, for their suggestions about the role of the curtain in this painting. Lovell believes that some of Anna's sensuousness and warmth has been transferred to Whister's handling of the curtain.

40. See Merrill, *A Pot of Paint*, 125–26.

CHAPTER 2: PICASSO IN POLLOCK

This chapter builds upon a paper I first presented in T. J. Clark's New York School Seminar at Harvard University's Department of Fine Arts in the spring of 1982. I benefited enormously from Tim's suggestions, as well as from the advice and criticism of all the students who took the seminar, including such important scholars of modernism as John O'Brian and Michael Leja. The paper was subsequently published in *Arts* 61, no. 10 (June 1987): 42–48, under the editorship of Richard Martin. Richard, a friend and champion of Queer Studies in art history, died in 1999 as I was completing this book. I wish to dedicate this chapter to his memory.

1. This single issue of *Possibilities* was published in winter 1947–48; as rpt. in Francis V. O'Connor, *Jackson Pollock* (New York: Museum of Modern Art, 1967), 40.

2. Ibid., 40.

3. For an example of the uses of Bloom's *Anxiety of Influence* in an art historical context, see Norman Bryson, *Tradition and Desire: From David to Delacroix* (Cambridge: Cambridge University Press, 1984).

4. Harold Bloom, *The Anxiety of Influence: A Theory of Poetry* (New York: Oxford University Press, 1973), and Bloom, *A Map of Misreading* (New York: Oxford University Press, 1975).

5. In 1936 Pollock participated in Siqueiros's "Laboratory of Modern Techniques in Art" in New York, and in 1940 he watched Orozco paint a portable

mural at the Museum of Modern Art. For a discussion of Pollock's debt to the Mexican muralists, see Ellen G. Landau, *Jackson Pollock* (New York: Abrams, 1989).

6. William Rubin discusses Pollock's Oedipal relationship to Picasso in his two-part essay "Pollock as Jungian Illustrator: The Limits of Psychological Criticism," *Art in America* 67, nos. 7–8 (November–December 1979): 104–17, 120–23, 72–91.

7. From an interview with Lee Krasner conducted by B. H. Friedman, originally published in *Jackson Pollock: Black and White* (New York: Marlborough Gallery, 1969); rpt. in Francis V. O'Connor and Eugene V. Thaw, *Jackson Pollock: A Catalogue Raisonné,* 4 vols. (New Haven: Yale University Press, 1978), 4:263.

8. Alfred H. Barr, ed., *Picasso: Forty Years of His Art* (New York: Museum of Modern Art, 1939).

9. Eunice Lipton, *Picasso Criticism, 1901–1939: The Making of an Artist Hero* (New York: Garland, 1976), 237.

10. Edward Alden Jewell, "Review of the Picasso Retrospective," *New York Times,* 19 November 1939, sect. 10, p. 9. Gertrude Stein's monograph *Picasso* was published in France in 1938 (Paris: Fleury) and in the United States in 1939 (New York: Scribner's).

11. "NEW YORK CRITICS COLDLY REVALUE THE ART OF PICASSO, ZEUS OF PARIS," *Art Digest* 14, no. 5 (December 1939): 8.

12. Anita Brenner, "Picasso versus Picasso," *New York Times Magazine,* 12 November 1939, sect. 7, p. 15.

13. Alfred Frankfurter, "Picasso in Retrospective, 1939–1900," *Art News* 38, no. 7 (18 November 1939): 10–28.

14. John Graham, "Primitive Art and Picasso," *Magazine of Art* 30, no. 4 (April 1937): 236–39.

15. For a discussion of Graham's influence on Pollock in terms of primitivism and the myth of the unconscious, see Michael Leja, *Reframing Abstract Expressionism: Subjectivity and Painting in the 1940s* (New Haven: Yale University Press, 1993), 94–96. According to Irving Sandler, after reading Graham's essay on Picasso, Pollock asked to be introduced to the author. Irving Sandler, Letter to the Editor, "More on Rubin on Pollock," *Art in America* 68, no. 8 (October 1980): 57.

16. See Pollock's draft of a statement written for *Possibilities*; rpt. in O'Connor, *Pollock,* 40.

17. Robert Goldwater, "Picasso: Forty Years of His Art," *Art in America* 28, no. 1 (January 1940): 43–44.

18. Barr, *Picasso: Forty Years,* 16. Christian Zervos recorded these statements, which were supposedly made in 1935. It is suspect that they are a word-for-word transcription, but they had Picasso's approval and have subsequently been taken as his words.

19. Ibid., 17.

20. Krasner interview, in O'Connor and Thaw, *Pollock: Catalogue Raisonné,* 4:263.

21. See Sigmund Freud, "Repression (1915)," in *Collected Papers,* vol. 4, trans. Joan Riviere (London: Hogarth, 1950), 85–88. Freud writes that "the satisfaction of an instinct under repression is quite possible; further, that in every in-

stance such a satisfaction is pleasurable in itself, but is irreconcilable with other claims and purposes; it therefore causes pleasure in one part of the mind and 'pain' in another." Freud continues by observing that *"the essence of repression lies simply in the function of rejecting and keeping something out of consciousness."* But later he adds, "it is not even correct to suppose that repression withholds from consciousness all derivatives of what was previously repressed. If these derivatives are sufficiently far removed from repressed instinct-preservation, whether owing to the process of distortion or by reason of the number of intermediate associations, they have free access to consciousness." In psychoanalysis the patient produces these derivatives, which through a process of free association and analysis reveal the "censored" content. In this sense repression made over into an artistic practice still reveals, under interpretation, the original inspiring "image," that material the artist began with but must alter in order to express the self.

22. Vernon Clark, "The *Guernica Mural*: Picasso and Social Protest," *Science and Society* 1, no. 1 (Winter 1941): 72–78; rpt. in *Picasso in Perspective*, ed. Gert Schiff (Englewood Cliffs, N.J.: Prentice-Hall, 1970), 98.

23. Goldwater, "Picasso," 44.

24. Excerpted in "Guernica: Horror and Suffering in Art," *Art Digest* 14, no. 2 (15 October 1939): 16.

25. Barr, *Picasso: Forty Years*, fig. 293.

26. See Alfred Barr, *Picasso: Fifty Years of His Art* (New York: Museum of Modern Art, 1946), 245. See also the effusive book by Sydney Janis and Harriet Janis, *Picasso: The Recent Years, 1939–1946* (New York: Doubleday, 1946), which, according to the *Catalogue Raisonné*, was in Pollock's library. For a discussion of Picasso's reputation in the United States during the war years, see Michael FitzGerald, "Reports from the Home Fronts: Some Skirmishes over Picasso's Reputation," in *Picasso and the War Years 1937–1945*, ed. Steven A. Nash, with Robert Rosenblum (London: Thames and Hudson; San Francisco: Fine Arts Museum, 1998). FitzGerald describes how immediately after World War II Picasso was seen as a hero by Americans. Barr in particular played up the idea that his presence in Paris was a symbol for the Resistance. He notes, however, that Picasso's reputation in the United States suffered in subsequent years because of his communism, only to recover when he withdrew from politics.

27. T. J. Clark, "The Unhappy Unconsciousness," in *Farewell to an Idea: Episodes from a History of Modernism* (New Haven: Yale University Press, 1999).

28. T. J. Clark, in his *Farewell to an Idea*, provides many examples in which Pollock continued to brush on paint after he began dripping. But this was not the myth.

29. For an exhaustive analysis of Hans Namuth's campaigns of photographing and filming Pollock painting, see Pepe Karmel, "Pollock at Work: The Films and Photographs of Hans Namuth," in *Jackson Pollock*, ed. Kirk Varnedoe, with Pepe Karmel (New York: Abrams, 1998).

30. Barr, *Picasso: Forty Years*, 4:17.

31. Krasner interview, in O'Connor and Thaw, *Pollock: Catalogue Raisonné*, 4:263.

32. *The Tempest*, 1.2.397–402.

33. As quoted in O'Connor, *Pollock*, 55.

1. Janet Malcolm, "The Family of Mann," *New York Review of Books*, 3 February 1994, 8.
2. Malcolm Jones, Jr., "All in the Family," *Newsweek*, 26 October 1992, 60.
3. Reynolds Price, Afterword in Mann, *Immediate Family*, n.p.
4. Mann, *Immediate Family*, n.p.
5. For a discussion of the myth of childhood innocence and the issue of childhood sexuality in art, see Anne Higonnet, *Pictures of Innocence: The History and Crisis of Ideal Childhood* (London: Thames and Hudson, 1998).
6. "FYI," *Forbes*, 23 November 1992, 98.
7. Chris Redd, interview with Sally Mann, *Art Papers: Contemporary Art in the Southeast* 13, no. 2 (March–April 1989): 17.
8. Higonnet, *Pictures of Innocence*, 204.
9. It could also be compared to the stain paintings of Helen Frankenthaler.
10. See my "Urination and Its Discontents," in *Gay and Lesbian Studies in Art History*, ed. Whitney Davis, special issue of the *Journal of Homosexuality* 27, nos. 1–2 (1994): 225–43.
11. Sigmund Freud, *Civilization and Its Discontents*, trans. and ed. James Strachey (New York: Norton, 1961), 37 n. 1. I want it to be clear that I do not endorse Freud's theory about the origins of civilization. Although Freud is speaking in defense of restraint and decorum, on another level he too is purposely shocking his audience, through words urinating in public.
12. According to Richard Goldstein, Mann "is working under the kind of inchoate threat few artists in this country have ever experienced. As veteran civil libertarian Edward de Grazia explained to one reporter, 'Any federal prosecutor anywhere in the country could bring a case against her in Virginia where Mann lives, and not only seize her photos, her equipment, her Rolodexes, but also seize her children for psychiatric and physical examination.'" Yet in fact she has never faced criminal prosecution. In contrast, Goldstein calls Jock Sturges "the most persecuted artist in America," noting that in 1990 his San Francisco studio was raided by the FBI. In 1998, Barnes and Noble was indicted for selling *The Eye of the Beholder*, his book of photographs of nude children (*Village Voice*, 10 March 1998, 32). See also J. R. Moehringer, "Child Porn Fight Focuses on Two Photographers' Books," *Los Angeles Times*, 8 March 1998, Metro ed., 3A.
13. Kathryn Harrison, *Exposure* (New York: Warner, 1993).
14. I want to thank Cassandra Albinson, whose paper "Alfred Stieglitz's *Photographic Journal of a Baby: An Investigation*," prepared in 1997 for my "Modernism and American Photography" seminar at Yale University, provided me with valuable information and insights into Stieglitz's project.
15. Richard Whelan, *Alfred Stieglitz: A Biography* (Boston: Little, Brown, 1995), 448–51.
16. Michael Powell, *Million-Dollar Movie* (London: Heinemann, 1992), 404.
17. Alice Miller, *The Drama of the Gifted Child: The Search for the True Self*, trans. Ruth Ward (New York: Basic, 1994), 33. Miller writes in the note that "by 'mother' I here refer to the person closest to the child during the first years of life. This need not be the biological mother, or even a woman."

18. Ibid., 29.

19. Ibid., 30–31.

20. Although *The Perfect Tomato* was not included in the book *Immediate Family*, it was included in the section entitled *Immediate Family* in Mann's book *Still Time* (New York: Aperture, 1994), 68.

21. As quoted in Vince Aletti, "Child World," *Village Voice*, 26 May 1992, 106.

22. Miller, *Drama*, 31.

23. Mann, *Immediate Family*, n.p.

24. Aletti, "Child World," 106.

25. Robert Enright, "Questioning Bodies: A Symposium on Censorship and Representation," *Border Crossings* 10, no. 2 (April 1991): 20.

26. Ibid.

27. Ibid.

28. The poem by Wallace Stevens that Mann alludes to is "Anecdote of the Jar," in *The Collected Poems of Wallace Stevens* (New York: Knopf, 1954), 76.

29. Aletti, "Child World," 106.

CHAPTER 4: THE HANDS OF THE ARTIST

1. For the most complete discussion of Demuth's poster portraits, see Robin Jaffee Frank, *Charles Demuth Poster Portraits, 1923–1929* (New Haven: Yale University Press, 1994).

2. For a discussion of Florine Stettheimer's career, see Barbara J. Bloemink, *The Life and Art of Florine Stettheimer* (New Haven: Yale University Press, 1995). Bloemink writes that Stettheimer was not against exhibiting her work in group shows; however, she repeatedly refused Stieglitz's offer of a one-person show (173–74).

3. For an extensive key to the figures in this painting, see Bloemink, *Florine Stettheimer*, 221–28.

4. See Henry Geldzahler, "Andy Warhol: A Memoir," in *Making It New* (New York: Turtle Point, 1994), 42.

5. Stieglitz said that the Intimate Gallery was dedicated to "the intimate study of Seven Americans: John Marin, Georgia O'Keeffe, Arthur G. Dove, Marsden Hartley, Paul Strand, Alfred Stieglitz, and Number Seven (six + X)." Demuth had been included in his 1925 "Seven Americans" show at the Anderson Gallery, but the best he seems to have managed later is the "X" slot. See Richard Whelan, *Alfred Stieglitz: A Biography* (Boston: Little, Brown, 1995), 480.

6. For an overview of the various interpretations of Picabia's caricature, see Abraham A. Davidson, *Early American Modernist Painting* (New York: Da Capo, 1994), 80.

7. William Carlos Williams to Charles Demuth, ca. 12 May 1929, Beinecke Rare Book and Manuscript Library, Yale University; cited in Frank, *Poster Portraits*, 75.

8. Herbert J. Seligmann, *Alfred Stieglitz Talking* (New Haven: Yale University Press, 1966), 22.

9. Ibid., 121.

10. Sarah Greenough, annotations for "Alfred Stieglitz on Photography," in

Sarah Greenough and Juan Hamilton, *Alfred Stieglitz: Photographs and Writings* (Washington, D.C.: National Gallery of Art, 1983), 202–3.

11. As quoted in Dorothy Norman, *Alfred Stieglitz: American Seer* (New York: Aperture, 1973), 25. A small reproduction of the Steiglitz photograph of the Encke portraits along with this quote appears in Norman, 25.

12. Alfred Stieglitz, "Pictorial Photography"; rpt. in Greenough and Hamilton, *Stieglitz*, 185.

13. As quoted in Stieglitz, "Pictorial Photography," 186.

14. Rosalind Krauss, "Stieglitz/Equivalents," *October* 11 (Winter 1979): 131.

15. Ibid.

16. Diana Emery Hulick has noted the relationship of the photograph to seventeenth-century Dutch painting. She is particularly struck by its similarity to Gabriel Metsu's *The Letter Writer Surprised,* ca. 1660. See her essay "Alfred Stieglitz's *Paula* (1889): A Study in Equivalence," *History of Photography* 17, no. 1 (Spring 1993): 90–94.

17. Sarah Greenough, "Alfred Stieglitz and 'the Idea of Photography,'" in Greenough and Hamilton, *Stieglitz*, 18–21. Greenough goes on to discuss how in attempting to isolate the medium of photography in opposition to abstract painting he had to demonstrate that the camera was not merely limited to describing appearances, hence the concept of the "idea photography," that is, a photography of a heightened reality.

18. Marilyn Kushner made this suggestion to me.

19. Seligmann tells the story of Stieglitz giving away a Marin to a young woman (Seligmann, *Stieglitz Talking*, 10–11).

20. See Timothy Robert Rodgers, "Alfred Stieglitz, Duncan Phillips and the '$6,000 Marin,'" *Oxford Art Journal* 15, no. 1 (1992): 54–66. See also his dissertation, "Making the American Artist: John Marin, Alfred Stieglitz and Their Critics, 1909–1936," Ph.D. diss., Brown University, 1994.

21. Seligmann, *Stieglitz Talking*, 40.

22. Greenough and Hamilton, *Stieglitz*, 185.

23. See Anne Middleton Wagner, *Three Artists (Three Women): Modernism and the Art of Hesse, Krasner, and O'Keeffe* (Berkeley: University of California Press, 1996).

24. See Maria Morris Hambourg, "Afterword," in Alfred Stieglitz, *Georgia O'Keeffe: A Portrait by Alfred Stieglitz* (1978; New York: Metropolitan Museum of Art, 1997), 125.

25. Georgia O'Keeffe, "Introduction," in Stieglitz, *Georgia O'Keeffe: A Portrait by Alfred Stieglitz,* n.p. [8].

26. Norman, *Stieglitz*, 10.

27. He first exhibited some of the photographs of O'Keeffe in 1919 at the Young Women's Hebrew Association. But it is actually difficult to determine which photographs in the series were exhibited and when, in that descriptions of subsequent exhibitions were vague and Stieglitz's titles are of little help. Presumably the most explicit images of O'Keeffe were excluded from public exhibition in Stieglitz's lifetime, but his friends, including the artists and critics in his circle, saw them. See Whelan, *Stieglitz*, 407.

28. Part of the journal was published in *The Photographic Times* 34, no. 1 (January

1902): n.p. This project has been mentioned only briefly in the published literature on Stieglitz. I want to acknowledge Cassandra Albinson's unpublished paper, "Alfred Stieglitz's *Photographic Journal of a Baby:* An Investigation," which she wrote for my 1997 Yale University seminar entitled "Modernism and American Photography."

29. See Anne Wagner's marvelous discussion of the way O'Keeffe's body mirrors her drawings in Stieglitz's photographs. Wagner, *Three Artists,* 85–88.

30. Greenough and Hamilton, *Stieglitz,* 22.

31. It was the only picture in the 1978 Metropolitan Museum of Art exhibition that was borrowed from another museum, the National Gallery, Washington, D.C., suggesting that O'Keeffe felt its presence was necessary to the success of the exhibition.

32. Wagner, *Three Artists,* 87.

33. Ibid., 85–86.

34. Betsy Fahlman reminds me that Stieglitz himself could not drive and rarely traveled beyond New York State.

35. Stieglitz, *Georgia O'Keeffe: A Portrait by Alfred Stieglitz,* n.p. [5].

36. Emily Farnham, "Interview with Susan Watts Street at New York City, 21 January 1956," in "Charles Demuth: His Life, Psychology and Works," Ph.D. diss., Ohio State University, 1959, vol. 3, p. 975.

37. Sherwood Anderson, "Hands," from *Winesburg, Ohio* (New York: Penguin, 1985), 28.

38. Ibid., 31.

39. Lewis Mumford, "The Metropolitan Milieu," in *America and Alfred Stieglitz: A Collective Portrait,* ed. Waldo Frank, Lewis Mumford, Dorothy Norman, Paul Rosenfeld, and Harold Rugg (New York: Aperture, 1979), 36.

40. Ibid., 37.

41. Richard Shiff, "Constructing Physicality," *Art Journal* 50, no. 1 (Spring 1991): 43.

42. Ibid., 44.

43. Martin Jay, *Downcast Eyes: The Denigration of Vision in Twentieth-Century French Thought* (Berkeley: University of California Press, 1993).

44. Seligmann, *Stieglitz Talking,* 97.

45. Hambourg, in Stieglitz, *O'Keeffe,* 126.

CHAPTER 5: WOMAN WITHOUT MEN

The Lynes numbers that follow paintings by Georgia O'Keeffe refer to Barbara Buhler Lynes, *Georgia O'Keeffe: Catalogue Raisonné* (New Haven: Yale University Press, in association with the National Gallery of Art and the Georgia O'Keeffe Foundation, 1999), 490–91.

1. Roxana Robinson, *Georgia O'Keeffe: A Life* (New York: Harper and Row, 1989), 461.

2. Clement Greenberg, "Review of an Exhibition of Georgia O'Keeffe," *The Nation* 15 (June 1946); rpt. in *Clement Greenberg: The Collected Essays and Criticism,* ed. John O'Brian, vol. 2, *Arrogant Purpose, 1945–1949* (Chicago: University of Chicago Press, 1986), 87.

3. Wagner, *Three Artists,* 73. See also Barbara Buhler Lynes's earlier discussion of

O'Keeffe's androgyny in relationship to her paintings' negotiation of gender difference in Barbara Buhler Lynes, *O'Keeffe, Stieglitz and the Critics, 1916–1929* (Chicago: University of Chicago Press, 1991).

4. For a discussion of the ways modern art has repressed the domestic, see Christopher Reed, ed., *Not at Home: The Suppression of Domesticity in Modern Art* (London: Thames & Hudson, 1996).

5. U.S. Postal Service, "FOR IMMEDIATE RELEASE: GEORGIA O'KEEFFE'S 'RED POPPY,' 1927 AND KEITH BIRDSONG'S 'AMERICAN INDIAN DANCES' ISSUED AS COMMEMORATIVE STAMPS BY UNITED STATES POSTAL SERVICE," Federal Department and Agency Documents, 22 April 1996 (Nexis Lexis).

6. "Georgia O'Keeffe," documentary directed by Perry Miller Adato, WNET and the Public Broadcasting Service, 1977.

7. Georgia O'Keeffe, *Catalogue Statement*, 1926; rpt. in Anita Politzer, *A Woman on Paper: Georgia O'Keeffe* (New York: Simon and Schuster, 1988), 189.

8. Georgia O'Keeffe, *Georgia O'Keeffe* (New York: Viking, 1976), 58. O'Keeffe offered up a different explanation for the painting when she was interviewed by Calvin Tomkins; she claimed she was specifically satirizing American Scene painting and photography (Calvin Tomkins, "The Rose in the Eye Looked Pretty Fine," *New Yorker*, 4 March 1974, 48, 50).

9. In the Adato documentary, for example, O'Keeffe denies the morbid implications of bones and calls them "lively."

10. For a discussion of the painting's iconography and its relationship to the Southwest, see Wanda Corn, *The Great American Thing: Modern Art and National Identity, 1915–1935* (Berkeley: University of California Press, 1999), 239–91.

11. Whelan, *Stieglitz*, 502–3. Whelan says that it might have been his first attack of "angina pectoris." In 1938 Stieglitz had a massive heart attack.

12. In relating her turn to the skull motif to the Stieglitz-O'Keeffe relationship I do not mean to limit the many other meanings it had for O'Keeffe. The original conscious or unconscious impetus to paint a subject does not fix its meanings when, as is the case of the skull, it is so rich with iconographic connotations and so central to an artist's practice.

13. O'Keeffe's full-sized panel for *Manhattan* resurfaced in her estate and has been given to the National Museum of American Art, in Washington, D.C. There is also a drawing (Lynes 800) for this panel. See Lynes, *Georgia O'Keeffe*, 490–91. Unfortunately, the original sketch for the three-panel project has been lost. It was published in black and white, however, in the catalogue (Lincoln Kirstein, *Murals by American Painters and Photographers* [New York: Museum of Modern Art, 1932], fig. 2).

I would like to thank Kristina Wilson for sharing with me her unpublished paper "Mural Expectation in the Early Depression: The Disaster of MoMA's 1932 *Murals by American Painters and Photographers*," which was written for a Yale University seminar given by Romy Golan in 1997.

14. Anna C. Chave, "Who Will Paint New York?" in *From the Faraway Nearby: Georgia O'Keeffe as Icon*, ed. Christopher Merrill and Ellen Bradbury (New York: Addison-Wesley, 1992), 78.

15. See Anna C. Chave, "O'Keeffe and the Masculine Gaze," *Art in America* 78

(January 1990): 114–24; Lynes, *Stieglitz and the Critics*, and Wagner, *Three Artists*.

16. Paul Rosenfeld, *Port of New York* (New York: Harcourt, Brace, 1924), 204.

17. Lewis Mumford, "O'Keefe [*sic*] and Matisse," *New Republic*, 2 March 1927, 41–42; rpt. in Lynes, *Stieglitz and the Critics*, 265.

18. For example, in 1939 she wrote, "Well—I made you take time to look at what I saw and when you took time to really notice my flower you hung all your own associations with flowers on my flower and you write about my flower as if I think and see what you think and see of the flower—and I don't." Quoted in O'Keeffe, *O'Keeffe*, 24–26.

19. For a history of the design of Radio City Music Hall, see Charles Francisco, *The Radio City Music Hall: An Affectionate History of the World's Greatest Theater* (New York: Dutton, 1979). For a study of Deskey's interior designs, see David A. Hanks, *Donald Deskey: Decorative Designs and Interiors* (New York: Dutton, 1987).

20. O'Keeffe to Rebecca Salsbury Strand, Fall 1932(?), Alfred Stieglitz/Georgia O'Keeffe Archive, Yale Collection of American Literature, Beinecke Rare Book and Manuscript Library, Yale University; as quoted in Roxana Robinson, *Georgia O'Keeffe: A Life* (New York: Harper & Row, 1989), 377–79.

21. The story of the mural fiasco is told in Robinson, *O'Keeffe*, 370–79, and in Benita Eisler, *O'Keeffe and Stieglitz: An American Romance* (New York: Doubleday, 1991), 429–36.

22. See Robinson, *O'Keeffe*, 373–4.

23. O'Keeffe to Blanche Matthias, 29 April 1929, *Georgia O'Keeffe: Art and Letters*, 188.

24. For the use of men's bathrooms for homosexual sex, see Laud Humphreys's controversial study *Tearoom Trade: Impersonal Sex in Public Places* (Chicago: Aldine, 1970).

25. Alexander Kira, *The Bathroom* (New York: Viking, 1976), 206. According to one study, "voluntary urinary retention" among women contributes to urinary tract infection. See Kiku Adatto, Kathleen Gormale Doebele, Leo Galland, and Linda Granowetter, "Behavioral Factors and Urinary Tract Infection," *JAMA* 241, no. 23 (June 8, 1979): 2525–26. For an interesting survey of the history of the bathroom in public culture, see Ellen Lupton and J. Abbott Miller, *The Bathroom, the Kitchen and the Aesthetics of Waste* (New York: Kiosk, 1992). Unfortunately, the authors have little to say about public facilities.

26. Kira, *Bathroom*, 206. I have only anecdotal evidence to support Kira's claim, since so little has been written on the history of the bathroom and, in particular, of public restrooms. I have spent considerable time querying my colleagues in Women's Studies and American Studies about my supposition that people have considerable anxiety about using public facilities. The result has been a wealth of stories about mothers instructing their children to avoid the use of public bathrooms, if possible. I found this attitude particularly true among women over the age of sixty. I would like to thank Cynthia Russett for relaying my queries to various Women Studies groups via the Web.

27. Clare Boothe, *The Women* (New York: Random House, 1937), 215. The play premiered at the Ethel Barrymore Theatre in New York City on 26 December 1936.

28. Crystal, played by Joan Crawford in the film version of *The Women* (1939), uses a telephone in her bathroom to plan assignations. Another famous Hollywood bathroom scene occurs in *All About Eve* (1950).

29. See Lee Edelman, "Men's Room," in *Stud: Architectures of Masculinity*, ed. Joel Sanders (New York: Princeton Architectural Press, 1996), 153. Edelman points out that although men urinate in view of one another at urinals, paradoxically, no one is supposed to look: "The law of the men's room decrees that men's dicks be available for public contemplation at the urinal precisely to allow a correlative mandate: that such contemplation must never take place."

30. Ernest Hemingway, *Men without Women* (New York: Scribner's, 1927).

31. As quoted in Rudi Blesh, *Stuart Davis* (New York: Grove Press, 1960), 54. For a discussion of the mural, including its relationship to Hemingway's book, see Lowery Stokes Sims, *Stuart Davis* (New York: Metropolitan Museum of Art, 1992), 218–21. Davis's masculine imagery is discussed in Lewis Kachur, "Stuart Davis and Bob Brown: The Masses to the Paris Bit," *Arts* 57, no. 2 (October 1982): 70–73.

32. This painting has also been titled *White Trumpet Flower* (Lynes 816) and is now in the San Diego Museum of Art. *Jimson Weed* (Lynes 815), or as it is also known, *White Flower No. 1*, now in the Georgia O'Keeffe Museum, has a similar motif.

33. According to Elizabeth Glassman of the O'Keeffe Foundation, in Abiquiu, New Mexico, no sketches for the mural were found in her estate.

34. See William A. Nering, *National Audubon Society Field Guide to North American Wildflowers, Eastern Region* (New York: Alfred Knopf, 1997), 802. For a discussion of the significance of jimsonweed for O'Keeffe, see Marjorie P. Balge-Crozier, "Still Life Redefined," in *Georgia O'Keeffe: The Poetry of Things*, ed. Elizabeth Hutton Turner (Washington, D.C.: The Phillips Collection and Yale University Press, in association with the Dallas Museum of Art, 1999), 61. I wish to thank Mary Miller for reminding me about the poisonous nature of the jimsonweed.

35. *Jimson Weed* is also referred to as *Miracle Flower* and *White Flowers* (Lynes 886).

36. I wish to thank Anne Wagner for suggesting the parallel between makeup and painting. Wagner reminded me that O'Keeffe did not use makeup. For Wagner, however, the exaggerated artificiality of O'Keeffe's flowers is a kind of masquerade of femininity.

37. O'Keeffe to Waldo Frank, New York, 10 January 1927, *Georgia O'Keeffe: Art and Letters*, 185.

38. Wagner, *Three Artists*, 102.

39. Whelan, *Stieglitz*, 480.

40. Ibid., 382. For the most complete discussion of the *Fountain* incident, see William A. Camfield, *Marcel Duchamp: Fountain* (Houston: Menil Collection and Houston Fine Art Press, 1989).

41. "Beauty Is Fun," *Town & Country*, April 1937, 152. A reproduction of the *Town & Country* spread is reproduced in Eisler, *O'Keeffe and Stieglitz*, n.p.

42. For a discussion of the commission and O'Keeffe's friendship with Arden, see Eisler, *O'Keeffe and Stieglitz*, 459–60. Eisler cites one member of the Stieglitz

circle, Claude Bragdon, as being dismayed by O'Keeffe's friendship with the "Beautician to the American Aristocracy of Dollars."

43. O'Keeffe to Dorothy Brett, September(?) 1932, *Georgia O'Keeffe: Art and Letters,* 207–8.

44. O'Keeffe to Russell Vernon Hunter, New York, October 1932, *Georgia O'Keeffe: Art and Letters,* 211.

45. For a history and photographs of O'Keeffe's Abiquiu home, see Myron Wood and Christine Taylor Patten, *O'Keeffe at Abiquiu* (New York: Abrams, 1995). I would also like to acknowledge Emily Sobel, who in 1996, while a senior at Yale University, wrote a marvelous essay under my supervision, "Georgia O'Keeffe at Home: The Art Spaces."

46. I wish to thank Barbara Buhler Lynes for reminding me about the collaborative nature of the Chabot-O'Keeffe reconstruction. Chabot's letters to O'Keeffe from the 1940s that are housed in Yale University's Beinecke Rare Book and Manuscript Library detail the process by which the house was "restored" and modernized. Chabot kept O'Keeffe informed of day-to-day progress and frequently requested her advice and permission for major improvements. But O'Keeffe was often too busy to respond and allowed Chabot freedom to follow her own eye. Frequently Chabot complains because O'Keeffe is not giving her enough direction. Crucial decisions, however, such as the installation of large plate-glass windows and the placement of the studio and the bedroom were clearly made in consultation with O'Keeffe.

47. For all the austerity of O'Keeffe's house, its relative luxuriousness becomes apparent when we compare it to the well-known hacienda of Antonio Severino Martinez in Taos, a restored early nineteenth-century complex that she undoubtedly knew. Although the Martinez hacienda is intensely sculptural and dignified, it is not particularly welcoming or comfortable. Like O'Keeffe's house, it utilizes a courtyard plan. A single row of darkly lit rooms wraps around two courts. The thick outer walls of the complex are windowless, providing the maximum protection. What few windows there are face the court, and they are small because glass was expensive in the frontier period. Most of the spaces are monotonously similar, with little difference between storage rooms and working and living quarters. The exception is the cocina, or kitchen, with its long shepherd's fireplace that doubled as a bed. This large room, where food was prepared, was the center of family life. But even this relatively spacious area has a decidedly Spartan quality. Although the Martinez family was rich by the standards of their day, their home's fortresslike plan and its lack of grand ceremonial spaces speak of the frugality and difficulty of frontier existence.

48. Corn, *Great American Thing,* 259.

49. For the best discussion of pueblo architecture, see Vincent Scully, *Pueblo: Mountain, Village, Dance* (New York: Viking, 1975).

50. For a discussion of Mabel Dodge Luhan's home, see Lois Palken Rudnick, *Mabel Dodge Luhan: New Woman, New Worlds* (Albuquerque: University of New Mexico Press, 1984), 156–57, and her *Utopian Vistas: The Mabel Dodge Luhan House and the American Counterculture* (Albuquerque: University of New Mexico Press, 1996). The complex was the creation of Mabel Dodge Luhan and

her husband, Tony Luhan, but Rudnick claims that Luhan was responsible for the interiors.

51. I wish to thank Edward Cooke, Jr., for giving me several suggestions for sources on adobe architecture. For a history of adobe buildings in Taos, see Bainbridge Bunting, *Taos Adobes: Spanish Colonial and Territorial Architecture of the Taos Valley* (Albuquerque: University of New Mexico Press, 1992), and Agnesa Lufkin Reeve, *From Hacienda to Bungalow: Northern New Mexico Houses, 1850–1912* (Albuquerque: University of New Mexico Press, 1988). For wonderful photographs of the interior of the Martinez hacienda, as well as an informal overview of adobe construction, see Orlando Romero and David Larkin, *Adobe: Building and Living with Earth* (Boston: Houghton Mifflin, 1994). For a discussion of the genesis of a southwestern regional architectural style, see Chris Wilson, *The Myth of Santa Fe: Creating a Modern Regional Tradition* (Albuquerque: University of New Mexico Press, 1997).

52. Chabot to O'Keeffe, 20 May 1947, Alfred Stieglitz/Georgia O'Keeffe Archive, Yale Collection of American Literature, Beinecke Rare Book and Manuscript Library, Yale University.

53. Ibid., 8 August 1946.

54. Ibid., 20 May 1947.

55. As quoted in Alice T. Friedman, "Domestic Difference: Edith Farnsworth, Mies van der Rohe, and the Gendered Body," in Reed, *Not at Home*, 185.

56. Seligmann, *Stieglitz Talking*, 60.

57. O'Keeffe visited Frank Lloyd Wright in Madison, Wis., in 1942. She wrote him an effusive letter: "I wish that I could tell you how much the hours with you mean to me—I've thought of you most of my waking hours since I left your house and I assure you that I left with a keen feeling of regret." She wrote that she was reading one of his books, which Sarah Greenough guesses is either *An Organic Architecture* or *Frank Lloyd Wright on Architecture*, both of which articulate his theory of plasticity (Georgia O'Keeffe to Frank Lloyd Wright [on the train from Chicago to New York, May 1942], *Georgia O'Keeffe: Art and Letters*, 232–33 and 287 n. 82.

58. See Vincent Scully, *Frank Lloyd Wright* (New York: Braziller, 1960).

59. "Georgia O'Keeffe," documentary.

60. The black door is an even more assertive element in the tiny and more abstract *Canadian Barn* (Lynes 810) from the same year.

61. For example, Clement Greenberg, "Towards a Newer Laocoon," *Partisan Review* (July–August 1940); rpt. in *Collected Essays and Criticism*, vol. 1, *Perceptions and Judgments, 1939–1944*, 34.

62. Sharyn R. Udall, *Contested Terrain: Myth and Meanings in Southwest Art* (Albuquerque: University of New Mexico Press), 94.

63. Barbara Buhler Lynes mentioned to me that the issue of water rights was crucially important in cementing the purchase of the Abiquiu house.

64. As quoted in Romero and Larkin, *Adobe*, 156.

65. See my discussion of Picasso's theory of abstraction and figuration in Chapter 2.

66. Greenberg, "O'Keeffe," 87.

67. Robert Penn Warren, "Pure and Impure Poetry," in *The Kenyon Critics*, ed. John Crowe Ransom (New York: World Publishing, 1951), 19. This essay was

originally delivered as one of the "Measures" Lectures at Princeton University in 1942. I want to thank William S. Wilson for bringing this essay to my attention.

68. Ibid., 39.

CHAPTER 6: A RAKE PROGRESSES

1. David Hockney, *David Hockney by David Hockney* (New York: Abrams, 1976), 90.

2. Henry Geldzahler, in his Introduction, discusses the way the painting investigates illusion, in *David Hockney by David Hockney*, 12.

3. Max Horkheimer and Theodor W. Adorno, *Dialectic of Enlightenment*, trans. John Cumming (New York: Continuum, 1991), 167.

4. Although in 1975 Hockney designed sets for Igor Stravinsky's opera *A Rake's Progress*, the libretto for which was written by W. H. Auden in response to Hogarth's work, Hockney told me that, at the time he was making the prints, he was not familiar with this work (interview with the author, Los Angeles, 23 February 1995).

5. Hockney, *Hockney by Hockney*, 65.

6. See Wayne E. Stanley, *The Complete Reprint of Physique Pictorial* (New York: Taschen, 1997).

7. For a discussion of Hockney's use of *Physique Pictorial* and the role it played in his fantasy of California, see Paul Melia, "Showers, Pools and Power," in *David Hockney*, ed. Paul Melia (Manchester: Manchester University Press, 1995), 53–63.

8. Hockney, *Hockney by Hockney*, 62.

9. Peter Adams, *David Hockney and His Friends* (Bath, Eng.: Absolute Press, 1997), 28.

10. Hockney, *Hockney by Hockney*, 68.

11. Kenneth E. Silver, *David Hockney* (New York: Rizzoli, 1994), n.p.

12. On Whitman and gay imagery in American painting, see my own *Speaking for Vice: Homosexuality in the Art of Charles Demuth, Marsden Hartley, and the First Avant-Garde* (New Haven: Yale University Press, 1993). On a tradition of gay imagery in post–World War II American painting, see Kenneth E. Silver, "Modes of Disclosure: The Construction of Gay Identity and the Rise of Pop Art," in *Hand-Painted Pop: American Art in Transition 1955–62*, ed. Russell Ferguson (Los Angeles: Museum of Contemporary Art, 1993), 178–203.

13. Hockney, *Hockney by Hockney*, 68.

14. Ibid., 62.

15. See Alan Woods, "Picture Emphasizing Stillness," in Melia, *David Hockney*, 30–48.

16. He appears to have applied both red and black to the same plate, which means that the areas that are red are carefully separated from the areas that are black.

17. Hockney, *Hockney by Hockney*, 65.

18. See Simon Faulkner, "Dealing with Hockney," in Melia, *David Hockney*, 11–29.

19. Charles Baudelaire, *The Painter of Modern Life and Other Essays*, trans. Jonathan Mayne (London: Phaidon, 1964), 9.

20. Hockney, *Hockney by Hockney*, 65.

21. Adam, *Hockney and His Friends*, 39.

22. Interview with the author, Los Angeles, 23 February 1995.

23. T. J. Clark, "In Defense of Abstract Expressionism," *October* 69 (Summer 1994): 23.

24. Hockney, *Hockney by Hockney*, 193.

25. Ibid., 102.

26. Melia, *David Hockney*, 61–62.

27. Kevin Gough-Yates (interviewer), "*A Bigger Splash*," *Studio International* 189, no. 974 (March–April 1975): 143.

28. In my interview with Hockney, he claimed that he was never following a script. Only later, when the film was finished, did he learn that the other participants were given lines that were supposed to elicit certain responses from the artist. Yet this seems a bit disingenuous. Surely he must have noticed that his friends' words seemed stilted, as if scripted.

29. Peter Webb, *Portrait of David Hockney* (Toronto: McGraw-Hill Ryerson Limited, 1988), 140–44.

30. Hockney, *Hockney by Hockney*, 286.

31. Woods, "Stillness," 35.

32. Hockney, *Hockney by Hockney*, 126.

33. Silver, *David Hockney*, n.p.

34. Hockney, *Hockney by Hockney*, 194.

35. David Hockney, *That's the Way I See It*, ed. Nikos Stangos (San Francisco: Chronicle Books, 1993), 16–19.

36. *Looking at Pictures* was used as the cover of the catalogue for the exhibition *The Artist's Eye: David Hockney: Looking at Pictures on a Screen*, which was organized by the National Gallery, London, in 1981. The title of the catalogue is different. It is called *David Hockney: Looking at Pictures in a Book at the National Gallery* in order to acknowledge the difference between looking at works of art in a museum or at reproductions in a book. David Hockney, *Looking at Pictures in a Book at the National Gallery* (London: National Gallery, 1981).

37. Gert Schiff, "A Moving Focus: Hockney's Dialogue with Picasso," in *David Hockney: A Retrospective* (Los Angeles: Los Angeles County Museum, 1988), 42.

CHAPTER 7: FAMOUS ARTISTS

1. James Agee and Walker Evans, *Let Us Now Praise Famous Men: Three Tenant Families* (Boston: Houghton Mifflin, 1988), xlv; hereafter cited as *LUNPFM*.

2. For a study of the families before and after the Agee and Evans visit, see Dale Maharidge and Michael Williamson, *And Their Children after Them* (New York: Pantheon, 1989). The book discusses the families' dire poverty and their struggle to make a living long after Agee and Evans left. As the book points out, the day Agee and Evans met Floyd Burroughs, Frank Tengle, and William Fields, the tenant farmers had just been rejected for relief work. James R. Mellow provides a useful synopsis of the chronology of the Agee and Evans visit with the three families in *Walker Evans* (New York: Basic, 1999).

3. Laurence Bergreen, *James Agee: A Life* (New York: Dutton, 1984), 260.

4. Margaret Olin, "'It Is Not Going to Be Easy to Look into Their Eyes': Privilege

of Perception in *Let Us Now Praise Famous Men,*" *Art History* 14, no. 1 (March 1991): 92.

5. Wayne Koestenbaum, *Double Talk* (New York: Routledge, 1989), 3–4.

6. Agee and Evans, *LUNPFM,* 13.

7. Ibid., 136.

8. Ibid., xlv.

9. Ibid., xlvii.

10. See James C. Curtis and Sheila Grannen, "Let Us Now Appraise Famous Photographs: Walker Evans and Documentary Photography," *Winterthur Portfolio* 15 (Spring 1980): 1–23. This essay is reworked in James C. Curtis, *Mind's Eye, Mind's Truth: FSA Photography Reconsidered* (Philadelphia: Temple Press, 1989).

11. Agee and Evans, *LUNPFM,* xlvii.

12. This picture is entitled *A Child's Grave,* in *Walker Evans' Photographs for the Farm Security Administration, 1935–1938,* introduction by Jerald C. Maddox (New York: De Capo, 1973), no. 345.

13. Ibid., 439.

14. Ibid., 42.

15. Ibid., 65.

16. Estate of Walker Evans, *Walker Evans at Work,* with an essay by Jerry L. Thompson (New York: Harper and Row, 1982, 125).

17. Maharidge and Williamson suggest that the only money that changed hands was for the room and board that Agee would have paid the Burroughses. For several years Agee kept in touch with the Burroughs family, though he never sent any member of the three families a copy of *Let Us Now Praise Famous Men* (Maharidge and Williamson, *Children,* 84–85).

18. Thompson, *Evans at Work,* 125.

19. Agee and Evans, *LUNPFM,* 8.

20. Agee and Evans, *LUNPFM,* 136.

21. One of the photographs of Dora Mae Tengle that didn't make it into the final book includes Evans's shadow. It is the one picture in the series that does convey a sense of Evans's physical presence. There is a spooky predatory quality to the image. As with the text, we become more aware of the artist than of the subject.

22. Koestenbaum, *Double Talk,* 3.

23. Agee and Evans, *LUNPFM,* 7.

24. Ibid., xlvi.

25. According to Bergreen, in the midst of writing *Let Us Now Praise Famous Men,* Agee arranged to have Evans have sex with his wife, Alma, while he watched. Agee later apologized to Evans in a letter, adding that he was "enough of an infant homosexual or postdostoevskian to be glad" (Bergreen, *Agee,* 238–39). Alma Neuman, Agee's wife, discusses the incident in her *Always Straight Ahead: A Memoir* (Baton Rouge: Louisiana State University Press, 1993).

26. Agee and Evans, *LUNPFM,* 62.

27. Ibid., 364.

28. Agee and Evans, *LUNPFM,* 375, 376.

29. According to Maharidge and Williamson, Evans kept his distance from the families and was not particularly liked by them (Maharidge and Williamson,

Children, 39–40). And James Mellow contends that Evans did not actually sleep at the Burroughs's farmstead, as did Agee. He probably slept at a nearby hotel.

30. According to the text of *Let Us Now Praise Famous Men* (450–51), the article by May Cameron entitled "A Note on the Photographs: Margaret Bourke-White Finds Plenty of Time to Enjoy Life along with her Camera Work" was published in the *New York Post.*

31. See Alan Trachtenberg's Foreword to the new edition of *You Have Seen Their Faces* (Athens, Ga.: Brown and Thrasher, University of Georgia Press, 1995).

32. Agee's dislike of Margaret Bourke-White's photographs for the article is mentioned in Bergreen, *Agee,* 145.

33. Margaret Bourke-White and James Agee, "The Drought," *Fortune,* October 1934, 79.

34. The *Life* cover was taken after the *You Have Seen Their Faces* project, but it appeared before the book was published.

35. Margaret Bourke-White, *Portrait of Myself* (New York: Simon and Schuster, 1963), 125.

36. Erskine Caldwell, *With All My MIGHT* (New York: Peachtree Publishers, 1987), 150.

37. Erskine Caldwell and Margaret Bourke-White, *You Have Seen Their Faces* (New York: Modern Age, 1937), 51; hereafter cited as *YHSTF.*

38. William Stott, *Documentary Expression and Thirties America* (Chicago: University of Chicago Press, 1986), 223.

39. Caldwell and Bourke-White, *YHSTF,* 48.

40. Bourke-White, *Myself,* 127–28.

41. Agee and Evans, *LUNPFM,* 15.

42. Caldwell and Bourke-White, *YHSTF,* 1.

43. Ibid., 48.

44. The later edition of *Let Us Now Praise Famous Men* included more images of African Americans. For example, there is the famous picture of black men posing on a Vicksburg street, which Nicholas Natanson praises for its "complex sociological particulars of a time and a place (important gradations within black society)" (Nicholas Natanson, *The Black Image in the New Deal: The Politics of FSA Photography* [Knoxville: University of Tennessee Press, 1992], 270 n. 8).

45. Caldwell and Bourke-White, *YHSTF,* 11.

46. Ibid., 11.

47. Neither Caldwell nor Bourke-White had much sympathy for the role of religion in southern rural life. In her memoir Bourke-White compares the black sermon to the "rhythm of the jungle." She is even harsher about a small white congregation: "This shoddy little ceremonial re-enacted each week in the name of religion, was the very antithesis of religion. . . . It illuminates the spiritual poverty of people who have no other emotional release, no relaxation and laughter, no movies or books and, far worse, no educational or other inner equipment with which to change the course of their meaningless lives" (Bourke-White, *Myself,* 134).

48. Caldwell and Bourke-White, *YHSTF,* n.p.

49. Natanson, *Black Dance*, 26.

50. Caldwell and Bourke-White, *YHSTF*, 51.

51. Alan Trachtenberg quotes an unnamed contemporary critic who insisted that "the roles of the text and illustration are completely reversed. . . . The pictures state the theme of the book, whereas the prose serves as illustrative material" (Trachtenberg, *YHSTF* [1995], v).

CHAPTER 8: THE BOMBING OF BASQUIAT

1. In his diary, Warhol reports with some delight that Basquiat had resorted to hustling when he was living on the streets. Supposedly Basquiat refused to accompany Warhol to a gay bar notorious for its hustlers because it brought back bad memories: "He called this morning and told me that in the old days when he didn't have any money he would hustle and get $10 and he didn't want to remember that" (Andy Warhol, *The Andy Warhol Diaries*, ed. Pat Hackett [New York: Warner, 1989], 594, entry dated 7 August 1984). Phoebe Hoban reports that Al Diaz, his graffiti partner, told her that Basquiat had sex with men (Phoebe Hoban, *Basquiat: A Quick Killing in Art* [New York: Viking, 1998], 49).

2. Flatley discusses at length the destabilizing role of fame in terms of asserting the self. Borrowing from a concept of Paul de Man's, he refers to this process as the "prosopopoetic economy, an economy that defaces as it gives face, that produces anonymity even as it enables recognition, and does not distinguish between the dead and the living" (Jonathan Flatley, "Warhol Gives Good Face: Publicity and the Politics of Prosopopoeia," in *Pop Out: Queer Warhol*, ed. Jennifer Doyle, Jonathan Flatley, and José Esteban Muñoz [Durham, N.C.: Duke University Press, 1996), 106.

3. From an interview that Henry Geldzahler conducted with Basquiat in 1983 (Henry Geldzahler, "Jean-Michel Basquiat," in Henry Geldzahler, *Making It New* [New York: Turtle Point Press, 1994], 202).

4. bell hooks, "Altars of Sacrifice: Re-membering Basquiat," *Art in America* 81, no. 6 (June 1993): 70.

5. He told Robert Farris Thompson, "I cross out words so you will see them more; the fact that they are obscured makes you want to read them" (Robert Farris Thompson, "Royalty, Heroism, and the Streets: The Art of Jean-Michel Basquiat," in *Jean-Michael Basquiat*, ed. Richard Marshall [New York: Whitney Museum of Art, 1992], 32).

6. Robert Hughes, "Requiem for a Featherweight: The Sad Story of an Artist's Success," *Time*, 21 November 1988, 34.

7. Mervyn Kurlansky and Jon Naar, text by Norman Mailer, *Faith of Graffiti* (New York: Praeger, 1974), n.p.

8. Rene Ricard, "The Radiant Child," *Art Forum* 20 (December 1981): 36. Ricard notes Basquiat's pride that his SAMO tag was not bombed over in a school yard.

9. Ibid., 40.

10. Ibid., 43.

11. Ibid., 39.

12. Ibid., 43.

13. Ibid., 40.

14. Warhol, *Diaries*, 4 October 1982, 462.

15. Ibid., 4 October and 5 October 1982, 462–63.

16. Jeanne Silverthorne, "Jean-Michel Basquiat," *Art Forum* 20, no. 10 (Summer 1982): 82.

17. Jeffrey Deitch, "Jean-Michel Basquiat, Annina Nosei," *Flash Art* 16, no. 107 (May 1982): 49–50.

18. Dick Hebdige, "Welcome to the Terrordome: Jean-Michel Basquiat and the 'Dark' Side of Hybridity," Marshall, *Basquiat*, 62.

19. Adam Gopnik, "Madison Avenue Primitive," *New Yorker*, 9 November 1992, 138.

20. Geldzahler, *Making It New*, 202.

21. Thompson, "Royalty," 33.

22. Klaus Kertess, "Brushes with Beatitude," in Marshall, *Basquiat*, 52.

23. Gopnik, "Madison Avenue," 137.

24. Greg Tate, "Black Like B.," in Marshall, *Basquiat*, 58. Tate wonders how Basquiat would have interrelated to "the explosive emergence of hip-hop as a redemptive and organizing force in the lives of young black men only a year after his death."

25. Hebdige, "Terrordome," 62.

26. Rene Ricard, "Golden Boy," *Vogue*, October 1992, 202.

27. As quoted in James Kaplan, "Big," *New York*, 12 August 1996, 35.

28. Schnabel appears to have had a prior history of appropriating the work of another painter. According to Thomas Lawson, he exchanged a picture with David Salle. He then reworked the Salle by reversing the diptych and painting Salle's portrait on one panel (Thomas Lawson, "Last Exit: Painting," in *Art After Modernism: Rethinking Representation*, ed. Brian Wallis [New York: New Museum of Contemporary Art, 1984], 160).

29. Schnabel writes, "I found a similarity in surfing and painting, maybe because it wasn't a team sport, maybe because of the constant sensation of drowning" (Julian Schnabel, *C.V.J.: Nicknames of Maitre D's and Other Excerpts from Life* [New York: Random House, 1987], 49).

30. Hoban, *Basquiat*, 329.

31. See Schnabel, *C.V.J.*

32. Jean-Michel Basquiat statement from an unreleased videotape interview with Tamra Davis and Becky Johnson, Los Angeles, 1986; as quoted in Richard D. Marshall, "Ein Besuch Floridas mit Jean-Michel Basquiat und Andy Warhol," in *Collaborations: Warhol, Basquiat, Clemente* (Italian and English ed.), ed. Tilman Osterwold (Osterfildern: Cantz, 1996), 46. I want to thank Richard D. Marshall for providing me with a copy of an English translation.

33. See, for example, Robert Hughes's damaging attack, "The Rise of Andy Warhol," *New York Review of Books*, 18 February 1982, 6–10.

34. Trevor Fairbrother, "Double Feature," *Art in America* 84, no. 9 (September 1996): 78.

35. Warhol, *Diaries*, 12 April 1984, 565.

36. bell hooks, "Eating the Other," in *Black Looks: Race and Representation* (Boston: South End Press, 1992).

37. hooks, "Re-membering Basquiat," 71.

38. Thomas Waugh, "Cockteaser," in Doyle, Flatley, and Muñoz, *Pop Out*, 106.

39. Vivian Raynor, "Basquiat, Warhol," *New York Times*, 20 September 1985.

40. Richard Marshall discusses Basquiat's use of hobo codes gleaned from Henry Dreyfuss's *Symbol Sourcebook*. According to Marshall, hoboes "left chalk or crayon signs graffitied on fences, walls, and doors, which conveyed messages such as 'dangerous neighborhood,' 'easy mark, sucker.'" (Marshall, *Basquiat*, 23).

41. *Paramount* includes the words "uranus," and "bum"—both obvious references to homosexuality.

42. Waugh, *Cockteaser*, 55.

43. José Esteban Muñoz, "Famous and Dandy like B. 'n' Andy: Race, Pop, and Basquiat," in *Pop Art*, 162–63.

44. Warhol, *Diaries*, 8 October 1984, 606.

45. Ibid., 153.

46. Or so Arthur Danto suggests in his "Three Decades after the End of Art," in *After the End of Art: Contemporary Art and the Pale of History* (Princeton: Princeton University Press, 1997), 21–39. For Danto the *Brillo Boxes* were a key work that summons what he believes is the "end of art." He claims that "a certain type of closure had occurred in the historical development of art" (21) where "no art is any longer mandated as against any other art" (27). Warhol's *Brillo Boxes*, for Danto, was evidence that henceforth questions of what is and what is not art would no longer be valid. Danto declares that "there is no further direction for the history of art to take. It can be anything artists and patrons want it to be."

47. Warhol, *Diaries*, 17 April 1984, 567.

48. Ibid., 17 September 1984, 600. Typical of Warhol, his compliment to Basquiat is colored by a complaint about not being paid as much as Clemente by Bruno Bischofberger for the pictures the three artists worked on.

49. The General Electric logo also appears in Warhol's 1960 Pop painting *199 Television*, in the collection of the Dia Art Foundation, New York.

50. For a discussion of this exhibition, for which Warhol "raided" the storerooms of the Museum of Art of the Rhode Island School of Design, see Michael Lobel, "Warhol's Closet," *Art Journal* 55, no. 4 (Winter 1996): 42–50.

51. Geldzahler, *Making It New*, 197.

CHAPTER 9: ADVERTISEMENTS FOR THE DEAD

A version of the section on Marc Lida was originally published as a catalogue for *Illuminating Proust: Watercolors by Marc Lida from the Maurice Sendak Collection*, Demuth Foundation, Lancaster, Penn., May 23–June 20, 1999, and again in *Loss within Loss*, ed. Edmund White (Madison: University of Wisconsin Press, 2001). I would like to thank Bruce Kellner, Edmund White, and Patrick Moore for their help with the text.

1. *Ecclesiasticus* (The Wisdom of Jesus the Son of Sirach), verse 44.

2. Of course, the story of van Gogh's troubled life, and the increasingly astronomical auction prices for his canvases, fuel this myth. But even van Gogh's life does not quite fit the myth, since before he died his work was already well

known to the French avant-garde; in addition, his brother was an influential art dealer.

3. Marc Lida, "Artist Statement," undated manuscripts in the possession of Marc's brother, David Lida.

4. Charles Demuth to Alfred Stieglitz, 30 October 1927, Alfred Stieglitz/Georgia O'Keeffe Archive, Yale Collection of American Literature, Beinecke Rare Book and Manuscript Library, Yale University.

5. See Emily Farnham, "Interview with William Carlos Williams at Rutherford, New Jersey, 26 Jan. 1956," in "Charles Demuth: His Life, Psychology and Works," 3 vols. (Ph.D. diss., Ohio State University, 1959), 3:990.

6. Marcel Proust, *Remembrance of Things Past: Time Regained,* trans. C. K. Scott Moncrieff and Terence Kilmartin (New York: Random House, 1981), 1095. Marc Lida was not fluent in French and therefore used this translation.

7. Proust, *Time Regained,* 1101.

8. Artists with HIV/AIDS, along with friends and family who are interested in getting information on how to prepare their estate should contact the Archives Project, c/o Visual AIDS, 526 West 26th St., No. 510, New York, N.Y. 10001.

9. Proust, *Swann's Way,* 47–48.

10. Proust, *Time Regained,* 912.

11. Ibid., 1105.

12. Ibid., 912.

13. Marc Lida, "Maurice Sendak—Drawings for 'Dear Mili,' The Pierpont Morgan Library, November 3–February 12," 7; manuscript of review in the possession of David Lida.

14. Here Lida is quoting directly from a Demuth watercolor entitled *Nana's Awakening.* The watercolor illustrates a scene from Zola's *L'assommoir* in which the young Nana peeks through a transom window and sees her mother in the midst of an adulterous affair.

15. Proust, *The Guermantes Way,* vol. 2, 617–18.

16. Marc Lida, "Drawings of Sex and Death," artist statement written on the occasion of an exhibition at the Pyramid Club, New York City, August 1983; manuscript in the possession of David Lida.

17. Proust, *Swann's Way,* 455.

18. For a discussion of the NAMES Project and the Vietnam Veterans Memorial, see, for example, Peter S. Hawkins, "Naming Names: The Art of Memory and the NAMES Project AIDS Quilt," *Critical Inquiry* 19, no. 4 (Summer 1993): 752–72, and Marita Sturken, *Tangled Memories: The Vietnam War, the AIDS Epidemic, and the Politics of Remembering* (Berkeley: University of California Press, 1997). For a discussion of the Memorial in relationship to naming and modern war memorials, see Vincent Scully, "The Terrible Art of Designing a War Memorial," *New York Times,* 14 July 1991, sect. 2, p. 28.

19. See Jeshajahu Weinberg and Rina Elieli, *The Holocaust Museum in Washington* (New York: Rizzoli, 1995).

20. It should be noted, however, that unlike remembering an individual with a single gravestone in a cemetery, there is no limit to how many panels can be made for a person. It is also not necessary that the panel maker(s) know the

person the panel is dedicated to. For example, there are multiple panels for celebrities like Rock Hudson, Keith Haring, and Ryan White. There are also panels dedicated to groups or professions.

21. Unless otherwise noted, all official statements from the NAMES Project are from its Web site (http://www.aidsquilt.org/) as of December 1999.

22. Cindy Ruskin, *The Quilt: Stories from the NAMES Project* (New York: Pocket Books, 1988), 9.

23. According to the NAMES Project Web site (December 1999).

24. For a history of the Gran Fury collective, which ran from 1988 until 1992, see, for example, Douglas Crimp and Adam Ralston, *AIDS Demo Graphics* (Seattle: Bay Press, 1990) and Richard Meyer, "'This Is to Enrage You': Gran Fury and the Graphics of AIDS Activism," in *But Is It Art?* ed. Nina Felshin (Seattle: Bay Press: 1995).

25. I should point out that not all of ACT UP's graphics were designed by Gran Fury. For a range of such graphics, see Crimp and Ralston, *Demographics*.

26. Meyer, "Enrage," 54.

27. Crimp and Ralston, *Demographics*, 20. Burroughs Wellcome was a drug company that ACT UP targeted because of the exorbitant prices it charged for its AIDS treatments.

28. "I came here today" is quoted from a speech given by Roger Lyon in Washington, D.C., on 2 August 1983 and appears in a panel sewn by Cindy "Gert" McMullin in his honor (Ruskin, *The Quilt*, 34). "My anger" is from a panel made by Norma Shumpert in honor of her brother, Billy Denver Donald (Ruskin, *The Quilt*, 98).

29. See, for example, Robin Hardy, "Die Harder: AIDS Activism Is Abandoning Gay Men," *Village Voice*, 2 July 1991.

30. For a discussion of the NAMES Project Quilt and the feminine quilt-making tradition, see Hawkins, *Naming Names*. As I have pointed out, quilt making is a double-edged model. I wrote in *Art in America:* "Certainly some 19th-century women were able to express their lives in their quilts, and, in certain cases, even incorporate political messages about contemporary issues like temperance and abolitionism. . . . But in another sense, quilts were a marker of women's oppression, a grid that emblematized the regimentation and categorization that kept them in the home, sewing rather than fighting for the right to make decisions about their own lives. Quilts were acceptable representations precisely because they were not taken to be representations at all" ("The Quilt Activism and Remembrance," *Art in America* 80, no. 12 [December 1992], 39).

31. In fact, panel makers sometimes ignore the size stipulations. Sometimes the NAMES Project accommodates a larger size; sometimes a panel is returned. On occasion people submit tiny quilts, which are later sewn together into a larger panel. The NAMES Project strongly discourages submissions that do not follow the basic guidelines.

32. Ruskin, *The Quilt*, 26.

33. Ibid., 37.

34. The panels made by fashion designers and their studios were published in the book *Always Remember* (New York: Simon and Schuster, 1996).

35. Ruskin, *The Quilt,* 117.

36. The NAMES Project has been extraordinarily tolerant in terms of accepting any quilt that comes its way, no matter how deficient or bizarre the workmanship.

37. Rico Franses, "Postmonumentality: Frame, Grid, Space, Quilt," in *The Rhetoric of the Frame: Essays on the Boundaries of the Artwork,* ed. Paul Duro (Cambridge: Cambridge University Press, 1996), 262.

38. Ruskin, *The Quilt,* 66.

39. Hawkins, *Naming Names,* 763.

40. Michael Bongiorni, interview with the author, May 1997, San Francisco.

41. Daniel Harris, "Making Kitsch from AIDS," *Harper's,* July 1994.

42. Ibid., 60.

43. Aaron Fogel, "Bruegel's *The Census at Bethlehem* and the Visual Anticensus," *Representation* 54 (Spring 1996): 13. In raising the issue of the nomadic, Fogel has in mind Gilles Deleuze and Félix Guattari's *A Thousand Plateaus* (Minneapolis: University of Minneapolis, 1987). I do not have the space here to give justice to Fogel's complex worries about the quilt and demographics. He is honest enough to admit that "a reverse argument could be made" to show that the quilt is "more popularly critical" than he allowed. However, I did want to cite his argument if for no better reason than to point the reader to one of the most subtle critiques of the NAMES Project Quilt. Like all great critiques of works of art, it does not dismiss its subject but leaves the reader with a greater sense of its specific qualities and contributions.

 For a different discussion of the relationship of the quilt to Deleuze and Guattari's concept of the nomadic, see Franses, "Postmonumentality," 268–69.

44. Sturken, *Tangled Memories,* 219.

45. Ibid., 189.

46. Ibid., 219.

47. George Renz, interview with author, May 1997, San Francisco.

Index

Abstract Expressionism, xii, xviii, 34;
art schools and, 145; Hockney and,
147, 149; legacy of, 159; Pollock
and, 49
abstraction, 24, 111, 132; figuration
and, 137; Hockney and, 167, 171,
172; Picasso and, 173
Abstraction (O'Keeffe), 102, *102*
ACT UP (AIDS Coalition to Unleash
Power), 259, 260–61
Adam, Peter, xiii, 156
Adhesiveness (Hockney), 143, 144, *146*
Adorno, Theodor, 141
Advertisement (Warhol), 227, 229
advertising, 78, 86, 141, 203
Agee, James, xvi, 179–97, 273;
collaboration with Evans, 179–97,
232, 259; dismissal of Bourke-
White, 196; quoted, 179–80, 185;
sexual attitude of, 192, 194–95,
292n25
AIDS (Acquired Immune Deficiency
Syndrome), 174, 243, 252; activist
groups and, 259–61; NAMES Project
Quilt and, 257, 258, 263, 270,
271–72; statistics concerning, 258
Alfieri, Bruno, 53
Allie Mae Burroughs (Evans), *188*, 189
American Gothic (Wood), 3, 4
American Place, An, 83
Amoco (Basquiat and Warhol), 234–35,
236
Anderson, Sherwood, 95
Andy Warhol Diaries, The (Warhol),
220, 229, 230, 236–37, 238
Arbus, Diane, 70
Architectural Digest magazine, 138, 168
*Arrangement in Grey: Portrait of the
Painter* (Whistler), 27–28, *28*

*Arrangement in Grey and Black: Portrait
of the Painter's Mother* (Whistler),
xiii, *4*, 17; influence on other
artists, 8–10; popularity of, 4, 6;
promotion of, 3–6; qualities of, 19;
sources of, 11, 13–16; on U.S.
postage stamp, 7–8, *8*, 25, 105
*Arrangement in Grey and Black No. 2:
Portrait of Thomas Carlyle* (Whistler),
23–24, *24*
Arrival, The (Hockney), 147, *148*
Art Digest magazine, 32, 33
Art Forum (journal), 217
art galleries, 217
Art News, 33
Artist and Model (Hockney), 172, *173*
artistic collaborations: Agee-Evans,
179–97, 232, 259; Basquiat-Warhol,
211–14, 218–20, 227–41, 259;
Caldwell-Bourke-White, 195–210,
259; large groups and, 259; NAMES
Project Quilt, 259–63, *264–67*,
265–74, 272
*Artist's Mother, Seated, in an Oriental
Headdress, The* (Rembrandt), 6, *7*
authorship, vii, 3
autonomy, 49, 66, 93, 136, 274
avant-garde art, 83, 137, 161

Barnhill, Gary, 263
Baron During the War, The (Lida), 253,
253
Barr, Alfred, 3–4, 7–8, 25; on Picasso,
48; Picasso and, 32; portrait of, 75,
76
Basquiat, Jean-Michel, xvi–xvii, 273;
collaboration with Warhol, 211–14,
255; death of, 214, 236; drug
addiction of, 236, 237–38; fame

and, 214; portrait of, *212;*
"primitivism" of, 220–23, 224;
relationship with Warhol, 218–20,
232–38; sexuality and, 230, 232–35,
235, 294n1
Basquiat (film), 214, 226
Bathroom (Kira), 114
bathrooms, 123, 285n26; men's, 117,
118, 119, 119–20, 287n29; women's,
114–17, *115–17*
Baudelaire, Charles, 153
Bauer, Margaret, 105
Bauhaus, 130
Bean (film), 8
Bearden, Romare, 225
Bedlam (Hockney), 158–59, *161*
Bell, Clive, 19
Benton, Thomas Hart, 31, 38
Beverly Hills Housewife (Hockney),
141–42, *142,* 165
Bigger Splash, A (film), 140–41,
164–68, 226
Bigger Splash, A (Hockney painting),
166, 167, 175
Billings, Henry, 116
Bischofberger, Bruno, 218, 236
Black Lion Wharf (Whistler), *15,* 15–16
Blind Woman, New York (Strand), 96,
98, *98*
Bloom, Harold, xii–xiii, 30–31, 215
Blow Job (film), 214
Blumenschein, Ernest and Mary,
127
Bob, "France" (Hockney), 163, *163*
Bongiorni, Michael, 269, 271
Boone, Mary, 226
Bourke-White, Margaret, xvi, 179,
195–210; collaboration with
Caldwell, 195–210; photography of,
197, 201–2, 204–5, 208–9; sexuality
and, 198–99
Boy about to Take a Shower (Hockney),
143, *145*
Brancuși, Constantin, 83, 169
Brenner, Anita, 33
Breuer, Josef, 181
Brillo Boxes (Warhol), 238, 296n46

Broadway Boogie Woogie (Mondrian),
224
Brueghel, Pieter, 168, 271
Bruening, Margaret, 33
Burial at Ornans (Courbet), ix
Burne-Jones, Edward, ix–x

Caldwell, Erskine, xvi, 179, 195–210;
collaboration with Bourke-White,
195–210; quoted, 205; sexuality
and, 198–99
Camera Work, 78, 83, 85, 87
Cameron, Julia Margaret, 64
Cameron, May, 196
canon, xiii, 3, 33, 64
Canova, Antonio, 14
Carlyle, Thomas, 23, *24*
Cassatt, Katherine Kelso Johnston
(mother of Mary Cassatt), 10, *11,
12,* 20–21, *21*
Cassatt, Mary, 10–11, 20, 27, 276n11
Cast Aside (Hockney), 158, *160*
castration, 17, 22, 107
Cathedrals of Art (Stettheimer), 75, *76,*
77–78
celebrity, xvi, xvii
censorship, 68
Census at Bethlehem, The (Brueghel), 271
Cézanne, Paul, 42
Chabot, Maria, 126, 128–29, 130,
288n46
Charles Demuth (Stieglitz), 95, *95*
Charles the First (Basquiat), 215, *216,*
223–24
Chave, Anna, 111, 112, 113
Child Proceeds, The (Pollock), 45, *46*
children, 54–70, 193–94
Child's Grave, A (Evans), 185, *186*
City Night (O'Keeffe), *110,* 111
Cityscape with Roses (Manhattan)
(O'Keeffe), 110, *111*
Civilization and Its Discontents (Freud),
57
Clark, Kenneth, 162
Clark, T. J., 49, 159
Clark, Vernon, 38–39
Clemente, Francesco, 229

"Club, The," 34
collage, 265–66
colors: in Basquiat's paintings, 225; in O'Keeffe's paintings, 106; in Picasso's paintings, 42, 45
commercialism, 86, 269
commodification, 230
competition, 194–96, 232, 235, 239
Composition in White, Red, and Black (Mondrian), 4
conceptual art, 222
"Constructing Physicality" (Shiff), 98–99
consumerism, 141–42, 169, 176, 193, 241
Corn, Wanda, 127
Courbet, Gustave, ix
Cow's Skull: Red, White, and Blue (O'Keeffe), 107–9, *108*, 114
CPRKR (Basquiat), 224
craft, vii, 82, 93
Creation of Adam (Michelangelo), 91
creativity, 14, 22, 73, 95
Crimp, Douglas, 259
cubism, 32, 111, 172, 265–66
Curtis, James C., 183

Dali, Salvador, 107
Dallesandro, Joe, 233
Damaged Child, 1984 (Mann), 64
Damaged Child, Shacktown, Elm Grove, Oklahoma (Lange), 64, *64*
David, Stuart, 117, 119–20
David Hockney by David Hockney (autobiography), 162, 172
de Kooning, Willem, xvi, 238
dealers, xviii, 85–86, 140
death, 11, 23, 224; in Evans's photography, 185–86, *186;* fate of artworks and, 243; of the father, 53; NAMES Project Quilt as memorial, 255–59, 270; obscurity and, 242–43; in O'Keeffe's work, 107, 109; Proust on, 246. *See also* mortality
Death in Harlem (Hockney), 156, *157*
death instinct, 17, 24
decadence, 116, 117, 176, 193

Degas, Edgar, x
Deitch, Jeffrey, 221–22
Déjeuner sur l'herbe, Le (Manet), ix
Demoiselles d'Avignon, Les (Picasso), ix, 40, 42
Demuth, Charles, xiii, 73, 75, 77, 266; correspondence with Stieglitz, 244–45; influence of, 244; portrait of, 78
desire, vii, xviii, 87–88, 99, 103
Deskey, Donald, 113, 116, 121, 125
Diaz, Al, 217
Dickinson, Emily, 55
Diebenkorn, Richard, 175
Dirty Jessie (Mann), 68
Disintegration (Hockney), 156, 159, *159*
Ditch, 1987, The (Mann), 56–57
Dixon, Deane, 267
Dixon, Rick, 267, *267*
documentary, 191, 193, 200, 226; art and, 205; claims to truth, 209
documentary art, 180, 181
Don Quixote (Pollock), 32
Dos Cabezas (Basquiat), 218–20, *219*
Double Talk (Koestenbaum), 209
doubling, 20, 21
Dove, Arthur, 73, 77
Drama of the Gifted Child (Miller), 63
Drawings of Sex and Death (Lida), 251–52, *252*
Drinking Scene, The (Hockney), *154*, 155
Dubuffet, Jean, 217, 221, 223
Duchamp, Marcel, ix, 57, 123
Dufy, Raoul, 124
Duncan, Charles, 73
Dürer, Albrecht, 11, 13–14, 23
Dürer, Barbara (mother of Albrecht Dürer), 11, 13, *13*
Dürer's Mother (Dürer), 11, 13, *13*

Eakins, Thomas, xvi, 9–10
Eames, Charles, 126
easel, rejection of, 30, 48
East Feliciana Parish, Louisiana (Bourke-White), *204*

Edelman, Lee, 117
ego, 17–19, 273–74
Elbow Creek, Arkansas (Bourke-White),
 200–201, *201*
Election Campaign, The (with Dark
 Message) (Hockney), 156, *157*
Eliot, T. S., 181
Elizabeth Arden Salon, 104, 121,
 123–25
Emerson, P. H., 82
Emmett, Jessie, and Virginia (Mann), 62,
 66
Encke, Ernst and Fedor, 80
Ernst, Max, 107, 124
essentialism, xviii, 17, 215
Evans, Walker, xvi, 179–97, 255;
 collaboration with Agee, 179–97,
 232, 259; photographs of, *184,*
 186–90; sexuality and, 292n25
exhibiting, xi
exhibitionism, 70, 117
expatriatism, 139
Exposure (Harrison), 59, 61–62
expressionism, 222, 223

Fairbrother, Trevor, 229, 237
Fall of Icarus, The (Brueghel), 168
fame/success, vii, xiii, 73, 75; African
 American artists and, xvi–xvii, 214,
 225; autonomy and, 136; fleeting
 nature of, 217; Hockney and, 150,
 162; obscurity and, 242; two faces
 of, 214; Warhol and, 229
family, xvii, 23, *190*, 190–95
Farnsworth house, *129*, 129–30
Faulkner, Simon, 152
Feldman, Marvin, 263, *264, 265*
femininity, 122, 130
feminism, xviii, 115, 277n23
fetishism, 99
figuration: Basquiat and, 222;
 Hockney and, 140, 145, 167;
 O'Keeffe and, 136–37; Picasso
 and, 48, 53, 137; Pollock and, 45,
 46, 53
Fischl, Eric, 222
Flatley, Jonathan, 214

flatness, 19, 51, 132
Flaying of Marsyas (Titian), 68, *69*
Flint, Ralph, 113
Floyd Burroughs's Work Shoes (Evans),
 186, *187*
Fogel, Aaron, 270–71
Force, Juliana, 75
formalism, 133
formlessness, 18–19, 27, 28
Fortune magazine, 196, 197, *197*
Foucault, Michel, xviii
Fountain (Duchamp), 57, 123
Frank, Waldo, 122
Frankfurter, Alfred, 33
Franses, Rico, 263
Freud, Sigmund, xiii–xv, 20; on
 civilization, 57; death instinct and,
 24; male collaboration and, 181;
 Melanie Klein and, 17; on
 repression, 279n21–280n21; as
 subject of painting, 243, 244, *245*
Freud Wrestling with Dora's Demons
 (Lida), 243–44, *245*
Fried, Michael, 159
Friedman, Alice T., 130
Fry, Roger, 19
Full Fathom Five (Pollock), *50*, 51, 53
Fuseli, Henry, 243–44

Garrowby Hill (Hockney), *175*, 175–76
Gauguin, Paul, 163, 223
gaze, subject and object of, 163
Geldzahler, Henry, 75, 168–70, 226;
 Basquiat and, 223; portraits of, *170,*
 171
gender, xvii, xviii, 17, 105
George Lawson and Wayne Sleep
 (Hockney), 169
George Washington (Stuart), 3
George Washington Crossing the Delaware
 (Leutze), 3
Georgia O'Keeffe: A Portrait—Feet and
 Sculpture (Stieglitz), 102, *103*
Georgia O'Keeffe: A Portrait—Hand and
 Wheel (Stieglitz), 93, *94*
Georgia O'Keeffe: A Portrait—Hands and
 Bones (Stieglitz), *109*

Georgia O'Keeffe: A Portrait—Hands and Breasts (Stieglitz), 100, *100*

Georgia O'Keeffe: A Portrait—Hands and Thimble (Stieglitz), *91*, 91–92

Georgia O'Keeffe: A Portrait—Hands and Watercolor (Stieglitz), 89, *90*, 91, 92

Georgia O'Keeffe: A Portrait—A Head (Stieglitz), 89, *89*

Georgia O'Keeffe: A Portrait—Neck (Stieglitz), 96, *97*, 98

Georgia O'Keeffe: A Portrait—Sculpture (Stieglitz), 100, 102, *102*

Georgia O'Keeffe: A Portrait—Torso (Stieglitz), 100, *101*

Ghost Ranch, 134–36

Girl Before a Mirror (Picasso), 40, 42

Girl Reading a Letter (Vermeer), 83, *85*

Glynn, Eugene, 17, 20

God's Little Acre (Caldwell), 197

Golden Marilyn Monroe (Warhol), 212, *213*

Goldwater, Robert, 34, 39, 46

"good object," 17

Gopnik, Adam, 222, 224

Gordon, Witold, 116–17

Gospel Singing, The (Good People) (Madison Square Garden) (Hockney), 150, *151*, 152

graffiti, 220, 224, 255; names and, 215, 217, 218; painting over and, 227

Graham, John, 33–34

Gran Fury, 259–62, *260*

Grannen, Sheila, 183

Greenberg, Clement, xv, 91, 104; on kitsch and avant-garde, 137; on premodernist painting, 133–34; view of advertising, 141

Greenough, Sarah, 80, 83, 283n17

Greenwood, Bob, 263, 265

Greer, Howard, 196

Guernica (Picasso), *37;* critics and, 32, 38–39; Pollock and, 36, 37–39, 40

Guzman, Simon, 263, 265

"Hands" (Anderson), 95

Haring, Keith, 217

Harmony in Grey and Peach Color (Whistler), 26, 27

Harris, Daniel, 269–70

Harrisburg, Arkansas (Bourke-White), 202, 203

Harrison, Kathryn, 59, 61

Hartley, Marsden, 73, 77, 78, 144

Hawkins, Peter, 268

Hayhook, 1989 (Mann), 68, 70

Hazan, Jack, 164, 168

Heaven and Hell (Serrano), 68, *69*

Hebdige, Dick, 222, 225

hedonism, 174, 175

Hemingway, Ernest, 119

Henry Geldzahler and Chrisopher Scott (Hockney), 169, *170*

Hershey, John, 186

heterosexuality, xiv, 174, 232

Hiffernan, Joanna, 16

Hightower, Reggie, 263, 265

Higonnet, Anne, 56

hip-hop, 225

Hockney, David: adoration of Picasso, 172–73, *173*, 176; alter ego of, 249; *A Bigger Splash* (film) and, 164–68, 226; consumer culture and, 141–42; fame/success and, 162–64, 176; first trip to United States, 139; homosexuality and, xviii, 142–49, 155–56, 159, 161, 162–64, 172; moral stance of, 162–64; 1960s culture and, 162; reaction to American life, 150, 153, 156, 158; superficiality and, 141–42

Hogarth, William, 142, 149, 153, 158; moral lesson of *Rake's Progress*, 159, 161

homoeroticism/homosexuality, xiv, xviii, 161, 181, 251; bathrooms and, 114; in Demuth's artwork, 244; gay narrative tradition, 232–35; gay nightlife, 243; hands and, 95–96; in Hockney's art, 142–47, *145–48*, 155–56, 159; illusionism and, 172; in Mapplethorpe's photographs, 59; NAMES Project Quilt and, 261; in

Proust, 247, 249–50; of Warhol,
 232, 235
Hood's Chapel, Georgia (Bourke-White),
 207, *208*
hooks, bell, 214–15, 230
Horkheimer, Max, 141
Horn Players (Basquiat), 224
Horse and Woman with Dead Child
 (Picasso), *40*
Hughes, Robert, xvi, 215
Hunter, Russell Vernon, 125

I Saw the Figure 5 in Gold (Demuth),
 73, *74,* 79
Icebox (Warhol), 240, *241*
Ici, c'est ici Stieglitz (Picabia), 78, 79
Immediate Family (Mann), 55–56,
 62–63, 66, 67, 70
immortality, 23–25, 242, 273
In the Patio II (O'Keeffe), 131–32, *132*
influence, xii, 30–31; Basquiat and,
 215; Pollock and, 38, 46, 51
innocence, 54, 67
integration, 25, 27, 49, 274
Intimate Gallery, 77, 83, 122–23
Introductory Lectures on Psycho-Analysis
 (Freud), xiii–xv

James, Henry, 244
Jay, Martin, 99
Jean-Michel Basquiat (Warhol, 1982),
 211–13, *212*
Jean-Michel Basquiat (Warhol, 1984),
 230, 231
Jessie McBride (Mapplethorpe), 57
Jewell, Edward, 32, 33
Jim and Tom, Sausalito
 (Mapplethorpe), 57
Jimson Weed (Miracle Flower)
 (O'Keeffe), *120,* 121–22, 124
Johns, Jasper, xi, xii, 144
Jones, Cleve, 257, 259, 263, 268
Jones, Malcolm, 55
Journal of a Baby (Stieglitz), 88
journalism, 180, 193, 196

Kasmin, John, 139, 140, 141

Katherine (Stieglitz), *60,* 60–61
Kertess, Klaus, 224
Kira, Alexander, 114
Kitaj, R. B., 145
kitsch, 137, 142, 269
Klein, Jerome, 33
Klein, Melanie, 17, 20, 22, 24, 25
Koestenbaum, Wayne, 181, 193, 194,
 209, 232
Krasner, Lee, 31, 51
Krauss, Rosalind, 82, 88, 159
Kristeva, Julia, 277n23
Kruger, Barbara, 259, 260
Kuniyoshi, Yasuo, 113, 121
Kuspit, Donald, 14, 17

Lady in Pink, The (Lida), 248–49, *249*
Lake George Window (O'Keeffe), 133,
 135
Landlord, Hale County, Alabama
 (Evans), 183, *184,* 193
Lange, Dorothea, 64
Last Supper, The (Leonardo), 231
Last Supper, The (Warhol), 229
Laura Minnie Tingle (Evans), *189,*
 189–90
Lawrence, Jacob, xvii, 225
Leaves of Grass (Whitman), 143
Leonardo da Vinci, xiv
Let Us Now Praise Famous Men (Agee
 and Evans), 179–95; comparison
 with *You Have Seen Their Faces,*
 196–97, 199; mass media and, 203;
 source of title, 242
Leutze, Emanuel Gottlieb, 3
Levine, Sherrie, 226
Lewallen, Janet, 262
Lida, Marc, 242, 243–54, *255,* 269
Lieberman, William, 150, 152
Life magazine, 197
Life Painting for a Diploma (Hockney),
 146, *148*
Lin, Maya, 255
Lincoln, Abraham, 150, 156
Lindstrom, Charles, 39
Lissitzky, El, 91
Little Splash, The (Hockney), 167

Looking at Pictures on a Screen
 (Hockney), 169–71, *171*
Los Gallos, 126
Louis, Joe, 223, 231
Louvre, 3, 16
Love (Basquiat), 239, *240*
Lowery, Douglas, 263, 265
Luce, Henry, 197
Luhan, Mabel Dodge, 126–27, 128
Lust for Life (film), 164
Lynes, Barbara Buhler, 112

McBride, Henry, 75
McDaniel, Georgia (Bourke-White),
 203, 205, *205*
McMullen, Cindy "Gert," 268–69
Madame Mère (Napoleon's Mother Seated)
 (Canova), 14, *14*
Mme Swann in the Allée des Acacias
 (Lida), 253, *254*
Mlle Vinteuil and Her Friend (Lida),
 249–50, *250*
Mailer, Norman, xiii, 215, 242
Malcolm, Janet, 54–55, 66
Man, Bull, Bird (Pollock), 36, *37*
Manet, Edouard, ix
Manhattan (O'Keeffe), 111, *112*, 121,
 285n13
Mann, Emmett, 54, 56–57, 65
Mann, Jessie, 54, 56, 64
Mann, Larry, 66
Mann, Sally, xiii, xvii, xviii, 54–70,
 281n12
Mann, Virginia, 54, 56, 57
Mapplethorpe, Robert, 57, 59, 68, 70
Marin, John, 73, 75, 77; portrait of,
 78; watercolors of, 86; works on
 paper, 83
Marries an Old Maid (Hockney), *154*,
 155–56
masculinity, 119
Masqued Image (Pollock), 39–40, *41*
Masson, André, 31
Matisse, Henri, 87, 168, 172–73
Matta, Roberto, 31
Mayor's Office, Moundville, Alabama
 (Evans), 183, *184*

Meeting the Good People (Hockney),
 150, *151*
Meeting the Other People (Hockney),
 158, *160*
Melia, Paul, 163
men: bathrooms and, 117, *118*, *119*,
 119–20, 287n29; power of, 117; as
 subject and object of gaze, 163
Men without Women (Davis), 117–20,
 119
Merrill, Linda, vii, ix, 22
Metropolitan Museum of Art, 75, 87,
 168
Mexican muralists, 31, 38
Meyer, Richard, 259
Michelangelo, 24, 91, 173
Mies van der Rohe, Ludwig, 126, 129,
 130, 131, 141
Miller, Alice, 63–64, 66, 67
Milo, Albert, 226
mimesis, 83
Mineshaft, The (Lida), 243, *244*
Mingay, David, 164, 168
Miró, Joan, 31
*Mrs. Cassatt Reading to Her
 Grandchildren* (Cassatt), 20–21, *21*
*Mrs. Robert S. Cassatt, the Artist's Mother
 (Katherine Kelso Johnston Cassatt)*
 (Cassatt), 10–11, *12*
Mizer, Bob, 143
modernism, vii, xv, xvii, 4, 8, 33;
 architecture and, 128, 131;
 conspicuous consumption and, 141;
 decadence and, 176; discursive
 modes of, 180; failures of, 142;
 gender and, 105, 137; history
 painting and, 38; as institution, 85;
 murals and, 110–12, 113; Paris as
 old center of, 169; Picasso and, 34;
 Pollock and, 45; portraits of artists
 and, 73, 75, 76–77, 77–80; self-
 reflexivity and, 140; tactility and,
 98–99; viability of, 222
Moncrieff, C. K. Scott, 247
Mondrian, Piet, 4, 224
money, vii, ix–x, xiii, 85–86
Moon Woman (Pollock), 40, 42, *43*

Moonert, Gary, 263, 265

Moore, Henry, 63

Morris, Chuck, 262

mortality, 23, 176, 185, 272. *See also* death

motherhood, 4, 6, 8, 16, 73; artists as mothers, 54–70; "bad mother," 65–66; idealization and, 25; psychoanalytic theory and, 17–18, 20, 277n23

mourning, 17

Mumford, Lewis, 96, 98, 112, 125

Muñoz, José Esteban, 236

Museum of Fine Arts, Boston, 176

Museum of Modern Art (MoMA), 3, 32, 104; Greenberg on, 137; mural competition and, 110–12, 113, 121

"Mutt, R.," 123

My Hustler (film), 214

Myself and My Heroes (Hockney), 150

NAMES Project Quilt, 242, 255–63, *256, 264–67, 265–74*, 272

Namuth, Hans, 49, 51, 164, 167, 226

narcissism, 61, 62, 63

narratives, xv, 271

National Gallery, 88

Neil, 1925 (Weston), 65, *65*

neoexpressionism, 222

Night Mist (Pollock), 32

Nightmare (Fuseli), 243

Nochlin, Linda, 10

Nocturne: Blue and Silver-Chelsea (Whistler), *18*, 18–19

Nocturne in Black and Gold: The Falling Rocket (Whistler), vii, *viii*, ix–x, 27, 29

Nude Descending a Staircase (Duchamp), ix

No. 1A, 1948 (Pollock), 29, *30*, 49

Obemeyer, Emmy, 60

Ocean Park series (Diebenkorn), 175

Oedipal narrative, xii–xiii, 15, 17, 238

O'Keeffe, Georgia, x–xi, xvii, 73, 255; ascendancy in art world, 104; biographies of, 105, 113; Chabot

and, 288n46; gendered view of, xviii, 105; modernism and, 270; in New Mexico, 125–38, 139; portraits by, 108; quoted, 107; Radio City Music Hall commission and, 110–25; relationship to her artwork, 273; relationship with Stieglitz, 86, 87, 99–100, 102, 109; Stieglitz portraits of, xiii, 60, 86–89, *89–91*, 91–93, *94*, 95–96, *97*, 98–100, *101–3*, 102–3, 258–59; Stieglitz's influence on, 109; works on paper, 83

Olin, Margaret, 180–81

Onebane, Thad, 265, 267

Orozco, José, 31, 38

Oxidation Paintings (Warhol), 57, 211–14

Pack, Arthur, 136

Painter with a Model Knitting (Picasso), 52, 53, 172

painting, xviii–xix, 19; illusionism of, 147; Oedipal urges and, 238; as preeminent medium, 49; tactility and, 98–99

Paramount (Basquiat and Warhol), 227, *228*

Parker, Charlie "Bird," 223–24, *225*, 226

Pater, Walter, 20, 244

Patio with Black Door, 1955 (O'Keeffe), 132, *133*

Peart, Ronald F., Jr., 265, *266*

Peeping Tom (film), 61–62

Perfect Tomato, The (Mann), 64, 65–66

Peter Getting Out of Nick's Pool (Hockney), 165, *165*

phallic imagery, 100, 102, *102*, 107–8, *108*, 117, 119

Photographic Journal of a Baby (Stieglitz), *58*, 59–60

photography, 54–70, 283n17; Agee-Evans collaboration, 179–97; Caldwell-Bourke-White collaboration, 195–210; Hockney and, 166–67, 169; Stieglitz and,

81–103; writing and, 181–82, 210

Physique Pictorial magazine, *144*, *232;*
Hockney and, 142–43, 146, 147,
150; Warhol and, 231

Picabia, Francis, 78

Picasso: Forty Years of His Art (MoMA
exhibit), 32

Picasso, Pablo, ix, 137, 168, 223;
canon of modern art and, 32–35;
collage and, 265; Hockney and,
172–73, *173*, 176; influence on
Pollock, 31–32; postwar reputation
of, 46, 48; quoted, 35–36, 51;
reputation of, 280n26; Stieglitz
and, 83

"Pictorial Photography" (Stieglitz), 86

Picture Emphasizing Stillness (Hockney),
149, *149*, 168

Pietà (Michelangelo), 24

piss paintings, 211–14, *212*, *213*

Play within a Play (Hockney), 139–41,
140

Poe, Edgar Allan, 244

Poison (Basquiat and Warhol), 238, *239*

Pollock, Jackson, xvii, 57, 238, 255,
273; drip paintings of, 29, 30, *30*,
45, *50*, 51, 53; figuration and, 36;
on film, 49, 51, 164–65, 167, 226;
key Picasso works and, 36–40, 42;
quoted, xi–xii, 29–30; relationship
to his paintings, 49, 51

Pop Art, 159, 176, 227, 236

Pop Out anthology, 236

Popsicle Drip, 1985 (Mann), 65

pornography, 59, 68, 86

Porter, Arkansas (Bourke-White), 207,
209

Portrait and a Dream (Pollock), 52, *53*

Portrait of an Artist (Hockney), 165,
167

Portrait of an Old Woman (Rembrandt),
6–7, *7*

Portrait of Andy Warhol (Basquiat), *233*

Portrait of the Artist's Mother (Tanner),
8–10, *9*

postage stamps, art on, 105, *106*

postmodernism, 68, 226, 259, 271;

authorship and, vii; discontinuity
and, 271; identity and, 164

Pound, Ezra, 181

Powell, Michael, 61

prehistoric art, 48–49

Price, Reynolds, 55

"Primitive Art and Picasso" (Graham),
33–34

primitivism, 220–22

privacy, 105, 114, 180, 192, 207

Proust, Marcel, 244–49, 252

Proust Series, The (Lida), 246–54,
249–54

psychoanalysis, 17, 20, 36, 244;
motherhood and, 277n23;
repression and, 280n21

Puritan tradition, 4

queer studies, xviii

*Quilt: Stories From the NAMES Project,
The* (Ruskin), 262

race/racism, xvi–xvii, 10, 206–7,
234–35, 238; commodification of
black bodies, 230–31; critics and,
215; stereotypes, 222, 236

"Radiant Child" (Ricard), 217–18

Radio City Music Hall, 110–17,
115–17, *118–19*, 119–25, 138, 194

Raid the Icebox (RISD Museum show),
240

Rake's Progress, A (Hockney), 139–62,
214, 249. *See also individual etchings of*

Rake's Progress, A (Hogarth), 142, 155,
155, 159, 161

Rake's Progress, A (Stravinsky), 169

Ralston, Adam, 259

Rauschenberg, Robert, xvi, 238, 265

Ray, Man, 95

Raynor, Vivian, 234, 235

Read My Lips (Boys) (Gran Fury), 260

Reading Le Figaro (Cassatt), 10, *11*

Receiving the Inheritance (Hockney),
150, *151*

Red Poppy (O'Keeffe), 105, *106*

Rembrance of Things Past (Proust),
246–54, *249–54*

Rembrandt Harmensz van Rijn, 6–7, 22
Renz, George, 268, 273
representation, 49, 104
Rhode Island School of Design, 240
Ricard, Rene, xvi, 217, 242, 255
Rifka, Judy, 217, 218
Rivera, Diego, 38
Robinson, Roxana, 104
Rodin, Auguste, 83
Romanticism, xiv
Roosevelt, Franklin Delano, mother of, 3–4, 5
Rosenfeld, Paul, 112
Rothenberg, Susan, 222
Royal College of Art (London), 145
Rubin, William, 31
Ruskin, Cindy, 262
Ruskin, John, vii, ix–x, 27, 28, 29

Saarinen, Eero, 126
St. Joe Louis Surrounded by Snakes (Basquiat), 223, *223*
Salle, David, 222
Sargent, John Singer, 27
scatology, 104, 137
Schiff, Gert, 172
Schlesinger, Peter, 164, 165
Schmeling, Max, 231
Schnabel, Julian, xvi, 214, 217, 222, 225–27
Scully, Vincent, 130
sculpture, 22, 24
Seated Bather (Picasso), 45
Seated Woman (Picasso), 42, *44*
Segal, Hanna, 24
Self-Portrait (Warhol), 220, *221*
Self-Portrait with Brush and Palette (Steichen), 81, *81*
self-portraits, 14–15, 80–81, *81;* Warhol's, 220, *221;* Whistler's, 27–28, *28*
selfhood, 31, 49, 217–18; conscious and unconscious, 40; loss of, 18; Oedipal conflict and, xii
Seligmann, Herbert J., 79
Sendak, Maurice, 246, 248

seriality, 88
Serrano, Andres, 57, 68
7-Stone Weakling, The (Hockney), *153,* 155
Seventeenth V.N. Painting, The (Hockney), 173, *174*
Sexism Rears Its Unprotected Head (Gran Fury), 259, *260*
sexual identity, xvi
sexuality, xviii, 192, 198–99; Basquiat and, 230; children and, 55; homoeroticism of male collaboration, 193, 194, 232. *See also* heterosexuality; homoeroticism/homosexuality
Shakespeare, William, 53
Sharecropper's Family, The (Evans), *190,* 190–91
Shiff, Richard, 98–99
signature, vii, 51
silence, 19
Silver, Jonathan, 175
Silver, Kenneth, 168
Silverthorne, Jeanne, 221
simulation, 226
Sindt, David, 262, *264*
Siqueiros, David, 31, 38
Skulls (Warhol), 229
Smith, Michael, 257
social realism, 38
space, representation of, 19
Speaking for Vice (Weinberg), xviii
Splash, The (Hockney), 167
stage parents, 62–63
Standing Woman (Picasso), 45
stasis, 26, 27
Steichen, Edward, 83, 85–86
Stein, Gertrude, 32
Stella, Frank, xv
stereotypes, 207, 222, 236
Stettheimer, Florine, 75, 78
Stieglitz, Alfred, x, xi, xvii, 139, 273; on art and love, xiii; as art dealer, 85–86; circle of, 73, 77, 79–80, 122; daughter of, 59–61, *60;* death of, 126, 134; decline of, 104; Demuth's correspondence with, 244–45;

galleries of, 83, 122–23; Intimate Gallery (*303*) of, 77; modernism and, 75; as O'Keeffe's agent, 113; O'Keeffe's house and, 130; O'Keeffe's Radio City commission and, 123–25; photographs of Georgia O'Keeffe, 86–89, *89–91*, *91–93, 94,* 95–96, 97, 98–100, *101–3,* 102–3, 258–59; portraits of, *75, 76, 77,* 77–78

Stokes, Adrian, xvi, xix, 16–20, 27, 274; on death instinct, 23–24; ideal of integration, 24; on painting, 49

Stott, William, 199

Strand, Paul, 96, 98

Stuart, Gilbert, 3

Sturken, Marita, 272, 273

Summerside, Georgia (Bourke-White), 201, *202*

Sunlight and Shadows, Paula, Berlin (Stieglitz), 82–83, *84*

Surrealism, 107

Swann Tells Mme de Guermantes That He Is Dying (Lida), 250–51, *251*

Sweetfern, Arkansas (Bourke-White), 203, *204*

Swinburne, Algernon, 6

Taki (graffiti artist), 217

Tanner, Henry Ossawa, xvii, 8–10, 225

Tate, Greg, 225

Taylor, Francis, 75

Tchelitchew, Pavel, 75

technology, 93, 272

Ten Punching Bags (Basquiat and Warhol), 231

Terrible Picture, 1989 (Mann), 57

That's the Way I See It (Hockney), 172

The Start of the Spending Spree and the Door Opening for a Blonde (Hockney), 152, *152,* 155

Thompson, Robert, 223, 224, 225

Three Dancers, The (Picasso), 45, *48*

Tintoretto, 173

Titian, 68, 173

Tobacco Road (Caldwell), 197

Town & Country magazine, 123–24, *124*

Trachtenberg, Alan, 185

transcendence, 25

291 gallery, 83, 85

Two (Pollock), 32

Twombly, Cy, 217

Udall, Sharyn R., 134

unconscious, the, 33, 34, 36, 53, 221

United States Holocaust Memorial Museum, 255, 258

Untitled (Aaron) (Basquiat), 223, *223*

Untitled No. 582 (Pollock), 37, *38,* 39

urination, 54, 57, 59, 117

Van Gogh, Vincent, 176, 217

Vermeer, Jan, 83

Vietnam Veterans Memorial, 255, 258

Viewing a Prison Scene (Hockney), 156, *157*

Villa Curonia, 127

Virginia Asleep (Mann), 68

Virginia at 3 (Mann), 67

vision, denigration of, 99

voyeurism, 59, 61

Wagner, Anne Middleton, 87, 92, 93, 104, 112, 122, 137

Wallet Begins to Empty, The (Hockney), 156, *158*

Warhol, Andy, xvi, xvii, 75, 159; collaboration with Basquiat, 211–14, 227–41, 255; death of, 236, 237; homosexuality and, xviii, 294n1; moral position of, 163; relationship with Basquiat, 218–20, 232–38; scatological art and, 57

Warren, Robert Penn, 137–38, 270

Waugh, Thomas, 232

We 2 Boys Together Clinging (Hockney), 143, *147*

Weber, Andrew, 262

Weston, Edward, 64–65

Wet Bed, 1987 (Mann), 54, 57, 59, 66

What Is Modern Art? (Barr), 4, *5,* 8

Wheeler, Monroe, 75

Whistler, Anna (mother of James M. Whistler), 6, 9, 10, 11, 23; depiction

of, 25; relationship with artist-son, 15–16, 22

Whistler, James McNeill, xvii, 22–23; lawsuit against Ruskin, vii, *ix,* ix–x, 27; portrait of mother, xiii, 3–8

Whistler's Mother (painting). See *Arrangement in Grey and Black: Portrait of the Painter's Mother* (Whistler)

White Angel (Pollock), 45, *47*

White Canadian Barn, No. 2 (O'Keeffe), 133, *134*

Whitman, Walt, 143, 144, 150

Williams, William Carlos, 73, 75, 79

Winogrand, Garry, 70

womb envy, 56

women, 6, 113, 199; bathrooms and, 114–17; commodification of, 93; decadence and, 116, 117; female nude, 87; Freud on, 57; modernism and, 137; photographic portraits of, *188,* 189; in Picasso's art, 40, 42, *42;* power of, 115–16, 120; quilt making tradition and, 262, 298n30. *See also* femininity; feminism

Women, The (film), 115

Wood, Grant, 3

Woods, Alan, 165–66

Wright, Frank Lloyd, 130, 131

You Have Seen Their Faces (Caldwell and Bourke-White), 179, 195–210, *200*

Zenith (Basquiat and Warhol), 227, *228*

Zola, Emile, 244

Photo Credits

AKG London (fig. 1.10); © 2000 The Art Institute of Chicago, All Rights Reserved; Art Resource, New York (figs. 2.12, 5.10); © 2001 Artists Rights Society (ARS), New York / ADAGP, Paris (figs. 8.4, 8.5, 8.7, 8.8, 8.14, 8.19); © Center for Creative Photography, Arizona, Board of Regents (fig. 3.4); © 1979 The Detroit Institute of Arts (fig. 1.17); © 1985 The Detroit Institute of Arts (fig. 1); Duke of Devonshire and the Chatsworth Settlement Trustees; photograph courtesy of the Photographic Survey, Courtauld Institutes (fig. 1.11); © 1995 by Hester + Hardaway (figs. 5.14, 5.15, 5.16); © 2001 Paul Hester, Houston; © David Hockney (figs. 6.1, 6.2, 6.4, 6.5, 6.6, 6.8, 6.9, 6.10, 6.11, 6.12, 6.13, 6.14, 6.15, 6.16, 6.18, 6.19, 6.20, 6.21, 6.22, 6.23, 6.24, 6.25, 6.26, 6.27, 6.28, 6.29, 6.30, 6.31, 6.32, 6.33); Erich Lessing / Art Resources, NY (figs. 1.13, 3.5); Photo by Paul Margolies (figs. 9.9, 9.12, 9.13, 9.14, 9.15, 9.16, 9.17); Robert E. Mates (fig. 2.8); © 2001 The Museum of Modern Art, New York (figs. 2.1, 2.9, 2.13, 2.15, 5.11, 5.21, 8.3, 8.6); © 2000 Board of Trustees, National Gallery of Art, Washington (figs. 4.8, 4.9, 4.10, 4.11, 4.12, 4.13, 4.15, 4.16, 4.17, 4.18, 5.3); © 2001 The Georgia O'Keeffe Foundation / Artists Rights Society (ARS), New York (figs. 5.2, 5.4, 5.5, 5.6, 5.12, 5.18, 5.20, 5.21); Photo from New York, Coe Kerr Gallery, Mary Cassatt: An American Observer. A Loan Exhibit for the Benefit of the American Wing of the Metropolitan Museum of Art, 1984 (fig. 1.14); Murals by American Painters and Photographers [New York: Museum of Modern Art, 1932] (fig. 5.4); © 2001 Estate of Pablo Picasso / Artists Rights Society (ARS), New York (fig. 2.2); © 2001 Estate of Pablo Picasso / Artists Rights Society (ARS), New York (figs. 2.5, 2.7, 2.9, 2.12, 2.15); © 2001 Pollock-Krasner Foundation / Artists Rights Society (ARS), New York (figs. 2.1, 2.3, 2.4, 2.16, 2.8, 2.10, 2.11, 2.13, 2.14); © President and Fellows of Harvard College, Harvard University (fig. 1.16); © Réunion des Musées Nationaux (fig. 1.1); Courtesy of the University of Georgia Press (figs. 7.9, 7.10, 7.11, 7.12, 7.13, 7.14, 7.15, 7.16, 7.17, 7.18); UPI, Bettman Newsphotos (fig. 1.2); © 2001 The Andy Warhol Foundation for the Visual Arts / Art Resource, New York (figs. 8.1, 8.2, 8.3, 8.6, 8.11, 8.12); © 2001 The Andy Warhol Foundation / ADAGP, Paris / Artists Rights Society (ARS), New York (fig. 8.9, 8.10, 8.16, 8.18)